CATHERINE B. REYNOLDS FOUNDATION

1676 International Drive / Suite 501
McLean, Virginia 22102
Phone 703.442.3030 Fax 703.442.3031

The Catherine B. Reynolds Foundation is delighted to cosponsor the exhibition *Goya: Images of Women* at the National Gallery of Art in Washington, DC.

Goya is often called "the father of modern art" because of the bold technique of his paintings, the haunting satire of his etchings, and his belief that the artist's vision is more important than tradition. His uncompromising portrayal of his times marks the beginning of nineteenth-century realism. His individual genius has enlightened countless generations and will surely inspire generations to come.

The Catherine B. Reynolds Foundation is dedicated to programs that further the value of education, the power of the individual, and the pursuit of excellence. Our goal is to ignite the imagination, to build character, and to inspire young people to reach for greatness. All accomplishments begin with the talent of a single individual, whose new ideas lift civilization to unforeseen heights.

It is in this spirit that we celebrate Francisco Goya y Lucientes' remarkable achievements. We are honored to bring this unique exhibition of Goya's representation of women to the National Gallery of Art.

Catherine B. Reynolds

GENERAL DYNAMICS

Nicholas D. Chabraja
Chairman and Chief Executive

General Dynamics is pleased to support *Goya: Images of Women*, the first major exhibition of the representation of women by Francisco Goya y Lucientes (1746–1828), at the National Gallery of Art.

Enriched by loans from the Museo Nacional del Prado and other major collections in Europe and the United States, this exhibition includes paintings, drawings, prints and tapestries—many of which have never been seen in the U.S. The exhibition encompasses women from all stations—from those of the working class to aristocrats—and mirrors the many roles of women in Spanish society of the late eighteenth and early nineteenth centuries. It offers a unique opportunity to consider Goya's art through his representation of women.

Through our cosponsorship of this exhibition, we celebrate our friendship with the Spanish government and the people of Spain. We hope that visitors from around the world will enjoy looking at these beautiful works.

Sincerely,

Nicholas D. Chabraja

3190 Fairview Park Drive
Falls Church, VA 22042
Tel 703 876 3000

Goya

IMAGES OF WOMEN

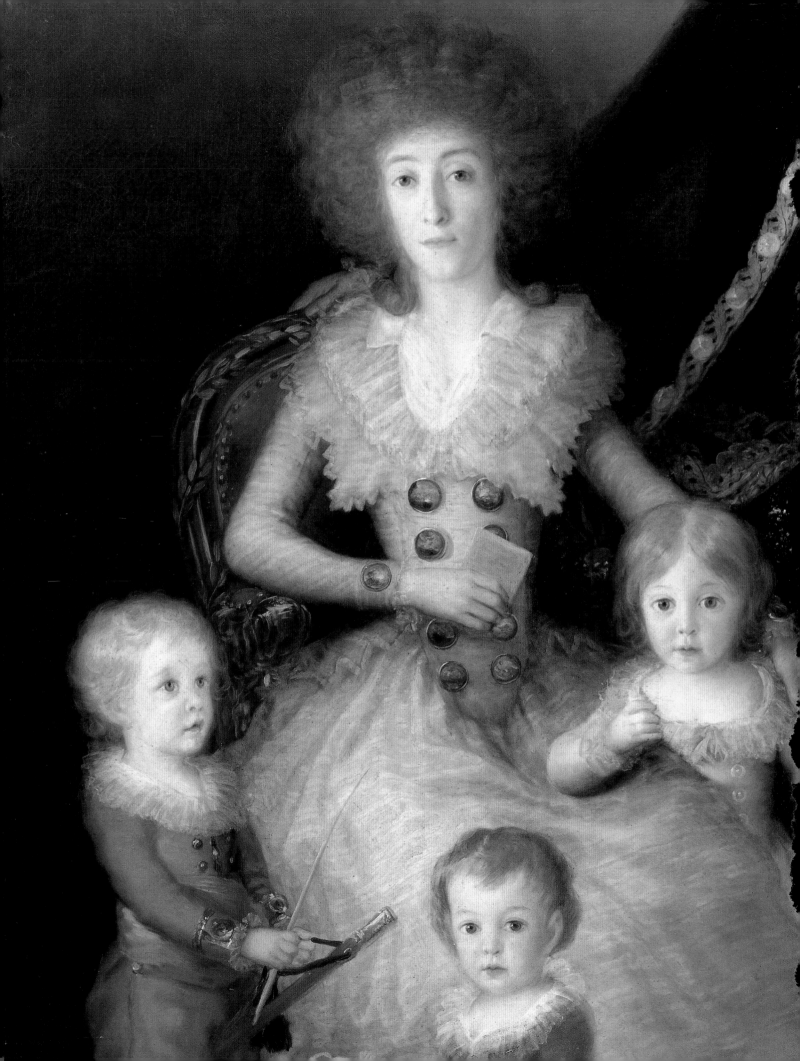

Goya

IMAGES OF WOMEN

JANIS A. TOMLINSON, EDITOR

WITH CONTRIBUTIONS BY

FRANCISCO CALVO SERRALLER

AILEEN RIBEIRO

CONCHA HERRERO CARRETERO

ANNA REUTER

NATIONAL GALLERY OF ART
WASHINGTON
YALE UNIVERSITY PRESS
NEW HAVEN AND LONDON

The exhibition was organized by the Fundación Amigos del Museo del Prado; Museo Nacional del Prado, Madrid; and the National Gallery of Art, Washington. It is supported by an indemnity from the Federal Council on the Arts and the Humanities.

EXHIBITION DATES
30 October 2001–9 February 2002 Museo Nacional del Prado
10 March 2002–2 June 2002 National Gallery of Art, Washington

This book was produced by the Editors Office, National Gallery of Art

Judy Metro, *Editor-in-Chief*
Alexandra Bonfante-Warren, Katherine Whann, Fronia Simpson, *Editors*
Helene J.F. de Aguilar, *Translator*
Chris Vogel, *Production Manager*
Designed by Lindgren/Fuller Design, New York, NY

Typeset in New York, NY, by Lindgren/Fuller Design and printed in Spain by Julio Soto.

The clothbound edition is published by the National Gallery of Art in association with Yale University Press, New Haven and London.

Library of Congress Cataloging-in-Publication Data
Goya, Francisco, 1746–1828.
 Goya : images of women / Janis A. Tomlinson, editor ; with contributions by Francisco Calvo Serraller...[et al.].
 p. cm.
 Catalog of an exhibition held at the National Gallery of Art.
 Includes bibliographical references and index.
 ISBN 0-89468-293-8 (paper)
 ISBN 0-300-09493-0 (cloth)
 1. Goya, Francisco, 1746–1828—Exhibitions. 2. Women in art—Exhibitions. I. Tomlinson, Janis A. II. Calvo Serraller, F. (Francisco), 1948– III. National Gallery of Art (U.S.). IV. Title.
 N7113.G68 A42002
 760'.092—dc21 2001059637

Entries written by Anna Reuter (AR), Janis A. Tomlinson (JT), and Concha Herrero Carretero (CHC).

Cover illustrations: (front) *Thérèse-Louise de Sureda* (cat. 33), detail; (back) *Autumn (The Grape Harvest)* (cat. 16), detail.

Frontmatter illustrations: (p. 2) *The Family of the Duke and Duchess of Osuna* (cat. 27), detail. (p. 12) *A Maja and Celestina* (cat. 62).

Contents

Directors' Forewords

The National Gallery of Art takes great pleasure in joining with our colleagues at the Museo Nacional del Prado in presenting the exhibition *Francisco de Goya: La imagen de la mujer / Goya: Images of Women*. Conceived by the Fundación Amigos del Museo del Prado and the Museo Nacional del Prado, the exhibition was brought to the attention of the National Gallery of Art, resulting in an enthusiastic transatlantic collaboration aimed at refining and enriching its contents to serve the needs of both Spanish and American audiences.

Although Francisco Goya y Lucientes has been the subject of numerous monographs and many exhibitions, rarely is his imagery of women examined. Looking at the works in this exhibition, we become aware of how Goya defies any simple categories, examining women from a wide range of classes and walks of life, oscillating between reality and fantasy. In Spain, many of his images of women have been taken as historical documents of costume and social mores. In the United States, we often think of Goya's imagery of women mainly in terms of his portraiture—admittedly sometimes harsh, but always captivating. Nevertheless, there is also a tendency to see Goya solely as a critic or satirist of women. This exhibition illustrates the fallacy of such a viewpoint and provides a unique opportunity for visitors in Madrid and Washington to begin looking at Goya's images of women in a new way.

In Goya's early tapestry cartoons we see his fascination with women of all stations, as reflected in their actions, gestures, and costumes. These early works reveal a will to observe the world around him and go beyond traditionally sanctioned subjects. Throughout his life, in smaller uncommissioned paintings, drawings, and prints, Goya would continue this exploration of women confronting their world. Each of his portraits investigates individual character to a degree that clearly distinguishes it from the more conventionally pretty renderings of women by many of his contemporaries. The diversity among these portraits is itself wondrous, as we are reminded each time we enter the room

in the National Gallery that includes *The Marchioness of Pontejos, Señora Sabasa García,* and *Thérèse-Louise de Sureda.* It would seem that Goya could not take his subject for granted. Even in painting the *Maja desnuda,* in the collection of the Prado, he updates the traditional voluptuous nude, transforming her into one of the dark-haired small-boned women often seen in his drawings. At some later date, he further confounds tradition by repainting her, now more voluptuous, more colored, and fully clothed.

Such an ambitious and beautiful exhibition would not be possible without the cooperation of many individuals. My deepest appreciation goes to the private and public lenders from around the world who have been willing to make their rare works available on loan. Encompassing paintings on canvas, drawings, etchings, lithographs, and miniatures on ivory, these works remind us once again of the awesome creative vitality of the artist and the generosity of lenders willing to share their treasures with a wider audience.

At the foundation of every exhibition is the expertise of its curators. We are extremely grateful to Francisco Calvo Serraller, *comisario* of the exhibition at the Prado, whose concept and vision provided the thesis for the exhibition in Washington. I am most grateful to Janis A. Tomlinson, the Gallery's guest curator for the project, who together with Philip Conisbee, senior curator of European paintings, refined the scope and selection of the exhibition in Washington. I also thank my colleagues Eduardo Serra, president of the Real Patronato del Museo del Prado, and Fernando Checa Cremades, former director of the Museo Nacional del Prado, for their personal support of the project from the beginning and for sharing this extraordinary exhibition with the National Gallery and the American people.

Special thanks go to Manuela B. Mena Marqués and José Manuel Matilla of the Prado for their parts in making this exhibition possible, and to Nuria de Miguel, director of the Fundación Amigos del Museo del Prado, and to María Luisa Martín Argila, Rosa Ventosa, and the staff of the Fundación for coordinating the administrative matters in Madrid. In Washington, I thank D. Dodge Thompson, Ann B. Robertson, Abbie Sprague, and Suzanne Sarraf in the department of exhibitions, who with the assistance of Florence Coman and Michelle Bird in the department of European paintings handled the administrative details. We hope this exhibition will become a model for future collaborations between our two institutions.

It is the organizers' intention that the exhibition and its catalogue, written by Spanish and American scholars, will serve to make the works of this great Spanish artist better known to and appreciated by audiences in both Madrid and Washington.

EARL A. POWELL III, DIRECTOR
NATIONAL GALLERY OF ART

Studies on the representation of women and on images related to feminine themes have become not only abundant but even routine in recent years. This research has resulted in art exhibitions, such as this one, that examine the iconography and images of an important subject of art history.

If at the beginning of the modern period there existed an artist who explored in depth and variety the universe of the feminine, this artist was Goya. His depictions range from the innocent, trusting, and youthful-looking women present in the genre scenes of many of his tapestry cartoons to the witches and grotesque imagery of the later paintings, drawings, and aquatints. Amidst this diversity, Goya also leaves us the best representations of aristocratic Spanish women of his age, from family portraits—in which women and children play a pivotal role—to the female nude, including the celebrated *Maja desnuda*, essential to any contemporary treatment of this topic.

In terms of stylistic and formal considerations, Goya employed the full range of artistic innovations of his time, from the gentle and pleasant images of the rococo, to the simple neoclassical solemnity of *The Countess of Chinchón*, and, in his last canvases, to the romanticism of the early nineteenth century. Each of these aspects is well represented in this wonderful exhibition. Francisco Calvo Serraller has gone to great lengths to treat this subject, which interests him so passionately, with sensitivity and intelligence.

I would like to thank the Fundación Amigos del Museo del Prado and their president, Carlos Zurita, duke of Soria, for their generous efforts on behalf of this exhibition. The Fundación celebrates both its twentieth anniversary and its chief curator, Francisco Calvo Serraller, former director of the Museo Nacional del Prado. My gratitude extends to all who have collaborated within the museum, and especially to the always generous sponsor, the Fundación Caja Madrid.

I would also like to extend my appreciation to the National Gallery of Art in Washington and to its director Earl A. Powell III, who from the very beginning welcomed the proposal with an enthusiasm that we in the Prado shared in equal measure.

FERNANDO CHECA CREMADES, FORMER DIRECTOR
MUSEO NACIONAL DEL PRADO

The remarkable work of Francisco Goya brings us face to face with the changed reality that he and his contemporaries confronted as the world of the ancien regime ended and the new one began. The creations of this Spanish painter embody all the important concepts and components of the age—the enormous social, cultural, artistic, and historic transformations taking place at the end of the eighteenth and beginning of the nineteenth century.

During the second half of the eighteenth century the role of women broadened, giving them a more active and significant presence, especially in aristocratic circles of society. This change, noticeable already in the French rococo paintings and in those of the new English school, was taken up in earnest by Goya. He never hesitated to depict his females as true protagonists, not only in their portraits, but also in vignettes and genre scenes. Goya displayed a special sensitivity toward the representations of women from his earliest cartoons to the end of his life's work.

The exhibition, organized by the Museo Nacional del Prado, the National Gallery of Art, and the Fundación Amigos del Prado, which celebrates its twentieth anniversary this year, explores Goya's world in the realm of the feminine from a variety of perspectives and seeks to better our understanding of the work of the painter from Aragon. Opening at the Prado in Madrid and culminating at the National Gallery of Art in Washington, the exhibition initiates collaboration between these great museums that will, I hope, deepen in the near future. To all the institutions and to the sponsor, the Fundación Caja Madrid, I offer my most sincere thanks.

EDUARDO SERRA, PRESIDENT
REAL PATRONATO DEL MUSEO DEL PRADO

Acknowledgments

Goya: Images of Women results from the cooperation of the National Gallery of Art in Washington, the Fundación Amigos del Museo del Prado, and the Museo Nacional del Prado in Madrid. The exhibition would not have taken place without the full support of Earl A. Powell III, director of the National Gallery of Art, to whom I express my deepest gratitude. I would also like to thank Eduardo Serra, president of the Real Patronato del Museo del Prado, for his unwavering support in this endeavor, and Fernando Checa Cremades, former director of the Museo Nacional del Prado. I am also extremely grateful to Carlos Zurita, duke of Soria and president of the Fundación Amigos del Museo del Prado, for his kind encouragement throughout the development of the exhibition.

This exhibition represents an international collaboration among scholars as well as institutions. First and foremost, Francisco Calvo Serraller must be thanked for his initial proposal of the exhibition's theme and for his central contribution to the catalogue. In Washington, Philip Conisbee, senior curator of European paintings, was unstinting in his help throughout the project. The catalogue has benefited greatly from the scholarly contributions of Aileen Ribeiro, Concha Herrero Carretero, and Anna Reuter. For their advice and assistance along the way, I thank Manuela B. Mena Marqués and José Manuel Matilla of the Museo Nacional del Prado. Many colleagues from a variety of museums have also been generous with their time and expertise. My thanks to Stephanie Stepanek of the Museum of Fine Arts, Boston; Lee Hendrix and Christine Giviskos of the J. Paul Getty Museum; Jennifer Tonkovich of The Pierpont Morgan Library; Colta Ives and Hubert von Sonnenberg of the Metropolitan Museum of Art; and Elizabeth Wycoff of the New York Public Library. Thanks to Nigel Glendinning for the support he lent to this project from its inception. My *agradecimiento* also to colleagues at the Fundación Amigos del Museo del Prado: Nuria de Miguel for her expert guidance; María

Luisa Martín de Argila and Rosa Ventosa for their coordination of all exhibition matters; and Beatriz Carderera for her assistance with publicity of the exhibition in Madrid. At the National Gallery, Deborah Ziska, chief press and public information officer, lent her great enthusiasm to the promotion of this exhibition, with the ready assistance of Lisa Knapp and Kristin Fuller.

Also in Washington I thank those already mentioned in the Directors' Forewords for their expert administration of loans and for their curatorial assistance. I am grateful to Susan M. Arensberg and Mark A. Leithauser for advice on the selection and installation of the works; to Michelle Fondas, registrar for the exhibition, for assisting with many details; and to Faya Causey, head of academic programs, for her crucial assistance. Judy Metro, editor-in-chief, along with several others guided me through the complexities of the catalogue and made the project pleasurable. My admiration and gratitude extend to Katherine Whann, Alexandra Bonfante-Warren, and Fronia Simpson for their editorial acumen. I also thank those who worked with good humor under pressure to produce the catalogue: in the editors office, Chris Vogel, production manager, and Mariah Shay, production editor; Helene J.F. de Aguilar, Marta Horgan, and Lydia Beruff for their prolific translations; and Laura Lindgren and Celia Fuller for the handsome design. To all, my deepest appreciation and gratitude.

JANIS A. TOMLINSON
GUEST CURATOR

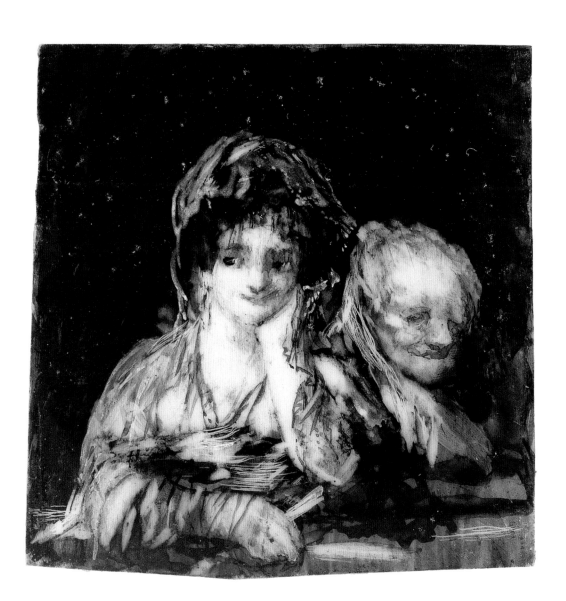

Lenders to the Exhibition

Arango Collection
The Art Museum, Princeton University
Biblioteca Nacional, Madrid
Mr. and Mrs. Leon Black
Brooklyn Museum of Art
Sterling and Francine Clark Art Institute
Fondazione Magnani-Rocca, Parma
The J. Paul Getty Museum
Marqués de la Romana Collection
The Metropolitan Museum of Art
Stanley Moss —Art Focus, Riverdale, New York
Museo Nacional del Prado, Madrid
Museum of Art, Rhode Island School of Design
Museum of Fine Arts, Boston
The National Gallery, London
National Gallery of Art, Washington
National Gallery of Ireland
The New York Public Library
Palais des Beaux Arts de Lille
Patrimonio Nacional, Madrid
The Pierpont Morgan Library, New York
Private Collections
State Hermitage Museum, St. Petersburg
Wadsworth Atheneum Museum of Art

Goya: Images of Women

JANIS A. TOMLINSON

When the Fundación Amigos del Museo del Prado and the Museo Nacional del Prado proposed to the National Gallery of Art in Washington an exhibition on Goya's imagery of women, the first question raised was: "Why Goya's women?" Apart from the initial attractiveness, and perhaps trendiness, of the topic, could it be justified? What would this exhibition show us about the artist or his era that we didn't already know? In other words, do Goya's images of women add up to a whole greater than the sum of the parts?

Goya was above all else a visual artist with an unrelenting drive to observe and represent the world around him. In a statement on the education of artists delivered to the Real Academia de Bellas Artes de San Fernando in 1792, he describes nature as the artist's source:

> What a profound and impenetrable arcanum is encompassed in the imitation of divine nature, without which there is nothing good, not only in Painting (which has no other task than its exact imitation) but in the other sciences.[1]

Nowhere in Goya's work do we find any indication of the kind of competition with the written word that dictated the subjects of his more academically oriented contemporaries. His perception of the world around him may even have become more acute as he grew accustomed to the deafness that struck him at

The Old Women, or *Time*, detail, c. 1810–1812, oil on canvas, Palais des Beaux Arts de Lille.

the age of forty-six and lasted to the end of his life thirty-six years later. If his observations of women in society are at times more perceptive than any written documents, it is because they encompass far more territory than do written records, which are generally concerned with specific issues and classes, such as the status of upper-class women in enlightened societies and academies, or the control of transgressors such as prostitutes or street sellers. In his images of aristocrats and unknowns, duchesses and shopkeepers, denizens of the court and anonymous women joining in the guerrilla war against Napoleon, Goya goes far beyond these concerns. The richness of his imagery is without written parallel.

It was difficult to select works for the exhibition, and inevitably we had to leave some paths unexplored. In Madrid, the exhibition was arranged around five major themes, conceived by Francisco Calvo Serraller: intimacies; events, mores, and customs; sacred and profane allegories; portraits; witchcraft and spells. The organizers of the exhibition at the National Gallery of Art in Washington, D.C., revised this arrangement in light of recent thematic exhibitions at U.S. museums investigating Goya's relationship to the Enlightenment, his small-scale works, and questions of attribution.[2] We concluded that the public had not been offered an overview of the artist's career, provided here through his depictions of women.

With this in mind, we decided to present "Goya's women" as a chronological arrangement of selected works. We began with tapestry cartoons—designs from which tapestries would be woven—painted by Goya from 1775 to 1792, along with selected tapestries woven by the Royal Tapestry Factory of Santa Bárbara during the same period. In 1780, as a result of financial constraints engendered by Spain's war with England, production of tapestries was suspended, and Goya turned to other work, mainly religious commissions and portraiture. His first known female patron and the subject of two portraits in the exhibition (cats. 22 and 23) was María Teresa de Vallabriga y Rozas, an Aragonese noblewoman who married Don Luís (1716–1788), the brother of Charles III (1759–1788). She also provides the focus of the masterful group portrait of *The Family of the Infante Don Luís*, exhibited here for the first time in the United States (cat. 24). This was the first of many major portrait commissions that Goya received from the Spanish aristocracy, including those of the duchess of Osuna (cat. 25) and of the duchess with her family (cat. 27).

Included among Goya's images of women are what we might term "gentlemen's paintings"—images of reclining or sleeping women that offer a context for his well-known paintings the *Maja desnuda* and the *Maja vestida* (cats. 54 and 55). Although the *Maja desnuda* might seem more quirky than erotic to a twenty-first-century viewer, we should consider her within the terms of Goya's

milieu. During the late eighteenth century, the Inquisition, despite its waning power, still censored the production and circulation of images. It even prosecuted owners of imagery deemed lascivious: among its targets was Goya's own patron Sebastián Martínez, whose portrait by the artist hangs in the Metropolitan Museum of Art, New York. In 1762, the ostensibly enlightened King Charles III had threatened to burn masterpieces by Titian, Paolo Veronese, the Carracci, Guido Reni, and Peter Paul Rubens because they showed "too much nudity." The paintings were saved only through the intervention of the court painter, Anton Raphael Mengs. When the works were again threatened by Charles IV in 1792, the marquis of Santa Cruz intervened to have them moved to a private cabinet in the Real Academia de Bellas Artes de San Fernando.[3] Given the controversial nature of the theme, the fact that Goya painted a nude in the later 1790s testifies to the power of his patrons, who evidently believed themselves beyond Inquisitional scrutiny.[4]

How did Goya come to receive the commission to paint the *Maja desnuda,* as well as the other images of buxom reclining women exhibited here? His correspondence with his friend Martín Zapater shows that as early as 1781 he executed decorative paintings for private patrons featuring the popular types seen in his tapestry cartoons. He writes in a letter of 13 November 1781, "in the house of Villamayor... I'm painting some popular types on the chimneys"; in a letter of 9 July 1783, he writes, "a librarian of the King has commissioned the painting of a dancer." A traveler's account of the period mentions three overdoor paintings by Goya in the Cádiz residence of Sebastián Martínez. The dimensions of *Gossiping Women* (cat. 48) and *Sleep* (cat. 53) suggest their appropriateness as overdoor compositions, fueling speculation that these might be two of the paintings once in Martínez' collection. That Goya had acquired a reputation as a painter of decorative, and possibly of erotic, figures, might help us to understand the genesis of the commission for the *Maja desnuda,* first documented in 1800 as "a nude by Goya with neither good drawing nor grace in its color."[5]

By the 1790s, Goya was enjoying a growing reputation as a painter of portraits, religious themes, genre scenes, and decorative figures. But the seemingly smooth progress of his career suffered an apparent setback in the autumn of 1792, when he was stricken by an illness that left him weak for several months; the following year a second attack of Madrid colic left him deaf.[6] During his recuperation, he turned to painting smaller, noncommissioned works, sending a series of these paintings to be presented at the Real Academia de Bellas Artes de San Fernando in January 1794. An accompanying letter betrays his enthusiasm for the freedom newly discovered in painting without a commission, which would eventually lead him to experiment with several other media and

formats—drawing, etching, miniature painting, and lithography. From this point onward, Goya's production of commissioned works would run in tandem with his experimentation with subjects for which no commission was given and no market readily available. Inevitably, both aspects of his oeuvre would prove mutually enriching. Goya's mature portraiture, for example, suggests that his observation was sharpened by the unfettered study of the world around him. Conversely, his experimental subjects assume the monumental proportions formerly reserved for commissions—*Two Old Women* (Musée des Beaux-Arts de Lille), *The Young Women (The Letter)* (cat. 60), and possibly the *Majas on a Balcony* (cat. 61).

The exhibition *Goya: Images of Women* parallels the chronology of the artist's career in organizing the works into seven groups. These are: tapestries and tapestry cartoons (1775–1792); aristocratic patrons and portraiture (1783–1804); "gentlemen's paintings" (1780s to around 1805); early drawings and the Caprichos (1795–1800); portraits (1800–1816); later prints and drawings (1810 to early 1820s); and genre scenes represented on canvas and in miniatures (1808–c. 1826). The catalogue essays present a variety of perspectives in exploring questions raised by works across these groups. Francisco Calvo Serraller, professor of the history of art at the Complutense University, Madrid, and cultural critic, gives a wide-angle perspective on Goya's imagery of women in light of broader trends in European art; Aileen Ribeiro, costume historian and professor of the history of art at the Courtauld Institute in London, sheds new light on the details and meaning of costume in several images of women; Concha Herrero Carretero, curator of tapestries at the Patrimonio Nacional, introduces the tapestries woven after Goya's cartoons by the Royal Tapestry Factory of Santa Bárbara in Madrid. My own contribution considers how the imagery of women is expanded through the prints and drawings that Goya produced outside of the limits imposed by commissioned works.

This selection of works also presents a certain symmetry that enables us to examine Goya's changing representation of women within a specific medium. We might choose to isolate the early genre scenes represented in the tapestry cartoons and compare them with those of the later works, or consider the fascinating evolution of Goya's portraiture of women, from the early studies of María Teresa de Vallabriga y Rozas to the late portrait of the reflective Rita Luna. Each category illustrates Goya's journey from an early imagery for which he seeks a vocabulary, often borrowing from other iconographic and formal sources, to a mature and original idiom. This evolution from the formulaic to the unprecedented also reflects the artist's insistent exploration of women's multifaceted role within society—even when a woman sits alone in a portrait, she is, after all, presenting herself to the artist and other viewers according to the conventions of their time.

Loans from the Museo Nacional del Prado and from the Patrimonio Nacional provided this exhibition with a selection of cartoons and tapestries woven after them by the Royal Tapestry Factory of Santa Bárbara. Goya's work for the tapestry factory, probably procured initially by his brother-in-law the court painter Francisco Bayeu, gave the young Aragonese artist a crucial entrée into the Madrid royal court. Following standard procedure, Goya would have been given the dimensions for tapestries intended for a specific room in a royal residence, such as the Pardo or the Escorial, and probably a general theme. He would then have created small sketches—*Spring* and *Autumn* are two examples in the current exhibition (cats. 13 and 15)—and presented these for his patrons' approval before painting the full-size cartoon. The cartoons were then delivered to the Royal Tapestry Factory, where the tapestries were woven. The cartoons themselves, never intended for public exhibition, would then have been relegated to storage.

When we look at the women in the cartoons, it is worth keeping in mind that Goya's images of women often appeared within a context provided by other images, and more specifically, as counterparts to images of men. At times, this counterpoint occurs within a single scene, as in *A Walk in Andalusia* (cat. 2). Thanks to the invoice description that Goya was required to deliver with the cartoon, we know that his chosen theme was a drama enacted by gypsies in the southern Spanish province of Andalusia. The woman stands at the center of the intrigue, as her escort prepares to confront the seated man who has audaciously flirted with his girlfriend. Another cartoon, *The Crockery Vendor* (cat. 5), presents another regional type—this time a Valencian—selling his wares to two young women as an old woman looks on. Behind, two men in military dress observe a woman glimpsed through the window of a carriage. Within this scene, Goya juxtaposes women from the popular classes, seated on the ground, with another from the upper classes, framed by the window of the carriage; he also introduces women of different ages. Here and in other tapestry cartoons he portrayed specific types that would have been recognized by his contemporaries. These include women from the popular class of Madrid, or *majas* (their male counterparts were *majos*), whose attitudes and dress were often imitated by members of the upper classes, as well as by the affluent women who slavishly followed French fashion and were known as *petimetras* (a term that finds its origin in the French *petit maître*, or dandy). The old woman who accompanies the young girl in *The Crockery Vendor* recalls the traditional figure of the bawd, or *celestina*. If she is a celestina, her presence suggests that there is more than crockery involved in the transaction between the vendor and the young woman. She also anticipates the celestina figures that populate the etchings of the Caprichos (1799), and recur throughout

Goya's oeuvre, as illustrated by a lithograph of the early 1820s (cat. 113) and a miniature of c. 1825 (cat. 62).

The tapestry cartoons also introduce compositions and themes to which Goya would often return. *The Parasol* (cat. 4) shows a comely young woman who directly addresses the viewer, with her attendant relegated to the background. Variations on this composition, in which the woman's flirtation breaks down the barrier of the picture plane, appear in later paintings of majas on balconies in the company of men in capes or celestinas. Also in the tapestry cartoons, Goya created scenes based on contemporary life on a scale traditionally reserved for historical subjects. He would return to this format in large genre images, painted after 1808, showing women young and old in scenes such as *The Young Women (The Letter)* and *Two Old Women*. This innovation has traditionally been overlooked by art historians, who see the presentation of genre scenes on such a scale as a mid-nineteenth-century novelty, often credited to Gustave Courbet. We might wonder if Courbet was influenced by Goya's *The Young Women (The Letter)* or *The Forge* (Frick Collection, New York), which were both exhibited in the Spanish Gallery of the Louvre from 1837 to 1848.

Besides compositions and scale, the tapestry cartoons also provide a basic lexicon of Goya's view of the interaction between the sexes. In cartoons painted before 1780—such as *A Walk in Andalusia* and *The Crockery Vendor*—these exchanges are presented as lighthearted flirtations. After 1786, when Goya was made first painter to the king, his tapestry cartoons assumed a new stateliness, as seen in *Autumn (The Grape Harvest)* (cat. 16). A new direction appears in Goya's final series of tapestry cartoons, which he left incomplete when he fell ill in 1792. Narrative is absent from the image of *The Straw Mannikin* (cat. 19), for example—we have no idea why these women are tossing a rag doll in a blanket. This was a frequent entertainment in popular fairs and at Carnival time, but Goya removed the scene from any such context, forcing us to focus on the game, which invites interpretation as an image of female dominance over an effeminized male. A comment on contemporary society? We cannot know. However, the theme itself was important enough to the artist for him to repeat and embellish it more than twenty years later in the etching *Feminine Folly* (cat. 125), illustrating the longevity of Goya's fascination with the not-always-happy relationship between the sexes.

The portraiture presented in this exhibition offers another perspective on Goya's views of women. His early commissioned portraits are often well documented: in his correspondence he discusses his stays with the family of Don Luís de Borbón at Arenas de San Pedro during 1783 and 1784, and invoices survive for the portraits of the duke and duchess of Osuna executed during the

same decade.[7] But as Goya matures as a portraitist, the documentation wanes. We often depend on inscriptions, the accounts of heirs who inherited portraits, or tradition to identify sitters—and often these received identifications do not hold up to scrutiny, as discussed in the catalogue entry for the portrait long believed to be of Josefa Bayeu (cat. 45). Goya was in great demand as a portraitist, even though contemporaries knew that the results could be uneven. When José Vargas Ponce became director of the Royal Academy of History in 1805, he wished to have his portrait painted by Goya. But, interestingly, he sought the intervention of a mutual acquaintance—Ceán Bermúdez—to ensure Goya's best effort. Vargas Ponce wrote to Ceán:

> Since I *am* Director, one of these days, willy nilly, I've got to have my portrait painted. I want Goya to do it. He's been approached and has given his consent. But I also want you to drop him a line—I beg you to do it— telling him who I am, and our mutual connections, so that, since the Academic barrel has to be filled, it won't just be with a hasty horror, but the way Goya can do it when he really wants to.[8]

In his early portraits, Goya drew upon a variety of sources: English conversation pieces might have inspired *The Family of the Infante Don Luís;* Diego Velázquez' portrait of Prince Baltasar Carlos seems to have been a model for Goya's image of the three-year-old María Teresa de Borbón y Vallabriga (cat. 21); and the name of Thomas Gainsborough is often invoked as a source for the 1786 portrait of the marchioness of Pontejos (cat. 26). Yet we are at a loss to cite such specific influences when we look at the later portraits. If the earlier portraits tend to be discussed in terms of influence, it seems appropriate to discuss the later works in terms of rivalry, as Goya seeks to equal, if not surpass, the masters who preceded him: Rembrandt and Velázquez.

When we contemplate portraits in the exhibition, we may well be reminded of Velázquez' *Woman with a Fan* (Wallace Collection, London) or more generally of Rembrandt's portraits of Saskia van Uylenburgh. But there are aspects of Goya's versatility in representing the character of his female sitters that are unprecedented. Turning his back on eighteenth-century conventions (again, possibly under the influence of his seventeenth-century predecessors), Goya eliminated props and details of setting to focus on the character of the individual. There is no generic definition of femininity: the natural elegance of the actress Antonia Zárate (cat. 41) suggests composure and confidence, while the stiffer pose and setting in the portrait of Thérèse-Louise de Sureda convey a forced attempt to appear regal (cat. 33). The subdued color used to represent Señora Sabasa García (cat. 43) reinforces the quiet

control manifested in her erect posture, direct gaze, and formality of dress as she covers herself with shawl and mantilla. Her possible antithesis might be the seemingly more vulnerable Josefa Castilla Portugal de Garcini, portrayed in a chemise and perhaps pregnant, as the pronounced asymmetry of her face lends a distracted air to her expression (cat. 34).

As I discuss in the essay to follow, we felt it was imperative to include Goya's drawings and prints for the insight these noncommissioned works offer into his contemplation of women. Loans from the Brooklyn Museum of Art, the Boston Museum of Fine Arts, the Metropolitan Museum of Art, the J. Paul Getty Museum, and the Museo Nacional del Prado have enabled us to include drawings, etchings, and lithographs of the highest quality. The first-edition impressions of the Caprichos exhibited here are (with one exception) from the fine, unbound trial-proof set from the Brooklyn Museum, and the impressions of the Disasters of War, lent by the Boston Museum of Fine Arts, are unique working proofs pulled during the artist's lifetime, unquestionably superior to the impressions of the first, posthumous edition published in 1863.

From the drawings undertaken in 1796, to the lithographs executed during the final decade of Goya's life, these images explore themes for which there would be no call in the commissioned works. This is not to say that the artist did not seek a market for them: many of the themes explored in the early drawings inspired etchings in the Caprichos, four sets of which were purchased by the duke and duchess of Osuna. Nevertheless, the Caprichos seem to have had a limited dissemination—not surprisingly, given that these groundbreaking aquatint etchings were entering a marketplace more familiar with simple engravings of religious motifs, popular types, and recent events. It remains a matter of speculation whether the artist ever intended to publish the etchings of the Disasters of War and the Disparates; ultimately, they went unpublished until the 1860s. Goya's waning concern with finding a market for his drawings and prints parallels an increasing freedom in his selection of subjects, which range from scenes of wartime atrocities to serene images of contemplative women, from portrayals of hysteria to depictions of women in manacles. The themes of atrocities that Goya first explored in drawings and etchings would inspire the two small, unsettling oil paintings of women raped and murdered (cats. 56 and 57), dated to the period of the Napoleonic War (1810–1812).

Seen in juxtaposition with the small sketches for tapestry cartoons executed some twenty-five years earlier, such disturbing images reflect Goya's journey from an artist of polite society to one who took his inspiration from all facets of the world around him, producing a body of work, some of which is still unmatched today for its unvarnished, even brutal, realism. At the same time, his oeuvre records the tumultuous history of his era, which encompassed the

demise of the old regime, the French Revolution, the Napoleonic invasion of Spain and occupation of the Spanish throne from 1808 to 1813, and the restoration of the conservative monarch Ferdinand VII. Thus, the answer to the question of whether Goya's images of women add up to a whole that is greater than the sum of its parts is a resounding "yes." From the lighthearted, popular themes of the early paintings, to decorous portrayals of aristocratic femininity, to images of women enduring the atrocities of war, Goya's representations of women both chronicle and evolve in concert with the changing society of Spain during this fascinating period.

NOTES

1. Translated in Tomlinson 1992, 193.
2. Boston 1989; London 1994; New York 1995.
3. Jean-François Bourgoing, *The Modern State of Spain*, trans. of 1807 Paris ed., London, 1808, 2: 243.
4. For further information and bibliography on the context of these paintings, see Tomlinson 1992, 115–127.
5. Goya 1982, 80, 105: "…en casa de Villamayor…yo ago unos majos sobre las chimineas" (13 November 1781); "Hun biblotecario del Rey me a echo ese encargo del bailarin" (9 July 1783); Enrique Pardo Canalis, "Una vista a la galería del Principe de la Paz," *Goya* 148–50 (1979), 307.
6. My thanks to Nigel Glendinning for providing this information.
7. Goya 1982, 107–110, 119–122; Gassier and Wilson-Bareau 1971, 383.
8. Cited and translated in Glendinning 1977, 42–43.

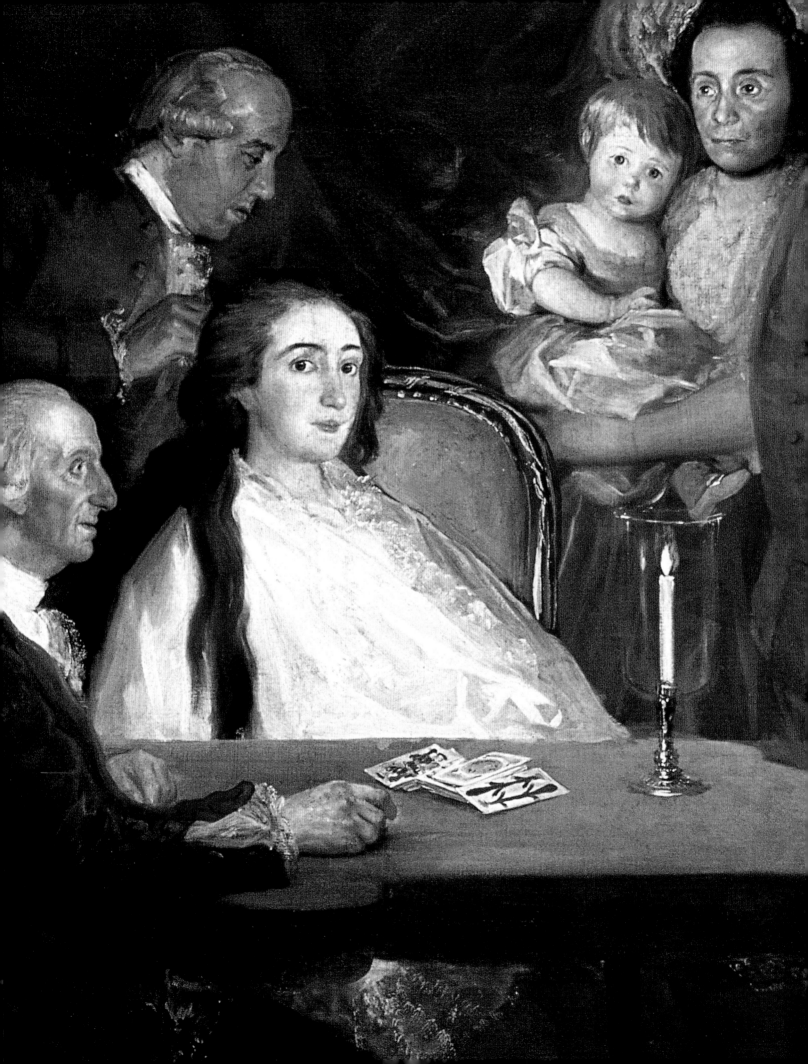

Goya's Women in Perspective

FRANCISCO CALVO
SERRALLER

I t is astonishing from the outset that not a single monograph has been entirely devoted to the image of women in the work of Francisco Goya, a painter whose opus would seem to have been approached from every possible angle.[1] True, nearly every distinguished book on the Spanish painter inevitably touches upon the subject, women having been essential in Goya's life, and the female figure having served as his artistic theme on occasions so numerous and so diverse. Nor have scholars and critics overlooked certain episodes involving Goya's relationships with women, which in some instances—the widely known affair of the duchess of Alba is a case in point—have elicited monographs. Yet despite the enormous body of professional literature published on this master painter, I would maintain that information dedicated exclusively to this question proves elusive. Rarer still, even over the last twenty-five years, which have witnessed progressive reinterpretations from feminist points of view, are studies based on the artistic evidence itself.

I begin with this observation not only to justify the following essay but also to stress, once again, the inexhaustible treasure to be found in works of artistic genius: works that must be rediscovered in each generation. One of Goya's merits is that he was ahead of his time, so much so that his time seems in great measure still to be ours; consequently the potential significance of his work may appear daunting, sometimes even overwhelming. Oppressive though this bounty may be, it is to my mind stimulating, first because it sharpens our

The Family of the Infante Don Luis
(cat. 24), detail

attention, and second, and more importantly, because it forces us to question ourselves immediately and directly. We are, when all is said and done, still "Goyescas."

Goya's genius is never in doubt, but this cannot be attributed merely to his vast store of female subjects; what matters is *how* the artist deals with them, in form as well as content. The eighteenth century is commonly referred to as "the century of Woman," a phrase open to many interpretations, among which quite a few are clearly debatable. The polemical overtones of the term, however, are beside the point here and do not negate the real societal change that took place in women's lives. The eighteenth century saw the start of a transformation in the role of women, who became first of all more visible, and visible in different ways. They also became more visible as the subjects of portraiture, and thus of interest to painters generally, let alone to one who, like Goya, based his art on "the solid testimony of truth"—the inscription on one of his initial sketches for Capricho 43. One need not even invoke the so-called *pintura galante* (what the French termed *fêtes galantes*, elegant scenes of erotic flirtation) or the century's proliferation of erotic, even salacious literature to confirm the sudden prominence of women's role and image.

A clarification is in order concerning the ensuing remarks on the situation of women and their image in eighteenth-century art and especially in Goya's work. I wish to emphasize that the increased presence of women in the century's social life does not imply that women fulfilled their potential, nor even that they attained a status qualitatively distinct from the traditional subjugation that had been their lot. This point is not made explicitly on every page of the present text nor, in general, of other interpretations cited here. The French Revolution took place at the very end of the eighteenth century; despite its unquestionably emancipationist intentions, it was obviously unable to transform overnight, as if by magic, laws, attitudes, and customs forged through long centuries. The same is true in the realm of ideas. The majority of Enlightenment philosophers and reformers opposed on principle all discrimination, whether on the basis of lineage, rank, race, or sex; this does not mean, however, that with the whisk of a pen they could erase prejudices and reservations accumulated throughout history. Lastly, since Goya was a product of his times, the light and the darkness of those times are both apparent in his work, for better and for worse, and especially in that portion of his art that concerns the image of women.

This explanation is not intended to avoid possible conflicts with a militantly feminist vision of art history. The background of this exhibition—the condition and image of women in the West in modern times—has become the object in recent decades of constant investigation and critical revision from

almost every possible perspective: historiographical, anthropological, sociological, psychological, and so on. The eighteenth century conceded much aesthetic importance to the sentiments and sensibilities they frequently assigned to the female world, and presumed to be women's "natural" characteristics. We cannot, therefore, ignore the complexities of the subject and their possibly slippery implications.[2]

These explanations concluded, we return to our central theme: the image of women in Goya and in the art of his times. And the first thing we notice, considering the topic from either or both angles, is the gradual increase in the presence of women, above all in a "realistic" mode. More and more "real" women seem to be represented, doing what they really used to do. This was true in the work of eighteenth-century French, Italian, and British realistic painters, but also in history painting, the genre of the ideal. This phenomenon is visible in the second and third generations of *fêtes galantes*, but especially in the production of portraitists ever more obsessed with greater psychological precision—whoever their model—and with "natural" effects. Then, too, the growing analytical tendency in genre scenes bordering on merciless satire was complemented by a new "sentimental" orientation, which informed narrative emotional scenes with overtly political critiques.

The English painter and engraver William Hogarth (1697–1764) was a dominant force in the development of this mindset, in an age notable for its liberal criticism and social and political satire. The artistic concept of *Comic History Painting*, a moralizing chronicle of reality illustrated via a series of vignettes, exerted almost as much influence as his series of pictures printed ad hoc, which circulated widely throughout Europe, no doubt including Spain. Equally influential was the new *larmoyant*, or lachrymose, genre, promoted in France by Jean-Baptiste Greuze, whose work, rather than a remote and cruel satire of manners, displayed sentimental effusions that tipped easily into melodrama. Both cases—Hogarth and Greuze—are inextricable from complex cultural and political matrices.

Greuze (1725–1805) was more than twenty-five years younger than Hogarth and belongs to a later artistic generation; he was, however, some twenty-one years older than Goya, and so of the generation preceding the Spanish artist. This sequence illustrates the new directions the revolution in genres was taking, as well as the innovative sense of realism, far removed from the classical canons in effect when Goya was starting out. Regarding images of women specifically, both Hogarth and Greuze played significant roles. In 1731, Hogarth published the first edition of his series titled *A Harlot's Progress*, consisting of a half-dozen etchings reproducing paintings he had previously executed on the theme. In 1735, he released a similar and better-known series, *A Rake's*

Progress. Here, too, women play a major part, something that would occur throughout almost all his subsequent series, which would develop what their creator called "contemporary moral themes," in which the tumultuous relations between men and women come close to occupying center stage. Hogarth's series *Before and After,* however, published in 1736, most directly relates to our subject (figs. 1a and 1b).

In 1761, Jean-Baptiste Greuze painted *L'accordée de village,* usually translated as *The Village Betrothal* or *The Village Bride* (fig. 2). The viewer witnesses the formal pledge of two young people in a rural setting. The painting is surprising for various reasons, primarily for its radical transformation of what was up to then understood as a "rustic scene," for the work not only lacks any trace of the customary burlesque tone but also displays the proportions and compositional type characteristic of history painting. The young couple—parties to the marriage contract being drawn up by the notary on the right—stands in the center of the composition's fluid, pyramidal structure. At either side, like counterpoised weights, appear distinct groups, divided like choruses: on one side the "female" parts, their figures intertwined by affection, and on the other the "male" voices, brought together solely through interest. It is easy to grasp the critical subtext of this "scene of manners," an obvious attack on

Fig. 1a William Hogarth, *Before,* from Book I of *Before and After,* 1736, Calcografía Nacional, Madrid

Fig. 1b William Hogarth, *After,* from Book II of *Before and After,* 1736, Calcografía Nacional, Madrid

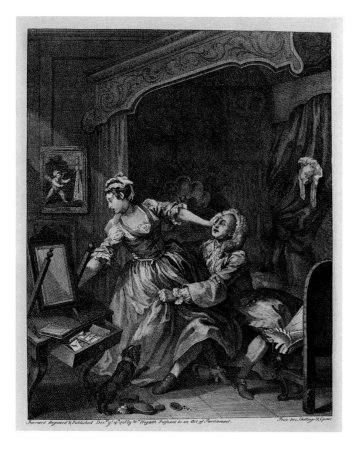

the traditional "marketing" of marriage, as opposed to the moral superiority of love matches.

Fig. 2 Jean-Baptiste Greuze, *The Village Betrothal*, c. 1761, oil on canvas, Musée du Louvre, Paris

These examples suffice to confirm that women's presence was not restricted to the innumerable erotic scenes of the *fête galante* tradition, though the importance of the latter should not be underestimated. Its three great masters, Antoine Watteau, François Boucher, and Jean-Honoré Fragonard, enrich the eighteenth century, and its complex and intriguing trails increasingly converge toward chronicles of contemporary daily life.

Goya was of course well informed about developments concerning "contemporary moral themes," in which women were becoming prominent protagonists. At the same time, he continued to derive inspiration on the subject from artists of his own generation who were closely connected with the cult of the "sublime." Joseph Wright of Derby (1734–1797), Henry Fuseli (1741–1825),

John Flaxman (1755–1826), and William Blake (1757–1827) were all associated in some way with the Spanish painter. I have lingered over these routes of development in European painting, because even though they are in principle somewhat distant from the pathways of Goya's own formation and from the artistic models he had more immediately at hand, they provided an incisive new basis for the representation of women.

What strikes us first about the relationship between the Enlightenment's traditional view of women, political progressivism, and Goya's work? Even without recourse to the age's most famous thinkers, from Jean-Jacques Rousseau (1712–1778) to Immanuel Kant (1724–1804), we understand that a complete change took place in the definition of female identity and social function; practically every eighteenth-century European moralist took on the controversial theme. In addition to the rationalistic, liberal, and egalitarian ideals characteristic of Enlightenment ideology, in addition to everything this meant for restating the role and significance of gender, there occurred a profound shift in moral orientation regarding what could rightly be considered "natural," now that Nature was no longer informed and stigmatized by original sin but was, on the contrary, the free-flowing source of a (natural) Goodness that society adulterated and corrupted.

Amid the many changes slowly taking place in eighteenth-century Europe, one of the most obvious, besides the steadily increasing visibility of women, was certainly their correspondingly increased participation in urban social exchanges. All this was nurtured by the growing importance of cities, and particularly the growing value of the city as a stage for public sociability. Replacing the rigid segmentation of urban space typical of the ancien régime, there arose in the course of the eighteenth century a reordering of urban possibilities. The traditional social hierarchies were increasingly confined to *de puertas para adentro,* that is to say, private quarters; meanwhile outside *(de puertas para afuera),* in more and more areas of the city, residents of all classes, financial status, ages, and sex mingled indiscriminately. The importance of these areas and of "publicness" in general—seeing everybody and being seen in turn—gained ground. It was a kind of prelude to what would soon be the urban world of the nineteenth century, marked by the hustle and bustle of anonymous crowds, into whose depths Charles Baudelaire urged the artist to plunge. Simply put, the city was progressively becoming a place for developing what is public, a place in which to lead a "public life."[3]

In the context of eighteenth-century French art, Thomas E. Crow offers contemporary evidence of the influence of this concept of the public, both as abstraction and as audience, where the Salon, a meeting ground for artists and for the public, already gave hints of its revolutionary potential.[4] And though

the social importance of public life cannot be restricted to women, this was unquestionably the site of women's greatest visibility, from which feminine influence was diffused in all areas, but most specifically in the cultural sphere. Female readership and authorship, for example, played a determining role in the evolution of certain literary genres, the novel being the most powerful of the era.[5] So if women were a topic ceaselessly debated (by men) in the eighteenth century, this was partly due to the fact that their physical presence and special importance in society was breaking down ancestral barriers.

Without engaging in a detailed analysis of the matter, we must remember that in Goya's Spain, too, these same changes were taking place and that this new visibility and behavior of women sparked passionate and prolific social and ideological debate. Goya came into direct contact with the issue from all angles: the experiential, the theoretical, and, of course, the artistic. We know he was well acquainted with the manifestations of the latter. The Enlightenment roots of Goya's art have been ascertained beyond any question, from Edith Helman's first studies to the major exhibition mounted in 1989 on this theme.[6]

In this sense, then, Goya was indubitably a man of his times and, as an artist, curious about a phenomenon so universally in fashion—Hogarth's "contemporary moral theme"—and so profound. What is remarkable about his work, whose subject matter is that shared by numerous contemporaries, is the variety, complexity, and intensity of his examination. Goya certainly depicted women in every possible genre, technique, style, and attitude; yet the "variety, complexity, and intensity" I refer to has more to do with his overwhelming subjectivity, which often renders problematic the interpretation even of images whose ideological meaning presents no difficulty. The question of just what Goya was truly—intimately—thinking and feeling when he dealt with a female image still plagues us, however well we grasp his ideas on the topic, where he got them, and how they connected with his times. Nor do the legendary realistic and expressionist instincts that were so fundamental to his work suffice to formulate an unqualified opinion on Goya's feelings and beliefs about women, either those he knew personally or the sex in general. Witness to a world in profound transition, Goya encountered diverse and even contradictory situations. His personal experiences and opportunities were the privilege of very few Spaniards, or even Europeans, of his age. Born in Fuendetodos, a little village, he was raised and educated in an important city, Saragossa; he came to hold a place at court, and triumphed there. At twenty-three he had traveled to Italy and he spent his last years in Bordeaux.[7] Just from these few facts we perceive that he crossed boundaries impassable to the majority. More importantly, he was acquainted with people of all social classes, from the

humblest to the highest and least accessible. Through his circle of friends and protectors—among whom figured the most gifted intellectuals of the Spanish Enlightenment—he broadened his world view to a degree rare among his colleagues. He saw the radical innovations then taking place in European art as stimulating challenges. In this sense, although much remains to be learned, it is indisputable that Goya's sojourn in Italy from 1769 to 1771, his intimate dealings in Madrid with international artists like Giovanni Battista Tiepolo and Anton Raphael Mengs, not to mention the innumerable channels through which he learned about contemporary art, resulted in an extraordinary degree of artistic sophistication.

Independent of his formidable genius, so extensive a range of experience and knowledge would suffice to explain why his reactions were neither simple nor predictable, especially on as vexed a topic as women. Goya's varied reactions involve ironic, satirical, sentimental, and ideological attitudes, all of them cut from the same compelling critical cloth, but joined to other currents, both traditional and commonplace. These elements were assembled by an artist of enormously energetic spirit, who swiftly revised his images in response to the whirlwind of current events. To what extent did his grave illness in the early 1790s, along with the ensuing deafness, affect him, arousing his darker genius and his misanthropy? This puzzle remains incompletely solved, but adds another factor to the inherently dynamic combination of elements that made up Goya's personality and determined his life's course.

In however fragmentary a fashion, the rich tapestry of Goya's destiny largely accounts for the fact that we find a range of viewpoints about women, fitting numerous contextual perspectives. In the exhibition as presented at the Museo Nacional del Prado in Madrid, the section titled "Intimacies" *(Intimidades)*, we examined the influence on Goya's art of his familiar, private, and cordial relations with several of his female models. Of course, not all the women with whom he maintained such direct and intense dealings were portrayed by him, or else we have no record of his having done so. Nor did this absolute revelatory frankness characterize his relations with all the women he painted, so that even on familiar ground Goya was obliged to respect certain restraints and nuances. We do possess some supplementary sources of information that allow us to fill in some existing blanks and ambiguities; for the most part, these are letters written by him or his closest contemporaries. Otherwise, Goya was reluctant to make his ideas public or even, according to Antonio de Brugada, who knew him in Bordeaux, to express opinions about art. Yet this epistolary material, while attesting to his eloquence and assurance, also proves ultimately unenlightening about not only Goya's artistic thinking but other private matters as well.

We know, for instance, little about his family feelings,[8] only that he never disregarded his financial duties to his parents and siblings; about these obligations he informs us with notary precision, interspersed with worries lest his relatives take advantage of his continuous rise in the world. He paid their debts, supported them, and even took his widowed mother into his home in Madrid for a short time. She left because she could not adjust to the atmosphere of the city. But he let slip scarcely any personal remarks about his relatives, nor did he reveal to what extent affection entered into his fulfillment of obligations toward them. This reserve is stranger still regarding his longtime faithful companion and wife, Josefa Bayeu. We know definitely of only one portrait of her (fig. 3), and the painter mentioned her only rarely in his correspondence with Martín Zapater—and then, without providing the slightest personal insight. He was more forthcoming with members of his family by marriage, but almost always in the context of professional rivalries, so that this man, whose pictorial expression bordered at times on brutal honesty, paradoxically revealed almost nothing about himself. Goya leaves us only to conjecture, with no way to confirm our assumptions about his personality or emotions. All that can be stated is that he was a good, respectful son; a proper, if wary, brother; a responsible husband, though only intermittently effusive; a devoted father, who concentrated all his paternal qualities on his sole surviving son, Javier. Judging by his relationship with Zapater he had a gift for friendship; but we lack conclusive evidence that he maintained the same tone of intense commitment in his relationship with other male friends.

And what of the women to whom he was connected by other than family ties? That he liked women and appreciated their many qualities is obvious from his work, but apart from his enigmatic relationship with the duchess of Alba, concerning which there are several obscure points, we know hardly anything. Did Goya have few or numerous extramarital affairs or encounters? Of what sort, degree, or intensity were they? This cloud of uncertainty does not dissipate even when nothing would interfere with or damage an open relationship, as was the case with Leocadia Zorrilla, the painter's companion in his last years. Even about this extended relationship we have little solid information.

Although Goya's letters disclose little regarding his daughter-in-law, Gumersinda Goicoechea y Galarza, who married his adored son, Javier, in 1805, we have a few important pictorial records, of her and of her family (to which Leocadia Zorrilla, although once removed, belonged). The full-length portrait of Gumersinda (fig. 4), like Javier's, is suffused with the painter's undisguised satisfaction with this marriage, which took place when the bride was seventeen years old and the groom twenty. Goya likewise displays a cordial

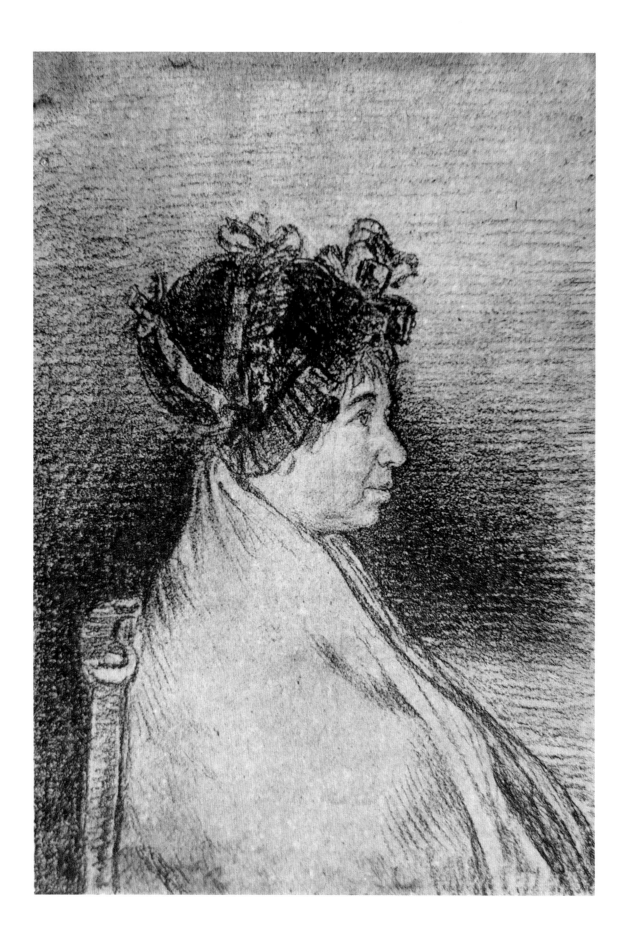

goodwill in his portraits of other female members of the Goicoechea y Galarza family, beginning with those of his son's mother-in-law, María Juana Galarza, born in 1758 and wed in 1775 to Miguel Martín Goicoechea. One of these portraits is a charming miniature of 1805 or 1806, another is a half-length portrait dated 1810. During the years 1805 or 1806, he also executed his marvelous miniatures of María Juana Galarza'a daughters, Cesárea (cat. 38), Gerónima (cat. 39), Manuela, and, once again, Gumersinda.

The terms of the marriage contract were amazingly generous, even given the privileged financial position of the father of the bride and the similarly flourishing state of Goya himself (who to the day of his death anxiously watched over the happiness and prosperity of both Javier and Javier's son, Mariano). If we compare his cordial attitude toward the Goicoechea y Galarza clan with his feelings toward his own in-laws, the Bayeus, also a family of painters, we find a very different situation. This is partly because when Goya married Josefa Bayeu there were no "terms," as there was no money, and partly because the initial sympathies on all sides were clouded by the professional jealousy of people forced to compete as rivals.

The misgivings that in one way or another estranged Goya from his brothers- and sisters-in-law never affected his relationship with his wife, Josefa Bayeu, whose life was an almost constant succession of pregnancies, many ending in miscarriages, and quite a few deliveries. Such was the prevailing condition of married women in Goya's time, and, judging by the statistical data available, not greatly improved in ours.[9] All this physical and emotional effort took its toll on Josefa Bayeu, and is reflected in the drawing the painter made of her in 1805, when she was fifty-eight and had seven more years to live. By the same token, however, she must have been a strong woman: she died at sixty five, an age few of her contemporaries reached, and fewer still after a lifetime that was arduous to the very end. Intimate relations with her husband were not chilled with the passage of time; the couple lived together for almost half a century, and though Goya did not mention her often in his letters to Zapater, when he did, his observations indicate a stable conjugal harmony. He also credited Josefa Bayeu with a shrewd wit and—occasionally—a dark humor. Her description of a house in a bad part of Saragossa (which Zapater had arranged to rent) as "a tomb for women" is often quoted.[10]

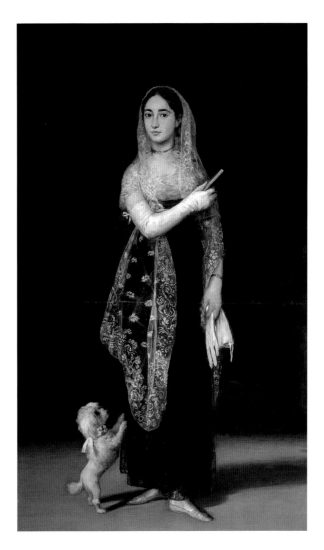

Fig. 3 Francisco Goya, *Josefa Bayeu*, 1805, black chalk?, private collection, Madrid

Fig. 4 Francisco Goya, *Gumersinda Goicoechea y Galarza*, 1805, oil on canvas, private collection

Goya's last companion, Leocadia Zorrilla, is shrouded in mystery, among other things because she was already married and separated from her husband Isidoro Weiss. When she entered Goya's house in 1812, Zorrilla was twenty-five and Goya sixty-eight, more than forty years her senior. From then on, she did not leave his side until his death sixteen years later; despite much speculation, little is known concerning the nature and scope of this relationship. Zorrilla brought with her Guillermo and Rosario, her two children, conceived during her marriage to Weiss; scholars have adduced their presence—and even more, Goya's unconcealed devotion to Rosario—as evidence that the painter was the children's biological father. Regarding this, Manuela B. Mena recently advanced a very suggestive theory: the portrait traditionally identified as that of Josefa Bayeu may represent Leocadia Zorrilla.[11] It is almost certain that Goya used Zorrilla as his model for the woman in black with the mantilla in the Black Paintings (Pinturas negras), but the face has been so disfigured by subsequent retouchings that identification of the features is impossible.

In any case, Josefa Bayeu and Leocadia Zorrilla were Goya's wives, in the bourgeois sense: the women of the family, the home, the life "behind closed doors." However, Zorrilla, forty-one years younger and of very different character and formation from Bayeu, would not have understood her cohabitation with Goya in such terms. The women belonged to two very different generations, and in that interval profound historical changes had occurred in all social interactions, including the status of and outlook on women. By the same token, Goya treated them differently: with Josefa Bayeu, he was simple and familiar, even evincing an old-fashioned touch of protective superiority, whereas he treated Leocadia Zorrilla more as an equal, so far as direct and indirect evidence confirms. Were she no more than an "outstanding servant," the age difference between them being so great and the artist then being at the peak of his genius and renown, such equality would make no sense.

Not all the social changes preceding Bayeu's death and Zorrilla's sudden appearance in Goya's domestic life were positive ones, and this was especially true regarding women, who were increasingly at risk in the reigning climate of tempestuous violence. Furthermore, the revolutionary changes and continuous warfare of the Napoleonic era immensely heightened most people's anxiety, dismay, and fear. There was no direct link between the triumph of the French Revolution and the emancipation of women. But whatever ideological and legal changes might arise concerning women's status, what revolution and war often produce is an inevitable emancipation *in practice*. Women forced to go out into the streets and struggle for survival, as was the fate of many at the time, are unlikely to return willingly to the restrictive norms of their previous life, no matter what political or legal regime is reinstated. Leocadia Zorrilla is

a case in point, but perhaps the best evidence of this phenomenon is in the work of Goya himself.

The tremendous personal crisis the painter underwent in the early 1790s as a result of his illness, combined with deafness, its dreadful consequence, unquestionably exerted a determining effect on his personality and his work. Shortly thereafter came the episode of his allegedly sexual relationship with the duchess of Alba, which—whatever the degree of intimacy in the friendship—most assuredly exceeded the bounds of a straightforward professional exchange. This experience, too, marked the artist.

On 4 January 1794, not long after his recovery from his life-threatening illness, Goya wrote the famous letter to Bernardo de Iriarte, vice protector of the Real Academia de Bellas Artes de San Fernando, informing him that he was sending a series of cabinet paintings conceived and executed without the restrictions of commissioned pieces. "To occupy my imagination, mortified in consideration of my ills, and to recuperate in part the great expenses that they have caused, I devoted myself to a set of cabinet paintings, in which I have realized observations that are usually not permitted by commissioned works, and in which caprice and invention know no limits."[12] This declaration, articulated in the painter's forty-eighth year and immediately after his narrow escape from death, assumes a central importance in Goya's artistic trajectory. It is generally known that in this last decade of the eighteenth century his work took a new direction and gained new momentum; more significant is the fact that these were the result of a deliberate intention on the part of the painter. In line with this new consciousness, Goya became particularly active in the Academy, as Janis Tomlinson has shown, contributing to exhibitions in 1799, 1805, and 1808, and participated in the discussions encouraged by that institution between 1792 and 1799 on curriculum reform. From the minutes of the Academy we obtain priceless information on Goya's position, including the following: "Mr. Goya declares himself openly in favor of freedom in the methods both of teaching and of practicing styles, and proposes banishing all servile subjection of the primary school, mechanical precepts, financial aid, and other trivialities that degrade and effeminize Painting. Nor should a time be predetermined that students study Geometry or Perspective to overcome difficulties in drawing." These ideas coincide almost word for word with Antoine-Chrysostome Quatremère de Quincy's opinions, expressed in a missive of 1791 addressed to the National Assembly of France, which was then debating the same issue. For that matter, the artist's views agree with almost everything he had written informally years earlier, in letters and other reliable documents.[13]

We cannot know what impelled Goya to take unprecedented risks in his art. Perhaps the sudden acceleration of historical events played a part—not least

the revolution in a neighboring nation upon which Spanish reality depended—
but also an acute consciousness of his mortality. In any case, it is as if Goya
realized, beginning in the 1790s, that the time had arrived for him to enfran-
chise himself at once and in all directions. He had no excuses left for not pur-
suing such freedom, for his triumph was practically total: he had wealth,
prestige, success in the Academy and at court, and descendants. The moment of
truth had arrived for a man who knew he was a genius: the moment to demon-
strate that genius in his art. How and to what extent did Goya's personal revo-
lution influence his way of relating to and representing women? I believe that
in regard to his alleged affair with the duchess of Alba insufficient attention
has been paid to Goya's point of view, as though his role were that of a startled,
long-suffering victim. In 1796, when he turned fifty and supposedly enjoyed
his ducal interlude, he had already had ample opportunity to know the domes-
tic life of the Spanish aristocracy from the inside. His first visit to the small
court of Arenas de San Pedro, where he became intimately acquainted with
the Infante Don Luis' family life, had taken place in 1783, more than a decade
earlier. In 1787, he took part in decorating the new palace the duke and
duchess of Osuna were having built near Madrid. Goya maintained easy and
cordial relations with them, and it is in their halls that he most likely met the
duchess of Alba. His consecration as the preferred portraitist of the aristocracy
and their circle throughout the decade meant that the Goya who kept the
duchess of Alba company in her gilded retreat at Sanlúcar de Barrameda was
no longer an inhibited parvenu but an experienced man of the world, aware of
his prestige and independence and ready to use them to his advantage, both
personal and artistic. He was also by then quite accustomed to the exhibition-
ism characteristic of aristocrats: it did not shock him, although his middle-class
morality would never allow him to engage in it.

What we know of the personality, life, and habits of the fascinating
Cayetana, duchess of Alba, at the time a beautiful, recently widowed thirty-
three-year-old woman, shows her to be a cheerful, extroverted woman, lacking
in all discretion. Her informality and her friendship with Goya were long
established, as the painter himself relates in a famous letter to Zapater, proba-
bly dating from 1794, in which he describes how the duchess burst into his
Madrid studio "to make me paint her face, and she got her own way."[14] This
impetuousness colors many other well-known incidents—a sizable store of
anecdotes reflects the brazen sort of showing-off typical of the aristocracy of
the period and even more pronounced in the duchess' conduct. In the circum-
stances, I doubt that the sight of the duchess naked was a privilege reserved for
her lovers. It probably extended to anyone, including the household help, who
lived behind the walls of her mansion.[15]

To my mind, the uneasiness or resentment that undoubtedly affected Goya during and after his stay at Sanlúcar was not merely the result of suffering or rage over a romantic disappointment, but rather the product of a clash between two mentalities, two antithetical ways of understanding morality: the aristocratic and the bourgeois. And although the confrontation might not have taken Goya by surprise, the circumstances of the moment must have perplexed him. In addition, if the creation of the Caprichos dates from this time, as seems likely, this hypothesis is thereby strengthened, for in the Caprichos Goya exploits to the maximum the sense of existential contradictions, giving free rein to a state of mind one might call moral outrage.

The artistic outcome of Goya's relations with the duchess of Alba was quantitatively and qualitatively exceptional, as attested to by two full-length portraits of 1795 and 1797, from the collections of the Casa de Alba (fig. 5) and the Hispanic Society (fig. 6), as well as the charming scenes of manners featuring the duchess letting herself go, within her family sphere, with games and practical jokes that reflect her boldness and her talent for mischief (cat. 51). As if that were not enough, the legend that the nude body Goya painted in the *Maja desnuda* (cat. 54), currently dated around 1797, might be that of the duchess herself expands the range of variations Goya achieved with this same model. In any event, although the duchess' body is probably not the one we see in the *Maja desnuda*, it nonetheless closely resembles the bodies that appear in the so-called Sanlúcar album, album A. Among these are several that I and others believe feature the duchess in the most varied and daring poses and situations, all handled with enormous *verismo* touched with charm. Lastly, the duchess' alleged presence in the Caprichos, such as in the celebrated *Dream. Of Truth and Inconstancy* (cat. 94) and *Gone for Good* (cats. 92 and 93) completes the substantial catalogue of artistic options Goya pursued with this, his favorite female model. Leaving aside the question of an incidental erotic entanglement between them, everything leads us to wonder what stimulated so forcefully Goya's artistic interest, which in this case greatly exceeded the requirements of his position. He was obviously much taken with the duchess' irresistible charms; he was also attracted to her poses and affectations, for instance, her *majismo*.

The maja—discussed by both Janis A. Tomlinson in her introduction to this volume and Aileen Ribeiro in her essay here—was an element in the revival of nationalism in a time of crisis. As Carmen Martín Gaite notes, she also represented a class reaction aimed at distinguishing the aristocracy from the Spanish middle class, among whom anachronistic French modes of behavior were increasingly common. Martín Gaite perceptively remarks that the duchess in particular was set on flaunting her personal prerogatives in areas in which she alone would stand out. Her cultural and intellectual gifts were

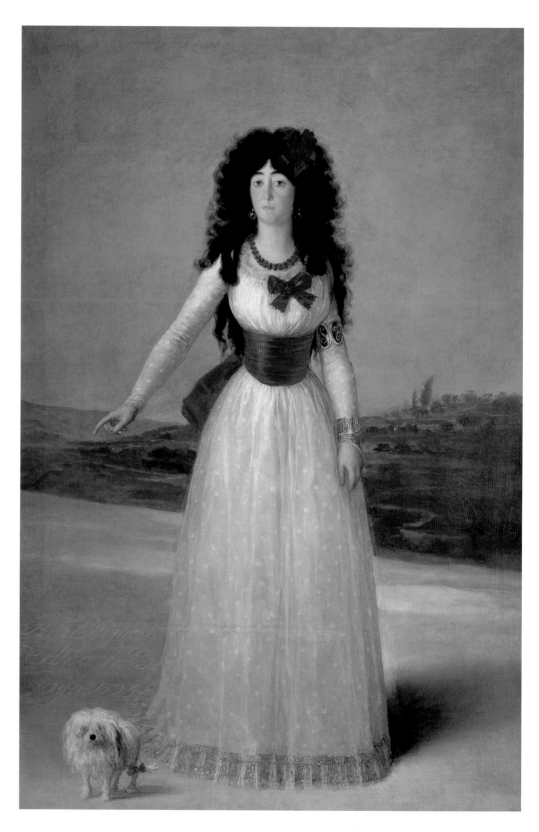

Fig. 5 Francisco Goya, *The Duchess of Alba*, 1795, oil on canvas, Fundacíon Casa de Alba, Madrid

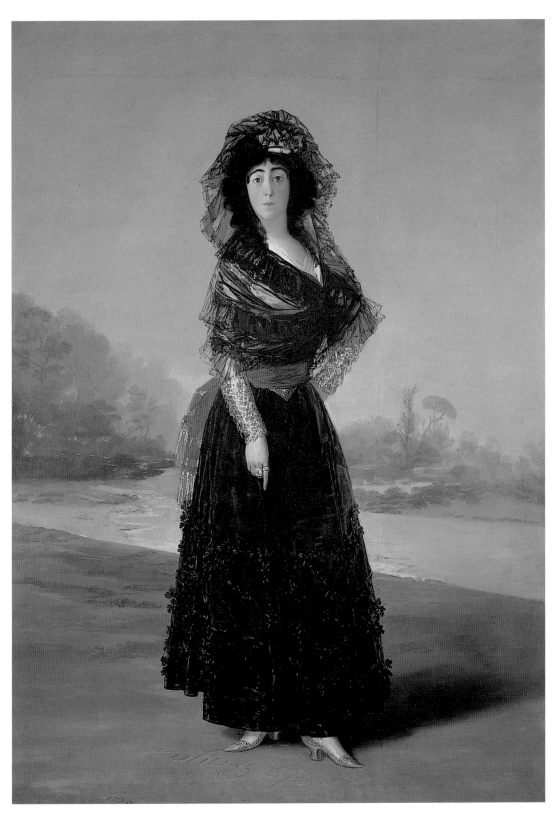

Fig. 6 Francisco Goya, *The Duchess of Alba*, 1797, oil on canvas, Hispanic Society of America, New York

weak, or so she thought, compared with her mother's or with those of her friend and social rival, the duchess of Osuna. Martín Gaite notes:

> It never occurred to Cayetana to copy her mother or this friend. She could not tolerate doing passably what they could do very well. But she wanted to shine, to be noticed, and the only turf she trod more firmly than these other ladies was that of the popular styles, sayings and modes of dress familiar to her since she was a little girl. So she had to get these styles into circulation, to appropriate them and launch them, as exaggeratedly as possible. That is just what she did. Nobody had done so before her. Imprudent, daring, and violent in her whims, she waved her beauty like a banner, decked out in the taste of the common folk, and she displayed it for them, in broad daylight, in the middle of the street.[16]

Goya presented the duchess of Alba from at least three different levels or viewpoints. The magnificent portraits constitute the first; in these, Goya managed to comply with the conventions of the genre without being conventional. The second level is far more personal; here, he portrayed her in amusing domestic scenes of manners, marked by a lively realism. In their subject matter, form, size, and intention, they fit the category Goya termed "cabinet paintings," among which, in my opinion, several of his drawings from album A should be included. The third is the viewpoint expressed in the Caprichos, in which the painter traced the fault lines between himself and the duchess: they were separated not only by a lover's grudges but rather, and above all, by what I earlier called "moral outrage," reflecting his personal and social uncertainty in the face of conduct he found reprehensible. In a sense, Goya portrayed the duchess in every possible way: from inside and out, to be sure, but also according to the reactions, psychological and moral, provoked in him by her behavior and way of life. There thus exists something that renders their destinies inseparable, something beyond any casual affair.

Goya sounded the depths of other aristocratic households, too, if not with the same lavishness of manner and meaning, yet with intimate intent—"intimate" in the double sense of portraying a subject in the privacy of home life and revealing the subject's inner feelings. The earliest of these households, a fruitful terrain for Goya, was the entourage of the Infante Don Luis in the palace of Arenas de San Pedro, where the painter was received with affection and trust. From it emerged one of his first masterpieces in the "conversation pieces" genre, then in fashion: the famous group portrait *The Family of the Infante Don Luis* (cat. 24). The work reveals a most ambitious modernity, commingling the naturalistic echoes of Giovanni Domenico Tiepolo with Wright

of Derby's chiaroscuro effects. This superb group portrait provides incontro-vertible proof of Goya's psychological insight—consider how shrewdly he con-veys female power in his depiction of María Teresa de Vallabriga, the infante's morganatic spouse. At Arenas de San Pedro, he also produced an extensive series of individual portraits whose models are mainly women and little girls, shown in diverse situations. The entire sumptuous ensemble demonstrates Goya's skill in exploiting his extraordinary opportunity to observe the nobility from a less formal, more relaxed angle: a more realistic point of view, and a more incisive one. Goya's personal and artistic experiences in Arenas de San Pedro yielded something else as well, something in theory unexpected: a chance to portray the passage of time, as he did in his other portrait of a family group, *The Family of the Duke and Duchess of Osuna* (cat. 27). Years later, when the very young children in that painting were grown to adulthood, he painted them again (see cat. 40), and the juxtaposition of the works reveals Goya's innermost artistic self, in the course of his aesthetic development. The most striking sequence is perhaps from *The Family of the Infante Don Luis* to *The Countess of Chinchón* (cat. 31). In the latter, Goya portrayed María Teresa de Borbón y Vallabriga at twenty years of age, pregnant, after three years of the unhappy marriage with Manuel Godoy forced upon her by Charles IV. The painting is stunning from any standpoint, but among its powerful attractions is its blend of formal refinement with psychological perceptiveness; the portrait exhibits Goya's profound grasp of what the woman posing for him was like, what she was enduring and feeling at that very moment.

Except in very obvious cases, relevant facts about Goya's female sitters are scarce, or the portraits are wrongly identified, or not identified at all. Or we may know a sitter's identity, but not Goya's degree of involvement. Nevertheless, it was the portraits that earned the painter his fame, and especially his prosper-ity; his skill in this genre was very quickly recognized by his contemporaries, who lauded his ability faithfully to capture not only a model's appearance, but the sitter's characteristic traits or gestures. Goya, appreciating their implications, as Aileen Ribeiro points out in her essay in this volume, was also very good at depicting current fashions. Not surprisingly, his services were much in demand—and portraiture was the period's most profitable genre. The criteria for measur-ing social worth were in the process of changing: very soon, wealth alone—the ability to pay for it—would become the sole requisite for commissioning a por-trait. Before 1800, Goya was monopolized by the court aristocracy. After that date, in line with the tenor of the times, his material security, and his self-confidence, he widened the social spectrum of his clientele, painting more and more members of the bourgeoisie in a more and more bourgeois manner, grad-ually yielding to the spontaneous pleasure of praising his friends in portraits.

Two predecessors in particular are fundamental for understanding Goya's portraiture: Diego Velázquez and Rembrandt. The former, unquestionably one of the best portraitists in the history of modern painting, was so important an influence on Goya that Edouard Manet's statement on the topic—that Goya owed almost everything to Velázquez—seems in no way exaggerated.[17] However, this judgment must be understood in the sense in which I think the French artist intended it: he saw Goya's chief merit as a "modernizer" of Velázquez. The latter was certainly more contained, more "objective," than the Aragonese genius, whose temperament and mindset were more fiery and more expressive. Yet Goya's admiration for the Sevillan master led him to an emulation at times bordering in my opinion on parody. Goya seems to have seen few of Rembrandt's paintings; he was fascinated by Rembrandt's drawings and prints, and particularly by the Dutch painter's images of women.[18] Both Velázquez and Rembrandt directly inspired the sometimes obsessive *verismo* of Goya's portraiture, as well as the feeling of existential depth in each portrait. Such influences detract nothing from Goya's worth or uniqueness; they only explain why his portraits never sacrifice truth and why they never fall into the common failing of even the best of his fellow eighteenth-century portraitists: affectation. Goya's portraits of women never look affected, instead, they are imbued with great dignity, even when the sitter possesses no impressive title. All his models hold themselves erect, even those who are "unimportant" in terms of position or occupation; they sit or stand straight and their bearing reveals an apparently natural grace.

In Book IV of Jean-Jacques Rousseau's *Confessions,* the author somewhat shamefacedly admits to a very specific erotic taste:

> Seamstresses, chambermaids, and shopgirls had not much temptation for me; I wanted young ladies. Everyone has his fancies; this has always been mine, and my ideas on this point are not those of Horace. However, it is certainly not the vanity of rank and position that attracts me; it is a well preserved complexion, beautiful hands, a charming toilet, a general air of elegance and neatness, better taste in dress and expression, a finer and better made gown, a nattier pair of shoes, ribbons, lace, better arranged hair—this is what attracts me. I should always prefer a girl, even of less personal attractions, if better dressed. I myself confess this preference is ridiculous; but my heart, in spite of myself, makes me entertain it.[19]

Rousseau's ideal "demoiselle" is easily recognized as the bourgeois model that soon dominated the times: the ideal woman, made desirable by her sensitivity, her refinement, her subtlety, and her education, rather than by physical

beauty or ostentatious gowns and jewels. Although all these values had been cultivated as far back as the sixteenth century, their expansion into the growing European middle class took a qualitative leap forward in the seventeenth, becoming virtually universal by the eighteenth century. At the same time, a counter current emerged from the bourgeoisie, creating a fashion for unaffected manners. Even at the outset of the eighteenth century in Regency France, manners "went bourgeois," exhibiting greater ease and naturalness, a shift noticeable in the design of domestic spaces and in the behavior and appearance of both women and men. Rousseau (1712–1778) was two generations ahead of Goya. His cultural horizons were also different, although by the last quarter of the century, the point of departure for Goya's career, Spain, like other European countries, displayed fewer national differences. So even in the absence of a personal declaration by Goya concerning erotic proclivities similar to Rousseau's, we need only look at his portraits of women to understand that the painter emphasized details of dress, gesture, and expression that displayed the now-prized quality of sensibility.

As Michael Levey wrote in his seminal, panoramic study of eighteenth-century art, the idealized concept of the "natural" underwent several profound transformations in the course of the century, until finally "optimism and belief in nature as a guide were shot to pieces by the fusillades which followed."[20] According to Levey, Goya's importance consists not only in his having lived through and incorporated all the stages of this process, but above all in his grasping and expressing the emerging chaos in a wholly unique way. In this sense, unlike other contemporaries such as Blake and Fuseli, who like Goya sensed the latent menace of chaos looming on all sides and—sheltered under the concept of the sublime—channeled their anxiety into fantastical images, Goya did not flee the world, but probed the depths of events, so that his nightmares always possess both tremendous verisimilitude and universal meaning.[21]

The variety of forms Goya employed in representing the family as well as the evolution they reflect are remarkable. *The Family of the Infante Don Luis* (cat. 24) and *The Family of the Duke and Duchess of Osuna* (cat. 27) are very different works, though in both the dramatic weight rests, significantly, upon the two young mothers. A third family group is the most popular and enigmatic: *The Family of Charles IV* (cat. 32),[22] a picture whose naturalism has inspired a variety of interpretations. The prevailing view, especially among the general public—that the painter caricatured his models with satirical intent— is simultaneously the most demagogic and historically the least convincing. In a more sophisticated analysis, Levey, Licht, and Rosenblum, each for different reasons, all talk of the "desacralization" of royalty. Janis Tomlinson sees in the

painting an interesting exception to the general tendency then dominant in Europe toward the "domestication of dynastic values."

But the portrait also epitomizes traits noted by Levey, in describing Goya in his maturity as portraitist:

> The artist becomes the receptive wax on which the sitter may impress himself. It is the sitter who takes the risk that Goya will serve him only too well, transmitting an image which has in it almost an over-awareness, affectionate, ironic, or both, of his real nature. All Goya's sitters are like the royal family group in being defenceless. It is no cliché to speak of them as being captured in paint; simply, they do not realize that it is happening, and it is their unawareness that is touching. It is hard to find any of Goya's mature portraits unsympathetic: either as works of art or for the sitters' personalities which now exist only in art. The mood changes in other ways, but this empathy remains.[23]

Let us set aside for a moment the question of artistic genius; Goya was gifted with extraordinary psychological penetration and with a refined taste for the nuanced particulars that encoded female erotic attraction. On this basis alone, he would deserve his standing as the most revered of portraitists. His superiority in this regard was such that nothing clouded his triumph, neither the envy of his colleagues nor the doctrinaire art criticism of the age, as Nigel Glendinning points out.[24] Nevertheless, when so authoritative an expert as Enrique Lafuente Ferrari writes, "Goya's work is a genuine paean to Woman,"[25] or "Woman for Goya is always, throughout all his descriptions of her, a provocative enigma of sin and temptation,"[26] it is clear that we should not limit our investigation to his lofty portraits.

In the sections of the exhibition as offered in Spain titled *Events, Predicaments, Labors, and Customs,* and *Spells and Enchantments,* as well as the segment dedicated to the drawings and etchings, we sought to bring together a collection of works that represented Goya's intuitive understanding of women, apart from the influence of direct personal acquaintance or private commitments. In painting contemporary women from every walk of life and in every sort of situation, Goya revealed his most secret, instinctive, even subconscious responses to them. The formidable parade of women who cross his paintings, drawings, and etchings are of all ages, conditions, and professions. Finally, as mentioned earlier, we see them evolve in the painter's fantasy as projections of his desires and fears. In a certain sense we can state that Goya's material is so rich, so abundant, so varied, and so complex that it proves almost literally overwhelming. As Oto Bihalji-Merin writes:

Goya's relationship with women is characterized by the ambiguous doubleness of the female sex. In a sense, it still carries the baggage of the patriarchal mentality's traditional prejudices. Woman is goddess and witch for Goya: sinner and saint, lover and procurer, worker and aristocrat, mysterious and enigmatic, tender and maternal, greedy and, when necessary, as tough as a man.[27]

Tapestry cartoons provide remarkably valuable material for analysis of the first stage of Goya's rise in court circles and also for assessing his first female images.[28] These weavings, of enormous interest for artistic, technical, and ideological reasons, might be seen, in my opinion, as part of a vast program of official political propaganda reflecting the Bourbon government's enlightened reformist aims. For more than fifteen years, between 1775 and 1792, Goya and other artists worked piecemeal on this project, with late payments and irksome thematic and technical restrictions rendering the work increasingly wearisome to him as his artistic stature grew. The interpretive problem posed by the tapestry cartoons lies precisely in the fact that they unfold over an extended period, during which Goya's personal and artistic development was becoming progressively more intense. In this sense there is a stylistic and thematic gulf between his earliest and his last sketches, as much in their quality as in the ever greater freedom of their creator. Populism and nationalism were the initial watchwords behind this project, but as time passed the motives behind it grew more ambiguous and complex, especially as regards Goya's participation.

Answering to this rallying cry, which transformed the traditional genre scene as set down by David Teniers especially, Goya was soon tackling motifs from the life of the Spanish people, depicting the popular classes at work and play and gradually expanding his thematic spectrum and, above all, his critical vision. Thus, in addition to work, games, and customs, we encounter increasingly dramatized situations, such as accidents—sometimes funny, sometimes tragic—and an increasingly acerbic view of society. Over time, Goya displayed an increased and improved command of naturalistic detail and greater confidence in his dramatic representations. Simultaneously, women became not only more conspicuous, but central to the artist's designs for the tapestry series.

The women who inhabit the tapestries include lower-class prototypes at the outset, and later ambiguous fixtures who are either majas or aristocrats disguised as such. They haul water from the fountains, they wash, they practice their crafts, they work in the fields, they buy and sell. They enjoy themselves, taking part in group games, excursions, fairs and markets, picnics, and romantic encounters. At leisure, they stroll or rest. As the series evolve, the social

range expands to include women from all classes or status. *The Wedding* (cat. 18) appears only at the last, a new motif approaching satire and the Caprichos.

In this assemblage of images there is, however, one clear and significant line of demarcation in the scenes that portray genuine common-folk, a separation—mutual indifference or distrust—between the women and the men, even when they are together or making plans to be. By contrast, when we move up the social ladder to the bourgeoisie and the aristocracy, encounters between the sexes are more harmonious (or complicitous). Recent studies have proposed new lines of interpretation applicable to the tapestry cartoons and enriching our understanding of their background. Victor I. Stoichita and A. M. Coderch cite *The Straw Mannikin* (cat. 19) and *Blindman's Buff* (see p. 93) and their association with carnival figures deeply rooted in cultural tradition.[29] Another investigation, by Lavater, suggests possible new sources for the works.[30]

For whatever reason, in the last decade of the eighteenth century, the festive gaiety that characterizes most of the *costumbrista* tapestry cartoons begins to alter. Paralleling historical events and Goya's inner voice, their tone turns more realistic, alienated, and gloomy, reflecting a world growing daily more violent, cruel, and dehumanized. These upsetting scenes, in conjunction with fantastic and sinister images of witchcraft, became more common with the passage of time and the repetition of tragic events, although I believe that attributing Goya's growing "black" spirit specifically to a change in his relationship with women and the female image is an oversimplification. Toward the end of his life, the painter, now intensely visionary, evinced anxiety and distrust of the whole human race, men and women alike, although in his relations with women he could not help but project his masculine fantasies as well as those of his cultural heritage, his turbulent era, and his no less troubled nation.

Théophile Gautier once remarked, perceptively, that Goya, "intending to serve new ideas and beliefs, traced the portrait and the history of the old Spain."[31] In other words, allying himself with his country's modernizing impetus, the artist found himself confronting the dead weight of its atavistic past, a virtually insuperable obstacle. Ambivalence suffuses his images, not only of the Spanish people but of all people, an expression of his weakened faith in the human capacity to advance without destroying. Whatever fears and suspicions Goya entertained, as a man, about women, I doubt he thought them better equipped than men for working either good or evil. When, for example, his images appear to express delight in overtly vicious or irrational aspects of female attitudes or behavior, almost invariably there surfaces in Goya the Enlightenment censor, stern and punitive. Inside him a constant guardian warns against reason's dangerous sleep, but this watchman is also the artist,

disinclined to shut his eyes against the monsters he sees, monsters he considered viscerally real, or, as Baudelaire put it, "verisimiles."[32]

NOTES

1. Among the very scarce and uneven bibliography that I have been able to find on this subject are the following books: Solvay 1905–1906, 193–203; Mayer 1920–1921; Ostalé Tudela 1926; Villamana and Baeza 1928, 96–97; Ferrari 1969; Bihalji-Merin 1987, 101–118; Volland 1993; Sarasúa 1996, 65–72; Morales 1997a, 235–296; Hadjinicolaou 1997, 297–307.

2. Iglesias 1999.

3. Ariès and Aymard 1935.

4. Crow 1985.

5. Berger 1977; Calvo Serraller 1990.

6. Helman 1963; Pérez Sánchez and Sayre 1989.

7. Goya also traveled around the peninsula with documented visits to Valencia, Seville, and Cádiz, as well as trips to cities closer to Madrid, such as Ávila, and we naturally know about his frequent comings and goings between Saragossa and Madrid. As is known, he also made a short visit to Paris.

8. Torralba 1990.

9. Anes 1994, 13–14.

10. Agueda and Salas 1982, 125.

11. Mena 2001, 149–182. See cat. 45.

12. Canellas 1981, 314.

13. Ibid, 310–312. Goya's address to the academy in October 1792. See also Tomlinson 1992a, 191–192.

14. Agueda and Salas 1982, 225–226.

15. Ezquerra del Bayo (1928b) 1959; Waldmann 1998.

16. Martín Gaite 1972, 107.

17. Wilson-Bareau 1988.

18. Rose 1999, 27–95.

19. Rousseau (1782) 1997, 1991.

20. Levey (1966) 1998.

21. Bozal 1994.

22. Salas 1944; Tomlinson (1992) 1993, 199–211.

23. I quote from the Spanish edition of Levey (1966) 1998.

24. Glendinning 1992a, 183–185.

25. Ferrari 1969.

26. Ferrari (1947) 1987, 130.

27. Bihalji-Merin 1987, 117–118.

28. Sambricio 1946; Arnaiz 1987; Tomlinson (1988) 1993; Herrero and Glendinning 1996, 23–37; Held 2001, 17–33.

29. Stoichita and Coderch 1999.

30. Ibid.

31. Gautier (1858) 1985, 156.

32. Baudelaire 1976, II: 568.

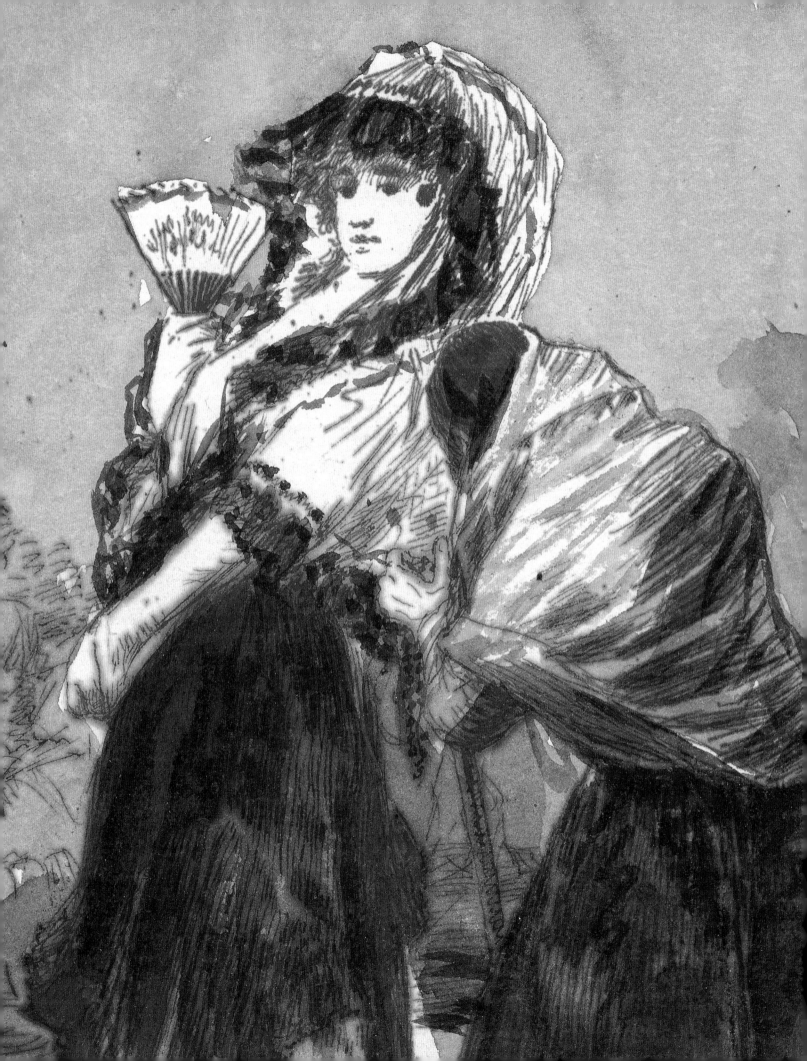

Images of Women in Goya's Prints and Drawings

JANIS A. TOMLINSON

Goya: *Images of Women*. What might we think of first? Certainly the *Maja desnuda* (cat. 54)—an uncanny image of a petite, dark-haired, naked woman, whose curious mix of confrontation and timidity challenges the nonchalance of the idealized nudes that preceded her. Her clothed counterpart, the *Maja vestida* (cat. 55) would also come to mind, her brazen demeanor intimating an extremely inappropriate—and thus all the more titillating—wantonness. Beyond these images, unique in Goya's oeuvre, his many portraits of women betray a versatility unmatched by any other artist. How can one summarize a body of portraiture that encompasses the formal and distant marchioness of Pontejos (cat. 26), the engaged and sympathetic duchess of Osuna with her family (cat. 27), and the proud Queen María Luisa in her many guises: among the royal family, on horseback, or dressed in a black mantilla and *basquiña*? Not to mention the masterful and often more intimate portraits done for nonaristocratic friends and patrons, sitters known only because they had the privilege of sitting for Goya. But in spite of their wide variety, we assume, in the absence of documentation, that all of these portraits have one thing in common: they were commissioned.

As commissioned works, these paintings display the artist's willingness to flatter his patrons to a greater or lesser degree—a compromise acknowledged by the artist in the self-satirizing etching from the Caprichos, *Neither More nor Less* (fig. 1). Here the monkey painter—the ape of nature—denies nature in order to flatter the patron. The sitter is an ass, aggrandized on the canvas as

She Is Ashamed That Her Mother Should Speak to Her in Public, and Says, Please Excuse Me (cat. 76), detail

41.

Ni mas ni menos.

Fig. 1 Francisco Goya, *Neither More nor Less (Ni mas ni menos)*, plate 41 from the Caprichos, 1797–1798, aquatint etching, National Gallery of Art, Washington, Rosenwald Collection

the painter adds a wig and white collar, elements outdated by the late 1790s when Goya conceived the image, that imply the sitter's preference to be portrayed in the guise of his more glorious ancestors.

Neither More nor Less manifests Goya's consciousness of the constraints and compromises imposed by patronage. Concomitantly, he was also aware of the liberties he might take in noncommissioned works. It was not until late 1793, at the age of forty-seven, that Goya began to explore this freedom in a series of small cabinet paintings, created during his recuperation from a year-long illness in late 1792, and subsequently submitted to the Real Academia de Bellas Artes de San Fernando. In offering the paintings to Bernardo de Iriarte, vice-protector of the Academy, Goya described them as "a set of cabinet paintings, in which I've managed to make observations for which there is no opportunity in commissioned works, and in which caprice and invention have no limits."[1] Goya's use of the term *capricho*, which might be translated as "whimsy" or "fantasy," to describe the freedom allowed by these works is significant, since it would eventually serve as the title for his series of aquatint etchings published in February 1799—the artist's first major venture in presenting noncommissioned imagery to a wider audience.

The cabinet paintings of late 1793–1794 were the point of departure for a steady production of noncommissioned works that the artist would produce until his death in 1828. Paintings comprise a relatively small part of this work, which is dominated by Goya's drawings and prints. The prints fall mainly into four series of aquatint etchings: the Caprichos; the Disasters of War; the Tauromaquia; and the Disparates, as well as a lithographic series, the Bulls of Bordeaux. Goya's drawings encompass preliminary ideas and sketches for the prints as well as eight groups of drawings, or albums, unified by medium and paper.[2] Ranging from quick studies in chalk or ink, to intensely labored prints that developed through drawings, preliminary sketches, and multiple states, these works were all created without regard for patronage. They attest to Goya's drive to represent the multifaceted characters and situations of women and are essential to an exploration of those themes.

Although Goya's prints, drawings, and paintings are often examined and exhibited separately, these activities are interrelated. His recognition of the liberty found in painting without a commission opened the way to his experimentation with drawings in the mid-1790s, which may have led him in turn to the production of the Caprichos. It was probably on a sojourn to the Sanlúcar estate of the duchess of Alba in 1796 that Goya began sketching women, including the duchess, in a variety of poses. Some of these were probably observed, but other, more sexually explicit postures were undoubtedly imagined. The drawings of the Sanlúcar album are simple compositions of one or two figures, without an implicit narrative (fig. 2). Many of them have a very rococo flavor: delicate washes describe a contemporary ideal female figure—petite, dark-haired, and wasp-waisted with an ample bosom. The thematic and formal complexity seen in the subsequent Madrid album (1796–1797) marks a breakthrough that is not easily explained. In contrast to the precise handling of wash in the Sanlúcar album, there is a tendency here toward broader, more economical brushstrokes that capture postures, gestures, and expressions. More complex, multifigured compositions replace the one or two figures seen in the smaller drawings of the Sanlúcar album, and gestures become less theatrical as Goya imagines more natural interactions between men and women.

We might wonder if the deafness that resulted from his illness of 1792–1793 had increased the artist's sensitivity to the gestures and expressions that accompany daily social exchanges. But even if Goya did not hear the words, he formulated his own. He began to add explanatory captions to the drawings of the Madrid album, something that he would continue to do in drawings throughout his life. These captions anticipate the pithy engraved captions of the etchings of the Caprichos. They serve multiple purposes, sometimes explaining the image, sometimes standing in ironic opposition to what the image presents, and sometimes implying a theme, but leaving the viewer to fill in the blanks. For whom were these captions intended? Particularly when they explain the

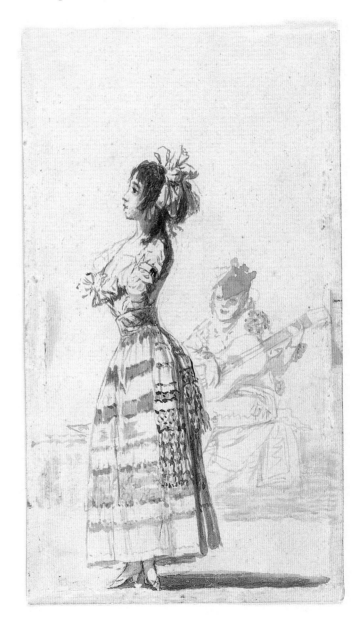

Fig. 2 Francisco Goya, *A Girl Listening to a Guitar*, Sanlúcar album, 1796, indian ink wash, Museo Nacional del Prado, Madrid

image, their addition suggests that Goya shared that image with a small circle of friends. In this, these drawings of women and commentaries on human mores and foibles—even when not overtly pornographic—might be seen as a visual counterpart to the erotic poetry that was circulated in manuscript form among enlightened circles.[3]

The evolving imagery of women is here presented in three parts: the first addresses the Caprichos (1799) and the related drawings; the second, those drawings unrelated to specific prints that span the artist's mature career; and finally, the imagery presented in the Disasters of War (c. 1810–1816) and the Disparates (c. 1817–1820).

Women in The Caprichos and Related Drawings

> When God surrendered the world to the disputes among men, he foresaw that there would be innumerable points that would always be argued, without ever arriving at a conclusion. One of these, it seems, had to be the intelligence of women.[4]

Goya's depictions of women are of their time in that they reflect in part contemporary discourse in eighteenth-century Spain, where women's education, marriage, fashion and luxury, and even prostitution were often discussed among progressive circles and provided subjects for extensive commentary in the press. Circulated in periodical literature and intended for the same elite public for which Goya created the Caprichos, such commentaries can be considered as context for Goya's imagery, although connections between specific writers and the artist are few. With the exception of the discussions relating to prostitution and social transgression, much of this writing was directed toward women of the upper classes, and as a result has nothing to say about the working-class women who often appear in Goya's images.

The prints and drawings do not reveal where Goya stood on specific issues. Looking at the range of this work, we realize that the artist did not represent a single point of view: women are sometimes portrayed as virtuous, at other times victimized, and even as the perpetrators of violence. In the Caprichos, a decidedly more negative view seems to govern the imagery, but this is a revelation not so much of Goya's attitude toward women, as of the satirical intent of the Caprichos. Before the artist's censorious eye, no one looks good: in dealing with women—in scenes of courtship, marriage, and prostitution—Goya seems just as critical of the men involved in less than ideal relationships. In this, he echoes the sentiments of the early eighteenth-century writer Fra Benito

Feijoo, whose 1726 essay *In Defense of Women (Defensa de las Mujeres)* served as a point of departure for discussion of the status of women in eighteenth-century Spain.[5] According to Feijoo, women were not to be blamed for their lack of education or intellectual shortcomings—these were clearly the fault of the men who had denied them a proper education. He dared to state what the Caprichos would so well illustrate at the end of the century: "Whoever would like to make all women good should convert all men."[6]

Goya's initial conception for the Caprichos is based on a series of numbered pen and ink drawings of witches that carry the manuscript title of *sueños,* or "dreams." The dependence on line and the impression of the etching plate left on these drawings leaves no doubt that they served as preliminaries for etchings (cats. 65 and 67). Although traditional attacks against witchcraft might be based on distrust of socially deviant women, Goya's own witchcraft scenes do not seem to present a pointedly misogynist theme. His imagery of witches does, however, subvert the idealized conventions of female beauty that are reflected in other images of the 1790s such as drawings of the Sanlúcar and Madrid albums, and the *Maja desnuda* (cat. 54). It would be difficult to move further from this ideal than we do with the abundant figure of the witch carried by helpers in *Where Is Mother Going?* (cat. 66) or the emaciated woman who teaches the young witch the tricks of the trade in *Pretty Teacher!* (cat. 68).

If, at this early stage in the formulation of the Caprichos, Goya's ultimate intent was to satirize the stupidity and errors of society, the witchcraft scenes may have served as an indirect commentary on those who believe in them. Alternatively, if the artist had not yet formulated the concept for the entire series, the scenes of witchcraft might be understood as a graphic counterpart to a series of oil paintings of witchcraft scenes commissioned by the duke and duchess of Osuna for their country house in 1798. In any case, Goya soon went beyond the theme of witchcraft, as he introduced drawings dealing with mutual deceptions between the sexes in courtship and marriage.

In the sequence of *sueño* drawings, number fifteen (cat. 79), which would serve as the preliminary drawings for the Capricho *What a Sacrifice!* (cat. 80), immediately follows scenes of witchcraft and marks an abrupt change in theme. The manuscript caption to the drawing, showing a young woman ogled by suitors, offers an insight into her situation: "Sacrifice for Gain: They Are Young Men Each One Richer than the Next and the Poor Woman Doesn't Know Which to Choose." This drawing repeats the theme of the more explicitly fantastic *Cruel Masks* from album B (cat. 78), where the theatrical gesture of the distraught young woman only reveals her neck and bosom, making the ogling all the easier. In both images, the woman is a coconspirator in her victimization, and also stands to gain by the sacrifice. Knowledge of these

drawings and their captions confirms the irony underlying the pithy engraved caption of the etching that ultimately evolved from them: *What a Sacrifice!*

But why could the pretty and well-endowed young woman of *What a Sacrifice!* not find a more suitable companion? Late eighteenth-century critics lamented the unwillingness of young men to fulfill their social and patriotic responsibility by settling down and having children. According to one contemporary writer, a young man may "remain all at once without reserves of body and spirit, [as,] submerged in the arms of a courtesan, he loses entirely the desires and sentiments for our honest and virtuous daughters."[7] This suspected relation between prostitution and the unwillingness of eligible men to marry might have inspired Goya to slip, in the series of *sueños* drawings, from the imagery of *What a Sacrifice!* to scenes of streetwalkers in Madrid in the pages that follow. Contemporary commentators recognized that there were other social dangers: men who frequented prostitutes contributed both to this underground economy and to the spread of venereal disease.

The appearance of all women in urban public spaces in eighteenth-century Spain was itself a sign of transformation in society. Throughout the previous century, women had been relegated to the house of their parents or husbands, or to the convent. As women increasingly frequented public spaces, they became more aware of their dress and gestures, and of how they might attract attention. This change in attitude was qualified by contemporaries as *marcialidad*, defined in an account of 1774 as the custom of speaking freely and of liberating oneself from the old-fashioned honesty and modesty of past generations.[8] The public places frequented by men and women gave rise to new subjects, recorded in the tapestry cartoons of Goya and his contemporaries such as Ramón Bayeu and José del Castillo:[9] in the late 1770s, Goya painted a series of tapestry cartoons illustrating the annual fair of Madrid, where women of all classes mingle among the stalls of crockery vendors (cat. 5) and secondhand dealers. A decade later, he would record the attendance of women at the festivities celebrating the day of Saint Isidore, patron saint of Madrid, in two sketches never executed as tapestry cartoons. Another decade would pass before the Caprichos would show a shift away from the daytime world of the tapestry cartoons to the nighttime world of the women dressed in black veils and overskirts, a dress characterized as being that of the *maja*, a young woman from the popular classes of Madrid, known for her forthright—and sexy—demeanor.

The dress of a maja did not of itself denote a woman of ill repute—upperclass and aristocratic women often wore the costume, as seen in Goya's 1799 portrait of Queen María Luisa (cat. 29), whose costume is a possible indication of solidarity with the popular and traditional classes, during a period of increasing nationalist sentiment.[10] But majas themselves had a reputation for

their outspoken manner, as implied in one article of a royal decree establishing rules for schools to educate poor girls in Madrid, stating that: "Teachers will use a simple and clear style of explanation . . . and will not be permitted to use indecent words, double entendres, or words that are considered to be associated with majas."[11] In the Caprichos, Goya offered a clear indication of these women's profession in their décolletage, confident gazes, and—above all else—in the company they keep. Men petition them in transactions observed by the ever-watchful bawds, or celestina.

In the Caprichos, the recurrent figure of the prostitute—chatting with a potential customer, adjusting her stocking, taken into custody—suggests a familiarity with her lifestyle that had been immortalized in the satire by Nicolás Fernández de Moratín the elder, *Art of Whoring (Arte de la Putas)*, which circulated in manuscript form in Madrid during the 1770s. To quote the poet: "It would be easier to count the stars / girdling the globe, or calculate / the grains of sand beneath the seas / the lap from the Indian shores to Africa / than to count the girls in Madrid."[12] Yet, like that of Moratín, Goya's tone is indulgent, if not sympathetic. These scenes of prostitution point up the mutual nature of the duplicity and victimization, illustrated by Capricho 5: *Two of a Kind* (cat. 72). The preliminary *sueño* drawing for this etching again reveals more than the etching itself (cat. 71). In contrast with the linear drawings of the witchcraft scenes, this drawing illustrates Goya's manipulation of ink wash to create significant highlights, which draw attention to the lower face and bosom of the prostitute, the disappointed expression of her customer, and the grinning celestina behind. The reason for her mirth is described in the caption: *The Old Women Laugh Themselves Sick Because They Know He Hasn't a Bean.* Although in modern society we might think of the streetwalker as the victim, Goya clearly turns the tables, as seen again in Capricho 7, *Even Thus He Cannot Make Her Out* (cat. 74). The literally unseeing client scrutinizes, but nevertheless fails to perceive the danger that awaits him—one of several etchings in the Caprichos where diminished perception signals diminished understanding.[13]

A return to the theme of matrimony is seen in Capricho 2, *They Say Yes and Give Their Hand to the First Comer* (cat. 81), which takes its title from verses in *A Arnesto*, a satire by Gaspar Melchor de Jovellanos published in the periodical *El Censor* in 1786. Jovellanos writes of the bride who contracts a marriage only to gain her freedom, so that, "without invoking reason, or weighing / in their hearts the merits of the groom / they say 'yes' and give their hands to the first who comes!"[14] Jovellanos is unambiguous in assigning blame to women—and thus represents only one side of the arguments presented in contemporary literature;[15] in contrast, Goya forces us to see that self-interest is shared by male and female alike. He takes pains to delineate the clearly

unappealing nature of the groom, whose folly lies in believing that this woman marries him for love. The final placement of this image in the published series—immediately following the self-portrait of the artist that serves as a frontispiece—attests to the importance that Goya assigned to its theme.

One element of the uniqueness of the Caprichos is the ambiguity of many of its images, although today we might miss the ironic tone of the captions. Appearances can be deceptive, as illustrated by Capricho 32, *Because She Was Susceptible* (cat. 83). To a modern viewer, this may seem a sympathetic image of Woman cruelly castigated for her "susceptibility" in an intolerant society. Yet this woman is probably María Vicenta Mendieta, who had aided and abetted her lover in killing her husband Francisco de Castillo, a well-known businessman, on 9 December 1797. The murder was much discussed in Madrid, since Castillo was killed in his bed, in his residence on the Calle de Alcalá (the same main street on which the Real Academia de Bellas Artes de San Fernando is located). The culprits were quickly identified. Goya was undoubtedly familiar with the case, not only because it created a sensation in Madrid, but also because the ensuing trial involved at least two government officials whom the artist knew and portrayed in 1797 and 1798, respectively: Juan Meléndez Valdés, counsel for the crown, and Gaspar Melchor de Jovellanos, minister of justice and author of the satire *A Arnesto* cited above. During the course of trial, the defense made reference to the wife's mental instability, citing her pathologically apathetic behavior in prison, an attitude reflected in Goya's etching. The public execution of both the wife and her lover took place in February 1798. Although we will never know if Goya sympathized with the woman, it seems unlikely, and we must admit the possibility that his ironic caption is intended as a condemnation of her unrepressed sensuality.[16]

Much of the commentary on women in eighteenth-century Spain was somehow related to a larger social concern about the demise of marriage as an institution—although it has recently been suggested that this was an invented crisis.[17] Nevertheless, few discussions of female weaknesses were divorced from the topics of marriage or motherhood. Even women's propensity to indulge in fashion, encouraged by their new visibility in public, was related to these issues. A writer to the *Correo de Madrid* lamented:

> Current fashion is to instruct them from the cradle in *marcialidad*, the harmony and variety of colors, the handling of a fan, mantilla, and other accessories, in the contortions of the body and the play of the eyes, in the perfection of all dances, without omitting the allemande, the fandango, and the famous bolero, but not in the management or economics of the home, because this is for ordinary people. From this wonderful upbringing,

the goal of all women becomes to get married, not to make a husband happy or procreate, but simply to enjoy and to run through (at the very least) the savings of this unfortunate, who, to live in peace, is condemned to spend the rest of his life in continual unrest.[18]

The female penchant for adornment underlies, of course, the elegant costumes of the streetwalkers, so often juxtaposed with the plainly dressed celestinas who accompany them. Women's increasing preoccupation with fashion in late eighteenth-century Spain coincided with a European trend, as changing fashions in late eighteenth-century Europe anticipated the division that would become common in subsequent centuries, with male costume becoming less ornamented and female costume more so.[19] As Aileen Ribeiro also discusses in her essay, a concern with the growing luxury of female dress led in 1788 to a proposal, dedicated to the minister of state, the count of Floridablanca, for a national costume for women.[20] Three variations on the costume were warranted, depending on the social status of the wearer and the occasion. Although the impracticality of the proposal was soon recognized, the government did not remove itself entirely from the question of female costume. During Holy Week of 1798, several women appeared in the street in overskirts, or *basquiñas*, of brown and other colors—instead of the traditional black. Their dress caused an upset among "members of the lower classes" *(gente del populacho)*, who insulted the women and even threatened to rip off the offending overskirts. In response, any such reaction to *basquiñas* or other articles of dress was outlawed. However, a year later, in March 1799, a royal order was published that allowed only black overskirts to be worn, and outlawed any excessive colored, silver, or gold trim. Capricho 26, *Now They Have a Seat* (cat. 90), or in Spanish, *Ya tienen asiento*, offers an ironic play on the word *asiento*, which may mean "seat" or "judgment"—which these young ladies clearly lack. The etching may also allude to the blind following of fashion, as women parade their *basquiñas* on their heads to the amusement of the onlookers behind. And female obsession with adornment that long outlives natural beauty provides the theme for Capricho 55, *Till Death* (cat. 91), which introduces a theme that Goya would revisit in the late painting of 1802–1812, *Two Old Woman* (Musée des Beaux-Arts de Lille).[21]

Women in Goya's Album Drawings

The albums of drawings that have been denoted as "A" and "B" (the Sanlúcar and the Madrid albums, respectively) were the first two of eight that the artist

would create from the mid-1790s to the end of his life. The drawings vary greatly in their degree of completion, which might suggest that some were created as finished works and others were more private experiments. Many of the drawings seem to record specific incidents, suggesting a connection with observed reality that has been recently emphasized by Juliet Wilson-Bareau, who has titled certain albums according to their content.[22] But to christen an album in light of only some of the subjects presented within, or to title an album in such a way as to imply that all of its drawings have a basis in everyday experience, is a somewhat reductive approach. As Pierre Gassier has noted: "[I]t cannot be said that this or that album, such as the one in the Prado, is actually a 'journal' in the strict sense of the term . . . The fact is that Goya's art is much more complex."[23]

Over a thirty-year period, Goya's drawings offer variations on themes associated with women who openly express passion, sorrow, maternal love, and at times, hatred. The juxtaposition of male and female reactions might serve to underscore a female emotionalism, as in a drawing from album B (cat. 95), where a man and woman react to the pronouncement issued by a third figure, whose sex is not easy to define. The clasped hands of the man suggests that he pleads, whereas the woman breaks down in sobs—as does a second female figure behind. These stereotypes were undoubtedly perpetuated in the theater of Goya's day, and we might even wonder if what is witnessed in the drawing is some kind of melodrama enacted at an aristocratic gathering for an evening's entertainment. About fifteen to twenty years later, Goya revisited the theme of female passion—and perhaps hysteria, a disease that was associated with women during Goya's time—in a drawing of album E (cat. 109). The detailed handling and description of costume seen in the drawings of the Madrid album have given way to a bolder treatment appropriate to the subject portrayed. The drama takes place outdoors, as a woman dressed in only a chemise tears at her hair while others look on without reaction. Behind her, an unseen figure points (perhaps to the source of her anguish?). The disparity between the woman's passion and the blasé reaction of the onlookers suggests a strange disconnectedness that anticipates what we see in the etchings of the Disparates, where the sadistic treatment or suffering of one person seems to have no impact on the onlookers. In the drawing, this detchament suggests that the woman is beyond help and beyond sympathy, as passion overwhelms reason.

There seems little doubt that Goya, like many of his contemporaries, associated the virtuous woman with home and motherhood. Even reformers in favor of women's education justified their cause by appeal to the need for mothers to be educated:

What man would deny that women form the hearts of children until the age of seven or eight? And can this be done without talent, capacity, and without a soul more finely tuned that that of man? ...Happy the State that comes to have a large number of women so virtuous, that propagating the human species, they improve it and are the joy of their families.[24]

The identification of female and maternal virtue is expressed in the Sanlúcar album, as Goya depicts a young woman traditionally identified as the duchess of Alba with Mariluz, the duchess' adopted daughter (fig. 3). Alternatively, the bad or ignorant mother becomes a villain, as seen in the drawing bearing the caption *What Stupidity! To Determine Their Fates in Childhood* (cat. 104). A peasant woman forces two children into something they don't want to do, as one struggles and the other, resignedly, follows. This child mimics the attitude of the woman, who walks forward with bowed head and closed eyes, similarly resigned to her fate.

The range of Goya's representation of women is unmatched by any artist of his time. In some images, women contemplate their choices: *Think It Over Well* (cat. 105) emphasizes the woman's reflection, rather than the choice to be made, since the viewer is not told what "it" is. Elsewhere, Woman is scorned as the embodiment of frivolity. In *It's a Pity You Don't Have Something Else to Do* (cat. 106), a woman assumes the costume of a peasant carrying water from the well, although her hair ornament, necklace, slippers, and poise suggest that she is in fact an upper-class woman in masquerade. Goya's caption clearly condemns the "deceit."[25] He illustrates a very different side of women in the superb drawing *You'll See Later* (cat. 108), in which she is the embodiment of temperance, her restraint underscored by contrast with the man who guzzles wine, to her obvious disapproval. Clearly beyond the bounds of traditional femininity is a drawing showing a woman poised to murder a sleeping man (cat. 110).

In Goya's drawings, women plead, cry, and are victimized by circumstance, by society, by men. With few exceptions, the men are usually in control. Even

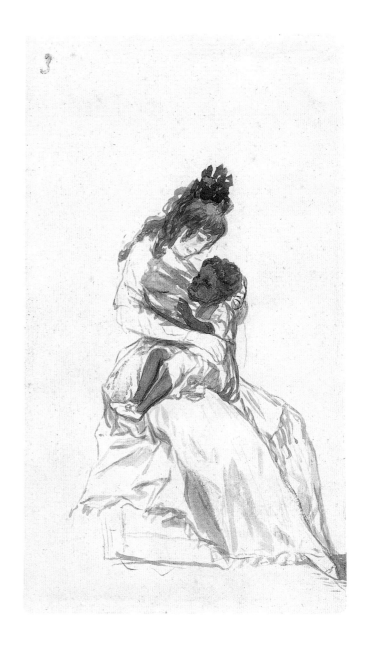

Fig. 3 Francisco Goya, *The Duchess of Alba and Mariluz*, Sanlúcar album, 1796, indian ink wash, Museo Nacional del Prado, Madrid (recto of fig. 2)

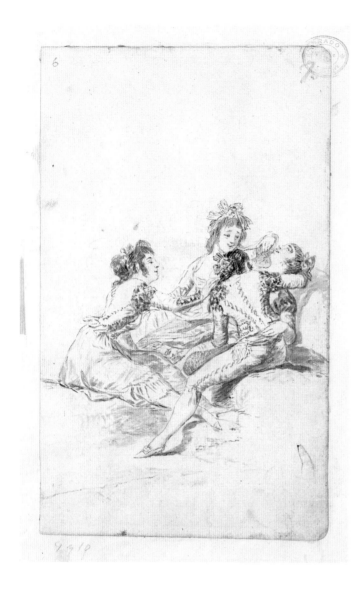

Fig. 4 Francisco Goya, *A Group with a Fainting Woman*, Madrid album, 1796/1796, indian ink wash, Museo Nacional del Prado, Madrid

when this control is not depicted, the male artist has the upper hand, directing interpretations of his female figures by the captions he provides. Perhaps, then, it should not surprise us that the artist was drawn to the theme of Pygmalion and Galatea—translated from the classical to the modern world (cat. 111). In Ovid's *Metamorphoses*, the sculptor Pygmalion asked Venus if he might have a wife as lovely as a sculpture he had just created. Venus granted his wish; Pygmalion kissed the ivory sculpture and it came to life. Goya's drawing transforms the myth: Pygmalion is given the pug nose and sunken eyes that suggest this to be a self-portrait of Goya, although his costume combines the Rembrandtesque, in its broad, white collar, and the eighteenth century, in his knee britches. And in lieu of a chastened kiss, the penetration of his suggestively placed chisel seems to awaken the figure of a woman, whose chastity is implied by her all enveloping dress. She turns toward the viewer, her wide eyes ostensibly expressing surprise rather than any kind of displeasure.

Goya's early experimentation with lithography, a technique introduced in Madrid only in 1819, shows his continued involvement with the portrayal of women. In *Woman Reading to Two Children* (cat. 113), he apparently attempted to create a composition enhanced by strong tonal contrasts (possibly originally a woman reading by a now unseen source of illumination) but the coarse grain of the stone apparently prohibited this.[26] The composition has an improvisational quality to it: if we block out the two figures looking on, we are left with a very sensitive image of a woman engrossed in reading—one of the few images within Goya's oeuvre of a woman's intellectual absorption in a task. So involved is she, that she remains unaware of the children who hang on her words, to reinforce the suggestion that they were perhaps a subsequent addition.

The woman in the lithograph variously titled *Group with Sleeping Woman* or *Woman in a Trance* (cat. 114) is the antithesis to the woman reading. Sleeping or fainted—and thus recalling an early drawing from album B (fig. 4)—she remains oblivious to all around her. In contrast to the huddled form of the

woman reading, this woman sprawls across the paper: if Goya began each composition with the central figures, these clearly present opposites. Yet, as in *Woman Reading to Two Children*, the added onlookers seem secondary to the subject at hand, and we sense here again an improvised composition. That Goya was more interested in experimenting with lithography than with sales is suggested also by the rarity of each of these images, of which no edition was offered.

The Disasters of War and The Disparates

Undoubtedly, the most famous image of a woman in the Disasters is that of Agustina of Aragon (cat. 116). During the siege of Saragossa, Agustina surmounted the Portillo battery after all the male combatants had been killed. Taking a match from the hand of one of the dead soldiers, she fired the twenty-four-pounder and saved the day. Her fame spread throughout Spain and beyond, after she was celebrated in *Childe Harold* by Lord Byron, who met her in Madrid in 1809, and whose verse inspired David Wilkie's painting *The Defense of Saragossa* of 1828 (Collection of Her Majesty the Queen). As has been pointed out, Agustina's celebrity is in part explained by the uncommon nature of her deed: although the exploits of women in combat were celebrated in propaganda and myth, in fact, such instances were rare.[27] Women generally "fought, like Agustina did, when there were no men left, when they were protecting their children, and when they were defending their sexual integrity."[28] These are the roles of women that Goya represented. Other roles played by women during the war, as nurses of the wounded, as spies, and as disseminators of misinformation to the French, go unrecorded in his etchings. The unique image of Agustina approaches allegory: her identity is hidden, her face is cast in shadow, and her delicate figure is clad in a classically inspired Empire gown. She seems ethereal, compared with other women portrayed in the series, who offer a far less sensational imagery of female heroism. In *And This, Too* (cat. 117), determined women, heads held high and gazes straight ahead, try to escape the ravages of war with children, housewares, and farm animals in tow.

The uniqueness and power of much of Goya's imagery of war lie in the fact that he isolates individual vignettes, giving the paradigmatic "inhumanity of war" an all too human face. Often that face is transformed by the violence it imposes or suffers, as in Goya's scenes of rape. Sexual atrocity during wartime was not a novelty, and had been depicted in the seventeenth century by Jacques Callot in his etchings *The Miseries of War*.[29] Callot presents rape as one act of violence in a panorama of atrocity;[30] Goya forces the viewer to confront the

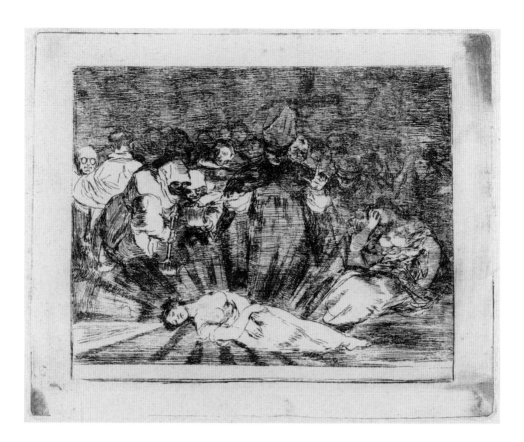

violation. Whereas once a young and old woman together were cast as the amusing figures of streetwalker and celestina, in *They Do Not Want To* (cat. 118), they are transformed into a woman in a virginal white dress, who fights off the advances of a burly soldier, and an older woman who approaches to attack from behind. In the subsequent etching, *Nor Do These* (cat. 119), desperation and violence are communicated through the depiction of a struggle in which limbs and bodies can be neither deciphered nor untangled. The body of the woman in the foreground is contorted as she flails helplessly; we detect behind her the upraised legs of another female. That the men clearly outnumber the women only heightens the viewer's feeling of outrage before their actions.

A third type of imagery of women in the Disasters undoes gender distinctions, showing that the extremes of war leave no room for roles common to polite society. In *Ravages of War* (cat. 123), the bodies of women and men are twisted and indiscriminately intertwined with what appears to be a collapsed home—its past domestic tranquility hinted at by a single armchair suspended in space. A bare-breasted mother, her legs indelicately spread, holds her dead child in this image of a world literally made topsy-turvy by war's devastation. And in *Rabble* (cat. 122), a masculinized woman beating the perhaps already dead body of an enemy or traitor recalls Goya's drawing of a woman murdering

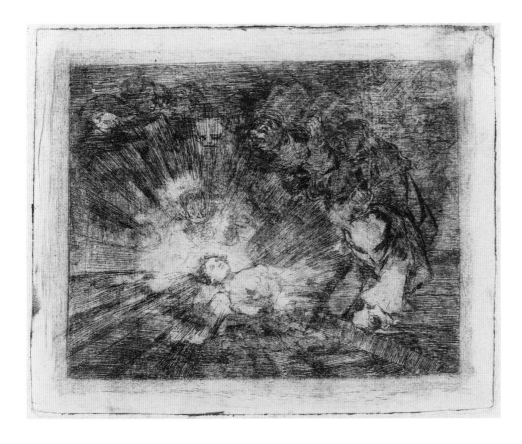

Fig. 6 Francisco Goya, *Will She Rise Again?* (working proof), c. 1814, etching and drypoint, touched with graphite, Museum of Fine Arts, Boston

a sleeping man (cat. 110). Again, the niceties of the conventional female are lost, as a desire for vengeance distorts her face and gives her arms unexpected strength. With the exception of the image of Agustina of Aragon, there are no recognizable individuals portrayed in the Disasters; only the anonymous confront and react to specific situations—rape, executions, and the need to seek refuge from the violence.

As Goya developed this series he added a group of etchings identified in an early title page as *"caprichos enfáticos,"* or Emphatic Caprichos.[31] The imagery of these allegorical etchings, which refer at least in part to the authoritarian restoration of Ferdinand VII, as well as the larger size and quality of the plates, suggests that they were etched during the postwar period. In their unique imagery, they provide a link between the seemingly documentary images of the Disasters and those of the Disparates. In the most accessible Emphatic Caprichos women assume a clearly allegorical role, illustrated in *Truth Has Died* and *Will She Rise Again?* (figs. 5 and 6), where Goya exploited the technique of etching to equate truth with light, against the figures of darkness who attempt to bury her. Other Emphatic Caprichos are more ambiguous. *What Is This Hubbub?* (cat. 124) shows two women, young and old, who cover their ears and bow their heads against the raging forces around them; they become victims of the wars caused by men, embodied by the soldier on the left who

Fig. 7 Francisco Goya, preliminary drawing for *Feminine Folly*, 1816/1820, sanguine wash with traces of red chalk, Museo Nacional del Prado, Madrid

calmly witnesses and seems to register the commotion he causes. The meaning of *What Is This Hubbub?*, like that of many of the Emphatic Caprichos, is more easily intuited than it is explained—it presents an image of disorientation, suffering, and victimization, pitted against an official doing his job. The man's uniform suggests an identification with Napoleonic forces, but, beyond this, the image cannot be explained by narrative, a trait that characterizes many of the etchings of the Disparates.

The drawings for the Disparates (a title that translates only loosely as "follies") are freely brushed in sanguine wash, and present images that underwent significant transformation as Goya etched the plate. In the drawing for *Feminine Folly* (fig. 7), Goya returns to a theme of women tossing a doll in a blanket, first seen in the tapestry cartoon *The Straw Mannikin* (cat. 19). The limp rag doll lies in the blanket, as spectators wait for the game to begin. In the final etching (cat. 125), the onlookers disappear—removing the scene from

the carnival context where it might have taken place—and two more women join the group, tossing two dolls now suspended in midair. A man and a donkey lie in the shadows of the blanket. What might previously have been explained as a game or carnival scene, or even as an allegory of the relationships between men and women, has now become an image of nonsense, or disparate.

In the drawing for *Poor Folly* (fig. 8), two female figures, apparently frightened by the apparition that appears in the sky above, run toward a shelter, where a man in a greatcoat awaits. The combined themes of apparition, fright, and a possible reference to Napoleon's troops (the male figure) recall the imagery of the Emphatic Caprichos. However, the story becomes more complex, as in the final etching (cat. 127) figures run from no apparent danger, the central woman has sprouted a second head, and their fright is juxtaposed with the calm of the figures waiting within the shelter. The result is a story without a story line: we can discuss individual elements, but in the end they simply do

Fig. 8 Francisco Goya, preliminary drawing for *Poor Folly*, 1816/1820, sanguine wash with traces of red chalk, Museo Nacional del Prado, Madrid

not add up. Unlike the women of the Caprichos or the Disasters, the women in the Disparates cannot be assigned social roles. They evoke very basic human emotions—fear (cat. 128), agony, or passion (cat. 126)—removed from specific time or places. Nor can the women of the Disparates be seen as allegorical figures, since they stand outside of narrative, and, as purely visual conundrums, resist reduction to verbal equivalent.

The Disparates do not offer Goya's last depiction of women: these are found in later lithographs, the drawings of albums G and H, and in the late (though recently disputed) painting *The Milkmaid of Bordeaux* of 1825–1827 (Museo Nacional del Prado, Madrid). Nevertheless, they mark the ultimate in his representation of a theme that began in the tapestry cartoons and continued in the Caprichos and in early drawings. There, Goya presented identifiable social types who also represented specific classes: street sellers and streetwalkers, maids and majas, aristocrats and middle-class *petimetras*. In subsequent drawings and etchings, the specific position of women in society is difficult to discern; they represent not so much social types as feminine archetypes or emotional states. In the Disasters, women have become anonymous victims, often sharing their fate with men, as the war erases the luxury of gendered roles. Ultimately, the actions of women and their interactions with men in the Disparates lay bare emotions in dream-like images that defy narrative reduction or any equivalence in the visible world, in which Goya's art was once so firmly grounded.

NOTES

1. The original text is reproduced in Gassier and Wilson 1971, 382: "... un juego de quadros de gabinete, en que he logrado hacer observaciones a que regularmente no dan lugar las obras encargadas, y en que el capricho y la invención no tienen ensanches" (translated by the author).

2. Wilson-Bareau 2001.

3. Haidt 1998.

4. *Memorial literario*, Madrid, 1786; cited in Aguado et al., 1994, 283: "Quando Dios entregó el mundo á las disputas de los hombres, previó, que habría infinitos puntos, sobre los quales se altercaría siempre, sin llegar á convenirse nunca. Uno de estos parece que había de ser el entendimiento de las mugeres" (Josefa Amar y Borbón, *Discurso en defensa del talento de las mujeres y de su aptitud para el gobierno [Discourse in Defense of the Talent of Women and Their Aptitude for Government]*).

5. Kitts 1995, 13–15.

6. Feijóo 1997, 17: "Quien quisiere hacer buenas á todas las mujeres, convierta a todos los hombres."

7. "Disertación sobre los medios de promover mayor número de matrimonios," Don MM. de B. y B., Real Academia de Santa Bárbara de Derecho Español, published in *Espiritu de los mejores diarios*, nos. 141–145; cited in Kitts 1995, 188: "Quedan de una vez sin resortes el cuerpo y la alma, y sumergido el ciudadano en los brazos de una cortesana, pierde enteremente los deseos y sentimientos para con las hijas honestas y virtuosas."

8. Ramírez y Góngora 1774, 6–7.
9. See Held 1971, cat. nos. 95, 109, 231, and 234.
10. Tomlinson 1992, 82.
11. *Real Cédula de Carlos III de 11 de mayo de 1783*, cited in Aguado et al., 1994, 247: "Usarán las Maestras de un estilo claro y sencillo en la explicación..., y no permitirán a éstas usar de palabras indecentes, equívocas, ni de aquéllas que se dicen propias de...majas."
12. Cited by and translated in Haidt 1998, 102: "Más fácil fuera el estrellado globo / contarle los luceros, las arenas / al mar que baña desde el Indo al Moro, / primero que yo cuente las muchachas / que hay en Madrid" (III, ll. 95–99).
13. Schulz 2000, 153–181.
14. Quoted in Sayre et al., 1989, 86: "sin que invoquen la razón, ni pese / su corazón los méritos del novio, / el sí pronuncian y la mano alargan / al primero que llega!"
15. Bolufer 1998, 73–77.
16. Glendinning 1978a, 130–134.
17. Bolufer 1998, 267–272.
18. *Correo de Madrid*, no. 15, 60; cited in Kitts 1995, 206: "La moda corriente es instruirlas desde la cuna en el aire marcial, en la armonia y variedad de colores, en el manejo del abanico, mantilla y demás muebles; en las contorsiones de cuerpo y juego de ojos, en la perfección de todo baile, sin omitir alemanda, fandango, y famoso bolero, pero no en el gobierno y economia de una familia, porque esto es de gente ordinaria. De tan bellisima crianza resulta que todo el fin de la señoritas es de casarse, no para hacer feliz a su esposo y multiplicar su especie, sino para disfrutar de una nociva libertad y destruir (cuando menos) el caudal de aquel infeliz que, por vivir tranquilamente, se condena a pasar el resto de su vida en continue zozobra."
19. Bolufer 1998, 198–199.
20. Bolufer 1998, 169–176; Kitts 1995, 208; Aguado et al. 1994, 310–313.
21. Madrid, Archivo Histórico Nacional, Consejos, Sala de Alcaldes de la Casa y Corte, 1798, fol. 222; Juan Meléndez Valdes, *Discursos forenses* (Madrid, 1821), 195. For a discussion of these rulings in relation to the costume seen in Goya's court portraiture of these years, see Tomlinson 1992, 81–83. On the interpretation of Caprichio 26, see Helman, 1967, p. 87.
22. Wilson-Bareau 2001, 16–20.
23. Gassier 1973, 14.
24. Vicente de el Seixo, *Discurso filosófico y político sobre la capacidad ó incapacidad natural de la mugeres para las ciencias y las artes* (Madrid, 1801), Article 1. Cited in Aguado et al. 1994, 241: "Qual será el hombre que niegue que las madres forman el corazón de los niños hasta los siete ú ocho años de edad? Y esto, puede hacerse sin talento, sin capacidad, y sin una alma más finamente templada que la del hombre? ... Dichoso el Estado que llegase á tener un crecido número de madres tan virtuosas, que propagando la especie humana, la mejorasen é hiciesen la felicidad de sus familias!"
25. Holo 1985, 108.
26. Vega 1990, 57.
27. Tone 1999, 259–266.
28. Tone 1999, 267.
29. Charles Yriate was the first to make this comparison, which has now become a standard within the literature on the series. See Blas and Matilla 2000, 13; and Cuno et al., 1990.
30. Wolfthal 1999, 93–96.
31. Harris 1963, I: 40; Glendinning 1978b, 186–191.

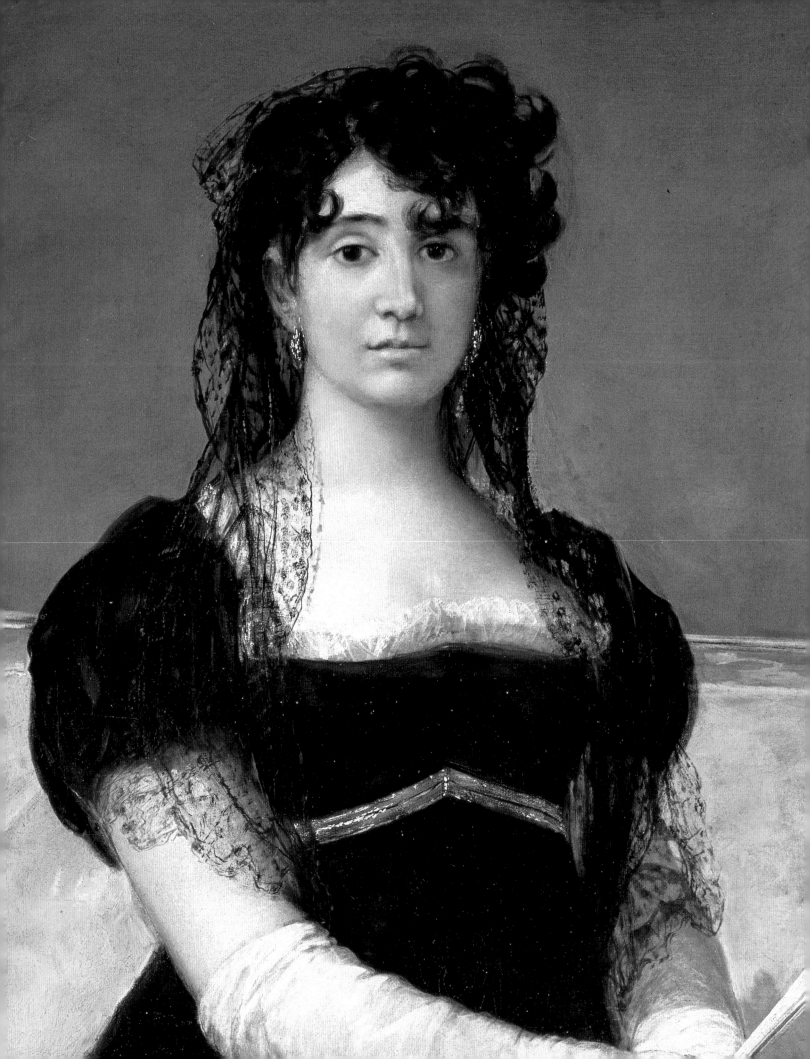

Fashioning the Feminine:
Dress in Goya's Portraits of Women

AILEEN RIBEIRO

"Goya possesses a peculiar talent for giving an accurate representation of
the manners, the diversions, and costume of his native country."
Jean-François Bourgoing, *The Modern State of Spain* (1808)

Like most great artists, Goya depicts the clothing of his time with expert-
ise and imagination. In the context of the turbulent times in which he
lived, he also reflects the prevailing—and sometimes conflicting—polit-
ical and cultural influences on fashion, those dictated by France and England,
and by a newly popular nationalist agenda. In the 1780s, all over Europe, even
in Spain, disturbing ideas of political and social reform were increasingly dis-
cussed, fostered by the works of English and French philosophers, and encour-
aged by the American colonies' successful struggle for independence. The
progressive classes in Europe, including some members of the nobility who
hoped for reform of moribund political systems, at first welcomed the Revolu-
tion, until the demise of the French monarchy and the expansionist ambitions
of France reversed this opinion. "With the French Revolution came for the
first time intrusive politics, a greater awareness of class differences, and a rest-
less need for change and for self-expression—all ideas which were to be
reflected in dress, that most sensitive of social barometers."[1]

For much of the eighteenth century, women's dress in Spain, especially
among the elite, and under the ruling Bourbon dynasty, was influenced by
French fashion. Formal dress, such as that worn at court, was made of luxurious

Antonia Zárate (cat. 41), detail

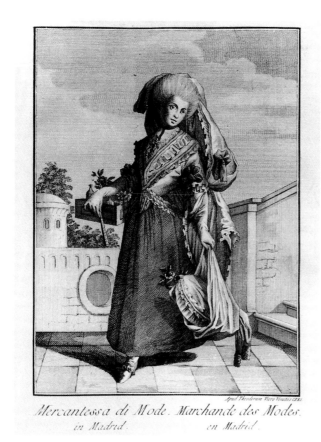

fabrics with elaborate decoration. Goya in his portrait *Queen María Luisa* of 1789 (Museo Nacional del Prado, Madrid) draws our attention to the large and somewhat ungainly hoop skirt *(tontillo)* made of shimmering silk gauze stamped with gold and trimmed with the gold and silver lace which Spanish women delighted in.[2] Her extraordinary vast headdress—a confection of lace, ribbons, and feathers—must have been imported from France or made up by a French dressmaker resident in Madrid, possibly inspired by such styles created by Rose Bertin, modiste to the French queen, Marie Antoinette. The French diplomat Jean-François Bourgoing, writing in the late 1780s, noted that, although imported luxury goods were heavily taxed, French fashions prevailed among Spanish women (fig. 1), but could not always be successfully interpreted by Spanish dressmakers, so that "French milliners are employed to invent and make new dresses for the ladies."[3] While we have to be aware that French writers on Spain were keen to promote French fashions as part of a program of political and cultural propaganda that had originated with Louis XIV,

Mercantessa di Mode. Marchande des Modes.
in Madrid. en Madrid.

Fig. 1 Teodoro Viero, *Mercantessa di Mode in Madrid,* from his *Raccolta di 126 Stampe rappresantando Figure ed Abiti di varie Nazioni…,* 1783, colored engraving, British Museum, London, photograph courtesy of the Courtauld Institute of Art, London

their reports appear to be based on fact.

Although Spain produced much silk (the best was made in Valencia), the industry was hampered by "ancient processes," in Bourgoing's words, and the quality of the fabrics was inferior to that of the brilliant and sophisticated French silks from Lyons. Again, it seems likely that in Goya's famous group portrait *The Family of Charles IV* of 1800 (cat. 32) the glittering, gauzy silks worn by María Luisa in her court dress would be French, as was the high-waisted style with attached train made fashionable by Josephine Bonaparte in France and soon to be worn as official court dress throughout the Empire. It is not clear at what date the Spanish court began to wear this type of dress: Elizabeth, Lady Holland, refers to hoops in 1803,[4] but by 1805 Laure Junot, later the duchess of Abrantes, after being presented to María Luisa, noted that Spanish court dress was similar to that worn in France. Madame Junot's unflattering comments on the appearance of the queen—her stout, matronly figure clad in a dress "cut exceedingly low on the neck and shoulders," her badly fitting artificial teeth, and her wig styled *à la grecque*—are well known.[5] What is also worth pointing out, however, in Goya's images of María Luisa (see cats. 29 and 30) is the distinctive hispanicizing of French modes, a theme that can be seen in portraits of other elite women by the artist as well, and that was manifested

in a love of jewelry—the queen loved to show off her diamonds[6]—and a fondness for the glitter of gold and silver lace.

Foreign visitors and native commentators, often in the context of discussing the place of women in society, noted the greater social and sexual liberties allowed to upper-class Spanish women by the late eighteenth century, as evidenced, for example, by the popularity of the *tertulias* (informal assemblies for entertainment or intellectual discussion) and the *cortejo* (an intimate male friend, accepted as part of the household).[7] With the increased opportunities for public display, Spanish women of the elite constructed their own distinctive interpretations of fashions, both English and French. While satires of the 1770s and 1780s complain that Spanish women adopted such styles as the "polonaise in the French fashion,"[8] a flirtatious, ultrafeminine dress with looped-up overskirt at the back, arranged in swags, it seems, from portraits by Goya and his contemporaries, that their sitters, at any rate, did not slavishly copy foreign modes. The marchioness of Pontejos, in a portrait of c. 1786 (cat. 26), for example, wears her own version of the *polonesa*, the gauzy overskirt kilted up on all sides and trimmed with ribbons and flowers, a decidedly pastoral effect, enhanced by the English straw hat.

Looking at such full-length portraits, we can see the influence of Thomas Gainsborough, both in the outdoor setting and in the play of light on the fashionable filmy fabrics in vogue during the 1780s. At this time—the decade of Anglomania—many upper-class women in Spain began to wear the more relaxed and less highly decorated English styles of dress, such as the robe *à l'anglaise*, characterized by a tight bodice, curving into the waist and cut in one at the back. As the language employed for the name implies, this fashion came to Spain by way of France; in 1782, Goya refers to his wife, noted for her dressmaking skills, as making a "*baquero a la ynglesa*."[9] In Goya's portrait *The Countess of Altamira and Her Daughter* of about 1788 (The Metropolitan Museum of Art, New York), while the style of dress is English, the fabric—pink satin with delicate embroidery—owes more to French taste, as does the puffball of frizzed hair.

Goya's 1785 depiction of the duchess of Osuna in a blue satin robe *à l'anglaise* (Fundación Bartolomé March, Majorca) and in a family group in 1787–1788 (cat. 27) both reveal an English influence. The portrait of Goya's enlightened and progressive patrons displays an awareness of the family portrait groups seen in contemporary English art, where the informality and intimacy of the sitters are reflected in their unpowdered hair, the understated clothes they wear, inspired by practicality and the fewer social demands of country life. This can be seen particularly in the dress of children in the late eighteenth century, notably the simple white linen or cotton frocks worn by

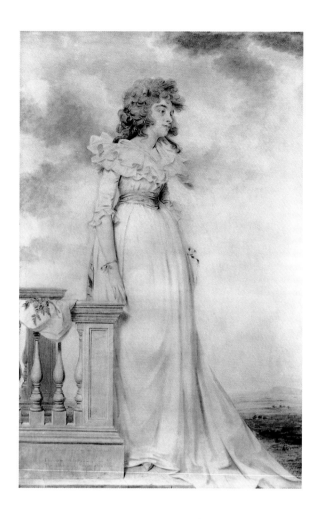

Fig. 2 John Downman, *Georgiana, Duchess of Devonshire*, 1787, water-color, Trustees of the Chatsworth Settlement

girls, and the "skeleton suit" (jacket and trousers buttoned together under a sash at the waist) worn by boys. These styles, some of the first garments specific to children, can be seen in Goya's painting *The Family of the Duke and Duchess of Osuna* (cat. 27). The "very light and airy" figure of the duchess, "the most distinguished woman in Madrid"—according to Lady Holland[10]—is shown in a simple bodice-and-skirt ensemble of white striped muslin, probably of English manufacture. Although foreign cottons were officially banned for protectionist purposes,[11] native cottons, such as those being manufactured in Catalonia by the end of the eighteenth century, were not of high enough quality to compete with the fine white English muslin so much in fashion from the 1780s on.

This gossamer fabric, originally imported from India and then imitated by manufacturers in the Lancashire cotton industry, was particularly suitable for the fashionable "chemise" dress (based on the female shift, or chemise, an undergarment), a simple T-shape with full, gathered folds and tied around the waist with a sash. The style was popularized by Marie-Antoinette and the fashionable women at the French court, and in England by the society beauty Georgiana, duchess of Devonshire (fig. 2); it thus became an Anglo-French fashion like the *robe à l'anglaise*. Translated to the Spanish context, such a dress is worn by a number of Goya's sitters over a pastel under-dress, creating the more complex effect of a gauzy, transparent fabric over an opaque silk. In her portrait of 1790 (Museo Nacional del Prado, Madrid), Tadea Arias de Enríquez wears a dress of embroidered white muslin over a pink silk skirt; in hers, of 1804 (Museo Nacional del Prado, Madrid), María Tomasa de Palafox is shown in an equally sophisticated ensemble of flowered muslin (or silk gauze) over yellow silk.

The events of the French Revolution had a strong impact on Spain, which after the execution of Louis XVI in 1793 had first allied herself with England by declaring war on France. But as the French occupied several towns in Spain by the summer of 1795, Spain had then to sue for peace and open hostilities against the English. Caught between the English and the French, the Spanish developed a tactful sartorial compromise, adopting Anglo-French fashions with a defiantly nationalistic twist.

In 1795, Goya painted his famous first portrait of the stylish duchess of Alba (see p. 40), famed for her beauty and her liberated lifestyle; the work

echoes the comments made by a French visitor to Spain in the 1780s, Fleuriot de Langle: "The Duchess of Alba possesses not a single hair that does not awaken desire. Nothing in the world is as beautiful as she. ... When she walks by, all the world stands at the window."[12] Goya shows her outdoors, English-style, in a chemise dress of white spotted English muslin. But, in the same way that his portrait of Tadea Arias de Enríquez demonstrates a Spanish influence in her fringed black sash tied at the waist, so Alba might be said to indicate her patriotism by wearing a gold lace trimming at the hem of her dress, large red ribbon bows, and a red sash *(faja)* borrowed from Spanish majo costume, another indication, perhaps, of her liberated lifestyle and willingness to cross—albeit in a minor way—sexual boundaries. How far Alba declares her political sympathies in her costume is not clear; she may have intended the red accessories to indicate revolutionary ardor and the white dress to signal liberty and enlightenment. Or not: the combination of white and red (cheekily under-lined by her "painted," i.e., made-up, face, probably the work of Goya himself) was in vogue, as contemporary fashion plates indicate, and certainly provided a striking contrast to her mane of black hair (fig. 3).[13]

By the turn of the century, a kind of demotic simplicity inspired by the French Revolution was the vogue in women's dress in Europe, both in style and fabric. One form in which this was expressed was the fashionable pelisse dress, a wrap-over gown with long sleeves tight to the wrist; this should be dis-tinguished from the earlier eighteenth-century pelisse—called a *cabriolé* in Spain—which was a fur-lined cloak with slits for the arms, as can be seen in *The Parasol* of 1777 (cat. 3). Seated on an elegant neoclassical chair in the French style, Thérèse-Louise de Sureda, in Goya's c. 1803–1804 portrait of her (cat. 33), wears a high-collared silk pelisse gown, wrapped around at the waist, the epitome of stylish modernity. The long sleeves extend well beyond the wrist, following the dictates of the fashion plates (fig. 4), a style that can also be seen in Goya's *Isabel de Porcel* of c. 1804–1805 (cat. 36), where they reach almost to the fingers.

In France by the late eighteenth century, the Revolution was increasingly identified with a classical past admired for its virtue and heroism; the ancient world—both Greece and Rome—inspired a range of art forms, including fashion. Compared to the extremes of neoclassical costume at the very end of the eighteenth century—the simplest of white muslin dresses, often mere rec-tangles of fabric knotted on the shoulders—popularized in France by the lead-ers of the somewhat raffish demimonde of the Directoire and Consulate, women's dress in Spain retained more modesty, although its wearers were sometimes accused of being "transformed into Greeks," that is, of appearing in skimpy, body-revealing draperies.[14] Perhaps the most neoclassical image of a

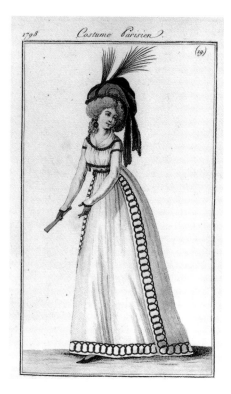 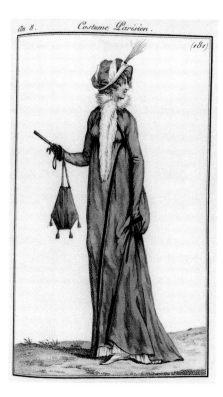

Fig. 3 Fashion plate of an open robe, deco-
rated with red chenille, from the *Journal des
Dames et des Modes*, 1798, colored engraving,
Victoria and Albert Museum, London, photo-
graph courtesy of the Courtauld Institute of
Art, London

Fig. 4 Fashion plate of a blue pelisse gown
from the *Journal des Dames et des Modes*,
1799, colored engraving, Victoria and Albert
Museum, London, photograph courtesy of
the Courtauld Institute of Art, London

Fig. 5 Fashion plate of a white muslin gown
and cashmere shawl from the *Journal des
Dames et des Modes*, 1800, colored engraving,
Victoria and Albert Museum, London, photo-
graph courtesy of the Courtauld Institute of
Art, London

woman in Spain is Goya's 1805 portrait of the beautiful marchioness of Santa
Cruz (cat. 40), reclining on a pink daybed in a sleeveless white dress, holding a
lyre-guitar, and representing either one of the muses, or possibly—with her
headdress of vine leaves and grapes—Erigone, who entertained Dionysus and
received from the god the gift of wine.[15]

During the height of neoclassical influence in costume, when a simple
white dress was de rigueur, good taste and elegant deportment both required
the correct accessories, the most important of which was the shawl: French
fashion plates from the *Journal des Dames et des Modes* indicate the different
ways in which such a garment (cashmere was especially fashionable) could be
draped, to achieve the requisite "antique" ideal (fig. 5). In Spain, the shim-
mering, gauzy shawls of Indian silk were more suitable to both the climate and
Spanish taste. In Goya's 1799 portrait of María del Rosario Fernández—"La
Tirana" (Museo de la Real Academia de Bellas Artes de San Fernando,
Madrid)—the actress wears a dress of white spangled muslin, decorated at the
hem in typically Spanish fashion with a border of gold lace or embroidery, and

she is swathed in a long, fringed Indian shawl. The fabric seems especially suited to Goya's loose, almost impressionistic brushstrokes.

Another example of the way in which the fairly rigid neoclassicism in French dress of the period could, in the Spanish context, offer a greater range of individual expression can be seen in Goya's portrait of the countess of Chinchón of 1800 (cat. 31). The young wife of the royal favorite, Manuel Godoy, indicates her pregnancy by clasping her hands over her belly; the wheat sheaves in her hair, while perhaps another allusion to her personal fruitfulness, were a fashionable signifier of classical/pastoral simplicity—at around this time, for example, Laure Junot remarked on Josephine Bonaparte's wearing poppies and golden ears of corn in her hair.[16] The countess of Chinchón's dress is a superb example of Goya's mastery of shifting light on insubstantial, even transparent fabrics. The gown is of white stamped silk gauze over white silk, decorated on the sleeves and hem with applied blue ribbon; twisted blue and white silk form the belt of the dress. This arrangement of white and blue, featured in the bonnet as well, is a pretty and youthful costume, but also a reference to the sitter's family and marital connections. On her right hand the countess wears a ring with a large miniature of her husband, Godoy, who is shown in the blue and white sash of the Order of Charles III, uncle of the countess of Chinchón.

So far I have alluded to relatively minor elements of "Spanishness" in women's dress of the late eighteenth and early nineteenth centuries. We ought now turn to the question of what Spanish dress was, how it was interpreted in elite fashion and represented in portraiture, and how far it can be identified with a nationalist agenda, in a period when Spain, blown about by the prevailing winds from England and France, seemed to have lost control over its destiny.

Two interrelated themes are worth mentioning in this context. The first is part of the debate about luxury taking place all over Europe. In Spain, a protectionist and moral agenda promoted home-manufactured textiles and styles of dress at the expense of foreign (and costly) fabrics and garments, thus creating clothing that was purely Spanish, unpolluted by imported styles inimical to traditional customs and costumes. The Habsburg monarchy of the seventeenth century attempted to ban French fashions, and although these sumptuary laws were revoked under the French Bourbon dynasty that succeeded the Habsburgs in 1700, there remained a sense that somehow "Spanishness" ought to be encouraged among the educated classes and opinion-formers. In 1788, a pamphlet was published in Madrid by "M.O.," an anonymous (presumably female) author, who argued for the creation of a national costume for women of all classes. This *Discurso sobre el lujo de las señoras y proyecto de un trage nacional,*

E.SPAÑOLA.

Fig. 6 The *Española* dress from the *Discurso sobre el luxo de la señoras y proyecto de un trage nacional* by "M.O.," Madrid, 1788, colored engraving, British Museum, London

presented to the *Junta de Damas* (Women's Committee) of the influential Economic Society of Madrid, attacked the expense of foreign fashions—*las modas extrangeras*—and aimed to promote distinctively Spanish styles made of Spanish materials. However, the proposed costumes, as illustrated in the *Discurso* (fig. 6), have nothing Spanish about them, being versions of the fashionable *robes à l'anglaise* for the upper and middle classes, and simpler bodice-and-skirt ensembles for lower-class women. Moreover, as a counterproposal stated, such dresses, being extravagantly decorated, would not diminish luxury, nor could the limited manufacturing capacity of Spain supply the fabrics needed.

The second theme is the better-known topos of *majismo*, the wearing of "national" Spanish costume, described by Susannah Worth as "an indigenous Romanticism which operated at all levels of society."[17] The word maja comes from *maya* (the month of May) and it was the custom on May Day, the first day of the month, for working-class women to dress up and dance around the streets accompanied by music (there were similar traditions all over Europe). The costume they wore on this and other holidays, which originated in Andalusia (called by Alexandre Laborde "the country of majas")[18] and was related to gypsy dress, consisted of a bodice and skirt trimmed with lace, braid, and frills; by the late 1770s, the dress was usually black, and sometimes over the skirt was worn another skirt known as the *basquiña.* The headdress was either a net *(redecilla),* a *cofia* (a silk cap or coif decorated with tassels or ribbons—see Goya's tapestry in this exhibition *The Parasol,* cat. 4), or a comb with a large ribbon rosette, often with a veil or mantilla over it. In the same way that Highland dress came to be the Scottish national costume, so the costume of the maja from Seville came to be identified as Spanish, and was gradually adopted by women of the middle and upper classes. Majas, noted for their wit, coquettishness, and impertinence, and their middle-class imitators, the *petimetras* (from the French *petit maître,* or dandy) feature in fashion plates of the period, such as Juan de la Cruz Cano's *Colección de Trajes de España* (figs. 7a–c)[19] and Antonio Rodríguez' *Colección general de los Trajes....* (1801), as well as in the work of Goya and his contemporaries.

In the political and social climate of the later eighteenth century, increasingly open to picturesque non-elite fashions, maja costume was a popular

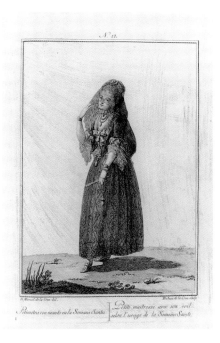

choice for masquerades. A portrait by Anton Raphael Mengs, for example, *The Marchioness of Llano* (fig. 8), shows the sitter wearing such a costume, composed of a black-and-white-silk bodice and skirt; her headdress comprises a net and a black velvet *montéra* hat decorated with carnations.[20] This dress corresponds perfectly with that of the maja described by Joseph Baretti in his *Journey to Genoa through England, Portugal, Spain and France* (1770); such a woman wore "a tight jacket, so open before as to form two hanging flaps under the breast, something in the form of wings, with sleeves close to the fist, a short petticoat...a black apron...a montera...."[21]

The French Revolution further encouraged the vogue for the low life, and Jean-François Bourgoing was not alone in noting that in Spain, among "persons of distinguished rank," there were those who "imitate the dress, manners and accents of the populace," and were flattered when it was said of them "one would take her for a maja."[22] In fact, such elite women as those painted by Goya would not really have been pleased to be taken other than fleetingly as majas; a more penetrating scrutiny would have revealed the high-quality fabrics and aristocratic deportment that would have disclosed their status. It is interesting that it was women who wished to adopt such role-playing and not men; it may indicate a new enjoyment of freedom of manners and lifestyles, a fashionable caprice, a flattering costume. It may have been even suggested by the artist himself, no stranger to the ways in which clothing outside the mainstream of fashion can transform an image. Goya's self-portrait of the mid-1790s (Museo de la Real Academia de Bellas Artes de San Fernando, Madrid)

Fig. 7 (a) *Frontispiece*, (b) *Maja* (plate 6), and (c) *Petimetra* (plate 12) from Juan de la Cruz Cano's *Colección de Trajes de Espana...*, Madrid, 1777, engravings, British Museum, London, photographs courtesy of the Courtauld Institute of Art, London

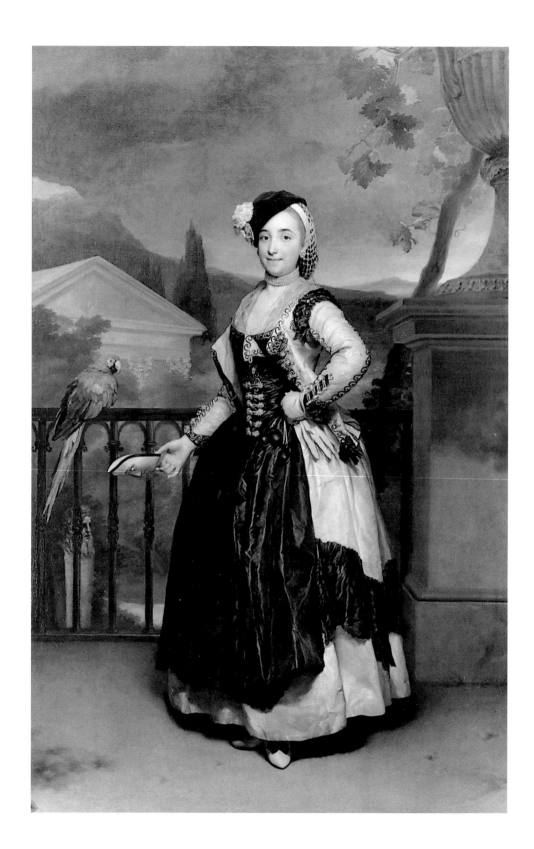

Fig. 8 Anton Raphael Mengs,
Marchioness of Llano, c. 1773, oil on
canvas, Museo de la Real Academia
de Bellas Artes de San Fernando,
Madrid

depicts a somewhat ambivalent fancy dress based on that of the *petimetre* (the long hair, the short jacket), but that follows the fashionable line of menswear with the striped vest, tight pantaloons, and high-crowned hat. Within Goya's lifetime, certain Spanish fashions—sombreros and cloaks, for example—had been banned as garments indicative of subversion, and although by the end of the eighteenth century there was no longer an anti-French agenda implicit in the wearing of such clothing, the artist may be signaling here his sympathies with Spanish nationalism as well as enjoying, like so many artists, the pleasures of dressing up.

Goya relished the seductive aspect of maja dress, and the possibilities it created for a confusion and mingling of identities. In his *Maja vestida* of 1800–1805 (cat. 55) we see an erotic juxtaposition of French and Spanish styles in dress, the flimsy, body-displaying white muslin chemise dress (worn straight over the naked body), and the maja bodice with its short upper sleeves,[25] which draws our attention to the clearly uncorseted breasts of the unknown woman, possibly Manuel Godoy's mistress. Drawings by Goya show similar bodices, as does his painting *The Duchess of Alba and "La Beata"* of 1795 (cat. 51); here the duchess wears an elaborately trimmed bodice with braid and tassels, and the kind of flounced skirt that is also part of maja dress, and that the artist frequently sketched in his albums.

The 1790s are the decade of the great Goya full-length portraits in maja costume, most famously *The Duchess of Alba* of 1797 (see p. 41). Pointing to the ground, on which Goya's name is written (on one ring is inscribed "Alba," on the other "Goya"), the duchess wears a bodice of gold brocade; a fringed red silk sash *(faja)* borrowed from the majo, like the one she wears in the 1795 portrait; a black silk *basquiña* trimmed with black silk flowers; and a mantilla with a wide, frilled border wrapped over her breasts, which are thrust out by the fashionable corset. How far Alba promoted the maja style in her salon as a contrast to the more intellectual *tertulias* hosted by her rival the duchess of Osuna (who preferred the more mainstream Anglo-French fashions), is not clear; nor is it clear how far she identified with a nationalist and anti-French agenda through her choice of costume here. Fashion was probably Alba's guiding inspiration, for the maja dress conformed to the prevailing demotic mood; allied to the Spanish sense of theater and dance, it was a seductive style that both men and women found attractive.

The essential elements of this style of dress were the *basquiña* and the mantilla; they had the additional virtue of being worn over fashionable clothing, and were sometimes transparent so that this could be revealed (fig. 9). According to Christian-August Fischer's *Travels in Spain in 1797 and 1798,* the *basquiña* and the mantilla comprised "the Spanish female dress out of doors,

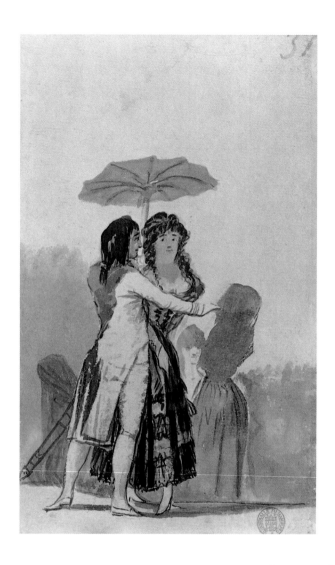

Fig. 9 Francisco Goya, *A Couple with an Umbrella*, album B, 37, 1796–1797, aquatint, Hamburger Kunsthalle

and without them women never appear in public…it is indispensably necessary to have both to be completely dressed." Fischer noted that elite ladies wearing this dress ("dangerous syrens") had "a light and bold walk, their short and fluttering petticoats, of which the long and transparent fringe exposes to view at every step a delicate and beautiful leg, those enticing veils which rather display than conceal their charms, their large nosegays, and the coquettish play of their fans…."[24]

There are a few references to colored *basquiñas*, as Janis Tomlinson discusses in her essay in this catalogue, women were insulted for wearing them during Holy Week in Madrid in 1798, which may have led to a royal order the following year decreeing black,[25] but on the whole black was the rule, being both traditional and flattering to most women. The *basquiñas* were "generally silk trimmed with single, double, or triple flounces, very broad and adorned with silk tassels. They are open in front, being tied with ribbands, and are only closed below."[26] They were removed indoors (except at church), which is why Goya's portraits in this costume are set out-of-doors. His full-lengths provide an opportunity for portraying the balletic stance of the women and their fine high-heeled shoes "embroidered with silk, gold, silver, pearls and spangles."[27] Many commentators found the contrast between the black silk of the skirt and the white silk of the stockings quite erotic. In 1823, the British visitor Michael Quin, for example, admired the women in their "handsomely flounced" black silk gowns and their "snow-white silk stockings" with openwork decoration at the ankles; such a contrast, he thought "sets off a neatly turned instep and ankle to great perfection."[28] However, the German botanist and geologist Henry Frederick Link thought that the short black skirt revealed too much of the legs and gave the women "an unpleasant, but at the same time, a licentious look."[29] This is exactly the effect (and possibly the intention) in Goya's portrait of the marchioness of Santiago of 1804 (J. Paul Getty Museum, Los Angeles), whom Lady Holland described as "very profligate and loose in her manners and conversation" and apt "to boast of her nocturnal revels."[30] Her maja costume is adapted to the new, slender, high-waisted style of mainstream fashion; the black silk bodice is embroidered with gold on the sleeves, and the short skirt of costly black lace reveals the latest vogue in shoes, flat-heeled coral-colored kid pumps. Her

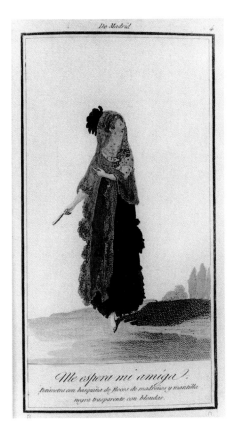

mantilla is a tour de force of Goya's skill in painting the essence of fabric as well as the reality—a delicate embroidered white net with the faintest touch of pink; instead of the customary ribbon rosette on the head, the marchioness wears a small bunch of orange blossoms.

The mantilla—today, along with the fan, the essence of "Spanishness"—was either black or white (figs. 10a–c). Writing in the early years of the nineteenth century (his *View of Spain* was published in 1806), Alexandre Laborde had the Frenchman's preference for the neoclassical effect that could be created by the white mantillas "of muslin plain or sprigged; of gauze, lawn, crape or taffeta"; he particularly liked the way in which a woman held up her mantilla with a fan so that "it floats above her head, and flutters about her person; it gives prominence and brilliancy to her eyes."[31] The marchioness of Solana, in Goya's portrait of her (c. 1794–1795, Musée du Louvre, Paris), wears a white muslin mantilla, the border of which has an edging of scalloped zigzags, known to the English as "Vandykes." In her hair is a large pink ribbon rosette; the mantilla, according to the informative Fischer, is "attached to a pad, which is kept in its place by a comb or to the riband."[32] Isabel de Porcel also wears a large ribbon rosette, to which her black lace mantilla is fixed (cat. 36), as does Queen María Luisa in her famous portrait by Goya of 1799 (cat. 29).

Fig. 10 *Petimetras* (plates 4, 6, 11) from Antonio Rodríguez' *Colección general de los Trajes que en la actualidad se usan en España, principiada en el año 1801 en Madrid*, Madrid, 1801, colored engravings, British Museum, London

Fig. 11 After Charles-Antoine Coypel, *La Folie pare la Décrépitude des ajustements de la Jeunesse*, 1745, engraving, British Museum, London

The wearing of the mantilla was a minor art form, according to foreign visitors who admired its feminine and flirtatious possibilities. Joseph Townsend, visiting Spain in 1786–1787, described it as "a kind of muslin shawl, covering both the head and the shoulders and serving the various purposes of the hood, of the cloak, and of the veil. No foreigner can ever attain their ease or elegance in putting on this simple dress."[33] There were various ways of arranging the mantilla on the body: crossed over in front, with the ends tied at the back (women were supposed to be as seductive from the back as from the front); draped softly in front, with the ends allowed to hang over the shoulders; and so on. Goya found it one of the most engaging aspects of Spanish dress, an accessory that could tantalize the male viewer by simultaneously hiding and revealing the face and torso. In his portrait of Antonia Zárate of 1805–1806 (cat. 41), Goya painted perhaps the most subtle and beautiful mantilla of all—of finely textured embroidered black silk net, it falls over the shoulders of Zárate's fashionable short-sleeved black dress. In the elegance and simplicity of the dress and accessories, and the sensitivity and intensity with which they are painted, there is a resonance here with the portraits by the great French artist Jean-Auguste-Dominique Ingres.[34]

The inspiration of maja costume had the potential to flatter women both young and old, even the queen of Spain, who by the time of Goya's portrait *Queen María Luisa in a Mantilla* (cat. 29) had "long lost the charms of youth";[35] we might wonder, nonetheless, how far this costume indicates a sexual rivalry with the duchess of Alba. Standing in the gardens of the palace of La Granja de San Ildefonso, the queen wears a short-sleeved pink dress that shows off her arms; Goya had difficulty painting her right arm. María Luisa wears a black silk *basquiña* trimmed with chenille, and a black lace mantilla; her passion for imported lace (criticized by the *Junta de Damas*) equaled her love of jewelry. She found this costume appealing, and she obliged her ladies to wear it for their morning promenades in the palace gardens. By this time, such clothing had largely lost its connotation of the "dress of the people" and provided the opportunity for a display of rich lace and decoration, as well as creating an elegant presentation of "Spanishness," a politically astute move, given the politics of the time.

How far Goya's terrifying painting *Two Old Women* (Musée des Beaux-Arts de Lille) is a *"critique acerbe de la libertine reine"*[36] or a ferocious parody of

María Luisa's appropriation of Spanish and French fashions is unclear. It is, of course, a traditional *vanitas* image, an indication of the ultimate futility of sartorial splendor in the face of the ravages of time. Goya may have been aware of Charles-Antoine Coypel's *La Folie pare la Décrépitude des ajustemens de la Jeunesse* (Folly Adorns Decrepitude with the Embellishments of Youth) of 1745 (fig. 11), where, as the title suggests, an old crone is being decked with a battery of artificial aids to beauty, while Cupid flies away with his arrow—the arrow also signifying the flight of Time. In Goya's painting we see the coexistence of two styles of dress in uneasy times (in 1808 Charles IV abdicated, and soon afterward Joseph Bonaparte was proclaimed king). On the left in Goya's painting is an aged hag in maja costume with red ribbons and black mantilla; her false teeth echo the pearls on her bony arm. On the right is a toothless old woman with a blonde wig (the diamond arrow in her coiffure is identical to that worn by María Luisa in Goya's *Family of Charles IV,* cat. 32), and dressed in inappropriately youthful, gauzy, and spangled French finery. Whatever the genesis of the painting, Goya uses dress—as he does so often in his work—to "point a moral and adorn a tale," as well as to reveal humanity in all its splendor and decay.[37]

For his kindness, help, and encouragement, my greatest thanks go to Nigel Glendinning, to whom I would like to dedicate this essay.

NOTES

1. Ribeiro 1988, 19.
2. These "gold and silver edgings, lace and fringe" were made all over Spain, but could not keep up with demand; see Laborde 1809, 4:347. Sometimes this kind of decoration was added inappropriately to functional garments; the playwright Richard Cumberland noted that when María Luisa, then princess of Asturias, gave an audience to his wife and daughters she insisted on taking a pattern from their riding habits, although she then "caused a broad gold lace to be carried round the bottom of the skirt" (Cumberland 1807, 2:92).
3. Bourgoing 1789, 2:196. As a result of a law of 1779 that forbade the importation of garments made outside Spain into the country, many French modistes settled in Madrid; see Charles E. Kany, *Life and Manners in Madrid 1750–1800* (Berkeley, 1932), 208.
4. Holland 1910, 75. It may be that hoops were retained for gala dress, on the grandest and most formal of court occasions. Hoops were cumbersome and difficult to cope with, as Laure Junot found when she was presented at the Portuguese court in 1805. She described herself as "like an ass, just harnessed with his panniers, swinging to the right and swinging to the left" (Junot 1831–1835, 4:226).
5. Junot 1831–1835, 4:141.
6. Holland 1910, 75.
7. See Kitts 1995.
8. I am indebted to Nigel Glendinning, who sent me his translation of a 1778 satire on fashion (MS 10942, Biblioteca Nacional, Madrid) lamenting the rise of French fashions: "It makes me laugh nowadays to see Doña Escotofía wearing a polonaise in the French fashion."

There is a play on words here, as "Doña Escotofía" can be translated as "Madame Décolletage," a reference to the vogue for low-cut dress *à la française.*

9. Information from Sarah Symmons.
10. Holland 1910, 195.
11. Lynch 1989, 215. Many foreign cottons did enter Spain, including English muslins exported by English traders in Portugal.
12. Quoted in Waldmann 1998, 12–13.
13. In a letter to his friend Martín Zapater, Goya says that Alba "barged into my studio to have her face painted and I went along with it. Certainly, I like this better than painting on canvas." Quoted in Hara 1997, 61.
14. Fischer 1802, 148.
15. Junot (1831–1835, 3:383) described Josephine Bonaparte at a fancy-dress ball as Erigone, wearing a headdress of vine leaves and black grapes. Lady Holland in 1804 referred to a miniature by an unidentified French artist of the marchioness "in the Spanish costume, full-length" (Holland 1910, 196).
16. Junot 1831–1835, 2:209.
17. Worth 1990, 13.
18. Laborde 1809, 2:149.
19. Juan de la Cruz Cano's brother Ramón was the author of popular contemporary farces, in which majos and majas play key roles.
20. The Mengs portrait is one of a growing number of manifestations of *espagnolisme* in the eighteenth century, a subject that needs further study from the points of view of both art and dress.
21. Joseph Baretti, *A Journey from London to Genoa through England, Portugal, Spain and France,* 2 vols. (London, 1770), 1:103. Baretti states that this costume was popular for masquerades in Spain, an assertion endorsed some years later by Michael Quin, who admired the various regional Spanish costumes that he saw at *tertulias,* especially "the ancient dress of Andalusia…extremely beautiful." See Quin 1823, 213. Female visitors to Spain, especially the English with their love of the picturesque, often donned Spanish dress, although it is not always clear what they actually wore. Richard Cumberland's daughters in the 1780s "conform[ed] to the costume of Spain to the minutest particular…wearing nothing but silks of Spanish fabric" (Cumberland 1807, 2:93), and Lady Holland, upon arriving in Spain in 1802, bought "some black petticoats and draperies" to make herself *"bien costumée à l'Espagne"* (Holland 1910, 7, 10).
22. Bourgoing 1789, 2:223. According to Laborde (1809, 5:318), women often had twenty or thirty fans.
23. The maja bodice derives from a seventeenth-century fashion: the sleeves were tied in at the shoulder, the join covered by a kind of short over-sleeve or epaulette; later, a decorative trim replaced this epaulette, in the same way that a similar form of braid or embroidery replaced the original lacing-in of the sleeves at the wrist. See Worth 1990 for a useful discussion of this garment.
24. Fischer 1802, 139. The fan, usually French or English, was used for flirtation and for protection from the heat and the sun, "as their head-dress is ill calculated for this purpose" (Quin 1823, 107).
25. Tomlinson 1992, 81.
26. Fischer 1802, 180.
27. Laborde 1809, 1:52. It took a while for flat-heeled shoes, in fashion in the rest of Europe from the mid-1790s, to be accepted in Spain; Fischer (1802, 184) noted that in 1797–1798, Spanish women still wore high heels and ridiculed Frenchwomen who wore the new style.

28. Quin 1823, 306.

29. Henry Frederick Link, *Travels in Portugal and through France and Spain*, trans. John Hinckley (London, 1801), 97.

30. Holland 1910, 198–199.

31. Laborde 1809, 5:318–319.

32. Fischer 1802, 181.

33. Joseph Townsend, *A Journey through Spain in the Years 1786 and 1787*, 3 vols. (London, 1791), 1:335.

34. See, for example, Ingres' *Madame Devauçay* of 1807 (Musée Condé, Chantilly) in her square-necked black velvet dress. Goya's *María Martínez de Puga* of 1824 (Frick Collection, New York) is close in spirit, as well as in dress, to Ingres' *Jeanne Gonin* of 1821 (Taft Museum, Cincinnati).

35. Robert Semple, *Observations on a Journey through Spain and Italy to Naples*, 2 vols. (London, 1807), 1:216. In 1809, Semple went on a second journey to Spain, and published his account the same year, illustrated with costume plates taken from Rodriguez' *Colección general de los Trajes…* of 1801. English interest in Spain was increased by the Peninsular campaigns led by the duke of Wellington; typical of the resulting publications is the Rev. William Bradford's *Sketches of the Country, Character and Costume in Portugal and Spain, Made during the Campaign and on the Route of the British Army, in 1808 and 1809* (London, 1809).

36. Anne Norton in Paris and New York 1992, 172.

37. Samuel Johnson, *The Vanity of Human Wishes* (London, 1749).

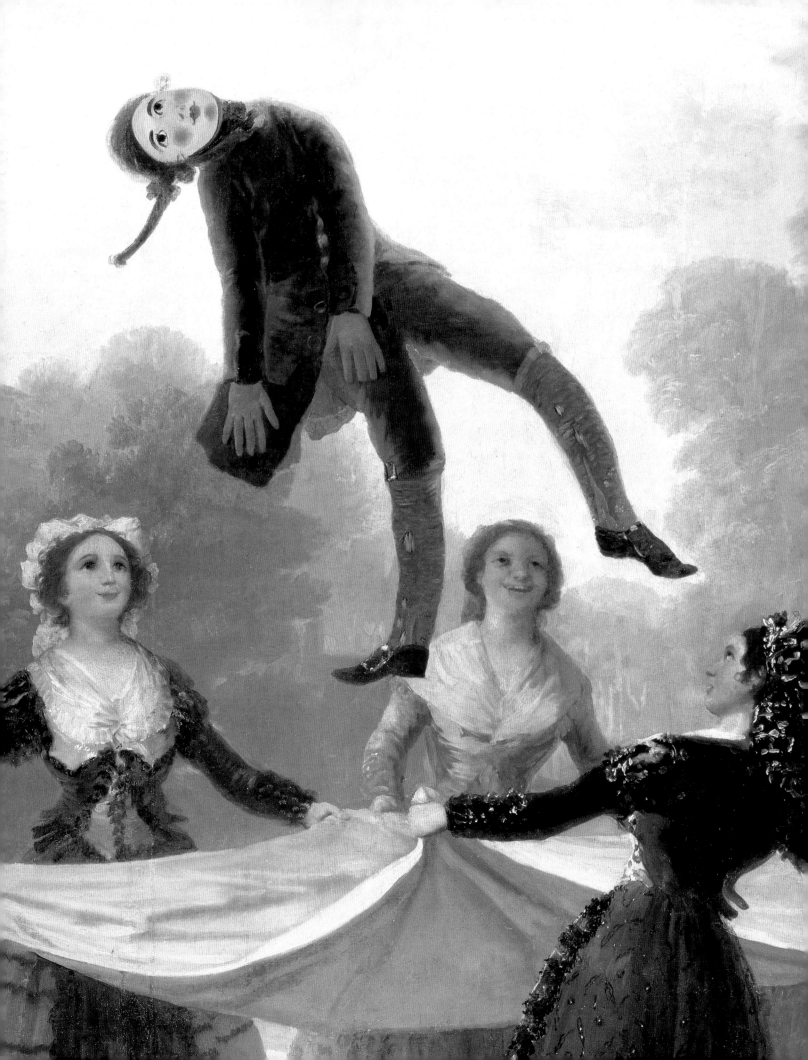

An Introduction to Goya's Cartoons and Tapestries

CONCHA HERRERO
CARRETERO

I n February 1869, Gregorio Cruzada Villaamil was named inspector of fine arts and antiquities in Spain as well as head of the Commission on Palace Inventory. This appointment led to the fortuitous discovery of twenty-two rolls of preliminary paintings for tapestries, or cartoons, in the basement of the Royal Palace of Madrid. Among these rolls were forty-five oil-on-canvas cartoons by Francisco Goya, previously known only through the tapestries woven after them. This discovery set in motion research into the production at the Royal Tapestry Factory in Madrid and into Goya's work as cartoonist.

The paintings that served as tapestry models were all executed in oil on a red ground. On the verso of each canvas, handwritten notations from the period in ink or pencil indicate the creator or creators of the painting, and sometimes the room for which it was intended. Cruzada observed that, in addition, Goya's cartoons display white lines delineating the contours, evidently added so that when the workers in the factory traced the painting for transfer to the threads of the weaving there would be no uncertainty—and no excuse for mistakes.

It was Cruzada, too, who proposed establishing the Tapestry Museum at San Lorenzo del Escorial to house the priceless collection, property of the Patrimonio Nacional, that was at the time dispersed among various buildings belonging to the Crown. Yet despite the decree founding the museum, despite Cruzada's reports, and despite the architect Domingo Inza's sketches, blueprints, and budgets, the project was never realized.

The Straw Mannikin (cat. 19), detail

In 1870, Goya's canvases were relined, placed on stretchers, restored at the expense of the Commission of the Tapestry Museum of the Escorial, then sent to the Museo Nacional del Prado for preservation. There had been eight more canvases originally: two long-lost—*The Dog* and *The Fountain*—and six others whose disappearance was discovered during a museum inventory. Two of the six made their way to museums in the United States: *Children with the Cart* in the Toledo Museum, Ohio, and *The See-Saw* in the Philadelphia Museum of Art; a third, *The Doctor*, is now in the National Gallery of Scotland, Edinburgh. The remaining three are now in the Museo Nacional del Prado.

Two other cartoons never passed into the Prado's holdings. *Boy with a Sheep* remained in the personal possession of Livinio Stuyck y Millenet (1876–1942), director of the factory, until its sale in 1911 to M. Fau, for Knoedler and Co. of New York, whence it entered the Deering Collection; today it is in the Art Institute of Chicago. *The Wild Boar Hunt* remained in the Royal Tapestry Factory in Madrid until 1946, when it entered the collection of the Spanish Patrimonio Nacional.

The Tapestry Cartoon: A Brief History

Throughout the sixteenth and seventeenth centuries, a design model for a tapestry consisted of a drawing on paper, sometimes in color, showing the composition or figure on the same scale as the proposed tapestry. Since tapestry manufactures usually handled sizes larger than a sheet of paper, storyboards called "cartoons" *(cartones)* came to be used: sheets of paper attached to one another with glue or paste to equal the dimensions of the tapestries that would be woven after their design. Raphael's cartoons for the *Works of the Apostles* tapestry suite, commissioned by Leo X for the Sistine Chapel, are one example: seven of these models are in London's Victoria and Albert Museum. Another is the group of cartoons executed by Jan Cornelisz Vermeyen for the tapestry cycle commissioned by Charles I of Spain (the Holy Roman Emperor Charles V of Germany) to chronicle his campaigns in North Africa. Only ten cartoons for *The Conquest of Tunisia* survive, in the Kunsthistorisches Museum of Vienna.

Peter Paul Rubens (1577–1640), working for the Flemish tapestry factories in 1616, was the first to use oil on canvas for cartoons, rather than ink, watercolor, tempera, or charcoal on paper. The Ringling Museum of Art in Sarasota, Florida, for instance, holds six cartoons in oils by Rubens for the series called *The Triumph of the Eucharist*, commissioned by Isabel Clara Eugenia in 1628 for the convent of the Descalzas Reales de Madrid. However, given the difficulty

of transposing the color range of the canvases—a difficulty in many cases exacerbated by the discrepancy between the size of the models and that of the wall space the tapestries were meant to cover—tapestry makers were obliged from this point on to trace the cartoon designs in order to transfer the compositional lines to the warp, or lengthwise strands. The definition of a cartoon was consequently extended to include copies on paper of the oil paintings the painters had submitted as tapestry models (figs. 1 and 2).

Once the tapestry was finished, the cartoons and patterns were rolled up and deposited with the master weaver, so that copies or replacements might be created at the clients' request. These designs frequently disappeared, or were damaged or cut down as a result of successive or protracted installation on the looms. Designs might be stored or forgotten in the factory basement, like the forty-five Goya cartoons that were discovered in 1869. Given the fact that they were rolled up on poles (just as they were delivered by the factory director) and were never valued as artworks in and of themselves but merely as patterns for tapestry, we are fortunate that cartoons by the great masters of European painting have survived to the present day.

Tapestry was traditionally viewed as a lesser art than painting, since it was governed by the cartoon being copied. Yet tapestry had its own standards: in many instances, painters admitted publicly that a tapestry surpassed the painting that had served as its pattern. The competition between the media of painting and tapestry in the eighteenth century was furthered first by advances in coloration, thanks to the improved nuances attained with wool and silk fabric dyes, and next by the technical brilliance of the weavers, a mastery perfected in only a few exceptional compositions woven from Goya's cartoons. The exquisite coloration in *Blindman's Buff*, of 1788, and its wonderful balance—the cartoon's distant background scenes, whose splotches, glaze, and chiaroscuro effects proved impossible to transfer, were eliminated in the tapestry—resulted in one of the most harmonious weavings ever produced by the Royal Tapestry Factory (fig. 3). Other Goya models posed less easily resolved problems, as evidenced in the clumsy execution of some of his works, such as the tapestry after *The Bullfight (La novillada)* of 1780 (Museo Nacional del Prado, Madrid). Among the more successful weavings included in the present exhibition are *The Swing* (cat. 8), *The Laundresses* (cat. 10), and *The Straw Mannikin* (cat. 20). In these three works, the silk blends achieve exquisite tonal gradations, thanks in part to the dexterity and precision of the foremost tapestry masters, in part to the quality and texture of the fibers, and in part to the quality of the colors used at the Dye Works instituted by Charles III in the Royal Tapestry Factory.

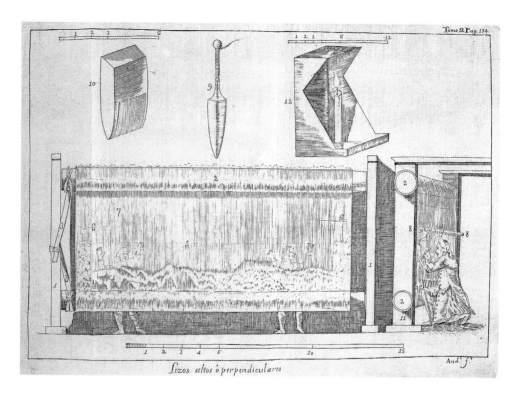

Fig. 1 Juan Bautista de la Peña,
Profile and back view of a low-warp
loom from A. Pluche, *Espectáculo de
la naturaleza*, Madrid, 1757

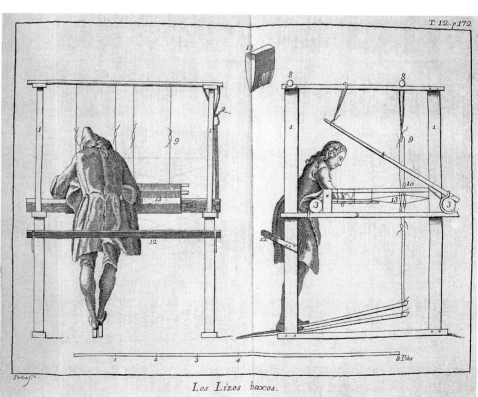

Fig. 2 Juan Bautista de la Peña,
View of a high-warp loom from
A. Pluche, *Espectáculo de la natu-
raleza*, Madrid, 1757

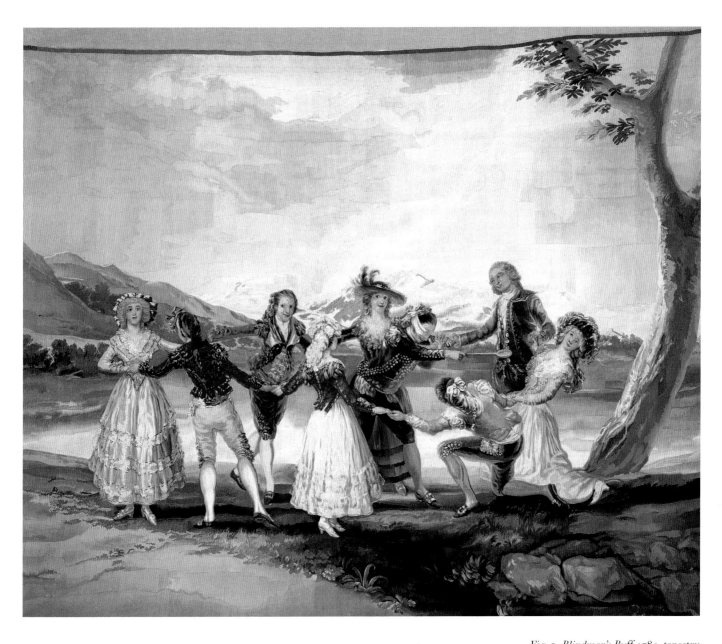

Fig. 3 *Blindman's Buff,* 1789, tapestry
from the bedroom of the infantas at
the Pardo palace, Patrimonio
Nacional, Madrid, inv. 10002903

Goya as a Painter of Tapestry Cartoons

Under Charles III, major decorative projects were undertaken in the palaces of
San Lorenzo del Escorial, northwest of Madrid, where the court spent the
autumn months, and the Pardo palace, occupied during later winter and
spring. Tapestries—movable objects, fixed in frames—were the predominant
decoration in palaces and royal residences outside Madrid, where the laws of
propriety mandated themes of relaxation, rural well-being, and games for the
monarchs' country estates. Topics related to hunting—the traditional leisure

pastime of kings, queens, and nobles—recur throughout the Escorial, where Charles III and his son devoted months to the delights of the chase.

In 1775, Francisco Goya was commissioned to paint a series of cartoons for tapestries intended for the chamber of the prince and princess of Asturias, the future Charles IV and María Luisa, in the Escorial. (fig. 4). These first works for the tapestry factory were to be painted under the supervision of the court painter Francisco Bayeu, who was also Goya's brother-in-law. The motifs chosen for the renovated decor were scenes of the hunt, a favorite pastime for the king and the infante, that involved the usual trophies: deer, wild boar, rabbits, quail, red owls, grouse, and duck.

To fulfill the commission, which he delivered to the Royal Tapestry Factory on 24 May 1775, Goya painted several scenes of the hunt, which are not included in the exhibition because no women are depicted in them. His "works on the hunt" replaced the images of Flemish villagers and the copies of paintings and prints by David Teniers the Younger (1610–1690) in the royal collections, previously produced by painters whose service to the monarchs included submitting designs to the factory. The royal collection of paintings had exhausted its fund of subjects to copy a decade before Goya painted his first cartoons; yet, despite the general boredom induced by the old models, a new supply of similar subjects was ordered from Paris: one hundred and fifty additional Teniers prints.

The most striking tapestries in the Pardo palace feature scenes from the outskirts of the capital and the entertainment typical of the area, an allusion to the suburban character of the residence. Goya was the first to explore this new subject matter, which was soon imitated by many of his contemporaries. Goya's second series of designs, for the dining room of the prince and princess of Asturias in the Pardo palace (1776), a series that includes *A Walk in Andalusia* (cat. 2) and *The Parasol* (cat. 3), represents a radical departure from convention. Goya's invoice for these cartoons states clearly that they are of "my invention."[1] The court painter Andrés de la Calleja recognized that since these designs were original creations, Goya must have worked harder and longer than ordinary copyists. In their valuations of the pieces, the court painters who assessed Goya's work—Mariano Salvador Maella, for instance—praised the artist's imagination as warmly as his compositional strength, the latter defined by Anton Raphael Mengs as "the art of integrating correctly the objects chosen by the imagination."[2]

The serialized iconographic programs that had characterized tapestry suites throughout the sixteenth and seventeenth centuries were losing importance and complexity in the decorative schemes of the second half of the eighteenth century. Goya, however, developed sequences in which the series often provides a context for a single cartoon, something that could be lost when the tapestries

Fig. 4 Francisco Goya, *Wild Boar Hunt*, 1775, cartoon for the tapestry in the dining room at the Escorial palace, Patrimonio Nacional, Madrid, inv. 10010069

were moved from the room for which they were designed. Goya continued to receive praise for his innovation as a painter of tapestries—Maella lauded the "delightful" composition of *The Blind Guitarist* presented by Goya on 17 April 1778.[3] Nevertheless, when the tapestry's destination changed (originally commissioned for the bedchamber of the prince and princess of Asturias, it was subsequently intended for the antechamber), the canvas was returned to Goya for the corrections necessitated by the altered measurements. Maella found the six new cartoons for the bedroom tapestries likewise "very well painted";[4] these included *The Crockery Vendor* (cat. 5) and that for *The Fair of Madrid* (cat. 6). Such favorable reception encouraged Goya's unsuccessful petition for appointment as court painter in 1779: he had fulfilled his commissions, in particular these last six pieces, to the satisfaction of all the art professors and, most importantly, of the king himself.

As a result of the nation's war with England and the need to cut expenses, the operations of the Royal Tapestry Factory were suspended on 15 March 1780. By this time, Goya had delivered his final designs for the antechamber tapestry suite for the prince and princess, including *The Swing* (cat. 7), *The Laundresses* (cat. 9), and *The Rendezvous* (cat. 11).

Since interrupting the works could have ruined of the Royal Tapestry Factory financially, Charles III ordered the completion of tapestries sufficient to decorate fifteen rooms in the Pardo palace, in spite of the economic troubles. The subjects were to remain "merry and pleasant" *("jocosos y agradables")*, in line with the others intended for the prince and princess of Asturias since 1778.[5] Thus, the factory managed to survive without grave financial harm to the more than eighty workers and their families employed there.

In 1786, Goya returned to the tapestry factory, now as a regularly salaried painter to the king. The following year, he delivered his design models for the suite in the king's dining room, or "conversation room"—both names appear in the expense invoices submitted by the painter and by the carpenter responsible for the stretchers.[6] Discovery of the architect Francesco Sabatini's (1722–1797) plan for the expansion of the palace, combined with analyses of documents pertaining to the many artisans involved in the decorations, has made it possible to identify the king's conversation room and to establish the correct distribution of the twelve tapestries along its four walls. The six main weavings included four representations of the seasons, among them *The Flower Girls*, exhibited here as a sketch (cat. 14), and *Autumn (The Grape Harvest)* (cats. 15 and 16).

Despite their anger at the confirmation of Livinio Stuyck as director of the Royal Tapestry Factory in 1786, the Spanish masters continued to work with their accustomed brilliance. And despite the difficulty of weaving "the pictures they paint these days of majos and majas, with so many ornaments of hairnets,

ribbons, frog fastenings, chiffons, and other trivialities, that one wastes great quantities of time in fussy detailing,"[7] they still applied themselves, triumphantly, to the weaving of *Blindman's Buff* from the sole cartoon Goya completed for the infantas' bedchamber in the Pardo palace.

Upon the death of Charles III, in 1788, the court abandoned the royal residence of the Pardo palace. The project for its refurbishing was dropped, and Charles IV decided to send the tapestries he had requested, with their merry rustic scenes, to the royal quarters at the Escorial. In 1791, Goya and his brother-in-law Ramón Bayeu received commissions to paint more tapestry cartoons, but excused themselves. Bayeu alleged work-related reasons: in 1791, he was occupied with other royal obligations—painting portraits of the infantas. Goya offered no explanation. He merely informed the director, Livinio Stuyck, on 13 April 1791, "that he neither is painting nor desires to paint."[8] Stuyck informed the king that if Bayeu and Goya failed to carry out the tapestry designs needed for the Escorial, the factory would grind to a halt and a considerable number of employees would be let go. Threatened with losing their salaries as court painters, the artists fulfilled the royal commissions.

Thanks to the list of expenses Goya presented on 1 July 1791, we know that he was painting, by royal order, the cartoons for *Girls at the Fountain, The Wedding* (cat. 18), *The Straw Mannikin* (cat. 19), and *The Stilts* for the king's study at the Escorial.[9] After 1792, Goya ceased submitting pictures to the Royal Tapestry Factory—not so much because he disliked the "ornamental" work now required of him, but because he had in his own words "labored exclusively in narrative pictures and in the human figure," and therefore doubted his "capacity to carry out pure ornamentation having never done so."[10]

The Afterlife of Goya's Tapestries

It was not only the cartoons that suffered displacement; tapestries woven after them were also misplaced or lost. As a result, the collection of the Spanish Crown does not own tapestries after all Goya's catalogued cartoons, while other museums and collections do hold Goya tapestries of royal provenance.

In 1795, the Royal Tapestry division auctioned off a number of furnishings. One hundred and fifty tapestries woven at the royal factory passed into private hands: those that remained unsold were burned in order to extract the silver employed in the woof. Numerous tapestries woven after Goya's cartoons figured among those sold to Fernando Gomendi. Through successive changes in ownership these weavings came into the hands of Pedro de Acuña y Malvar, canon of the Cathedral of Santiago de Compostela and minister of Charles IV,

ART GALLERY, OR MEMORIAL HALL.

Fig. 5 Engraving of the Art Gallery and Memorial Hall, Philadelphia, site of the 1876 International Exhibition

who bequeathed to the town council of Compostela his textile treasures, the core of the present tapestry museum in the cathedral.

Apart from these sales, the popularity of tapestries as diplomatic gifts also contributed to their dispersal. Some were a gift from the Spanish Royal House to the Royal House of Portugal at an unknown date, possibly in 1790 on the occasion of Princess Carlota Joaquina's wedding with the future King Juan VI. Isabella II gave tapestries to King Leopold I of Belgium in 1832, to celebrate his marriage to Princess Charlotte, daughter of the future George IV, king of England, and Alfonso XII gave tapestries to the prince of Wales in 1881. All this helps explain the absence from the royal collection of numerous tapestry designs repeatedly rewoven throughout the eighteenth and nineteenth centuries—starting with the most remarkable Goya creations—as well as the difficulty of distinguishing accurately the original weavings from the copies.

As tapestries were shifted from one location to another at the turn of the nineteenth century, many were left without documentation, dates, or cataloguing. This continued dislocation of the tapestries reached a geographical limit in 1936 when, for their protection during the Spanish Civil War, they were removed from the walls of the Royal Palace in Madrid, the Pardo palace, and the Escorial, and shipped to Valencia and Geneva. Their reinstallation in the Pardo and Escorial palaces began in 1943.

The first appearance in North America of Goya tapestries from the royal collection of Spain—"precious objects from the palace"—dates to their presentation at the Philadelphia International Exhibition (1876). On 27 September 1876, by congressional resolution, royal tapestries hung in the Art Gallery and Memorial Hall (fig. 5). Alfonso XII received an award from J. R.

Hawley, president of the exhibition, for his contribution to the success of the occasion. In the twentieth century, during February and March of 1917, ten Goya tapestries were displayed in New York, as part of the *Exhibition of the Royal Manufacture of Tapestries and Carpets of His Majesty the King of Spain*, at the Hispanic Society of America. The show, proposed by Alfonso XII personally, was made possible by the collaborative efforts of Archer Milton Huntington, the Society's founder and director, and Juan Riaño y Gayangos, the Spanish ambassador to the United States. The present exhibition in Washington is the first in the United States to display the tapestries alongside Goya's cartoons within the broader context of his oeuvre.

NOTES

1. Sambricio 1946, Doc. 22, XV.
2. Don José Nicolás de Azara, *Obras de D. Antonio Rafael Mengs, primer pintor de cámara del rey*, Madrid, 1780.
3. Sambricio 1946, Doc. 45, XXVI.
4. Ibid., Doc. 53, XXX.
5. Ibid., Doc. 78, LI.
6. Ibid., Docs. 103 (LXXVIII); 106 (LXXX).
7. Ibid., Doc. 85, LX.
8. Ibid., Doc. 139, XCVIII.
9. Ibid., Doc. 145, CI.
10. Ibid., Doc. 204, CXXXIV.

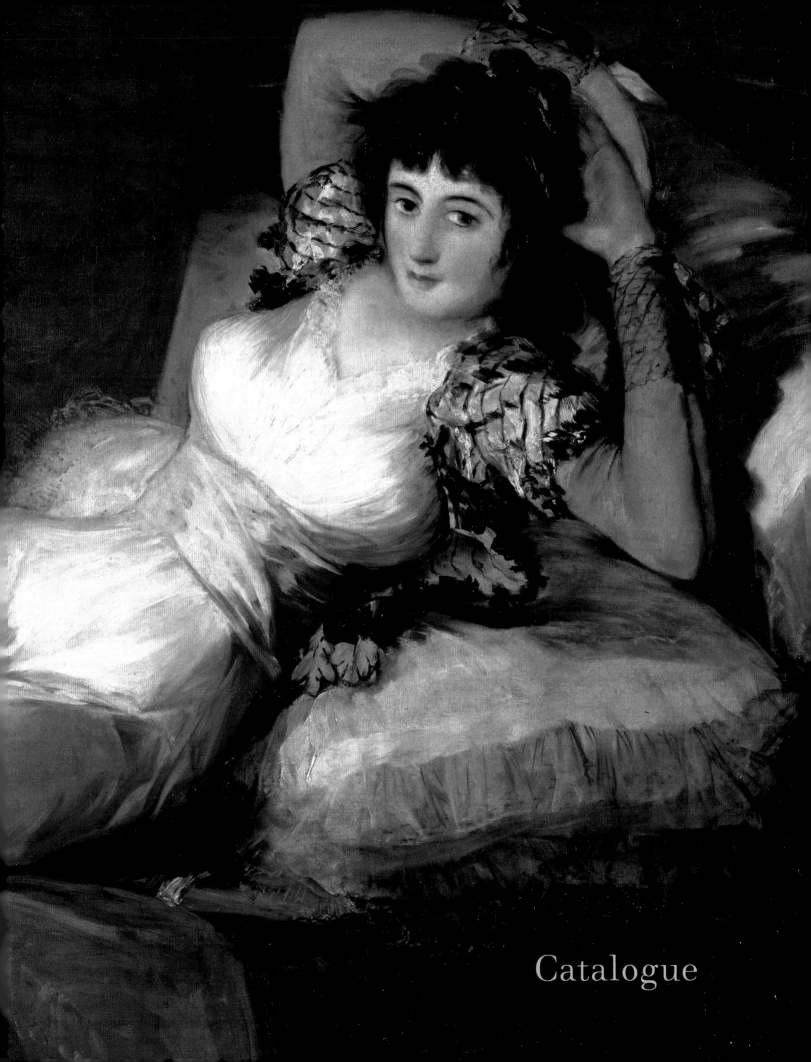

Catalogue

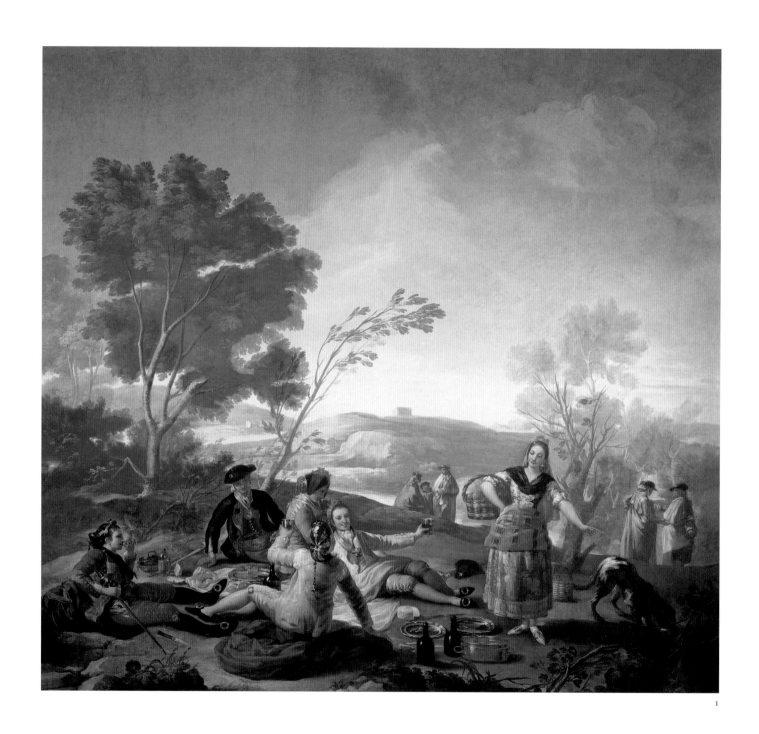

1

1. *The Picnic*, 1776

The scene shows "a picnic which five youths hold in the countryside, and an orange seller who is going to sell them oranges."[1] This is Goya's invoice description, dated 30 October 1776, of his tapestry cartoon, which formed part of the Pardo palace dining room decor for the prince and princess of Asturias. Apparently the artist operated with considerable freedom in executing this commission from the Royal Tapestry Factory, for he notes with pride that the design is "of my own invention."[2] When he conceived this cartoon Goya was no longer under the tutelage of Francisco Bayeu, who had supervised his first commission for the Escorial dining room of the prince and princess of Asturias. Here was Goya's chance to demonstrate his own talent. He prepared the project carefully, making drawings, some of which—studies of seated gentlefolk and background figures—have been preserved (Instituto Valencia de Don Juan and Museo Nacional del Prado, Madrid). In the cartoons he meticulously detailed their attire: the fops' short jackets, sashes, neckerchiefs, and hairnets; the majas' dresses and veils, fastened to netting. For the landscape he culled ideas from his Italian notebook, in which he had sketched out the suburbs of Madrid. It took Goya a year to deliver the first installment of cartoons: a very long time, which Andrés de Calleja, first court painter, explained as a consequence of working from one's own "invention."[3]

In the foreground a group of stylish youths is dining. A woman selling oranges intrudes to sell the merchandise, perhaps imported from the Levant, in her basket. Such itinerant saleswomen, often from Murcia or Valencia, were fixtures in eighteenth-century Madrid and quickly became picturesque characters in scenes of manners, where they tend to appear in nonchalant attitudes, surrounded by flirtatious men, just as popular culture described them in pictures, plays, and music. This archetype occurs not only in the works of Goya but also in those of his contemporaries Francisco and Ramón Bayeu. It is present, too, in earlier genre paintings by Lorenzo Tiepolo. In the print series *Cries of Madrid*, an anthology of typical eighteenth-century figures, the illustrator Manuel de la Cruz includes similar roving female merchants.

Oil on canvas
271 x 295 cm
Museo Nacional del Prado,
Madrid, inv. 768
Madrid only

PROVENANCE: Royal Tapestry Factory of Santa Bárbara; 1856–1857, Royal Palace of Madrid; 1870, Museo Nacional del Prado; 1876, first mentioned in the museum's catalogue.

EXHIBITIONS: Barcelona 1977, no. 1; Madrid 1996c, no. 7.

BIBLIOGRAPHY: Gudiol 1970, no. 62; Gassier and Wilson 1971, no. 70; Arnaiz 1987, 69–71, no. 13C; Tomlinson 1989, 31–37.

For the first time Goya's work depicts specifically and authentically Spanish types. The conventional Flemish models, on which preceding generations had merely exercised variations or after which they had made copies, were abandoned. But the hoped-for authenticity does not entirely erase the underlying picturesque view and its stereotypes. Here Goya's orange seller, with her somewhat artificial stance, is a case in point. Vandergoten, technical director of the tapestry works, thought she displayed a "swaggering gesture," suggesting she spurns the young people's gaiety.[4] Goya underscores the delightful qualities of the scene, still far from the realism to which his later tapestry cartoons aspire. AR

NOTES

1. Sambricio 1946, Doc. 22, XV.
2. Sambricio 1946, Doc. 22, XV.
3. Sambricio 1946, Doc. 34, XX.
4. Sambricio 1946, Doc. 24, XVI.

2. *A Walk in Andalusia*, 1777

Oil on canvas

275 x 190 cm

Museo Nacional del Prado,
Madrid, inv. 771

———————

PROVENANCE: Royal Tapestry Factory of Santa Bárbara; 1856–1857, Royal Palace, Madrid; 1870, Museo Nacional del Prado, Madrid; 1876, first listed in the museum's catalogue.

EXHIBITIONS: Paris 1919, no. 19; New York 1965, unnumbered; Paris and The Hague 1970, no. 2; Barcelona 1977, no. 2; Geneva 1989, no. 63; Madrid 1996c, no. 10.

This cartoon is one of a series of ten that Goya designed for the prince and princess of Asturias' dining room at the Pardo palace and produced for the Royal Tapestry Factory of Santa Bárbara. After *The Picnic* (cat. 1) and *The Dance on the Banks of the Manzanares*, Goya delivered in August 1777 *A Walk in Andalusia*, *Fight at the New Inn*, and *The Drinker* in his third shipment to the factory (all Museo Nacional del Prado, Madrid). As was Goya's usual practice, his request for payment is dated earlier—3 March—and attached to the invoice is a detailed description of the setting, the characters, and the plot of the present cartoon: "It represents a grove of pine trees, through which a charming girl and a well-dressed man are strolling; a rogue, seated with his cape and round hat, his scarlet breeches with gold stripes and fastenings and matching stockings and shoes, seems to have made some flattering remark to the girl, upon which her companion stops to pick a quarrel and the girl urges him to walk on; there are two friends of the man with the round hat waiting to

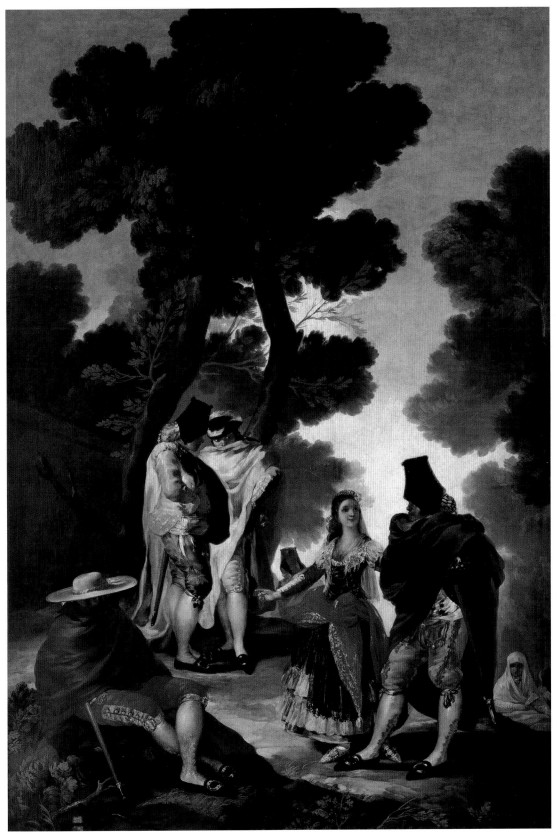

2

BIBLIOGRAPHY: Gudiol 1970, no. 66;
Gassier and Wilson 1971, no. 78;
Bozal 1983, 70; Arnaiz 1987, 77–78,
no. 17C; Bozal 1987, 127; Tomlinson
1989, 46–48; Bozal 1994, 95; Morales
1994, no. 62; Herranz Rodríguez
1996, 268.

see what happens."[1] The title suggests that the setting is a pathway in Andalu-sia but is in fact invented; it corresponds to no real place. The figures distributed along the three oblique planes are fops and one young girl, unquestionably the central character.[2] The eyes of all the men are on her, including those of her newest suitor, the masked man, who sits on a low knoll in the foreground. His two friends stand on the other side of the composition, excitedly awaiting the reaction of her escort, whose grim profile suggests a possible fight, which Goya terms, in popular jargon, a *camorra*—a fisticuff or quarrel. In the far back-ground is a mysterious female figure veiled in a white mantle and watching the events.

There is a clearly picturesque dimension about such amorous play. For this reason Sambricio believes that the theme of this painting is taken from Ramón de la Cruz' lyrics and farces.[3] Enlightenment audiences were interested in the common folk's customs and habits of dress, so Goya carefully details the cloth-ing. The man with his face covered wears the most luxurious garb of his class: a broad-brimmed hat, a wide cape, pants with gold trim, white stockings, and shoes with silver buckles. The girl is dressed in picturesque maja attire, wear-ing the typical *jubon*—a close-fitting jacket with long, very tight sleeves, open in front and fastened with a braid. Her breast, revealed by the deep décolleté of the jacket, is shielded by a white kerchief, or *fichu*. A red triangular-shaped cloth is tied over her flounced *basquiña*, another accessory typical of maja attire. The bold colors of her clothing are complemented by her traditional coiffure: a small hair adornment decorated with a flower and a veil fastened over the netting. AR

NOTES
1. Sambricio 1946, Doc. 33, XX.
2. Bozal 1983, 70.
3. Sambricio 1946, 207–209, no. 13.

3. *The Parasol*, 1777

When the princes of Asturias awarded Goya the commission to create the tapestry cartoons for their dining room, Goya took advantage of the opportunity to demonstrate that he knew the great European schools of painting. *The Parasol* shows the palpable influence of French painting. Jean Ranc's, *Vertumnus and Pomona* (Musée Fabre, Montpellier), engraved by Edelinck, is often associated with this cartoon. The parasol, which was a fashionable object in the paintings of the seventeenth and eighteenth centuries, is prominent in both works.

Goya's characters can be distinguished from French rococo figures by the fact that the painter from Aragon chose to represent a wider range of women in the milieu of eighteenth-century Spain. In *The Picnic* (cat. 1) of the same series, Goya portrays as the main female character a maja. The young woman in *The Parasol*, on the other hand, is characterized as a *petimetre*, a term used to refer to upper-class women who affected French fashions and customs. The woman sports a characteristic fan and wears an elegant sleeveless coat lined with fur and a delicate shawl. If majas, like the orange seller of *The Picnic*, are characterized by their bold attitude and their open, confident air in dealing with men, the petimetras appear to be more artificial in their manners.

This cartoon represents an important artistic achievement in relation to the previous ones. In this instance, Goya developed a composition strategy that he would apply to other large-format scenes. He places the protagonists in the foreground, within a pyramidal scheme, that he later sets into a landscape. The result is a simple composition, worked with sureness and an economy of means. With just a few brushstrokes that sometimes leave the red priming of the canvas uncovered, Goya produces the sensation of vibrant color and immediacy that characterizes his painting. With a very logical distribution, he divides the primary colors among the garments of both figures. Beginning with the yellow skirt that spreads generously over the grass, Goya plays off the red and blue of the petimetre's headdress and the hairnet of the young lad, then applies the same colors in reverse, red and blue in the bodice and the

Oil on canvas

104 x 152 cm

Museo Nacional del Prado, Madrid, inv. 773

Madrid only

PROVENANCE: Royal Tapestry Factory of Santa Barbara; 1856–1857, Royal Palace of Madrid; 1870, Museo Nacional del Prado; 1876, first mentioned in the museum's catalogue.

EXHIBITIONS: Mexico 1978, no. 30; Burdeos-Madrid-Paris 1979–1980, no. 13; Leningrad-Moscow 1980, no. 26; Munich-Vienna 1982, no. 16; Caracas 1983, unn.; Florence 1986, no. 88; Madrid 1996, no. 12; Saragossa 1996a, no. 14; Lille 1998–1999, no. 2; Rome 2000, no. 3

BIBLIOGRAPHY: Gassier and Wilson 1971, no. 80; Gudiol 1970, no. 67; Licht 1979, 29–32; Bozal 1983, 66, 68–69; Arnaiz 1987, 80-82, no. 19c; Tomlinson 1989, 48–52; Bozal 1994, 94–96; Morales 1994, no. 64

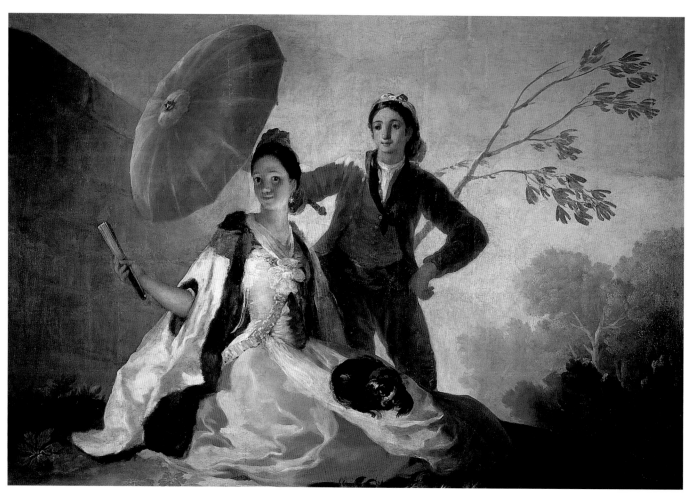

3

vest, respectively. The tree that bends toward the right compensates for the movement of the youth toward the left, and the green of the leafy trees in the background resonates with the parasol of the same green tone, in this way unifying the composition, foreground to background, by means of color. The highlights and the bright areas are obtained by using white lead paint that Goya applies unhesitatingly on the canvas when the painting is almost finished, thus producing a very natural effect of shadow and light. The use of warm tones in the clothes and to mark the demeanor of the young woman, who looks and smiles directly at the spectator, reveal a triangular composition derived from Italian models that gives the scene the stability typical of a classical painting. AR

4. *The Parasol,* 1777

Goya's invoice describes the scene as: "A girl seated on a hillock, a small dog in her skirt, at her side a boy shading her with a parasol."[1]

David Teniers' scenes of Flemish peasants and festivals, culled from his paintings and images in the royal collection, were copied to the point of exhaustion by painters in the crown's service, who were required to submit tapestry designs to the factory. These patterns were intended for the tapestries in the rooms of Charles III, in both the Pardo palace and the Escorial palace.

The shift in compositional content that began with the "works on hunting" was drastic after 1776, when Goya submitted his tapestry models for the prince and princess of Asturias' dining room in the Pardo palace. They portrayed lively rustic themes, majos, *chisperos* (rowdy dandies), *petimetras* and their boisterous amusements, and children at their games. Andrés de Calleja, first court painter, lauded Goya's inventiveness *(invención),* "in which each craftman's genius and talent is made known." In his formal statement on the models for the bedroom he expressed his approval in these words: "I have most carefully examined the four pictures executed by Francisco de Goya—*The Fight at the New Inn, A Walk in Andalusia, The Drinker,* and *The Parasol*—

Overdoor tapestry from the bedroom of the prince and princess of Asturias, Pardo palace
Low warp, silk and wool
86 x 211 cm
Cartoon by Francisco Goya
MP. inv. 773
Cornelius Vandergoten, 1777
Royal Tapestry Factory of Madrid
Palacio Real, Madrid
Patrimonio Nacional, Madrid

EXHIBITIONS: Philadelphia 1876; Madrid 1926; Seville 1929; Madrid 1996b; Saragossa 1996b; Jackson 2001.

which are to serve as designs for the tapestries … considering matters of size, the type of work, and the fact that they have been produced of his own invention, for which reason he must have invested far more time than is apparent in preliminary drawings and sketches from life."[2]

The royal collections hold three tapestries woven after Goya's cartoon of *The Parasol*: one is on display here; another, quite clumsily realized on a coarse-warp loom, is preserved in the tapestry warehouse; and the third has been in the Viana palace in Madrid, seat of the Ministry of Foreign Affairs, since 1956. CHC

NOTES
1. Sambricio 1946, Doc. 33, XX.
2. Sambricio 1946, Doc. 34, XX.

5. *The Crockery Vendor*, 1779

Oil on canvas

259 x 220 cm

Museo Nacional del Prado,
Madrid, inv. 780

———

PROVENANCE: Royal Tapestry Factory of Santa Bárbara; 1856–1867, Royal Palace, Madrid; 1870, Museo Nacional del Prado, Madrid; 1876, first listed in the museum's catalogue.

EXHIBITIONS: Geneva 1939, no. 38; New York 1965; Kyoto and Tokyo 1971–1972, no. 9; Madrid 1996c, no. 19; Rome 2000, no. 4.

In October 1778 the directors of the Royal Tapestry Factory of Santa Bárbara commissioned from Goya cartoons for the Pardo palace bedroom of the future Charles IV and his wife, María Luisa, then prince and princess of Asturias (cat. 6). He painted seven cartoons for this project, depicting diverse aspects of Madrid life, especially festivals and market places; *The Crockery Vendor* and its companion piece, *The Fair of Madrid*, are part of the series. Goya tied the sequence into his set of thirteen cartoons for the antechamber of the palace, which dealt with life on the outskirts of the city, for example, *The Swing* (cat. 7).

Between 1778 and 1779 the artist devoted himself to the swift completion of the tapestry cartoons for the future monarchs' bedchamber, a room of vital significance in palace life. The mastery revealed in these cartoons did not go unnoticed: the king himself, as well as the prince and princess of Asturias, were most appreciative. Goya wrote to his friend Martín Zapater on 9 January 1779, a few days after delivering the canvases to the Royal Tapestry Factory: "If I had leisure I would tell you how the king and the prince and the princess honored me, that for the grace of God I could show them four

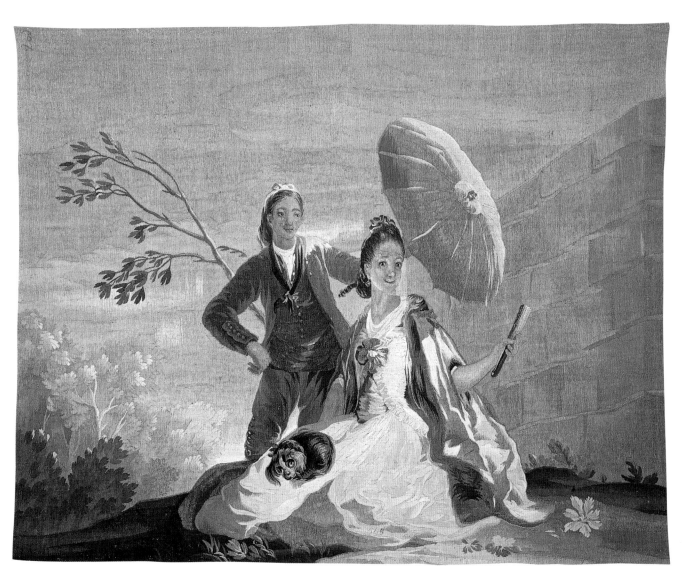

4

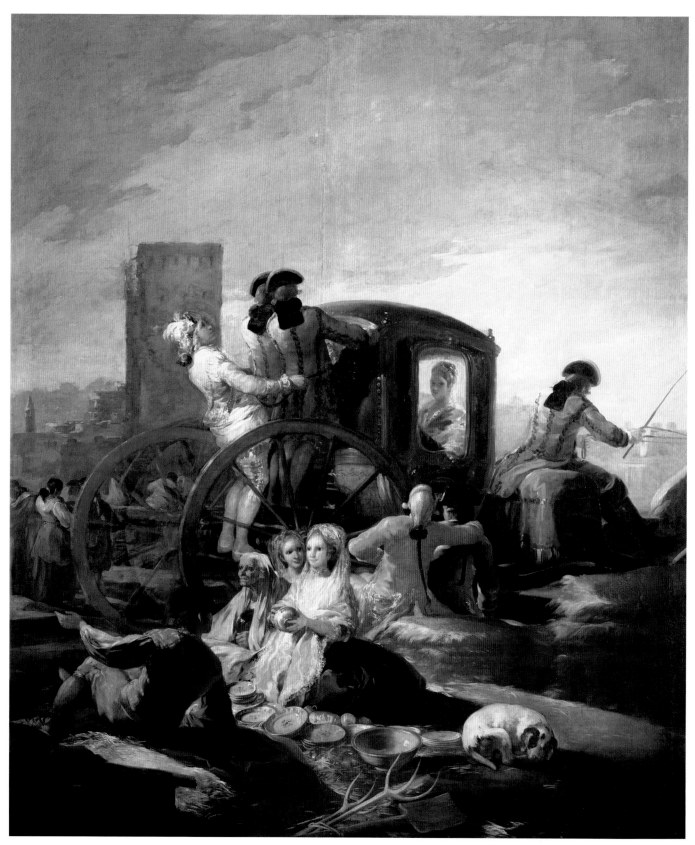

5

paintings, and I kissed the hand that had never before enjoyed such happiness, and I tell you that I could not wish for anything more insofar as their liking my works, to judge by the pleasure they had in seeing them and the satisfaction I achieved with the king and far more still with their highnesses."[1]

The crockery vendor—his back to the viewer—is the central foreground figure. Goya directs the viewer's attention, as do the other figures seen from behind, all of them male, to the composition's obviously female protagonists, all seen from the front, and especially to the lady in the carriage at the back, who passes through the scene by chance, yet attracts the viewer's notice. While other cartoons by Goya are more static in structure, like theatre scenes, this one captures a fleeting moment at a street market. The sense of movement is reinforced by the position of the footman in white, who leans back as the coach starts to roll and grabs the reins to avoid falling.

The tradition of street vendors as artistic subjects stems from the early seventeenth-century series of *gritos callejeros* (street cries) and *trajes típicos o nacionales* (typical or national costume) that circulated throughout Europe. The theme originated in Annibale Carracci's print series *The Arts of Bologna*, which also provided inspiration for painters at the Royal Tapestry Factory of Santa Bárbara. José de Castillo and the Bayeu brothers used these traveling vendors as the protagonists of many small cartoons, which would fit on narrower side panels or above windows and doors.

Goya's crockery vendor, however, is assigned a minor role in this large composition. The traditional figure is seen from behind while the viewer's gaze is directed toward the two young ladies, accompanied by an older woman seated at their side. This pairing of the older woman and the young girl prefigures the commonplace images of the celestina—the procuress—with a maja, the dominant figures in Goya's Caprichos etchings, which the artist released for sale in 1799. AR

NOTES
1. Salas and Águeda 1982, 49, Doc. 8.

BIBLIOGRAPHY: Gudiol 1970, no. 75; Gassier and Wilson 1971, no. 125; Mitchell 1982, 3–4; Arnaiz 1987, 95–97; Tomlinson 1989, 78–80; Morales 1994, no. 75.

6. *The Fair of Madrid,* 1779

Tapestry from the bedroom of
the prince and princess of
Asturias, Pardo palace
High warp, silk and wool
272 x 232 cm
Cartoon by Francisco Goya
MP. inv. 779
Cornelius Vandergoten 1779
Royal Tapestry Factory of Madrid
Palacio Real, Madrid
Patrimonio Nacional, Madrid

———————

EXHIBITIONS: New York 1917; Paris
1919; Seville 1929; Madrid 1946;
Paris 1989; Madrid 1995; Madrid
1996b; Saragossa 1996b; Jackson
2001.

In his invoice description, Goya describes the scenes as "a Landscape showing the Fairs in their season, with a pawn shop, the owner dealing with the sale of a jewel to a lady, accompanied by two gentlemen, one with a monocle observing certain paintings there for sale, behind them four others, and farther off, several people."[1]

Not only the "invention" *(invención)* or creativity but also the composition was evaluated in the statements issued by the court painters who judged Goya's work. The six cartoons for the Pardo palace bedroom—*The Fair of Madrid, The Crockery Vendor, The "Militar" and the Lady, The Haw Seller, Boys Playing Soldier,* and *The Boys with the Cart*—were endorsed by Mariano Salvador Maella as "very well painted," a compliment repeated by Goya when he (unsuccessfully) sought appointment as court painter in 1779.[2]

Two tapestries after *The Fair of Madrid* are in the possession of the royal collections; one is on exhibit here, and the other, woven in low warp, its cartoon composition inverted, now hangs in the Spanish embassy in Paris. CHC

NOTES
1. Sambricio 1946, Doc. 52, XXIX.
2. Sambricio 1946, Doc. 53, XXX.

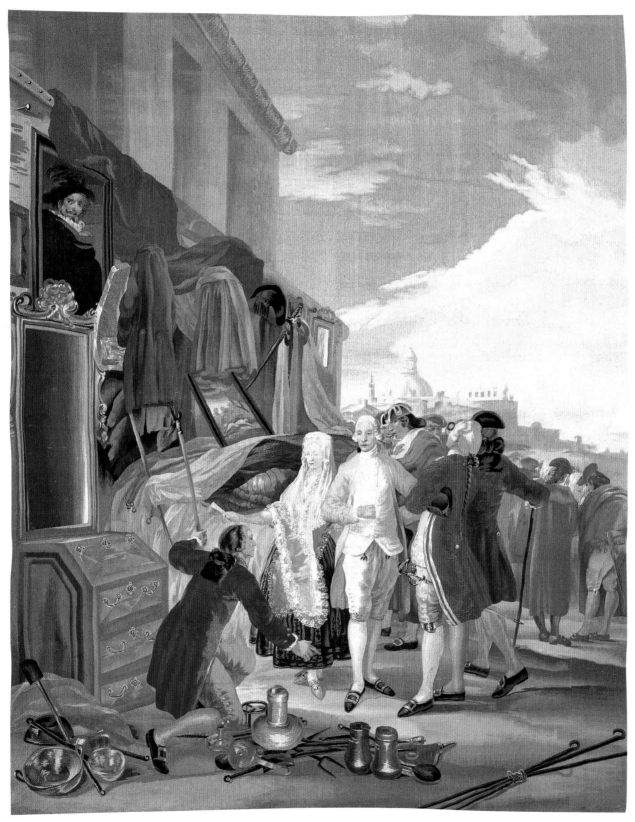

6

7. *The Swing*, 1779

Oil on canvas

260 x 165 cm

Museo Nacional del Prado,

Madrid, inv. 785

———————

PROVENANCE: Royal Tapestry Factory of Santa Bárbara; 1856–1857, Royal Palace of Madrid; 1870, Museo Nacional del Prado; 1876, first mentioned in the museum's catalogue.

EXHIBITIONS: Madrid 1996c, no. 25; Rome 2000, no. 5.

BIBLIOGRAPHY: Gudiol 1970, no. 83; Gassier and Wilson 1971, no. 131; Arnaiz 1987, 102–103, no. 32C; Tomlinson 1989, 97–101; Morales 1994, no. 83.

The Swing and its pendant, *The Laundresses* (cat. 9), belong to a series of cartoons created for tapestries to be hung in the antechamber of the prince and princess of Asturias in the Pardo palace. The remaining works in this series are the two weavings for the south wall, *The Bullfight (La novillada)* and *The Tobacco Guard*, and the two overdoor cartoons *The Woodcutters* and *The Majo with the Guitar* (all Museo Nacional del Prado, Madrid). All six depict scenes of manners set in the outskirts of Madrid. For more informal palaces, such as the royal residences, Charles III refused the sumptuous decoration of the royal palace, with its iconography of mythological, religious, or historic themes, and demanded instead "rustic and comic themes." In compliance with the king's wishes, Goya painted *The Swing*, a country scene that portrays, as he states in the invoice of 21 July 1779, "a family that has gone out to amuse themselves in the country, four children and two servant girls, one is swinging on a rope that is fastened to a tree."[1]

In this work Goya drew on a theme popular with rococo painters such as Antoine Watteau, François Boucher, and Jean-Honoré Fragonard. The very act of swinging carried for these artists an obvious erotic connotation: a man pushing his beloved on a swing was a symbolic representation of intercourse, in which the woman's legs "aired themselves" with abandon. The swing in Goya's cartoon, however, lacks any such connotation. Unlike the French works, the woman on the swing is accompanied, not by a lover, but by a little boy, dressed in the Dutch manner, who grabs the rope of the swing and prepares to pull it. The observer witnesses a slightly picaresque episode as well, in the activities of the background figures. Three herders, in charge of some apathetically grazing cows, are slyly eyeing the children's servant girls, while their footman waits beside the coach. The glances are returned: the girl whose back is to the viewer seems to be responding. Perhaps the herders are the servants' admirers, and the excursion has been organized to facilitate their meeting. Ignorant of all this, the children play freely, engrossed in their innocent games. Goya's instinct for the psychology of young children is apparent in a detail: two

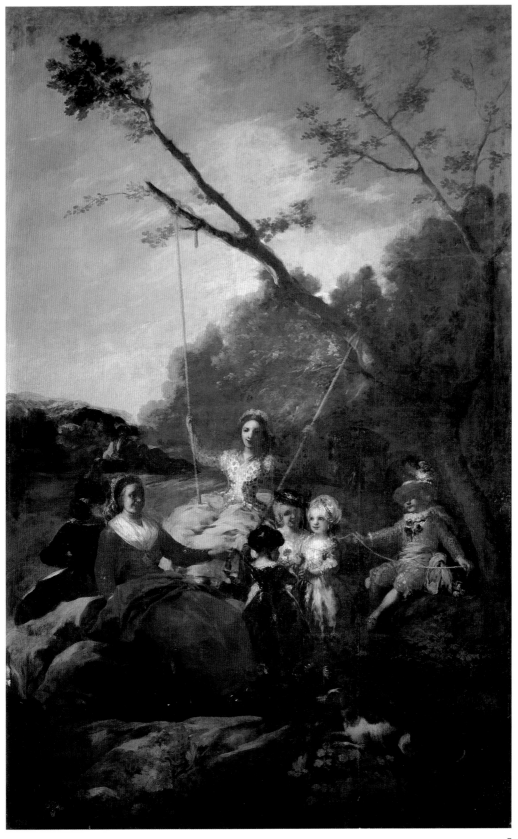

7

delicate little girls stand admiring the flower held by the smallest, who faces them and is in turn held by her nursemaid.

Tomlinson interprets the scene as an allegory of the three ages. The child with the flower represents the earliest stage.[2] AR

NOTES
1. Sambricio 1946, Doc. 62, XXXIV.
2. Tomlinson 1989, 99–100.

8. *The Swing,* 1779

Tapestry from the bedroom of
the prince and princess of
Asturias, Pardo palace
Low warp, silk and wool
268 x 176 cm
Cartoon by Francisco Goya
MP. inv. 785
Cornelius Vandergoten, 1779
Royal Tapestry Factory of Madrid
Palacio Real, Madrid
Patrimonio Nacional, Madrid

———————

EXHIBITIONS: Madrid 1946; Madrid
1995; Madrid 1996b; Saragossa
1996b; Jackson 2001.

According to Goya's invoice description, "A family that has gone out to amuse themselves in the country, four children and three servant girls, one is swinging on a rope that is fastened to a tree, and another holds the reins on the small child. The three girls with the children form the principal grouping in the painting and, in the distance, a waiting coach with the coachman and several shepherds with cattle."[1]

The six cartoons for the bedroom tapestries, which Mariano Salvador Maella pronounced "very well painted," allowed Goya, in 1779, to seek appointment to the post of court painter: according to his petition, Goya had fulfilled his royal commitments "to the satisfaction of all the professors and even of His Majesty."[2] Two designs, *The Ball Game* and *The Swing*, had been delivered to the factory director on 20 July, four days before Goya's petition, and Maella had assessed their "merits and dimensions."[3]

Two tapestries, both woven in low warp, which produces the apparent compositional inversion of Goya's model, are held in the royal collections; since 1939 one of these has been placed in the Buenavista palace in Madrid, seat of Army Headquarters. CHC

NOTES
1. Sambricio 1946, Doc. 62, XXXIV.
2. Sambricio 1946, Doc. 56, XXXI.
3. Sambricio 1946, Doc. 63, XXXV.

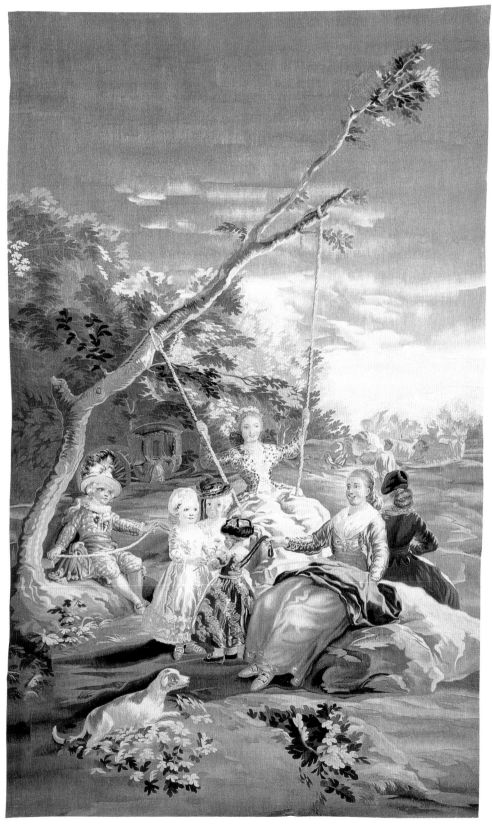

8

9. *The Laundresses, 1779–1780*

Oil on canvas
218 x 166 cm
Museo Nacional del Prado,
Madrid, 786
Madrid only

PROVENANCE: Royal Tapestry Factory of Santa Bárbara; 1856–1857, Royal Palace of Madrid; 1870, Museo Nacional del Prado; 1876, first mentioned in the museum's catalogue.

EXHIBITIONS: Paris 1919, no. 20; Madrid 1996c, no. 26; Lille 1999, no. 4.

BIBLIOGRAPHY: Sambricio 1946, no. 29; Gudiol 1970, no. 87; Gassier and Wilson 1971, no. 132; Arnaiz 1987, 104–105, no. 33C; Tomlinson 1989, 101–103; Morales 1994, no. 85; Stoichita 1999, 64.

Rest in the middle of work was a very popular topic in genre painting because it provided the perfect pretext for the amusing anecdotes so suited to the tastes of the period. Goya also made use of working folk who rested more than they worked—for instance, in his cartoon called *La era* or *El verano (Harvesting* or *Summer)*, in which peasants enjoy a nap (Museo Nacional del Prado, Madrid). *The Laundresses* is a charming creation intended for the antechamber of the prince and princess of Asturias. Its protagonists are working women whom Goya places in a landscape outside Madrid. In the background a mountain range closes the composition with snowy crests and silvery tones, in a style quite similar to that of Velázquez.

The foreground action is described by the painter in his invoice dated 24 January 1780: "It represents Washerwomen resting on the bank of the river, one of them falls asleep in the lap of another, whom they are going to wake up with a lamb that two of them place against her face, another is seated and laughs to see it, and another, with a bundle on her head, farther off where we see clothing hung up, belonging to those who are resting."[1]

Though Nordström associates the scene with Melancholy, Tomlinson interprets it as a symbol of female voluptuousness, since laundresses were reputedly loose in their morals: a decree of 1790 actually stipulated regulations regarding their appearance and behavior.[2] From then on they were forbidden not only from working along the banks of the Manzanares River but also from making obscene gestures—the sort suggested by the figure caressing the animal's horn—and from socializing with the middle-class people whose clothes they washed. Laundresses often appear, with erotic connotations, in French paintings of the eighteenth century; even Goya, in his later works, when he dealt seriously with the world of working people, includes in his Black Border album a drawing of these women in a libidinous context (private collection). The laundresses in the cartoon revel in their harmless play; those in the drawing seem intent on their labors, with their clothing adhering so tightly to their bodies that the shape of their buttocks is revealed.

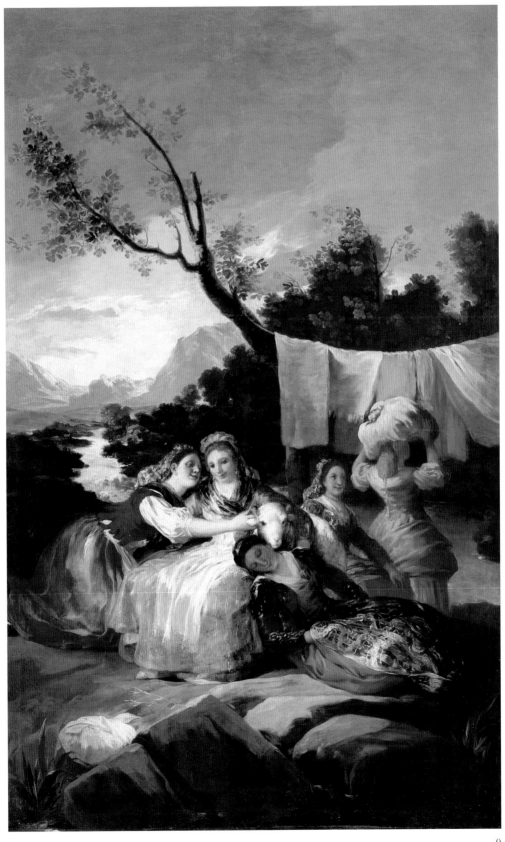

9

The subject of beautiful women resting occurs also in François Boucher's charming pastoral landscapes, which were also used as models of a tapestry series. The notion contrasts with the laundress painted by Giuseppe María Crespi in the early eighteenth century, in a scene in which the woman can take a break from her hard work for only a moment. The painter makes this abundantly clear by showing us the woman's powerfully muscled arms (The State Hermitage Museum, St. Petersburg).

Goya used cartoon sequences to tell stories. He arranged the cartoons so that each one extended into the visual space of the cartoon beside or facing it to unfold a meaning closely linked to the purpose of the room the sequence adorned. *The Laundresses* was paired on the north wall with the majas of *The Swing* (cat. 9), so that the women would face the brave young men of *The Bullfight (La novillada)* and the guards of *The Tobacco Guard* (both Museo Nacional del Prado, Madrid) in the cartoons on the opposite wall. In the scenes of men, the virile poses and glances are therefore addressed not exclusively to the spectator but to the young women in the pictorial space directly before them. AR

NOTES
1. Sambricio 1946, Doc. 68, XXXVII.
2. Nordström 1989, 37; Tomlinson 1989, 101–102.

10. *The Laundresses,* 1779

Tapestry from the bedroom or antechamber of the prince and princess of Asturias, Pardo palace
Low warp, silk and wool
268 x 176 cm
Cartoon by Francisco Goya
MP. inv. 786
Sketch, Oscar Reinhart collection, Winterthur
Cornelius Vandergoten, 1780

In his invoice, Goya describes the scene as: "Washerwomen resting on the bank of the river, one of them falls asleep in the lap of another, whom they are going to wake up with a lamb that two of them place against her face, another is seated and laughs to see it, and another, with a bundle on her head, farther off where we see clothing hung up, belonging to those who are resting. The landscape consists of bright clouds, a dense grove by the river, which is seen to come from a great distance, curving around outcroppings of earth and thickets, with snow-covered mountains in the distance."[1]

Before factory operations were suspended in 1780, Goya submitted twelve designs to complete the tapestry series for the antechamber or the bedroom of the prince and princess of Asturias. Cornelius Vandergoten's receipt, dated 24

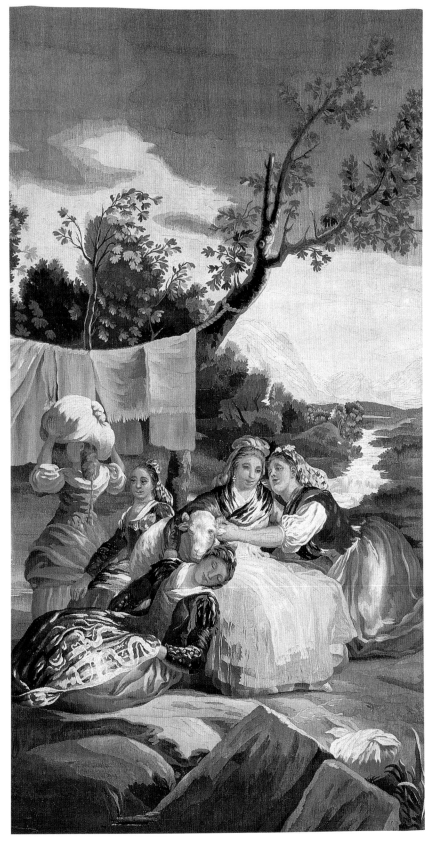

10

Royal Tapestry Factory of Madrid
Palacio Real, Madrid
On loan since 1939 to the Palacio
de Buenavista, Army Head-
quarters, Madrid
Patrimonio Nacional, Madrid

———

January 1780, cites models for *The Laundresses, The Bullfight (La novillada), The Dog, The Fountain, The Tobacco Guard, Boy with a Bird, Boy by the Tree, The Woodcutters, The Majo with the Guitar, The Rendezvous,* and *The Doctor.*[2]

To avoid ruin for the factory owing to a dearth of cartoons, Charles III ordered that, financial retrenchment notwithstanding, tapestries on "pleasant, lighthearted subjects" should be produced for fifteen rooms in the Pardo palace.

The present tapestry, woven in low warp, with a second in high warp adorning the queen's salon in the Escorial palace, are in the possession of the royal collection. The one displayed in this exhibition, along with the second copy of *The Swing,* was installed in the Buenavista palace, seat of Army Head-quarters, in 1939. Since that date it has remained there in the "Goya Room" (Salón Goya) and has never been exhibited until now. CHC

NOTES
1. Sambricio 1946, Doc. 68, XXXVII.
2. Sambricio 1946, Doc. 71, XXXIX.

11. *The Rendezvous,* 1779

Oil on canvas
100 x 151 cm
Museo Nacional del Prado,
Madrid, inv. 792

———

PROVENANCE: Royal Tapestry Fac-
tory of Santa Bárbara; 1856–1867,
Royal Palace of Madrid; 1870, Museo
Nacional del Prado; 1887, first men-
tioned in the museum's catalogue.

EXHIBITIONS: Madrid 1996c, no.33

The Rendezvous, as do *The Swing* (cat. 7) and *The Laundresses* (cat. 9), belongs to the cartoon series for tapestries for the antechamber of the prince and princess of Asturias. In the latter scenes Goya strove for glowing, happy protagonists; here he portrays a troubled woman, as he himself notes in the invoice for the picture, dated 24 January 1780: "It represents a woman seated and bending over on a terrace, behind her there are two others observing her sorrow, on the other side four figures in the distance."[1] It is unknown where this painting was to be hung in the room; it may have been paired over a doorway with *The Doctor* (National Gallery of Scotland, Edinburgh), with which it shares the same format, size, and morose atmosphere. Resting her cheek on the hand in which she holds a handkerchief, the woman leans against a rock. Nordström relates this with the image of Melancholy as illustrated in Cesare Ripa's *Iconología.*[2] The somber coloration and the leafless tree, traditional references to the autumn or winter months, accord well with the established emblem.

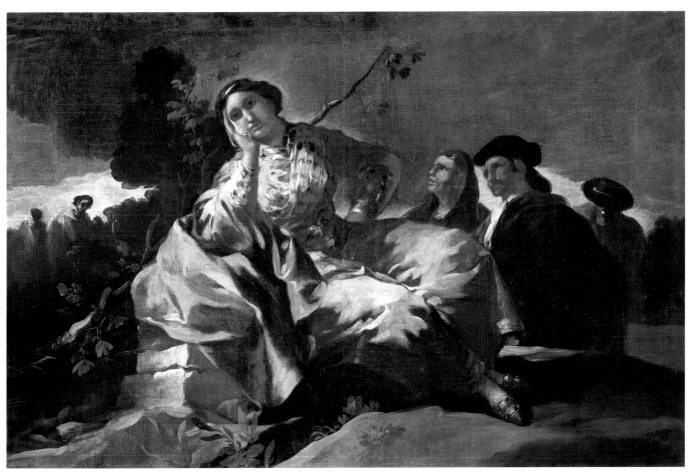

BIBLIOGRAPHY: Gudiol 1970, no. 94; Gassier and Wilson 1971, no. 141; Arnaiz 1987, 110–111, no. 42C; Nordström (1962) 1989, 22–31; Tomlinson 1989, 118–121.

Tomlinson analyzes the reasons behind the young woman's sorrow, concluding that her weariness is caused by an excess of sensual pleasures, a surfeit Ripa termed "worldly delights" *(delizie mondane)*.[3] She connects the figure with the world of prostitution, identifying the person in the middle ground as a procuress engaged in conversation with a potential client.[4] Yet, if we disregard the painting's title, given by Cruzada Villaamil in 1870, the woman's grief can be explained in other ways besides her supposed abandonment by a lover or her possible sorrow over an encounter with a client.[5] Her faraway gaze and the apparently tear-soaked handkerchief indicate her despair. AR

NOTES

1. Sambricio 1946, Doc. 68, XXXVIII.
2. Nordström (1962) 1989, 28–29.
3. Tomlinson 1989, 119.
4. Tomlinson 1989, 121.
5. Villaamil 1870, no. 29.

12. *The Rendezvous*, 1779

Tapestry from the bedroom of
the prince and princess of
Asturias, Pardo palace
Low warp, silk and wool
145 x 141 cm
Cartoon by Francisco Goya
MP. inv. 792
Cornelius Vandergoten, 1780
Royal Tapestry Factory of Madrid
Palacio Real, Madrid
Patrimonio Nacional, Madrid

EXHIBITIONS: Seville 1929; Madrid 1996b; Jackson 2001.

Goya's invoice description describes the scene as: "A woman seated and bending over on a terrace, behind her there are two others observing her sorrow, on the other side four figures in the distance."[1]

Two panels, woven on a low-warp loom, their composition the reverse of Goya's cartoon, belong to the royal collection. One is displayed as an overdoor in the formal dining hall of the Escorial palace. The other, removed from the Pardo palace in 1936, has remained in the tapestry storeroom of the Palacio Real. CHC

NOTES

1. Sambricio 1946, Doc. 68, XXXVIII.

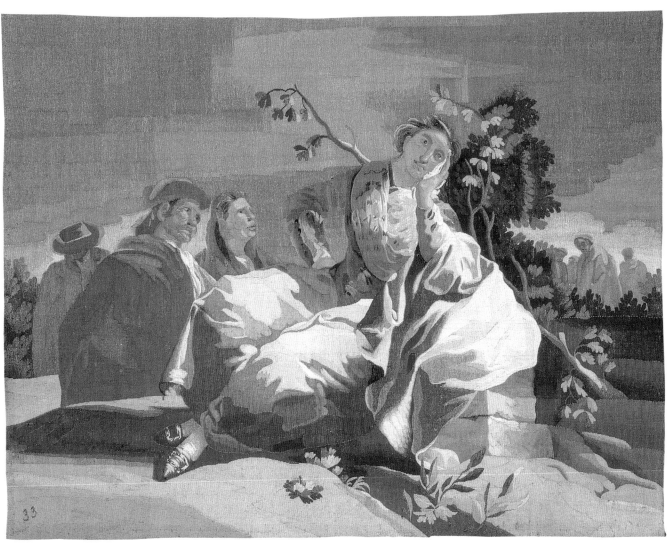

13. *Spring, 1786*

Oil on canvas

34.2 x 23.9 cm

Private collection

———————

PROVENANCE: 1798, duke and duchess of Osuna, La Alameda, Madrid; 1896, sale, ducal house of Osuna, no. 75; 1896, acquired by Felipe Falcó y Osorio, VIII duke of Montellano; private collection.

EXHIBITIONS: Madrid 1896, no. 75; Madrid 1928, no. 76; Madrid 1949, no. 106; Munich 1958, no. 57; Bordeaux 1959, no. 151; Paris 1961–1962, no. 28; Madrid 1965, unnumbered; Madrid 1983, no. 18; Lugano 1986, no. 9; Madrid, London, and Chicago 1993–1994, no. 19; Madrid 1995–1996, no. 7.

BIBLIOGRAPHY: Gudiol 1970, no. 214; Gassier and Wilson 1971, no. 266; Salas 1974, 187; Morales 1994, no. 153.

"I am at last painter to the king, with fifteen thousand *reales*. Although I have no time I will tell you briefly that the king sent Bayeu and Maella to find the two best painters they could to paint the models for the tapestries and for everything else in the palace, whether in fresco or oil. Bayeu picked his brother and Maella chose me."[1] Goya sent this letter to his friend Martín Zapater on 7 July 1786, excitedly informing him of his new position at court and announcing that among other things he was to create, under the auspices and tutelage of Salvador Maella, tapestry cartoons, thus establishing professional ties to the tapestry factory of Santa Bárbara. The factory commissioned from Goya the series for the prince and princess of Asturias' dining room at the Pardo palace, where King Charles III wished to see "pictures on gay and pleasant subjects needed for this place."[2] Following the factory's artistic policies and upon receipt of the required measurements, Goya completed preliminary oil sketches, which were crucial to the genesis of the composition, as the king had to approve the sketches before anything was transferred to a large canvas. It is therefore not surprising to find among Goya's billing records "a coach ride to the royal palace of the Escorial to show H.M. ... the rough drafts for the Pardo dining room."[3] It was only in the sketch that the king could assess the painter's original work, since the final large-scale composition functioned solely as a model for the weavers and, once copied, was stored in the factory warehouses. The draft version reveals the painter's most immediate vision of his theme and composition. In the sketch one can observe his working methods, as in the raised arm of the flower girl. The composition is drawn in black pencil, visible throughout the figure, over a red background and a layer of light-colored preparation. Goya often used the transfer to the final canvas to clarify the composition and to perfect the work's story line. The scene formed part of a cycle on the Four Seasons and was placed with *Autumn (The Grape Harvest)* (cat. 16); on the long wall of the room, the monumental *Summer (Harvest)* completed the group, together with the dramatic *Winter (Snowstorm)*. With the exception of this last

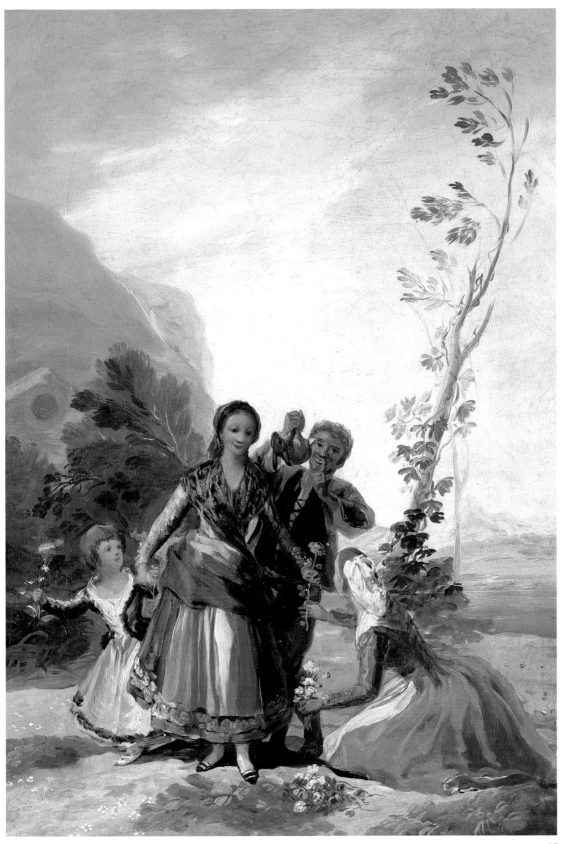

13

composition, where a group of peasants cross an icy landscape, women are portrayed in their traditional roles, as mothers with their children or, as here, with only one daughter, in just the type of "gay and pleasant" scene the king had requested.

Bozal notes the alterations made between the sketch and the cartoon, finding them primarily in the positions of the figures.[4] Yet the most definitive alteration with regard to the clarity of the composition lies in the fourth protagonist, who appears just behind the mother holding a hare, a symbol of fertility and a common *topos* for the season. His finger to his lips, he invites the viewer's complicity, planning to startle the woman with this animal. In the final version, Goya inverts the hare's position. With its head up, the shapes of all the figures come into sharper focus. The alteration also eases the solid and compact triangular composition constructed by the participants in this rural encounter. AR

NOTES
1. Salas and Águeda 1982, 148–149, no. 79.
2. Sambricio 1946, Doc. 78, LI.
3. Sambricio 1946, Doc. 103, LXXVIII.
4. Bozal 1983, 77–78.

14. *The Flower Girls, 1786–1787*

Oil on canvas
277 x 192 cm
Museo Nacional del Prado,
Madrid, inv. 793
Madrid only

PROVENANCE: Royal Tapestry Factory of Santa Bárbara; 1856–1857, Royal Palace of Madrid; 1870, Museo Nacional del Prado; 1887, first mentioned in the museum's catalogue.

On 12 September 1786 Goya wrote to his friend Zapater: "Just now I am very busy making sketches for a room where the prince eats," and several months later, in February of the following year, having completed the final cartoons, he told his friend, "I have never felt so hard pressed."[1] Six years had gone by since his last commission from the Royal Tapestry Factory—the antechamber decoration for the heirs to the throne (see cats. 7–12)—and the exhaustion was a result of his having to juggle tapestry work for the Pardo palace dining room with his other private commissions. Goya had already been appointed court painter and was regarded as a gifted portraitist; at this time, for example, he was also painting the extraordinary *Marchioness of Pontejos* (cat. 26).

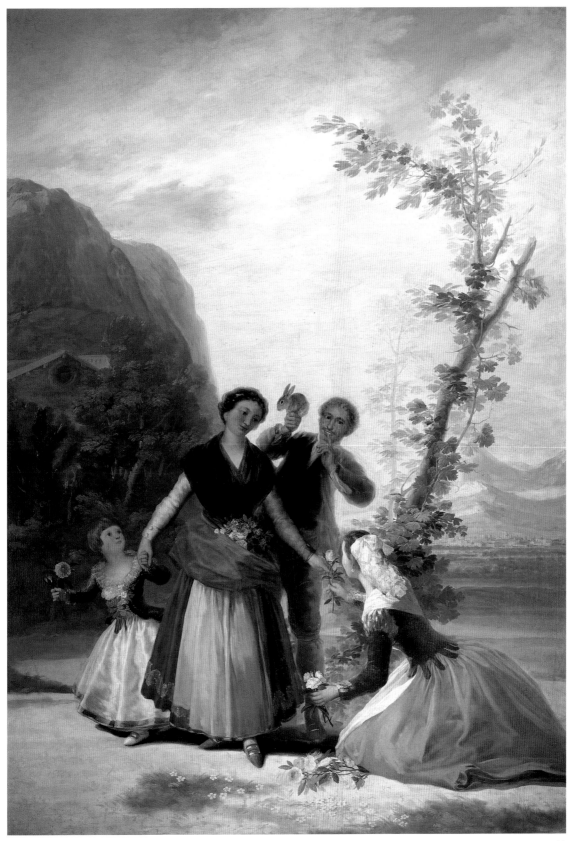

14

EXHIBITIONS: Madrid 1996c, no. 35.

BIBLIOGRAPHY: Gudiol 1970, no. 215; Gassier and Wilson 1971, no. 262; Bozal 1983, 77–78; Arnaiz 1987, 138, 144, 147, no. 44C; Nordström (1962) 1989, 42–49; Tomlinson 1989, 158–159; Morales 1994, no. 154; Wilson-Bareau 1993–1994, 160.

The series' theme is based on a long iconographic tradition stipulated by contemporary theorists as the proper decor for country palaces such as the Real Sitio del Pardo. At midcentury, Amigioni had used the four seasons in a series of cartoons for the royal box in the Buen Retiro Theater, and Goya took up the theme. As Bozal and Wilson-Bareau have observed, the preparatory sketches mentioned in Goya's letter suffered significant changes when they were transferred to canvas.[2] The painter rejected classical allegories and set his scenes in a modern context. Rather than depict the goddess Flora as she appears in the eighteenth-century French edition of Cesare Ripa's *Iconología*, Goya portrays regional women; a kneeling girl is dressed in the characteristic short jacket bordered with narrow lappets, commonly worn by majas. But to facilitate recognition of the allegorical content, he adds, as Nordström points out, the traditional attributes of Spring: the hare, symbolizing fertility, and the flowers, symbolizing growth.[3]

The abundance of flowers gathered in the mother's apron is the key to the scene. It concerns a mother who has been picking flowers and wild roses as she walks through the countryside with her daughter. A small sprig is pinned to the little girl's jacket, and she is holding a splendid flower with wide-open petals. Along the way they have chanced on a maja in a kneeling position, reminiscent, as Valerian von Loga noted in 1903, of the famous maid in Velázquez' *Las Meniñas* (Museo Nacional del Prado, Madrid).[4] Here she presents the walking ladies not with a jug of water, but with one of her roses. The surprise is provided by the man behind the group, whom only the child has noticed, and who is about to frighten the woman with a hare. His finger to his lips in a hushing gesture invites the viewer's complicity in the game. AR

NOTES
1. Salas and Águeda 1982, 156, no. 83 and 160, no. 86.
2. Bozal 1983, 77–78; and Wilson-Bareau 1993–1994, 162–163.
3. Nordström (1962) 1989, 48.
4. Loga 1903, 55.

15. *Autumn*, 1786

This small canvas is the preparatory sketch for the cartoon of *Autumn (The Grape Harvest)* (cat. 16), which Goya created for the prince and princess of Asturias' dining room in the Pardo palace. The sketch shows an encounter between a lady, a youth, and a child, which takes place in a vineyard; a peasant woman carries a basket of the vineyard's fruit on her head. A comparison of the sketch and the cartoon reveals the changes Goya made in the final composition. The cartoon displays a simple composition, in accordance with neoclassical aesthetic concepts: the colors are harmonious and the gestures are contained. The sketch, on the other hand, presents an amusing genre scene carried out with amazingly energized brushstrokes that reveal numerous revisions on an underlying base. The child seems livelier here: he leaps and stretches out to seize the bunch of grapes that eludes his reach. Also less solemn in this sketch than in the cartoon is the peasant girl, laden with harvested fruit; the slender vine branches and grape clusters stand out, dark and gleaming. Goya would later change them to a more orderly still life. While in the finished version the majo takes his place on the same low wall as the lady, the first version shows him lower down, on a wine barrel almost covered by his cape. The attitude calls to mind, as Wilson-Bareau notes, a "pretend Bacchus," god of wine, often used—as for example by Mariano Salvador Maella (Museo Nacional del Prado, Madrid)—to symbolize Autumn.[1] This deity, transformed in Goya's image into a "type" of contemporary Madrid society, was the iconographic alternate to the traditional depiction of Autumn as a mature woman, sumptuously dressed, with a branch of grapes or a cornucopia. Over the course of the eighteenth century, realistic figures displaced the old personifications of the seasons. Tomlinson sees the origin of this phenomenon in the poetry and prose of Goya's time.[2] The bunch of grapes the youth proffers to the lady is light yellow in tone. This fruit, quintessentially autumnal, would assume greater importance in the cartoon; in this sketch—hardly visible against the light background—the painter

Oil on canvas

34.4 x 24.3 cm

Sterling and Francine Clark Art Institute, Williamstown, Massachusetts

———

PROVENANCE: 1798, duke and duchess of Osuna, La Alameda, Madrid; prior to 1813, baron Alquier, ambassador to Spain under Joseph Bonaparte; heirs of baron Alquier, Nantes; 1939, M. Knoedler & Co., New York; 1939, R. Sterling Clark, Upperville, Virginia; 1955, Sterling and Francine Clark Art Institute.

EXHIBITIONS: Dallas 1982–1983, no. 4; Madrid, London, and Chicago 1993–1994, no. 21; Lille 1998–1999, no. 12.

BIBLIOGRAPHY: Gudiol 1970, no. 218; Gassier and Wilson 1971, no. 258; Tomlinson 1989, 159–163; Morales 1994, no. 157.

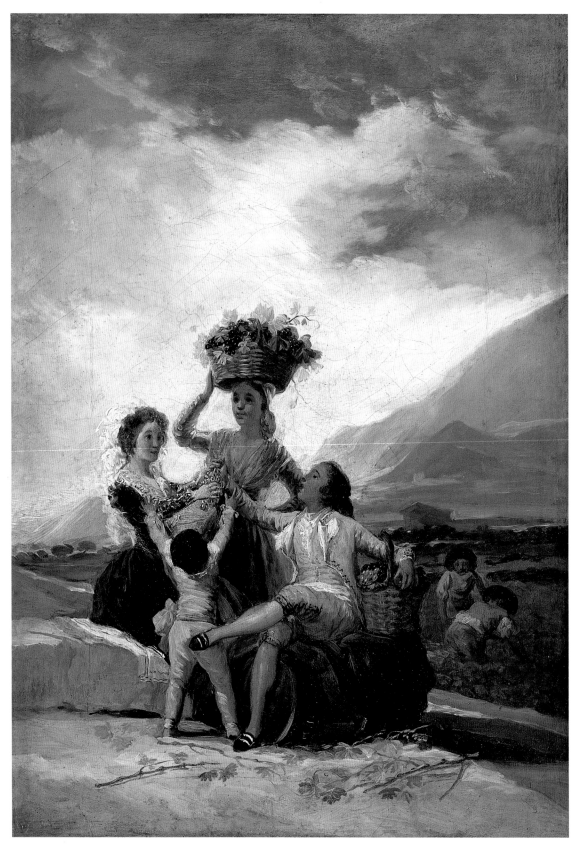

15

changed it to a branch of purple grapes, an easily recognizable symbol of the season depicted. AR

NOTES

1. Wilson-Bareau 1993–1994, 164.
2. Tomlinson 1989, 159–163.

16. *Autumn (The Grape Harvest)*, 1786–1787

Between 1786 and 1787 Goya painted the Four Seasons sequence for the prince and princess of Asturias' dining room at the Pardo palace. *The Grape Harvest* represents Autumn. Here, as in *The Flower Girls* (cat. 14), who embody Spring, Goya allocates a decisive role in the scene and in its allegory to vegetation and fruits. In *The Flower Girls* the composition is centered on the long-stemmed rose the kneeling maja offers the mother, reminiscent of the classical pose in offerings to the goddess Flora, the primary allegory of Spring. In the present work a beautiful cluster of grapes replaces the flower; an elegant majo seated on a low stone wall proffers the branch to a young lady while a child, his back to the observer, clutches at the grapes. As in *The Flower Girls*, Goya rejects conventional allegory, which for Autumn meant Bacchus, the god of wine, or a mature woman with an overflowing cornucopia, the image Cesare Ripa recommended in his book of emblems for depicting this season.[1] Goya prefers more realistic characters in popular dress. Yet the postures, the movements, and the restricted color range of the garments prove more elegant than the folkloric figures of earlier cartoons such as *The Picnic* (cat. 1). The gracious posture and graceful gesture of the man are better suited to a gentleman than to a majo. These people are probably the owners of the land dressed as majo and maja, in the strictly stylized fashion of the time, which Klingender interprets as a reflection of the philanthropic interests espoused by aristocratic followers of Rousseau.[2] The young lady, for example, wears a short jacket of fine black fabric, its broad shoulders and its sleeves adorned with gold braid. Her deep décolleté is covered with a white kerchief, or *fichu*, which matches her white hair netting and the shawl spread over the stone balustrade. The peasant behind the group, the newly

Oil on canvas
275 x 190 cm
Museo Nacional del Prado,
Madrid, inv. 795

———————

PROVENANCE: Royal Tapestry Factory of Santa Bárbara; 1856–1857, Royal Palace, Madrid; 1870, Museo Nacional del Prado, Madrid; 1876, first listed in the museum's catalogue.

EXHIBITIONS: Madrid, Bordeaux, and Paris 1979, no. 19; Madrid 1996c, no. 37.

BIBLIOGRAPHY: Gudiol 1970, no. 219; Gassier and Wilson 1971, no. 264; Held 1971, 60; Pita Andrade 1979, 238; Licht 1983, 44; Agueda 1984, 43, 45; Arnaiz 1987, no. 46C; Symmons 1988, 80; Tomlinson 1989, 159–163; Morales 1994, no. 158; Mena Marqués 2000, 181.

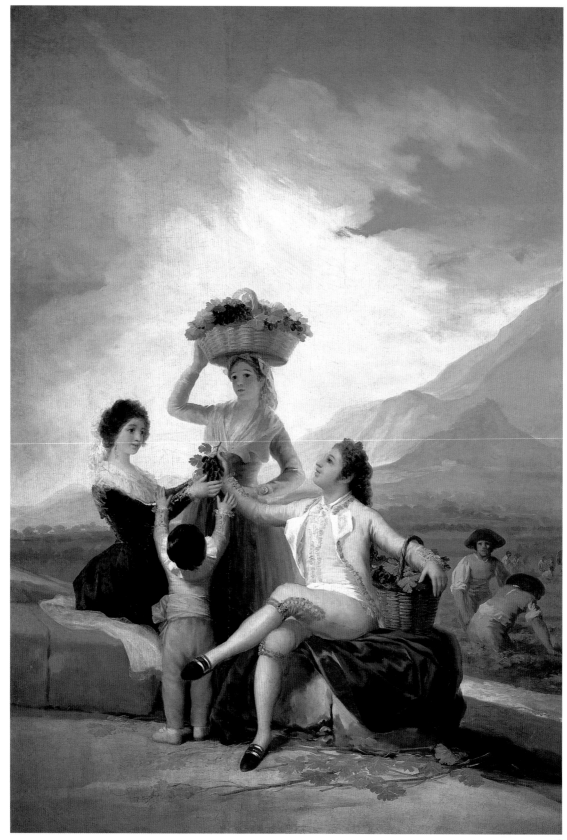

16

harvested fruit balanced in a basket on her head, is more rustic. She addresses a serene gaze toward the foreground and the observer, as do the harvesters working in the fields. Though her clothing is more simple, this peasant woman's classical beauty evokes ancient statuary. Her position recalls Ceres, goddess of agriculture, as pictured by Bernard Montfaucon in his imposing collection of works from antiquity, illustrated with engravings and published between 1719 and 1724, which Goya could easily have consulted in the library of the Real Academia de Bellas Artes de San Fernando. The placement of the peasant woman in the center of the principal group majestically crowns the pyramidal shape formed by the assembled figures. The arm resting on her hip completes the framework of lines formed by the arms of the majo, his wife, and the child, which together serve to focus the viewer's attention on the bunch of grapes. AR

NOTES
1. Nordström (1962) 1989, 58.
2. Klingender 1948, 60.

17. *The Meadow of San Isidro*, 1788

Until 1788 Goya had created cartoon series only for the adornment of rooms used by adults, but toward the end of 1787 the Royal Tapestry Factory of Santa Bárbara commissioned from him bedroom tapestries for the daughters of the prince and princess of Asturias at the Pardo palace. Carlota Joaquina was thirteen years old and Amalia, six. Besides the preliminary sketches for *The Cat at Bay* (private collection), *The Picnic* (cat. 1), and *Blindman's Buff* (Museo Nacional del Prado, Madrid), the series included *The Hermitage of San Isidro* (Museo Nacional del Prado, Madrid) and *The Meadow of San Isidro*, which depict the festivities in honor of the patron saint of Madrid held on 15 May. The first of the last two sketches shows the populace thronging to the saint's church to drink from the miraculous fountain which San Isidro, according to legend, had caused to spring up when he was a humble peasant; the second depicts the community picnic celebrated in the neighboring meadow. Goya's

Oil on canvas
41.9 x 90.8 cm
Museo Nacional del Prado,
Madrid, inv. 750

———————

PROVENANCE: 1798, ducal house of Osuna; 1896, acquired by the Ministry of Development, Public Education for the Museo Nacional del Prado; 1896, Museo Nacional del Prado; 1900, first mentioned in the museum's catalogue.

EXHIBITIONS: Madrid 1896, no. 66;
Geneva 1939, no. 29; Bordeaux,
Madrid, and Paris 1979, no. 21;
Leningrad and Moscow 1980, no. 28;
Madrid, Boston, and New York
1988–1989, no. 16; Madrid 1992–
1993, no. 51; Madrid, London, and
Chicago 1993–1994, no. 26; Madrid
1996c, no. 49; Lille 1999, no. 20.

BIBLIOGRAPHY: Sambricio 1946, no.
53; Gudiol 1970, no. 252; Gassier and
Wilson 1971, no. 272; Held 1987,
41–43; Arnaiz 1987, 187, no. 58B;
Tomlinson 1989, 179–183; Morales
1994, no. 187.

chosen topics are full of play and lack the ambiguous erotic allusions evident in the scenes for the parents' bedroom. They are probably based on the series produced two years earlier by José del Castillo for the newborn Fernando. The disciple and imitator of Corrado Giaquinto had undertaken similar subjects, among them a view of the meadow of San Isidro (Museo Nacional del Prado, Madrid), and the future Charles IV probably requested this theme to preclude the usual sibling jealousies. But Goya's work far surpasses Castillo's mannered creations, in both quality and invention. Instead of Castillo's flirtatious stroll along the banks of the Manzanares River, a scene in which only the silhouette of the Toledo Bridge identifies Madrid, Goya reveals in his *Meadow* a panorama of the city, demonstrating his enormous skill as a *vedute* painter, a popular eighteenth-century fashion. He captures atmosphere in the style of Michel-Ange Houasse and Antonio Joli. The landscape unfolds toward the Manzanares River. Beyond it we see Madrid, where the beauty of light and color is joined with topographic precision. The massive royal palace and the newly constructed church of St. Francisco the Great appear perfectly recognizable amid other towers. The city's silhouette provides a background for the bustle of the populace on the riverbank, where members of all social classes mingle to enjoy the community meal, to which yet more people are seen arriving by way of the Segovia Bridge Road. The atmosphere is charged with animation, intensified by various elements: by the carriages, which suggest a constant going and coming; by the leaping dogs; and by the people dancing *seguidillas* on the riverbank.

In place of his usual concentration on small groups, Goya here presents a human mass, distinguishing the women, both in the center and on the sides of the composition, so that the princesses would identify more easily with the painting. Perhaps because he was first trying out this style of composition, Goya confessed to his friend Zapater, "the subjects [are] so difficult and there is so much to do" that he even lost sleep over it: "I don't have it entirely together, for I can neither sleep nor rest until I'm done with the thing."[1] The exhaustion ended in suspension of the project, on the death of Charles III in 1788 and the subsequent abandonment of the Pardo palace. AR

NOTES

1. Salas and Águeda 1982, no. 104.

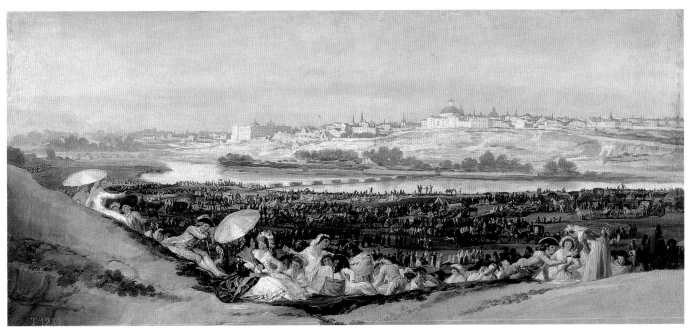

17

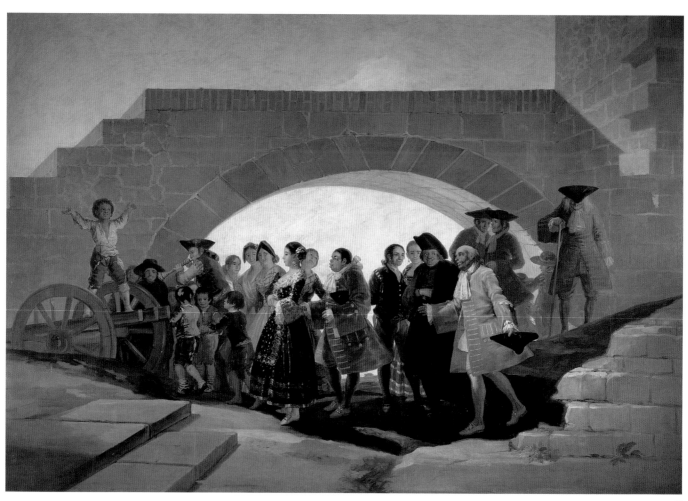

18

18. *The Wedding*, 1791–1792

In this cartoon Goya portrays the wedding procession just after the vows have been pronounced, when, according to the earliest description of the scene, "They lead the bride and groom to their house in the company of the Priest and the Godparents."[1] The event attracts people's attention, beginning with the small boy on the left and ending with an old man leaning on his staff at right. This configuration, forming a low, extended frieze set below a bridge— the sole architectural reference to the urban world—suggests an allusion to "the ladder of life" or to a *vanitas.*[2] In the center appears the lovely young woman, and just behind her comes her rich but ugly husband. The bride's father, in a somewhat shabby coat, follows the ill-matched couple with an expression half resigned and half complacent. The girls, friends perhaps of the bride, are laughing, as is the priest. The hilarity seems to irritate the bride's father. Since the married couple would otherwise prove difficult to distinguish in this setting, where Goya works with pale colors based on light earth tones, he dresses the bride in rich blue attire and her husband in a red frock coat. The spatial system is significant: it is based on the horizontal planes of procession and bridge and conforms with the demand in neoclassical painting for compositional simplicity, a concept Goya will again employ when, as has been noted in the literature, he sets the royal family against a bland, neutral wall in the monumental *Family of Charles IV* (cat. 32).

Weddings, and particularly rustic weddings, were a much-treated topic among seventeenth-century genre painters; for example, David Teniers and Philips Wouwerman. At the start of the eighteenth century Antoine Watteau presented *The Marriage Contract* (Museo Nacional del Prado, Madrid) as an elegant *fête galante*, a stately festivity. The disenchanted tone enters only later in the century, when marriages of convenience became one of the era's most hotly debated subjects, a topic William Hogarth also undertook in a famous series of paintings and etchings called *Marriage à la Mode*. More and more voices were raised against unequal marriages, in which a girl was obliged to marry a man she did not love to secure her family's well-being or to rise in the

Oil on canvas
269 x 396 cm
Museo Nacional del Prado,
Madrid, inv. 799
Madrid only

PROVENANCE: Royal Tapestry Factory of Santa Bárbara; 1856–1857, Royal Palace of Madrid; 1870, Museo Nacional del Prado; 1876, first mentioned in the museum's catalogue.

EXHIBITIONS: Barcelona 1997, no. 12; Madrid 1996c, no. 52.

BIBLIOGRAPHY: Gudiol 1970, no. 299; Gassier and Wilson 1971, no. 302; Cohen 1973, 81–88; Chan 1983, 33–36; Alcalá-Flecha 1984, 22–25; Tomlinson 1984, 23–29; Chan 1985, 51–52; Soler 1985, 47–49; Arnaiz 1987, 166–167, no. 62C; Alcalá-Flecha 1988, 335–336; Tomlinson 1989, 200–203; Morales 1994, no. 207.

social order. Leandro Fernández Moratín criticizes this behavior in his plays *El viejo y a niña (The Old Man and the Girl)* from 1790 and the 1806 *El sí de las niñas (When Girls Give Consent)*. Some years later Goya denounced the practice in satirical form in a Capricho with a legend citing a passage from Gaspar Melchor de Jovellanos' epistle *A Arnesto* ("To Arnesto"): *They Say Yes and Give Their Hand to the First Comer* (cat. 81). The painter does not, however, depict the bride as victim of a union forced on her by the men in her family, who consist solely of her father and her husband. Her profile shows a face that is proud to the point of disdain.

Together with *The Straw Mannikin* (cat. 19), *Girls with Water Jars, The Stilts* (Museo Nacional del Prado, Madrid), and the two cartoons on children's topics, *The Wedding* brings to a close, in 1792, the lengthy parade of cartoons Goya had been delivering to the Santa Bárbara tapestry works since 1775. AR

NOTES

1. The earliest description of scene dates from 1794 and is cited by Sambricio 1946, 171 and 274, no. 59.
2. Tomlinson 1984, 23–29. See also Chan 1983, 33–36.

19. *The Straw Mannikin,* 1791–1792

Oil on canvas

267 x 160 cm

Museo Nacional del Prado, Madrid, inv. 802

PROVENANCE: Royal Tapestry Factory of Santa Bárbara; Royal Palace of Madrid; 1870, Museo Nacional del Prado; 1876, first mentioned in the museum's catalogue.

The action of *The Straw Mannikin* takes place in the countryside. Four laughing girls wear the authentic head adornments of true majas—netted snoods, ribboned coverings, coifs, and *carambas.* The girls are tossing into the air a straw mannikin, breaking its fall in a blanket. Tossing a doll in a blanket has its origins in the pre-Lenten carnival and enjoys a long iconographic tradition. It was depicted by Andrea Procaccini in his tapestry series on Don Quixote, a series rewoven several times beginning in 1730, with Sancho Panza as the victim. It appears also in an illustration of 1681 for Mateo Alemán's picaresque novel, *Vida y hechos del pícaro Guzmán de Alfarache,* a classic of Spanish Golden Age literature. The book illustration prefigures the grouping of four figures, tossing the very Guzmán of the title, who is being attacked by "devils with dresses, hairdos, and masks."[1]

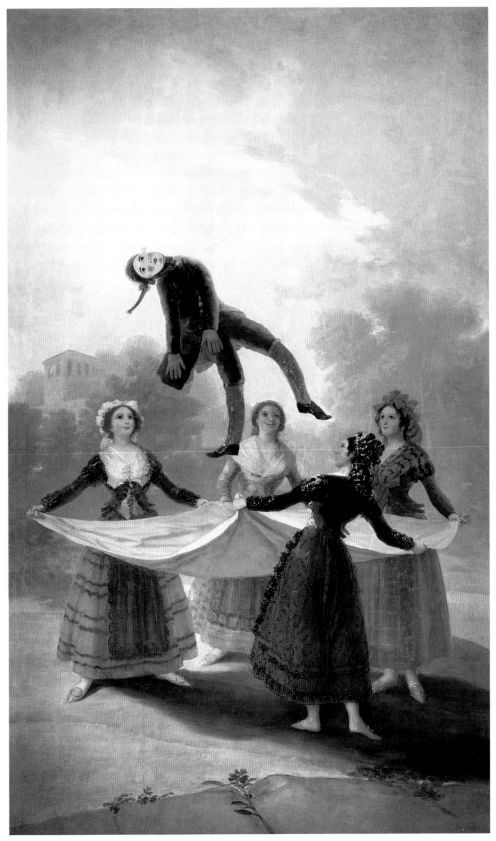

EXHIBITIONS: Paris 1919, no. 22; Kyoto and Tokyo 1971–1972, no. 15; Barcelona 1977, no. 13; Paris 1987–1988, no. 95; Madrid 1996c, no. 54; Rome 2000, no. 7.

BIBLIOGRAPHY: Gudiol 1970, no. 302; Gassier and Wilson 1971, no. 301; Held 1971, 61–62; Chan 1985, 50–58; Arnaiz 1987, 166, no. 64C; Starobinski 1988, 105–107; Tomlinson 1989, 207–210.

Although this cartoon has been interpreted as an allusion to the contemporary political situation, in which appointments and dismissals were subject to continuous and abrupt changes, it is clearly an allegory on woman's power over man, a leitmotif throughout the Caprichos and the Disparates, especially obvious in the one entitled *Feminine Folly* (cat. 125). The theme is found in *The Wedding* (cat. 18), in which a girl lands a good catch by marrying an old man, and in *The Stilts* (Museo Nacional del Prado, Madrid), in which youths risk falling to impress the village girls. With this composition for the king's study, Goya brought to a close his long career, begun in 1775, in the service of the Royal Tapestry Factory. His efforts as cartoonist were vital to his court beginnings, but over time became an obstacle to his intellectual and professional development. Not only did the work take a great deal of time, but he knew that the cartoons would never reach a public, because once copied they were stored in the factory vaults. Besides, he was comfortably established after being named court painter, and both his style and his technique were now fully mature.

Thus his new situation in life, together with the weariness of working for tapestry manufacture, led to Goya's reneging on the project. But at the instigation of Livinio Stuyck, then director of the factory, who claimed that Goya's "strike" had paralyzed his shop, the king threatened to withhold the painter's salary. Goya had no recourse but to capitulate and agree to complete it.

Nonetheless, Goya did not finish the commission. He fell ill toward the end of 1792 and after his recovery never returned to this series intended for the monarch, who had wanted in his study "rustic and comic themes" similar to those the master had provided on other occasions. AR

NOTES
1. Mateo Alemán, *Vida y hechos del pícaro Guzmán de Alfarache*, first part, III, 1.

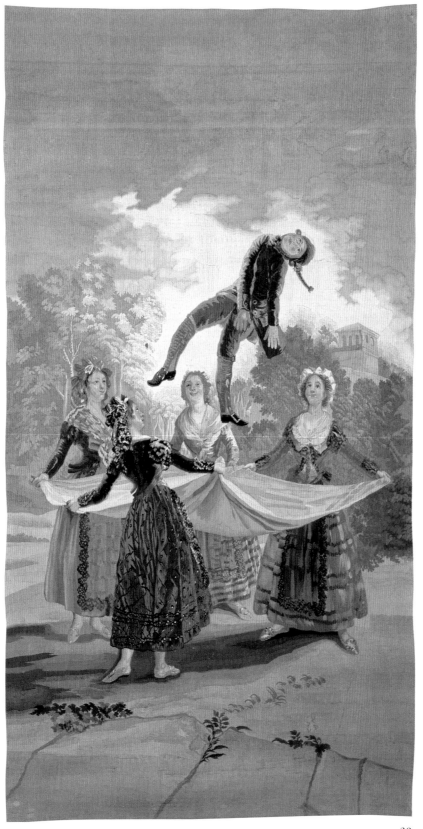

20

20. *The Straw Mannikin, 1791/1792*

Tapestry for the study of King
Charles IV, Escorial palace
High warp, silk and wool
293 x 162 cm
Cartoon by Francisco Goya
MP. inv. 802
Sketch, Rush H. Kress Collection,
New York
Sketch, Armand Hammer Foun-
dation, Los Angeles
Livinio Stuyck y Vandergoten,
1791–1793
Royal Tapestry Factory of Madrid
Palacio Real, Madrid
Patrimonio Nacional, Madrid

EXHIBITIONS: New York 1917; Paris
1919; Bordeaux 1951; Basel 1953;
Madrid 1996b; Jackson 2001.

Having abandoned the project to refurbish the Pardo palace, Charles IV ordered the tapestries with their "rustic and comic subjects" sent to the royal chambers in the Escorial palace. Expense invoices submitted by Goya on 1 July 1791 confirm that the painter was by royal order at work on designs for the king's study entitled *Girls with Water Jars, The Straw Mannikin, The Wedding,* and *The Stilts.*[1]

This is the sole tapestry woven following Goya's design, on a high-warp loom, in 1793, by the artisan Antonio Moreno (at which date only ten "palmos"—a measurement approximating eight inches in length and seventeen in height—had been completed). CHC

NOTES
1. Sambricio 1946, Doc. 145, CI.

21. *María Teresa de Borbón y Vallabriga, later Countess of Chinchón, 1783*

Oil on canvas
134.5 x 117.5 cm
National Gallery of Art,
Washington, Ailsa Mellon Bruce
Collection, 1970.17.123

María Teresa de Borbón y Vallabriga was the daughter of the Infante Don Luis de Borbón, brother to King Charles III, and María Teresa de Vallabriga. According to the inscription, she was only two years and nine months old when the portrait was made; this fits with her date of birth, 26 November 1780, as well as with the date of Goya's first stay at Arenas de San Pedro (Ávila) in August 1783. During that year Goya painted individual portraits of the

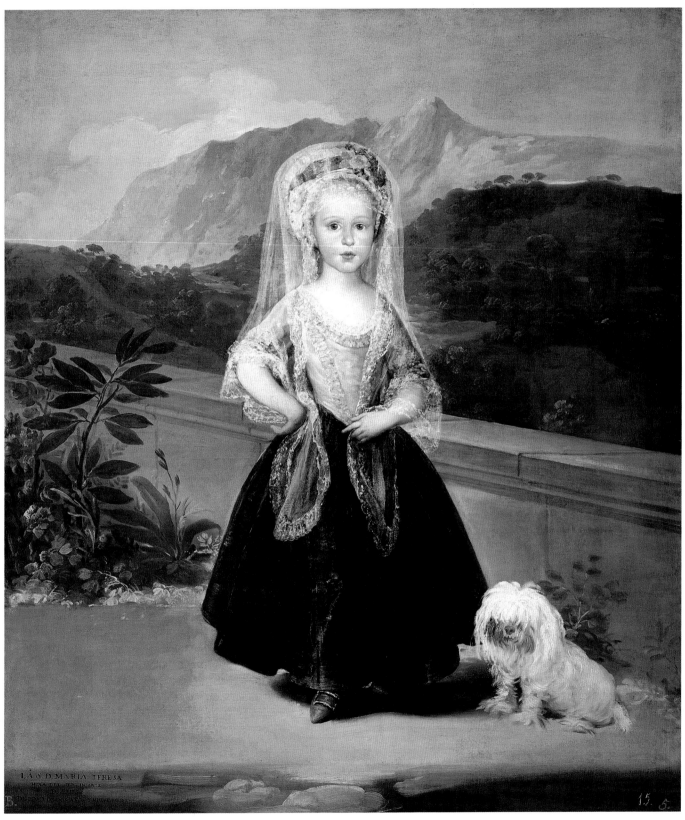

21

Inscribed in lower left corner: LA
S.D. MARIA TERESA / HIXA
DEL SER. INFANTE / D. LUIS
/ B. (at lower right, inventory
numbers: 15, 5)

PROVENANCE: since 1783, the palace
of Arenas de San Pedro (Ávila);
palace of Boadilla del Monte;
1867–1886, Carlota Luisa de Godoy
y Borbón; by inheritance, the collec-
tions of Adolfo Rúspoli, María Teresa
Rúspoli y Alvarez de Toledo, Paris;
Camilo Carlos Adolfo Rúspoli y Caro;
March 1957, sold at Wildenstein,
New York; 2 March 1959, Ailsa Mel-
lon Bruce, New York; National
Gallery of Art, Washington.

EXHIBITIONS: Washington
1986–1987, unnumbered.

BIBLIOGRAPHY: Gudiol 1970, no. 150;
Gassier and Wilson 1971, no. 210;
Gassier 1979, 13, 18; Glendinning
1981, 238; Brown and Mann 1990,
27–32; Morales 1994, no. 127;
Rúspoli 2000, 129–152.

infante's family members, including this one of his elder daughter, future bride of Manuel Godoy with the title countess of Chinchón (see cat. 31). Goya placed the model against a rustic Gredos mountain landscape, marked by dense, dark forest and enormous rocks bathed in a silvery light. The painting was paired with the portrait of her brother Luis María de Borbón, which survives only in a study (private collection). To accentuate their majesty, Goya portrayed both children full-length and standing, using a slightly lowered point of view. The little girl is shown outdoors on a garden terrace framed by a balustrade. She wears court attire and a white lace mantilla that covers her hair, adorned with a blue ribbon and a small flower. She mimics, gracefully, an adult stance, her left hand on her hip, extending one foot forward to show her blue slipper, topped with a golden buckle.

This image is poised between the older tradition of aristocratic portraits of children seen as miniature grown-ups and of the child portraiture of the Enlightenment, with its preference for a more naturalistic representation. The child's true personality is expressed, and the poses conform to new ideas on education: children wear lighter clothing, allowing greater freedom of movement. Rather than behaving like little adults, they are seen at play or, in the case of María Teresa's brother, at their studies. Even in this portrait, in which the child imitates conventional adult bearing—her headdress is excessively complicated, as is her court gown, which obstructs movement—Goya skillfully and accurately discovers her psychological profile. Her face displays the characteristics of the new fashion in child portraiture; her red lips and shining eyes attest to her health. Her friend the dog, described with brushstrokes only lightly loaded with paint, evokes an affectionate atmosphere, and his shaggy white coat brings him into playful alliance with the little girl's headgear, which at the same time betrays her real height.

No remarks on the painting would be complete without reference to the Velázquez portraits in which the Sevillan master sets his models against the Guadarrama mountains, using long, flowing strokes. These provided a perfect technical and iconographic prototype for Goya. Toward the close of the 1770s the Aragonese painter had copied Velázquez' famous portraits in a series of engravings, among them the one closest to the painting of María Teresa: the portrait of Prince Baltasar Carlos dressed as a hunter and accompanied by a dog (Museo Nacional del Prado, Madrid). AR

22. *María Teresa de Vallabriga y Rozas, 1783*

Many of the portraits Goya executed during the summers of 1783 and 1784 represent María Teresa de Vallabriga y Rozas, the beautiful wife of the Infante Don Luis de Borbón. Goya had painted her in strict profile during his first stay at Arenas de San Pedro in 1783 (cat. 23). In addition to that painting, evocative of the medallion and relief portraiture of antiquity, the prince commissioned one at half-length, also conforming to the demands of neoclassicism, in which his young spouse appears almost frontally. To relieve the exaggerated rigidity of the composition, Goya turned María Teresa slightly to the right. Her shoulders are relaxed, the folds of her stole are symmetrical, and the colors are restricted principally to tones of white and gray: the painter is clearly appealing to the tradition of classical marble busts, sharply defined against a dark background. In her profile portrait María Teresa looks natural: her hair shines and her simple garment suggests an intimate moment. In the present painting Goya shows her ready to grant an audience. Her hair, carefully coiffed by the hairdresser, is powdered, and her attire is enriched by an elegant stole, its surface sparkling with light. The fur trim across the bust of her dress accentuates the twist of her body. The observer faces her directly.

According to Beruete, this portrait of María Teresa, which was recently rediscovered, is the companion piece to a bust of the Infante Don Luis, a work Arnaiz believes may be by Anton Raphael Mengs.[1] This painting, showing Don Luis in dress uniform, is in the collection of the duchess of San Fernando. Beruete considers Mengs' portrait "more accomplished" than Goya's.[2] Yet the Aragonese painter employed a very polished technique: exploiting the wooden surface to create an enamel-like effect, he intensified the beauty of María Teresa, in whose eyes, through a few white touches, he shrewdly conveyed her vivacious personality. To reflect her husband's portrait, Goya duplicated the Mengs model, placing the woman frontally, her white dress complimenting her husband's uniform.

A technical analysis carried out in 1992 found an underlying sketch in the area of the eyes, and corrections and changes in the design of the clothing

Oil on panel

66.7 x 50.5 cm

Private collection, Mexico

———————————

PROVENANCE: 1783 or 1784, palace of Arenas de San Pedro (Ávila); until 1904, palace of Boadilla del Monte, Madrid; Prince Camilo Rúspoli, Florence; private collection, Great Britain; 29 May 1992, sold Christie's, London, lot 342; private collection.

EXHIBITIONS: Saragossa 1996b, 112–116; Lille 1999, no. 8.

BIBLIOGRAPHY: 1868, *Catalogue…Boadilla del Monte;* Viñaza 1887, 227, no. XXXV; Beruete 1916, 22–23; Mayer 1923, 186, no. 181; Angulo Iñiguez 1940, 49–58; Sánchez Cantón 1951, 28; Gudiol 1970, no. 153; Gassier 1979, 13, 18, 20, 21, nos. 30 and 55; Arnaíz 1987, 51; Morales 1994, nos. 557, 560.

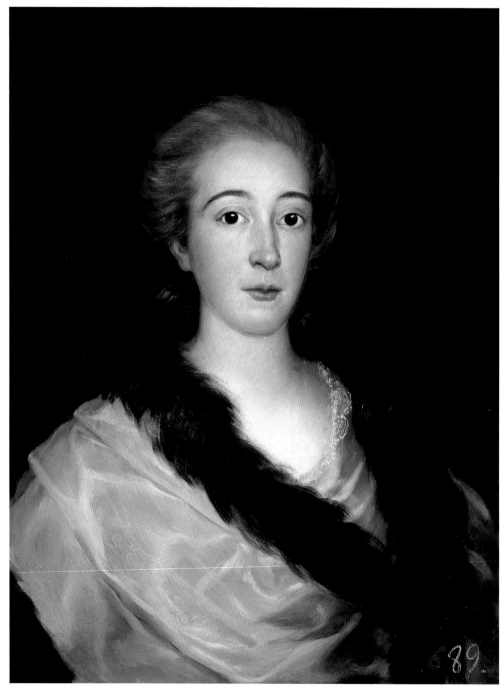

22

around the shoulders. At an earlier stage of the painting María Teresa wore a dress more French in style, similar to what the duchess of Benavente wears in her portrait of 1785 (cat. 25); this earlier dress vanished under the elegant stole in the definitive version.

Don Luis died in 1785. In his will the present painting is listed as "Another painting with a half-figure of the Señora Da María Teresa Vallabriga y Rozas, painted on wood, with its gilt and crystal frame, which measures two feet six and a half inches in height and one foot three and a half inches in width, its maker Dn Francisco Goya."[3] The work was assessed at 1,300 *reales*. AR

NOTES
1. Arnaiz 1986, 51.
2. Beruete 1916, 22–23.
3. Saragossa 1996b, 114.

23. *María Teresa de Vallabriga y Rozas, 1783*

María Teresa was born in 1759 to a captain in the cavalry regiment stationed in Saragossa, the capital of Aragón, and Josefa de Rozas y Drummond, the dowager countess of Torresecas. On the deaths of her parents and elder brother, in 1773 she left Saragossa for the court, where she resided with her aunt, the marchioness of San Leonardo. In 1776, at seventeen, she married the Infante Don Luis, who was thirty-two years older than she. The wedding put a stop to the none-too-pious lifestyle led by the king's brother, whose post as a cardinal of the Church scarcely suited his true inclinations, and also provoked Charles III to promulgate, in March 1776, a matrimonial decree barring the offspring of this morganatic union any possible right to the throne. By this means the aging king guaranteed the succession of his firstborn, the future Charles IV, who was born abroad. He likewise prohibited Don Luis' descendants from using the Borbón title or its coat of arms and in addition forbade them to live at court. María Teresa was separated from her children, a painful situation that improved only in 1797 when her eldest daughter, also called María Teresa

Oil on panel
48 x 39.6 cm
Museo Nacional del Prado,
Madrid, inv. 7695

PROVENANCE: Infante Don Luis; dukes of Sueca; marquis of Acapulco; marquis of Caicedo; 27 February 1985, sold Sotheby's, Madrid; 1996, acquired by the State, through non-payment of taxes, for the Museo Nacional del Prado.

EXHIBITIONS: Madrid 1961, no. 46; Paris 1961–1962, no. 20; Madrid 1985, no. 38; Madrid 1996c, no. 63.

BIBLIOGRAPHY: Gudiol 1970, no. 146; Gassier and Wilson 1971, no. 207; Symmons 1988, 96; Tomlinson 1989, 135–136; Baticle 1992, 91; Morales 1994, no. 123; Ansón Navarro 1995, 155.

(portrayed as a child in cat. 21 and as an adult in cat. 31), married Manuel Godoy, the favorite of the new monarchs. Through this marriage the family at last recovered its surname and titles.

María Teresa and Don Luis de Borbón were Goya's first important patrons. The painter visited Arenas de San Pedro (Ávila) during the summers of 1783 and 1784 to make portraits of the family. María Teresa's remarkable loveliness is obvious in the 1784 *Family of the Infante Don Luis* (cat. 24), where she appears in the center observing her observers. Further corroboration of her beauty is provided by the sketch for a magnificent equestrian portrait done the following year and by a third, less memorable, painting, now in Munich's Alte Pinakotek. Besides these, Goya painted several busts of María Teresa. One, in a private collection, shows her frontally posed, similar in style and technique to the group portrait. Both works delineate her lovely face against a dark background, although in the privately held portrait her hair is powdered and she wears a short, white silk cape edged in fur. A second version of the Prado painting exists, also in private hands and executed on canvas. It belonged to the estate of the infante's younger daughter, the duchess of San Fernando.

In the Prado portrait, Goya achieves, through his choice of surface material, enamel-like qualities. The alabaster of María Teresa's young, firm skin stands out against the nearly black backdrop. A simple diaphanous shawl, rendered in elongated white brushstrokes, makes her fine profile luminous. Her shining chestnut tresses are gathered up into braids, fastened at the back of the neck with a blue ribbon. The polished, perfectly executed technique, the surface employed, the gilded frame, and the glass used to cover and protect the painting according to provisions in the infante's will all refute the theory that this work was merely a preliminary study for something else.[1]

María Teresa "faces" her spouse, the infante, whom Goya painted on the same surface and also in profile, but looking right (private collection). The face-to-face positioning harks back to the medallions, reliefs, and stela of antiquity, a tradition revived in early Renaissance portraiture. Profiles played a significant role in the eighteenth century as well. An example of this is the silhouette, which reverses the color scheme of this painting, chiseling a black visage from a white background. The profile was important to theorists and students of physiognomy, intent on demonstrating a connection between physical appearance and personality. AR

NOTES
1. Gassier and Wilson 1971, no. 207; Arnaiz 1996, 26.

23

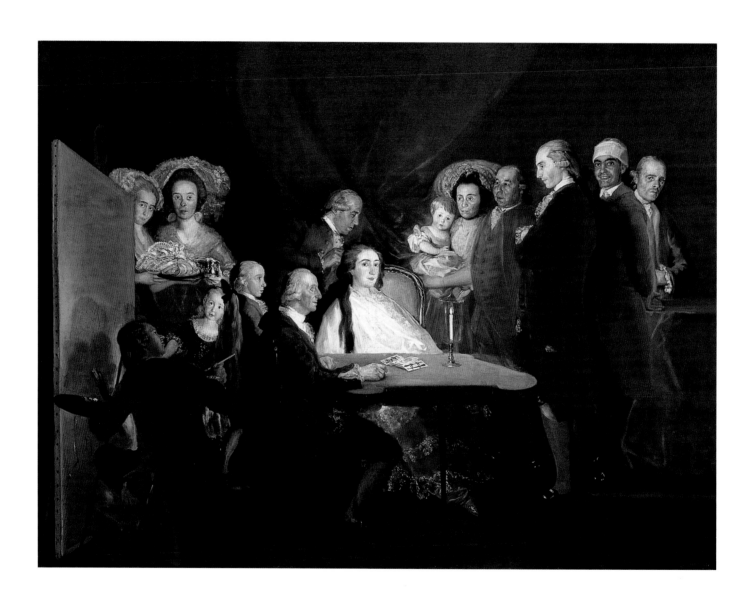

24. *The Family of the Infante Don Luis,* 1784

The edict of 23 March 1776 concerning "unequal marriages" was titled *La Pragmática Sanción* (The Pragmatic Sanction). With this decree, Charles III prohibited his nephews and nieces, the children of his brother Don Luis de Borbón, from bearing their father's name or displaying Bourbon symbols of rank; Don Luis' wife María Teresa de Vallabriga, being of relatively humble origin despite belonging to the Aragonese nobility, was barred from the court and from all other royal residences. Thus the family lived outside Madrid, first in their ancestral palace of Velada and later in their stately home at Arenas de San Pedro (Ávila), where the invited guests included various musicians and painters, among them Goya. It was at Arenas de San Pedro during the summers of 1783 and 1784, that the Aragonese master painted portraits of individual family members, starting with the infante, his wife, and their elder daughter María Teresa de Borbón y Vallabriga, later the countess of Chinchón (cats. 21 and 31). In the course of Goya's second visit Don Luis commissioned from him a work unusual in Spanish painting but very typical of the Flemish and English schools, of which the prince must have seen examples: a group portrait in which the painter would gather the entire family together with retainers in a kind of "conversation piece." Removed from the strictures of court protocol Goya could create a painting suffused with intimacy, combining the characteristics of genre scenes with the specifics of a dynastic portrait. It is night, probably after dinner, and the scene of the family gathering is lit by a solitary candle. Seated at a green table, the infante is ready to play cards—a symbol of chance in an era of ironclad determinism—while a hairdresser attends to his wife. The naturalness of María Teresa's bearing approaches that of her portrait in profile (cat. 23). In this group portrait she holds center place in the composition; she is unquestionably the core of both the portrait and the family. Her slightly melancholic gaze seeks out the observer, as if encouraging him to come closer and join the gathering. The couple's children have already done so: little María Luisa is in the arms of her nurse, and her older sister María Teresa stands on the left. Goya had painted María Teresa the year

Oil on canvas

248 x 330 cm

Fondazione Magnani-Rocca, Mamiano di Traversetolo, Parma

PROVENANCE: after 1784, family of the Infante Don Luis; 1904, prince Rúspoli, Florence, through his marriage to the infante's daughter; 1974, sold to Luigi Magnani for the Fondazione Magnani-Rocca.

EXHIBITIONS: Paris 1987, no. 94; Madrid, Boston, and New York 1988–1989, no. 5; Rome 2000, no. 9.

BIBLIOGRAPHY: Gudiol 1970, no. 151; Gassier and Wilson 1971, no. 208; Gassier 1979, 10–22; Arnaiz and Montero 1986, 44–55; Tomlinson 1989, 135–142; Arnaiz 1996, 19–35; Stoichita 1999, 219–244.

before, set against the nearby Gredos mountains (cat. 21), and had most likely gained the child's trust, for in the present canvas she peeks out, full of curiosity, to see how the painter's work is progressing. Goya also includes a self-portrait, as he would do again years later in *The Family of Charles IV* (cat. 32). The reference to Velázquez' *Las meniñas* is obvious; the painter is seen working before his easel, though here Goya sits on a stool. Luis María, the only son, stands in strict profile like his father, allowing Goya to display the physical resemblance and dynastic bond between Don Luis and his firstborn, who, were it not for Charles III's decree, would have been heir to the title and the remaining honors due his lineage. Servant girls look out from the background, proffering trays of accessories for María Teresa's hairstyle. A cluster of employees at the opposite end of the composition completes the nocturnal gathering: the infante's secretary and his butler, Don Manuel Moreno and Don Gregorio Ruiz de Arce, respectively; and an elegant gentleman placed in profile, like Don Luis and his son, sometimes thought to be the composer Luigi Boccherini, one of the infante's protégés. From the right-hand corner a man observes us with a touch of bitterness. He is perhaps Goya's colleague Alejandro de la Cruz, the court painter at Arenas de San Pedro. His gravity may be a consequence of his having failed, like Gregorio Ferro before him, in his efforts to paint the family. He appears to be astonished by the ease and genius with which Goya produces a portrait of so many distinct figures without repeating a single posture or expression. AR

25. *María Josefa de la Soledad, Duchess of Osuna, Countess of Benavente, 1785*

Oil on canvas

112 x 80 cm

Private collection

Madrid only

María Josefa de la Soledad Alonso-Pimentel y Téllez-Girón (1752−1834) was extraordinarily well educated from childhood. A highly cultured atmosphere pervaded the household of her grandfather, the duke of Huéscar. The duke kept a chamber orchestra under the direction of Manuel Canales, which played Haydn scores and concertos by Boccherini, the famed Italian composer who made his home in Spain. The duchess crowned her training and her cultural

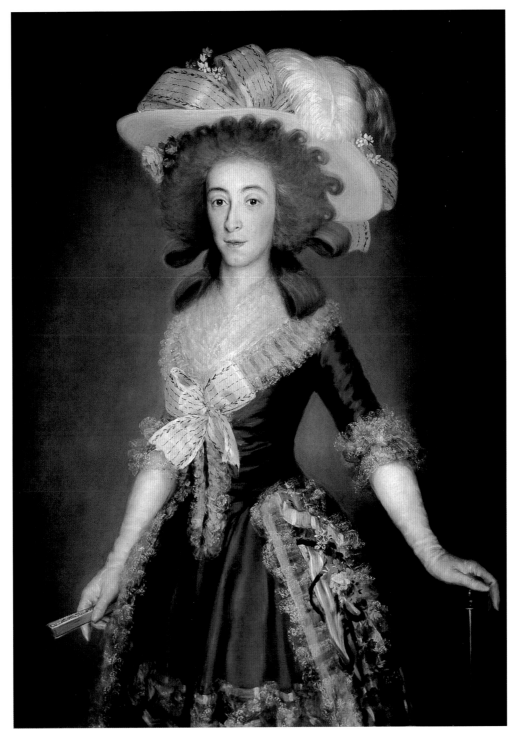

25

PROVENANCE: 1785, duke and duchess of Osuna, Madrid; 1896, sale, ducal house of Osuna, no. 64; Bauer collection, Madrid; Juan March Ordinas, by inheritance to the present owner.

EXHIBITIONS: Madrid 1896, no. 64; London 1901, no. 59; Madrid 1928, no. 14; Stockholm 1959–1960, no. 135; Paris and The Hague 1970, no. 5; Paris 1979, no. 4; Madrid 1983, no. 4; Brussels 1985, no. 4; Hamburg 1986, no. 264; Madrid, Boston, and New York 1988–1989, no. 6; Madrid 1996c, no. 5.

BIBLIOGRAPHY: Gudiol 1970, no. 165; Gassier and Wilson 1971, no. 220; Demerson 1971, 1; Williams Gwyn 1978, 97; Canellas López 1981, 432; Baticle 1992, 120–121; Morales 1994, no. 140.

aspirations with a stay in Paris in the years before the French Revolution. In 1771 she married the marquis de Peñafiel, who upon the death of his father, the duke of Osuna, inherited the family title. María Josefa belonged to the nation's highest aristocracy, bearing many titles: she was countess of Benavente, duchess of Béjar, Plasencia, Arcos de la Frontera, Mandas, and Gandia. She also bore the title of princess of Anglona and Esquilache, marchioness of Lombay and Jabalquinto, and countess of Mayorga.

But more significant than her noble descent was her lifelong devotion to preserving the arts. She developed friendships with the intellectual elite of her homeland, who frequented her Madrid palace and her resort estate, La Alameda, the walls of which were hung with numerous works by Goya, such as the "country scenes" (1787) and the series on witches and spells (1797–1798). She was in fact one of Goya's earliest clients and had already commissioned many paintings from him, beginning in the 1780s: the large family portrait (cat. 27), the present work, and its pendant, the duke's portrait, now in a private collection. Through her personal contacts she received permission from the Inquisition to read books forbidden by the Roman Catholic church, among them Rousseau and Voltaire, so that her palace quickly became the favorite meeting place of Madrid's intellectuals. There Ramón de la Cruz debuted his plays and Leandro Fernández Moratín was a constant guest. She concerned herself as well with her nation's financial affairs and was eventually admitted to the Economic Society of Madrid. When the organization formed a woman's division that worked for the advancement of the national welfare and progress, she became its president. As head of the Ladies' Council she rendered important services to education, industry, and charitable bodies, as well as organizing meetings dedicated to certain national problems: women's prisons, the condition of prisoners, social justice, and the improvement of hygiene among them. The duchess' contributions to the cultural world include her sponsorship of Meléndez Valdés and Isidro Máiquez. The former received from her a stipend; the latter she sent abroad to further his education.

During the second half of the century it became fashionable to imitate the dress and habits of the common people—a fashion endorsed by her great rival, the duchess of Alba—but the duchess of Osuna declined (except for her interest in bullfighting) to adopt this picturesque folklore. She was partial to refined French styles and inclined toward French attire, as is obvious in this three-quarter-length portrait. Here she wears the *dernier cri* of Paris. Goya accentuates the varied surfaces and tactile subtleties of the fabrics, the fine silks and the rustling laces that edge the sleeves, the neckline, and the side panels of the skirt. Goya describes very precisely the details of the remaining ornamentation: the rose-colored satin sash and the huge hat with its matching

ribbon and a large ostrich feather. Beneath the broad brim the duchess' elongated, fine features are surrounded by the curls of an elaborately powdered wig. The hairstyle is a variation by Brayeu, the duchess' French hairdresser, on the creations favored by Queen Marie Antoinette; the queen's spectacular style also inspired the duchess' clothing. She holds a fan in her right hand. In the left she holds the handle of a parasol, or perhaps a walking stick, or even the back of an armchair. By placing her arms slightly apart, Goya evokes the space around her body, silhouetted against a neutral background, touched with diffuse light. Her strikingly erect posture suggests the duchess' unusual and forceful personality. Lady Holland described her as "the most distinguished woman in Madrid for her talents, worthiness and taste."[1] AR

NOTES
1. Holland 1910, 195.

26. *The Marchioness of Pontejos,* 1786

In 1786 the twenty-four-year-old marchioness of Pontejos married José Moñino de Redondo, brother to the count of Floridablanca, then the prime minister of Charles III. Possessed of a generous dowry and ample income, Mariana de Pontejos de Sandoval embarked on marriage with absolute financial security, which nonetheless failed to ensure her happiness. She lost her children and suffered directly from political shifts affecting her husband's family. After Floridablanca's fall, her spouse found himself exiled to Murcia, where his wife followed him. The marchioness was widowed in 1808, at the start of the War of Independence, and married again; her second husband, a Sevillan noble named Fernando de Silva y Meneses, died in 1817, and his assets were impounded and sold during the reign of Joseph I. These reversals did not ruin Mariana financially, for she possessed a great fortune and became engaged eight months after being widowed for the second time. This time she chose a man of middle-class origins, twenty years her junior, Joaquín Vizcaino. He soon joined the national militia opposing Ferdinand VII, a position that in 1822 led to the couple's exile in Paris. The French police kept them and their political

Oil on canvas
210.3 x 127 cm
National Gallery of Art, Washington, Andrew W. Mellon Collection, 1937.1.85

PROVENANCE: family of the marquis and marchioness de Martorell y de Pontejos, Madrid; by inheritance to the collection of the marquis de Miraflores, Madrid; purchased by Andrew W. Mellon; National Gallery of Art, Washington.

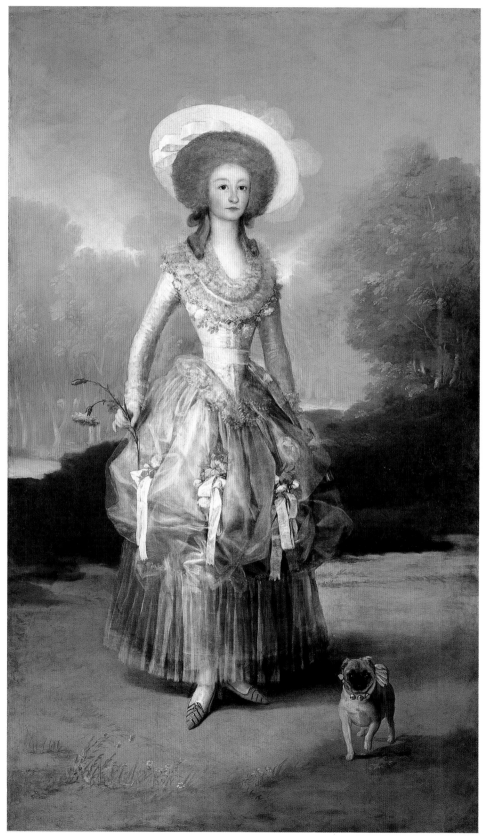

26

contacts under surveillance, and even remarked on the marchioness' supposed talent for intrigue, her eccentricities, and her savage stance against the clergy of her nation, to which she returned and where she died on 18 July 1834.

The French functionaries' view of her in no way fits the exquisite and fragile appearance of the woman Goya painted in 1786, probably on the occasion of her first engagement. But despite her youth and lack of experience, her arch and slightly disdainful posture indicates strength of character in keeping with her future political concerns and critical attitude toward the clergy. For the time being her role in Madrid society was limited to that of an upper-class lady, a fiancée or perhaps a new bride in a marriage of convenience, whose virtues the painter was obliged to emphasize. Goya portrays her full-length, as the incarnation of feminine fragility, stressing her elegance. In her right hand she holds a flower. Like her lap dog, the flower symbolizes fidelity, the most important virtue for a new wife. She wears a gray-toned gown, adorned with laces and flower sprigs fastened to the skirt with white satin ribbons. The skirt is composed of layers of transparent tulle. Her full wig is powdered the same color and crowned with a hat that surrounds her hairstyle with a faint yellow nimbus. Whitish ties emerge beneath the brim. She is surrounded by an expanse of lighter color, which is barely visible against the cloudy sky. Only the color of her roses, which enrich her attire, and the carnation, which she holds up with a graceful gesture, interrupt the monochrome of her dress. An elaborate landscape in gray-green completes the painting.

Goya often set his portrait subjects in a landscape, sometimes based on a real one, as in his portraits of María Teresa de Vallabriga (Galleria degli Uffizi, Florence) and her daughter María Teresa de Borbón y Vallabriga (cat. 21). At other times, as here, an idealized landscape offsets the sitter's personality. Portraits against a landscape belong to a long-established tradition, deeply rooted in French painting and above all in late eighteenth-century English portraiture. Portraits by Thomas Gainsborough and Sir Joshua Reynolds were of course widely known through engravings and etchings. In the royal collection itself Goya could see French precursors of this genre, such as painters to Philip IV like Jean Ranc, who had portrayed the royal family and relatives in front of a landscape. Among Goya's contemporaries we might mention Anton Raphael Mengs and his portrait of 1765 of the princess of Asturias, the future Queen María Luisa (Real Academia de Bellas Artes de San Fernando, Madrid). Here Goya fashioned an idyllic background more reminiscent of the "country subjects" seen in the paintings for the Osuna family's Alameda palace or the tapestry cartoons dating from the same period than of any realistic topography. The countryside serves merely to reflect the marchioness of Pontejos' personal qualities and to highlight her femininity. AR

EXHIBITIONS: Madrid 1900, no. 92; Madrid 1918, no. 20; Madrid 1928; Bordeaux, Madrid, and Paris 1979–1980, no. 14; Madrid, Boston, and New York 1989, no. 9; Madrid 1996c, no. 67.

BIBLIOGRAPHY: Gudiol 1970, no. 266; Gassier and Wilson 1971, no. 221; Camón Aznar 1980–1982, II, 47–48; Baticle 1992, 462; Morales 1994, no. 142.

27. *Family of the Duke and Duchess of Osuna,* 1787–1788

Oil on canvas

225 x 174 cm

Museo Nacional del Prado, Madrid, inv. 739

———————

PROVENANCE: dukes of Osuna; 6 June 1897, gift to the State from their descendants and accepted by royal order; 7 July 1900, enters the Museo Nacional del Prado; 1900, first mentioned in the museum's catalogue.

EXHIBITIONS: London 1963–1964, no. 68; Madrid, Boston, and New York 1988–1989, no. 17; Madrid 1996c, no. 73.

BIBLIOGRAPHY: Gudiol 1970, no. 292; Gassier and Wilson 1971, no. 278; Morales 1994, no. 191; Mena Marqués 2000, 207–210.

Devoid of any furnishings or decor to identify their social rank or surroundings, Goya portrays the family of one of his chief patrons against a neutral backdrop and with an austerity characteristic of Spanish art. The space is shaped solely by light and shadow evoked in the soft greenish-grays that predominate in Goya's work through the close of the century.

In this painting we see Maria Josefa de la Soledad, countess of Benavente, wife to the ninth duke of Osuna. She sits surrounded by her four children, holding Joaquina in a tender, maternal embrace. The older daughter, Josefa Manuela, is standing beside her father, who holds her hand. The two sons appear on the opposite side. Seated on a cushion is Pedro de Alcántara (later one of the first directors of the Prado) and, almost in profile, his older brother, Francisco de Borja, heir to their father's title. The affectionate poses of parents and children—the latter engaged in their games—show that the duke and duchess put into practice the new theories of pedagogy that arose during the Enlightenment and that emphasized the importance of such close parental ties. The depiction of the Osuna children indicates at the same time the difference in upbringing between boys and girls. The daughters wear white, gauzy dresses, simpler copies of their mother's. (The double row of buttons on their bodices are unpainted, unlike those of the duchess.) As if in preparation for their roles as high-ranking, sophisticated ladies, the girls carry little fans: even as small children they must learn to handle them with elegance and grace. The boys, in contrast, wear green suits and play with their toys. The younger pulls the cord of his toy coach while his elder brother rides on the baton of command belonging to his father, a lieutenant-general of the Royal Armies and colonel in the Regiment of the Royal Guards. The duke, as head of the family, is standing. Recent research shows that he wears, in accordance with royal regulations, "modified" mourning attire to commemorate the death of his own father in April 1787.[1] This dress code was obligatory after the first

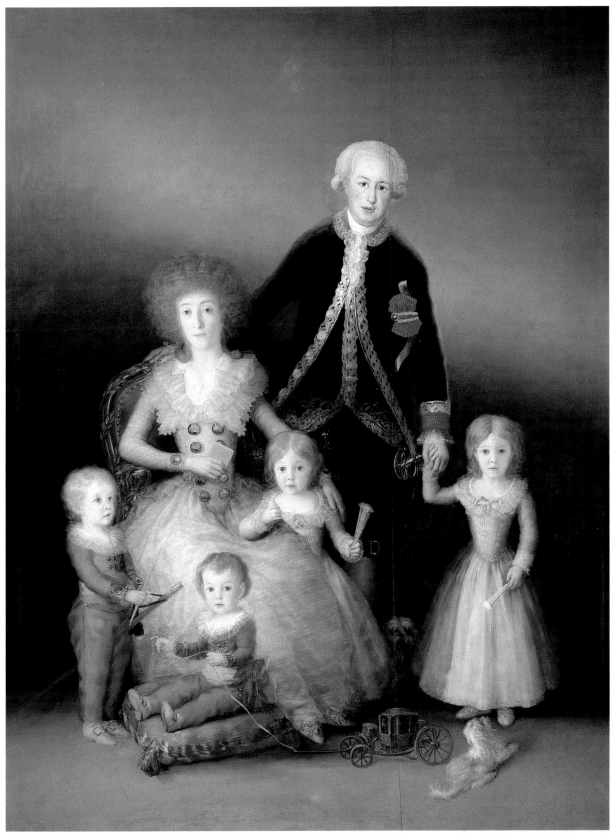

27

three months of "strict" mourning, information that helps date the painting more precisely, to between 1 July 1787 and 1 April 1788, his final day of mourning.

Although family portraiture as a genre barely existed in Spain, its lack proved no obstacle to Goya's skill in *The Family of the Infante Don Luis* (cat. 24) or to his genius in this painting. The Parma canvas owes something to the English tradition of "conversation pieces." The Osuna painting triumphs through its lack of anecdotal detail. Here the family members direct their attention to the painter, who successfully captures each individual's personality, including that of the small dog crouched in the shadow between the two little girls. Goya portrays everything: curiosity, both infantile and canine; the kindliness of the paterfamilias; and the intelligence in the eyes of the duchess.

Strikingly and soberly elegant, without makeup or jewels, the duchess is the very model of the Enlightenment Woman, possessed of her own aspirations, independent of her husband, open to and interested in new tendencies, whether cultural or financial. The duchess of Osuna was devoted to supporting scientists, artists, poets, musicians, and painters. She was the first female member of the Economic Society of Madrid and rose to be president of its Ladies' Council. When Goya was still an unknown painter, the duchess advanced him, commissioning assorted portraits and later on purchasing from him works he had undertaken on his own, such as the famous series on rustic subjects or the series on witchcraft, for her chamber in the Alameda. She also acquired four books of etchings from the Caprichos before they were offered for sale. In deference to all he owed her, Goya shows the duchess holding in her hand a letter, the established attribute of command. Thus her role in the family painting far exceeds that of wife and mother. AR

NOTES
1. Mena Marqués 2000, 208.

28. María Antonia Gonzaga, Marchioness of Villafranca, 1795

According to the 1801 *Gaceta* of Madrid, the marchioness of Villafranca was both charitable and competent: a woman able to manage, firmly and efficiently, the extensive interests and wealth of the house of Alba, to the management of which she was steadfastly committed after the death of her eldest son, José Álvarez de Toledo, husband to the thirteenth duchess of Alba.[1] During the mid-1790s Goya painted several major portraits for this family, among them one of the duke of Alba leaning over a table and studying a Haydn score (Museo Nacional del Prado, Madrid) and two of his wife, Cayetana, the duchess of Alba: one dressed in white (see p. 40, fig. 5) and another in black (see p. 41, fig. 6). These were full-length portraits, but María Antonia preferred something smaller and asked the painter to depict her in half-length. Goya may have undertaken this project during one of his visits to the Liria palace, when Cayetana allowed him to work on the genre scenes with "La Beata" (cats. 50 and 51).

María Antonia is shown close up, seated against a neutral background. To escape the rigidity common in frontal portraiture, Goya has her slightly angled toward the back. The austerity of the painting, in which there is no sign of the sitter's rank or profession, is typical of Goya's intimate portraits. He created them for his friends and colleagues—he was concerned only with the personality of the subject.

The result is an astonishingly convincing image of the lady's inner nature. Her fixed gaze and her slightly raised right eyebrow betray her strong character and great authority, an authority underscored further by the serenity with which she holds the fan and sits unsupported, her delicate torso not touching the back of her armchair, in a majestic, erect posture suggesting nobility. Goya's chosen tones make the painting an elegant symphony in grays, interrupted by passages of blue. The dark, shimmering dress and diaphanous shawl reflecting gray light, and the soft powdered hair that scarcely contrasts with

Oil on canvas

87 x 72 cm

Museo Nacional del Prado, Madrid, inv. 2447

PROVENANCE: bequest to the Museo Nacional del Prado, Madrid, by Alonso Álvarez de Toledo, XXI count of Niebla and XV marquis of Vélea; until 1926, usufruct his widow; 1926, Museo Nacional del Prado.

EXHIBITIONS: Geneva 1939, no. 19; Belgrade 1981, no. 17; Madrid 1996c, no. 88.

BIBLIOGRAPHY: Gudiol 1970, no. 444; Gassier and Wilson 1971, no. 348; Glendinning 1992, 121–122; Morales 1994, no. 254; Mena Marqués 2000, 210–212.

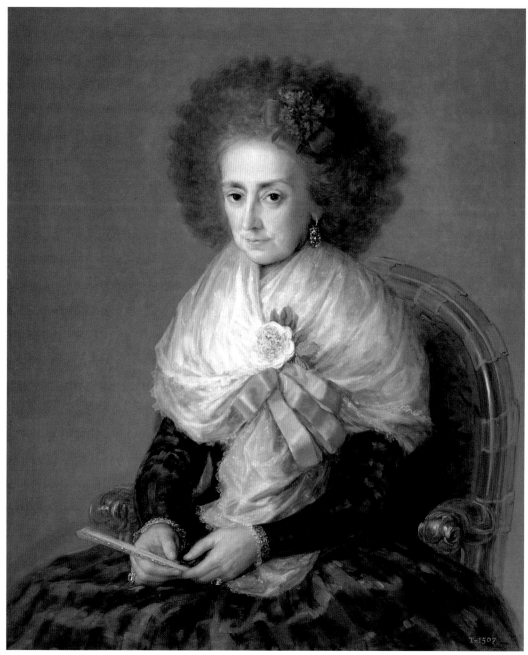

28

the still lighter background integrate completely Goya's gray palette. The sole focus of color is provided by the beautiful rose pinned to the white translucent shawl and the blue ribbons that fasten the shawl on María Antonia's breast, together creating the sense of a small bouquet. This conceit is repeated in the artificial flower of the tiara restraining the smooth, thick hair. Her face is rendered with great precision: above the unrouged lips the shadow of fine hairs is visible. Rings and a pendant complete the refined ensemble, as far removed as possible from the ostentatious and overladen finery displayed by the elderly Infanta María Josefa in Goya's monumental *Family of Charles IV* (cat. 32). AR

NOTES
1. Glendinning 1992, 121–122.

29. *Queen María Luisa in a Mantilla,* 1799

On 24 September 1799 the sovereign wrote to Godoy, from San Ildefonso: "Goya is painting me in mantilla, full-length; they say it's turning out very well." Satisfied with the result, María Luisa, in a letter composed several days later, insists that her "Friend Manuel" possess a copy by one of Goya's assistants (now Museo Nacional del Prado, Madrid). "I want you to have another copy made by Estevez of the mantilla painting and the one on horseback so that you always have Marcial alive and right beside you."[1] The queen's correspondence with her favorite alludes to the works that ultimately gained Goya his appointment as first painter to the king: the present work and the pendants *Charles IV in Hunting Dress* (Palacio Real, Madrid) and *Queen María Luisa on Horseback* (Museo Nacional del Prado, Madrid), in which she appears riding her horse Marcial, a gift from Godoy. These works form part of a series of royal portraits completed by Goya between 1799 and 1801, commissioned to replace the official portraits of 1789, the year that they ascended the throne.

Goya places the queen in front of a country landscape. The geometric shapes of the middle ground suggest the gardens of La Granja and the background trees recall the woods bordering San Ildefonso, where the painting was

Oil on canvas
208 x 130 cm
Palacio Real, Madrid
Madrid only

———————

PROVENANCE: since 1799, Palacio Nuevo, Madrid.

EXHIBITIONS: Madrid 1928, no. 37; Madrid 1946, no. 195; Brussels 1985, no. 18; Paris 1987–1988, no. 98; Madrid, Boston, and New York 1988–1989, no. 33; Madrid 1992, no. 2.

BIBLIOGRAPHY: Gudiol 1970, no. 419; Gassier and Wilson 1971, no. 775; Tomlinson 1993, 81–83; Morales 1994, no. 301; Herranz Rodríguez 1996, 257; Morales 1997, no. 29.

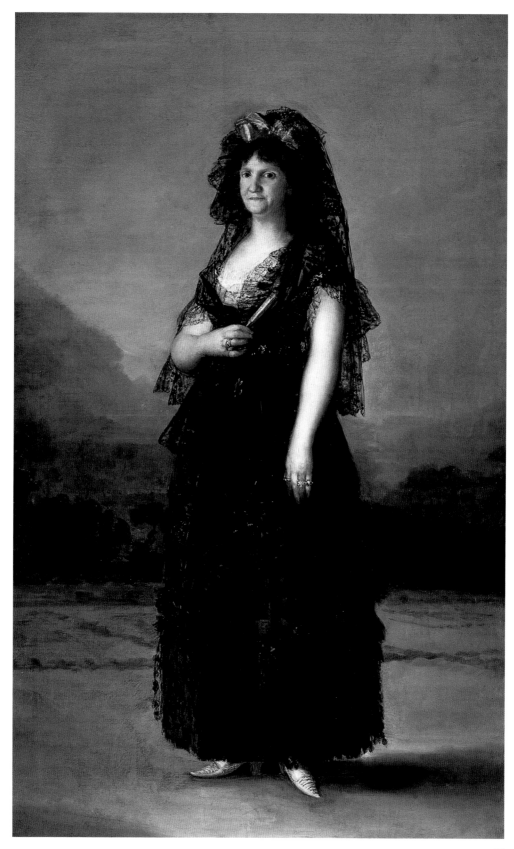

29

done. In contrast to her portrait of 1789, the queen has abandoned her French fashions and wears a gown based on a luxurious—and traditionally Spanish— *basquiña* and mantilla. The underskirt functions as a dark layer on top of which figure extensive passementerie and lace. Her head is covered with a black lace mantilla, flung back to reveal the satin ribbon in her hair. María Luisa is not wearing gloves. According to the duchess of Abrantes, the queen forbade gloves at court, preferring to expose her arms, of which she was quite proud. To display the queen's arms to their best advantage, Goya paints them well rounded and pearly, emphasizing the flawless whiteness of her skin against the black fabric of the *basquiña*.

For the compositional scheme, Goya reproduces his 1797 portrait of the duchess of Alba, where Cayetana appears in Spanish dress (see p. 41, fig. 6) and in the guise of a landowner posed before the landscape surrounding her palace at Sanlúcar de Barrameda (Cádiz). In this portrait, however, the queen's dress is even more solemn than that of the duchess, respecting the royal decree of 16 March 1799, which authorized only black greatcoats and prohibited all gold or silver adornments. Flashy displays of luxurious clothing during the 1799 Holy Week procession had provoked the fury of the populace, who saw in this lapse in gravity and propriety an offense to religion. Tomlinson calls the queen's dress the "epitome of Spanish dignity"; it satisfies the decency requirements of the new legislation.[2] This thesis contradicts Sambricio's belief that the queen's attire represents a frivolous display, typical of urban-class majo fashions.[3] Despite the grave austerity of its black color, the royal outfit is far from humble—and not only because of the slippers ornamented by the forbidden gold and silver thread. Lush fabrics and copious lace were needed for the *basquiña;* they were obtained by costly importation, which further worsened the financial state of the nation. For just such reasons did Juan Antonio Meléndez Váldez so crudely condemn, in his *Discursos forenses (Foreign Discourses),* the scandalous waste at court, where the aristocracy thought nothing of spending thousands of *reales* on a *basquiña* and a mantilla while the common people were besieged by poverty and hunger. A R

NOTES
1. Pereyra 1935, 233, 237.
2. Tomlinson 1992, 81–82.
3. Sambricio 1957, 92.

30. *Queen María Luisa in Court Dress, 1800–1801*

Oil on canvas

210 x 130 cm

Palacio Real, Madrid

Madrid only

———————

PROVENANCE: since 1800–1801, Palacio Real, Madrid.

EXHIBITIONS: Madrid 1946, no. 213; Madrid 1992, no. 4; Madrid 1996c, no. 39; Rome 2000, no. 23.

BIBLIOGRAPHY: Gudiol 1970, no. 414; Gassier and Wilson 1971, no. 781; Morales 1994, no. 305; Morales 1997, no. 41.

After *The Family of Charles IV* (cat. 32) Goya returned to individual portraits of the monarchs, like this one, *Queen María Luisa in Court Dress,* the companion piece to *Charles IV in the Uniform of Corporal of the Guards* (also Palacio Real, Madrid). From the stance of the models we can relate these works to the group portrait, but to render them autonomous Goya introduces slight changes of posture and pose. In the family portrait the queen shelters her daughter under her right arm while holding in her left the hand of the young Prince Francisco Paula. In this painting, however, her arms are crossed at the waist and she holds a fan. As noted recently by Mena Marqués, the spatial sense of the canvas is clearly related to that in *The Countess of Chinchón* (cat. 31), which was painted shortly before *The Family of Charles IV.*[1] Goya places the queen, as he did the countess, in a narrow, vertical format within a large empty space and surrounded by shadow, inside of which her image stands out, strongly illuminated. In the countess' portrait this ambiguous space heightens the sense of the lady's isolation, as well as her fragility; in the royal portrait, the space functions as an apt milieu for stressing the queen's majestic bearing: she confronts the observer directly, face to face.

The queen's taste for luxury are reflected in all of the portraits Goya painted of her; the style of her attire varies. Goya portrayed the queen wearing a black mantilla (cat. 29), in a riding habit in her equestrian portrait (Museo Nacional del Prado, Madrid), and in a simple Empire gown in the family portrait. Her ceremonial dress in this portrait is of French derivation. It was most likely a gift from Napoleon, who, after reestablishing relations with the Spanish royal house, made her many such gifts of sumptuous gowns designed by the famous Parisian designer Madame Nanette. The elegant dress is made of fine organdy, with elaborate gold and silver trim at the hem. A gray veil covers the dress, like an overskirt, from the corners of which hang charming tassels. The exotic turban on her head, with its white feather, completes the ensemble. The queen also displays the major royal insignia: the sash of the order of María Luisa, which she herself created, and the emblem of the Starry Cross. Gold

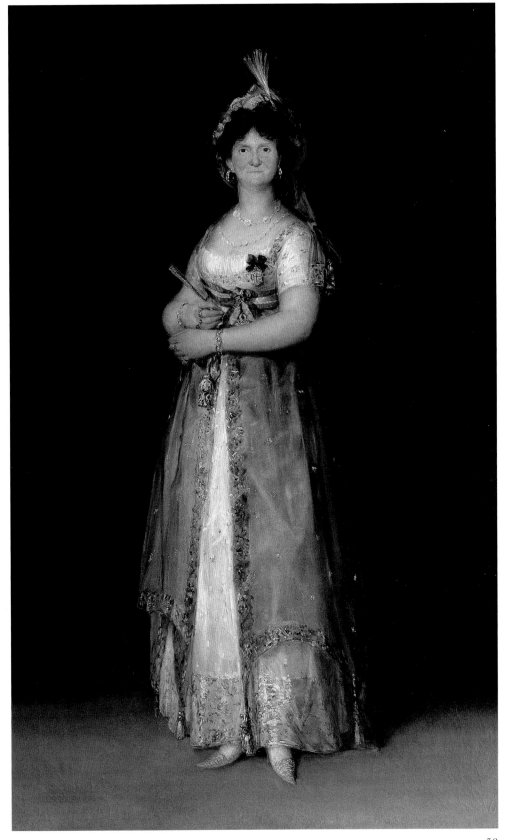

30

rings and precious stones adorn her arms and fingers; heavy pearl necklaces are fastened around her neck.

The painting was possibly intended for shipment to Paris, together with its pendant; diplomatic relations with France had been restored after the French Revolution. In exchange, Charles IV ordered his Prime Minister, Mariano Luis de Urquijo, to commission from Jacques-Louis David, through the Spanish Ambassador in Paris, a portrait of the French sovereign. This impressive equestrian portrait, *Napoleon Crossing the Alps* (Château de Malmaison), reached Spain in July 1802. The paintings of the Bourbon monarchs were ready for shipment on 30 June 1801, but the exchange was halted by the deteriorating relations between the countries after the so-called "War of the Oranges" The portrait of Bonaparte was returned to its homeland; Goya's paintings remained in Madrid. AR

NOTES
1. Mena Marqués in Rome 2000, 84.

31. *The Countess of Chinchón, 1800*

Oil on canvas
226 x 144 cm
Museo Nacional del Prado,
Madrid, inv. 7767
Madrid only

PROVENANCE: 1800, Manuel Godoy; by direct descent to the dukes of Sueca and siblings; by right of redemption acquired by the State in January 2000.

"There exist few souls so pathetic and indifferent," wrote Manuel Godoy to Queen María Luisa.[1] He was describing his wife, the countess of Chinchón, whom Goya portrayed as the height of sensitivity, refinement, and tenderness. That Godoy did not marry for love is well known. His choice was by order of the monarchs, who wanted to forge an alliance between their favorite, all-powerful minister and the house of Bourbon. The bride selected was María Teresa de Borbón y Vallabriga, offspring of the morganatic marriage between the Infante Don Luis, brother to Charles III, and María Teresa de Vallabriga, scion of Aragonese nobility. The sitter for this painting was born on 26 November 1780 in the Velada palace, because her parents were not permitted to reside at court. On Don Luis' death in 1785, the king sent María Teresa and her siblings, María Luisa and Luis María, to the convent of San Clemente de Toledo, where they passed the remainder of their childhood estranged from

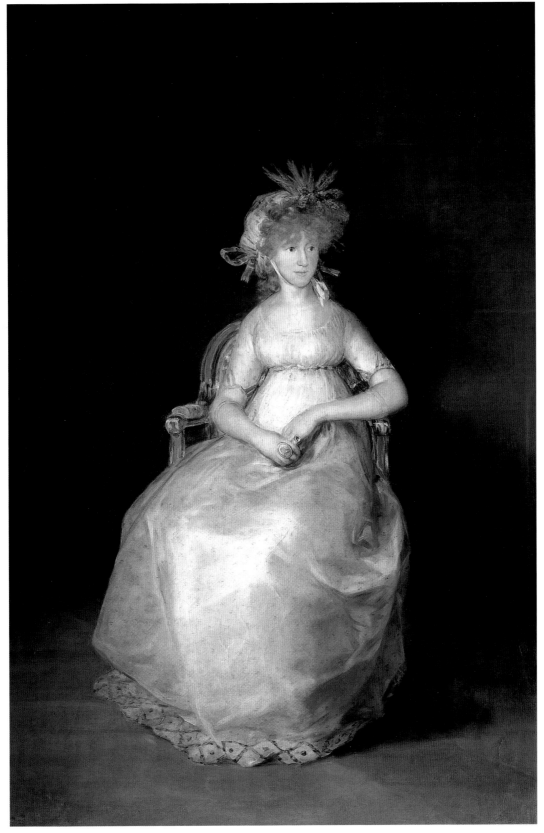

EXHIBITIONS: Madrid 1928, no. 19; Geneva 1939, no. 20; Madrid 1946, no. 13; Madrid 1961, no. XV; London 1963–1964, no. 87; Paris and The Hague 1970, no. 29; Madrid 1983, no. 30; Lugano 1986, no. 31; Washington 1986–1987; London 1987; Madrid, Boston, and New York 1988–1989, no. 63; Saragossa 1992, no. 37; Madrid 1992, no. 9; Stockholm 1994, no. 22; Madrid 1996c, no. 104; Rome 2000, no. 22.

BIBLIOGRAPHY: Gudiol 1970, no. 425; Gassier and Wilson 1971, no. 793; Glendinning 1982, 39, 299; Glendinning 1992, no. 9; Baticle 1992, 264; Morales 1994, no. 307; Tomlinson 1994, 156; Ruspoli 2000; Mena Marqués 2000, 199–202.

their mother. This separation, along with the humiliating consequences of the marital decree promulgated on the occasion of their parents' union, came to an end in 1797. María Teresa accepted Godoy's proposal of marriage, thereby liberating herself from the cloister, and her family recovered its lost rights.

In April 1800 the minister commissioned from Goya a portrait of his wife. At the time she bore the title of marchioness of Boadilla del Monte. She became countess of Chinchón three years after the painting was completed, when her brother Luis María was named cardinal and yielded his title to her. Goya had known María Teresa since she was a child and had painted her twice during the summers of 1783 and 1784. Invited to Arenas de San Pedro, he carried out the monumental portrait entitled *The Family of the Infante Don Luis* (cat. 24), in which little María Teresa is shown behind her brother. The next year he painted her full-length against a landscape of Gredos (cat. 21). Sixteen years later Goya once again encountered his patrons' daughter, now a married woman, pregnant with Carlota, who was born in September 1800 and whose godmother was Queen María Luisa herself. The outcome of this reunion was a portrait of astounding simplicity, often considered his quintessential female portrait. Goya displays his technical and expressive genius through an iconography precisely suited to the countess' personality.

As is characteristic of all Goya's portraiture from this period, the painter placed María Teresa before a dark, neutral background. She sits slightly sideways in a gilded armchair. Attention focuses on this delicate and timid young woman, who looks to the right, evading eye contact with the observer. To balance the movement of her head the painter angled her legs toward the left, giving her body a slight rhythmic twist. She wears an elegant chemise, a high-waisted French style. The cut meant freedom for the woman's body; it dispensed with the confining bodice and must have been far more comfortable in pregnancy. The countess' fashionable gown is organza, trimmed at the bust with white and blue ribbon, a pattern repeated on the borders of her sleeves, on her skirt, and in the netting on her hair. This net contains the heavy, light red ringlets that so irritated her husband. Godoy remarked to the queen in December 1806 that "one cannot even see her face for the forest of hair that covers her eyes, it must be the fashion, or maybe she likes it that way, and I don't want to give her a hard time by telling her that I do not."[2] Sheaves of wheat adorn her hairstyle, possibly a token of imminent motherhood. María Teresa's pregnancy is disguised by the fullness of her dress and by her hands, entwined on her lap as if to hide the physical evidence of her condition. On her little finger she wears a ring with the miniature of a gentleman, assumed to be

a likeness of her husband. Portraits of married couples were routinely based on the conventions of court portraiture, which often featured miniatures of the king on cameos and brooches. AR

NOTES
1. Ruspolí 2000, 131 n.5.
2. Ruspolí 2000, 138.

32. *The Family of Charles IV,* 1800

"The King says that as soon as Goya is done with your wife's portrait he is to come here and do one of all of us together," wrote Queen María Luisa in a letter dated 22 April 1800 and sent from Aranjuez to Manuel Godoy, whose wife, the future countess of Chinchón, Goya was painting at the time.¹ And indeed, the newly appointed first painter to the king received a commission to immortalize the king's family on an enormous canvas. Toward the end of June he therefore repaired to the royal residence of Aranjuez to carry out ten portraits of family members. Back in his Madrid studio Goya assembled the heads as though they were pieces of a puzzle, respecting each one's dynastic rank. The subjects seem conscious of being painted; they pose speechless and motionless before a smooth wall, as if in a frieze, its axis Queen María Luisa. Yet Goya forces his frieze to curve, placing King Charles IV and his successor, the prince of Asturias, in front of the others and filling in the outer corners with the other relatives. Goya includes himself, discreetly, as well, in an obvious allusion to *Las meniñas* with its self-portrait of Velázquez at his easel. Goya's spatial concept is simpler and more austere than that of the Sevillan master; it lacks the symbols of opulence characteristic of French, Italian, or English royal portraits—the immense columns and drapes depicted, for instance, in Louis-Michel van Loo's *Family of Philip V* (Museo Nacional del Prado, Madrid). This austerity in the presentation of space brings to mind Goya's other family portraits, such as *The Family of the Infante Don Luis* (cat. 24) and *The Family of the Duke and Duchess of Osuna* (cat. 27), where the figures likewise appear in a blank space, devoid of palatial ornamentation. Like

Oil on canvas
280 x 336 cm
Museo Nacional del Prado,
Madrid, inv. 726
Madrid only

PROVENANCE: Colección Real; 1814, Madrid, Palacio Nuevo; 1834, Museo Nacional del Prado (Gabinete de Descanso); 1872, first mentioned in the museum's catalogue.

EXHIBITIONS: Geneva 1939, no. 9; Madrid 1996c, no. 110.

BIBLIOGRAPHY: Gudiol 1970, 118, 149–150, no. 434; Gassier and Wilson 1971, no. 783; Licht 1979 (1983), 67–82; Tomlinson 1992 (1993), 79–97; Traeger 1990, 147–181; Baticle 1992, 266–267; Morales 1994, no. 316; Mena Marqués 2000, 235–240.

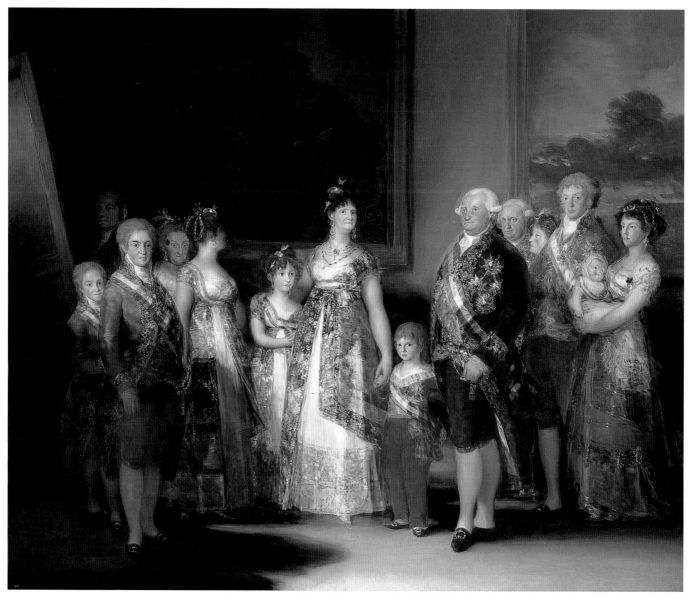

32

Margarita of Austria in Velázquez' painting, or María Teresa Vallabriga and the duchess of Osuna in the above-mentioned portraits, María Luisa occupies the center of this composition, compelling the viewer's gaze through her luxurious trappings and her splendid Empire gown, cut on a pattern used exclusively for her and her daughters in 1796. (The design is still on file in the Royal Archives.)

In the painting two others wear this gown: the Infanta María Isabel, in her mother's protective embrace, and the unknown woman on the left who averts her face. This mysterious personage was earlier thought to be the future Fernando VII's fiancée, but Salas has shown that in the year 1800 the prince's marriage was not yet planned. She may be Carlota Joaquina, the firstborn daughter, queen of Portugal, who was not present when the portrait was painted. The Infanta María Luisa Josefina, accompanied by her husband, Luis de Borbón, is also stylishly dressed, but with less elaborate finery. All the female relatives wear the queen's sash and ornaments perhaps created by the court jeweler, Leonard Chopinot. Arrow-shaped hairpins decorate almost all their coiffures, even that of the woman seen in profile in front of Antonio Pascual, the king's brother, who is possibly his wife.

Thanks to the recent restoration, we can more clearly appreciate the tonal qualities that establish the role of each person within the family hierarchy, singling out the figure of the king, whose head is placed against a light background, and the heads of the queen and the heir apparent, set against a darker one.

Goya adjusts his technique to the demands of the painting's enormous size. He applies color with sweeping brushstrokes and repeated splashes, which suggests that the work was to be displayed in one of the great halls of the palace. From a distance the flourishes of color and the abstract shapes converge into the various textures: tulles and silks, shimmering ribbons, sashes, and gems. The painter displays extraordinary skill in depicting skin tones, in the hair and its dressing, which range in hue from the yellow of Antonio Pascual's hairpiece to the powdered gray hair of the prince of Austria to the king's impeccable white wig.

Goya is generally thought to have intended this painting as a critique of the royal family. The queen stands at the center not because she was rumored to be the real power behind matters of state, but because this would be her place in any European family portrait: women occupied the center, flanked by husband and children. Goya employed the same arrangement in other canvases. Nor is the somewhat paralyzed physiognomy of the sitters a veiled caricature. It is simply the result of the huge painting's not being drawn from life but rather assembled from studies. The final version, if anything, plays down excessively

realistic details: comparing the early sketch of the elderly Infanta María Josefa (Museo Nacional del Prado, Madrid) with the final product, we see that Goya has tempered her vanity, concealing her face in the shadows of the background. AR

NOTES

1. Pereyra 1935, 284.

33. *Thérèse-Louise de Sureda*, c. 1803/1804

Oil on canvas

119.7 x 79.4 cm

National Gallery of Art, Washington, Gift of Mr. and Mrs. P.H.B. Frelinghuysen in memory of her father and mother, Mr. and Mrs. H. O. Havemeyer, 1942.3.1

PROVENANCE: Pedro Escat (?) collection, Palma de Mallorca; until 1907, Sureda family, Madrid; Louisine Havemeyer, New York; by descent to her daughter, Adeline Havemeyer Frelinghuysen, Morristown, New Jersey; 1941, gift to the National Gallery of Art, Washington.

EXHIBITIONS: New York 1915, no. 10; New York 1936, no. 9; Washington 1986–1987; Madrid 1996c, no. 123.

BIBLIOGRAPHY: Gudiol 1970, no. 534; Gassier and Wilson 1971, no. 814; Salas 1979, no. 102; Camón 1980–1982, III, 159; Brown and Mann 1990, 16; Morales 1994, no. 342; Tomlinson 1994, 170–173.

The woman in this painting is the wife of Bartolomé Sureda, a talented, well-trained draftsman who became the director of a number of production works, among them the Royal Porcelain Factory of Buen Retiro and the Crystal Works of La Granja. Thérèse-Louise Chapronde Saint-Armand was born in France. Some commentators theorize that the she met Sureda through Abraham-Louis Bréguet, the renowned watchmaker and inventor of scientific instruments, who was friendly with her before her marriage and who had connections with her protector, Agustín de Bethancourt.[1] Thérèse-Louise and her husband formed part of Goya's circle of acquaintances, and he portrayed the couple in paired canvases, each of which displays a different compositional scheme. Sureda is shown standing, leaning informally against a pedestal. Thérèse-Louise, seen almost in profile, is seated, rigidly erect, her back not touching the back of her chair. As is typical of female portraiture of the period, Goya's image of Thérèse-Louise, unlike that of her spouse, stresses her serenity. The composition, attire, and chair attest to the young woman's taste for French fashion and the imperial style. The furniture is elegant; on the lower section of the arm the exotic detail of the sphinx is clearly visible, a popular design after Napoleon's Egyptian campaign. The decoration on the chair is completed by the gold inlay that lines the wood, balancing the yellow damask tapestry. Through the armchair, angled inward and almost sideways, Goya organizes the space surrounding his model. Thérèse-Louise is thus forced to turn her torso to show her face, a movement that adds a sense of spontaneity to the painting. Goya seats her in strict profile, letting the lines of the chair

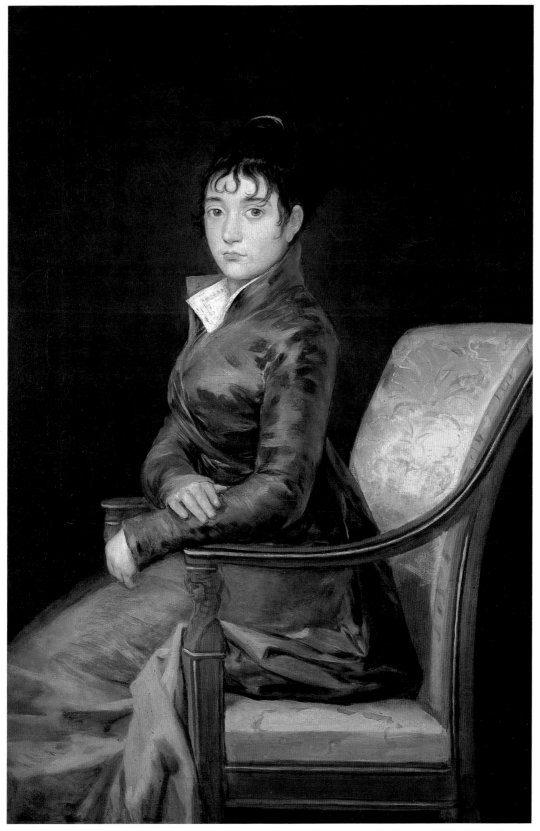

33

practically brush against the lower and right-hand edges of the canvas. He had used this device in 1792, when he painted his friend Sebastián Martínez in a private setting, as suggested by his simple rattan chair and relaxed posture (Metropolitan Museum of Art, New York). Thérèse-Louise's chair has become a kind of throne, supporting its delicate subject, who wears a simple blue gown. As was the style during the First Directory, her outfit has no ornamentation other than the bustle, the folds of which fall gracefully from the chair. Her gown closes without any lapel, crossing over her chest, and the white shirt collar emerges as a subtle opening. This high collar emphasizes the slightly static quality of her raised head; it centers the viewer's attention on Thérèse-Louise's youthful face. Her fine pink cheeks, the candor of her somewhat constrained expression, and her small, cushion-like mouth, indicate a child's facial expression, not what she strives to be—an Enlightenment society lady. Her elegant hair, shining and black, is pulled back and fastened in a bun; her face is framed with small bangs, stylized curls that fall almost symmetrically over her forehead. Far removed from the old wigs, the gray powder, the complex accessories of plumes, laces, and spectacular combs that were so greatly in vogue throughout the eighteenth century, this hairstyle is finished with a modest gilded hairpin, insinuated by one yellow brushstroke at the top, much like the one seen in the hair of the marchioness of Villafranca as she paints her husband (cat. 35). AR

NOTES

1. Brown and Mann 1990, 16.

34. *Josefa Castilla Portugal de Garcini y Wanasbrok*, 1804

Oil on canvas

104.1 x 82.2 cm

The Metropolitan Museum of Art, New York, Bequest of Harry Payne Bingham, 55.145.2

This painting is generally considered the pendant to the portrait of the sitter's husband, Ignacio Garcini y Queralt, also in the collection of the Metropolitan Museum of Art (fig. 1). However, the compositions pose the question whether they were in fact intended to be seen side by side. Their dress is not compatible: Ignacio—a colonel in the regiment of engineers—is shown in full uniform (the Cross of the Order of Santiago was added after his admission to the order

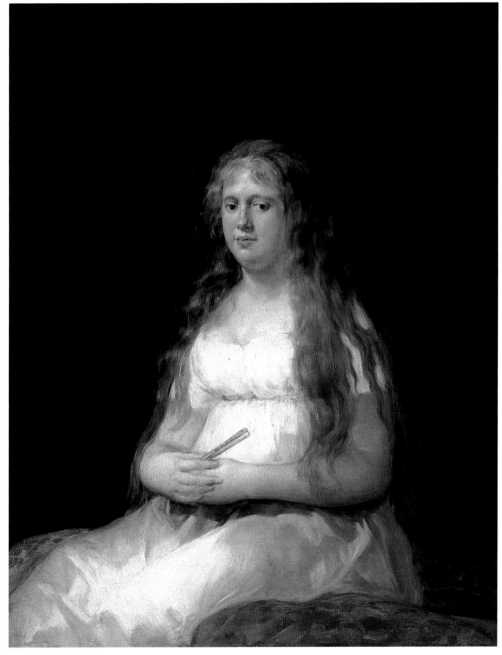

34

PROVENANCE: Vicente Garcini, Madrid; Harry Payne Bingham, New York, by 1920; The Metropolitan Museum of Art, New York, Bequest of Harry Payne Bingham, 1955

EXHIBITIONS: Madrid 1992, no. 68; New York 1995, fig. 12.

BIBLIOGRAPHY: Gudiol 1970, no. 492; Gassier and Wilson 1971, no. 821; Madrid 1991, 23–36; Morales 1994, no. 338; Tomlinson 1994, 169–170; Fernández 1996, 104.

in 1806), whereas his wife is shown in a chemise. Moreover, both sitters face left instead of one another, which is a more common formula for pendants of husband and wife, as seen, for example, in Goya's pendants of Charles IV and his consort, María Luisa.

The portrait of Josefa is far more interesting than the formulaic likeness of her husband. Her reddish blond hair and flushed complexion, presumably attributable to her Flemish ancestry, forced Goya to work in a palette uncommon in his works; it seems indebted to the paintings by Peter Paul Rubens he would have seen in the royal collection. She appears to be pregnant—a state that would justify her dress, which is more suitable for confinement than for a formal portrait. Although elsewhere I commented—perhaps too hastily—on the sitter's seeming lack of intelligence, it now seems to me that this impression results from the natural asymmetry of her face, which gives her a somewhat distracted look.[1] Nor is the sitter's appearance helped by the fact that her left arm has suffered from abrasion: loss of the uppermost layer of paint has resulted in its awkward appearance. JT

NOTES
1. Tomlinson 1994, 170.

Fig. 1 Francisco Goya, *Ignacio Garcini y Queralt,* 1804, oil on canvas, Metropolitan Museum of Art, New York, Bequest of Harry Payne Bingham, 1955.

35. *The Marchioness of Villafranca Painting Her Husband*, 1804

Portraits of painters frequently include a female figure representing the artist's muse. If this figure is herself holding the brush, then she is an allegory of painting. Cesare Ripa stipulates these meanings in his book of symbols, the accepted authority on such matters until the eighteenth century.[1] With the dawn of the Enlightenment, though, portraits of real women in the act of painting became more common. Little by little women entered painting schools, and María Tomasa Palafox, portrayed here, was one of them. The marchioness of Villafranca sits in front of a canvas painting her husband, Francisco de Borja Álvarez de Toledo, marquis of Villafranca. Born in 1780, the daughter of the countess of Montijo, María Tomasa was an honorary member of the Real Academia de Bellas Artes de San Fernando. She shared her artistic aspirations with her brother, the count of Teba, a distinguished academic and also an honorary member of the Academy.

French women painters portray themselves in self-portraits as teachers, with their disciples, or else as engaged in history painting, the genre regarded as most challenging in the academic hierarchy. Goya presents the marchioness at home painting her husband, a subject which, along with still lifes, floral displays, miniatures, and copies after the old masters, constituted the themes most often undertaken by women admitted to the Academy.

The Marchioness of Villafranca Painting Her Husband, which Goya exhibited in 1805 at the Academy, has little in common with the portrait of his brother-in-law Francisco Bayeu (Museo Nacional del Prado, Madrid), exhibited in the same institution in 1795. Bayeu, one of the most famous painters of his day, appears paintbrush in hand, sole and sufficient emblem of his profession. The marchioness, by contrast, surrounded by the tools of the trade, sits in a huge armchair, her feet resting comfortably on a cushion. She is looking at her husband, who poses for her outside the confines of the canvas, and whom Goya paints as a portrait within the portrait. Yet her gaze lacks the intensity of

Oil on canvas
195 x 126 cm
Museo Nacional del Prado,
Madrid, inv. 2448

Inscribed on the palette: DNA
MARIA PALFOX

PROVENANCE: bequeathed to the Museo Nacional del Prado by Alonso Alvarez de Toledo, XXI count of Niebla and marquis de los Vélez; until 1926, usufruct his widow; 1926, Museo Nacional del Prado, Madrid.

EXHIBITIONS: Madrid 1805; London 1972, no. 115; Madrid 1992, no. 28; Madrid 1996c, no. 120; Saragossa 1996a, no. 48; Rome 2000, no. 24.

BIBLIOGRAPHY: Gudiol 1970, no. 490; Gassier and Wilson 1971, no. 810; Glendinning 1992, 124; Morales 1994, no. 334.

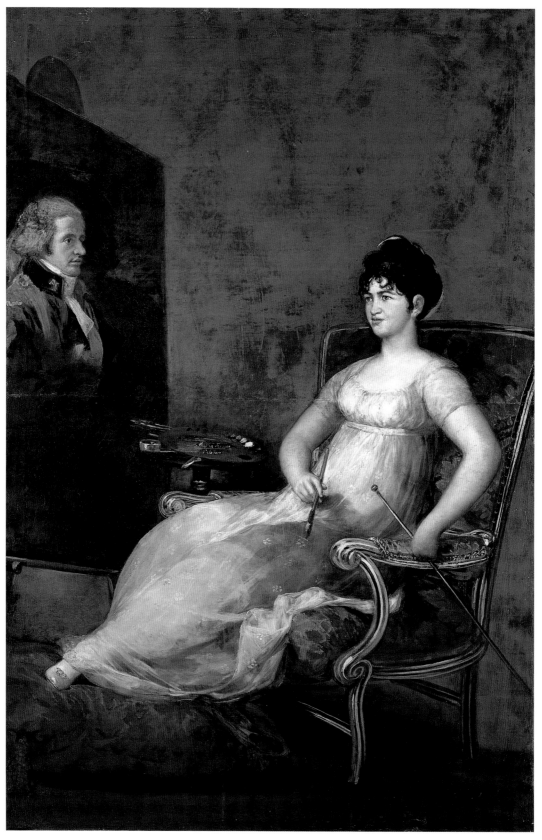

35

"real" painters, the intensity Goya conveys in the Bayeu portrait or in his own self-portraits, where the eyes seem to be hard at work, fixed on the object of their attention. Everything suggests that the Aragonese master had no wish to paint a painter, but merely another proud lady of rank who enjoyed assuming a role in the privacy of her study. AR

NOTES
1. Ripa 1698, 515–516.

36. *Isabel de Porcel,* before 1805

The sitter in this portrait is identified in a modern inscription on the back of the canvas used to reline the painting during the late nineteenth century: she is Isabel Cobos de Porcel, wife of Antonio Porcel, a counselor of Castile. In 1980, removal of the lining canvas revealed a second, handwritten inscription, "La Exma. Sra. Dna. Lobo de Porcel, Pintado por Goya," whose family name, Lobo, had been mistakenly transcribed in the latter inscription. These inscriptions suggest an identification of this work with "The portrait of the wife of Sr. Don Antonio de Porcel" exhibited at the Real Academia de Bellas Artes de San Fernando in 1805, as was a full-length portrait of the marchioness of Villafranca—presumably the one exhibited here (cat. 28).

X-rays of this portrait revealed a male portrait, finished or nearly finished, underneath the female sitter. The portrait of the male revealed by X-rays cannot be securely identified as the work of Goya. The canvas was reused without being reprimed, and today the right eye of the male sitter is visible under Isabel's chin, a problem that might have been avoided had the artist turned the canvas, so that the previous sitter's head would be more easily hidden by the darker colors of the background.[1] It is also strange that Goya would have reused a canvas for a portrait that was presumably commissioned.

Isabel de Lobo was born in the southern town of Ronda to an administrator of the city and a woman from Madrid, who returned to the capital

Oil on canvas
82 x 54 cm
The Trustees of the National
Gallery, London

BIBLIOGRAPHY: Gudiol 1970, no. 510; MacLaren 1970, 12–14; Gassier and Wilson 1971, no. 817; Wilson 1977, 121; Wyld 1981, 38–43; Helston 1983, 48; Morales 1994, no. 345; Baker 1999, no. 279.

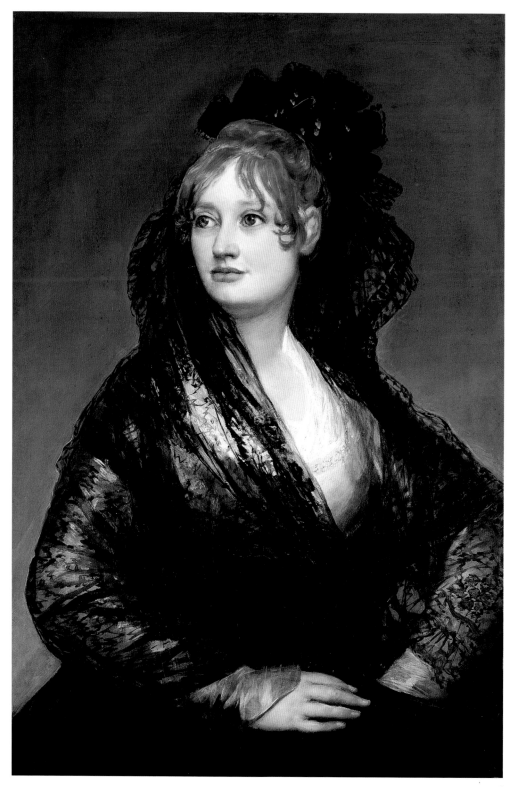

36

after the death of her husband. Her husband was a friend of the royal favorite, Manuel Godoy, and held various positions in the government.[2] His portrait by Goya, inscribed and dated 1806, was in the Jockey Club, Buenos Aires, until it was destroyed by fire in 1953. Both portraits show the sitters in informal dress: Isabel wears the costume of a maja, while her husband was shown in hunting costume, holding a rifle and with a hunting dog by his side. JT

NOTES
1. Wyld 1981, 38.
2. Fernández 1996, 134.

37. *Young Lady Wearing a Mantilla and Basquiña,* c. 1800/1805

The paucity of information regarding the identity of some portrait models has sometimes led to rather romantic identifications, as was the case with the supposed "painter's wife" (cat. 45) and with this young woman, known since Yriarte named her in 1867, with folkloric flair, "The Bookseller's Wife."[1] Viñaza expanded the title in 1887: "The Book Lady from Las Fuentes Street."[2] Beruete connected her with the wife of Antonio Bailó, a bookseller on Carretas Street.[3] This Bailó testified on Goya's behalf when the painter was subpoenaed by the courts in the course of the dreaded purges that Ferdinand VII instituted upon taking power. Goya was absolved, and Sambricio thought that this portrait might have been Goya's expression of gratitude.[4] María Mazón[5] had married Bailó, forty years her senior, on 1 July 1807, and the tale of the beautiful bookseller's wife has been preserved even by contemporary critics.[6] The most recent research, however, rejects this identification and connects the painting with an entry in Serafín de la Huerta's inventory, carried out between 1840 and 1842, which mentions "The lady in mantilla and *basquiña.*"[7] The figure appears in three-quarter length, wearing a black *basquiña*—a distinctive and costly article of clothing worn by ladies only when going out. The young woman is ready to leave the house; her arms and

Oil on canvas
109.5 x 77.5 cm
National Gallery of Art,
Washington, Gift of Mrs. P.H.B.
Frelinghuysen, 1963.4.2

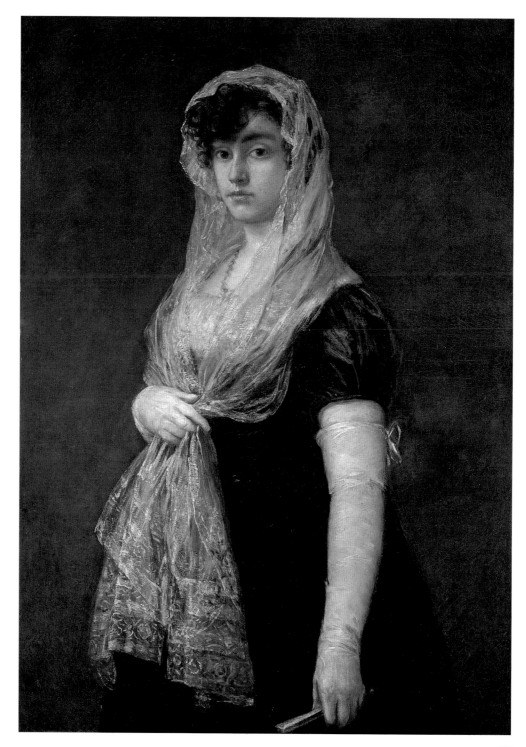

37

hands are sheathed in long, light-colored kidskin gloves, with ties on the forearm; her head is covered with a white lace mantilla. Her attire is discreetly embellished by her fan and her red necklace, which balances her full lips and interrupts the black and white tonal range of her clothing. Her dress, with its dark silhouette, defines a voluminous, slightly sculptural body. Dismissing the earlier notion of a "bookseller's wife," we can compare *Young Lady Wearing a Mantilla and Basquiña* with the rounded features, curly hair, and somewhat heavy shape of Gumersinda Goicoechea (see cat. 42, fig. 1). The eyebrows are different; they are thicker in the Washington painting. The close-fitting dress and the mantilla that covers her chest also indicate a more modest personality than that of Gumersinda. The two women are similar but not the same, as though they were relatives. Perhaps this is a portrait of Gumersinda's elder sister, Manuela, with whom Goya was in contact during his exile and whom he had previously depicted in a miniature on copper. Although in the miniature Manuela appears in profile, her features match those of this sitter, and the broad eyebrows are a family trait, resembling those of her father and her brother. AR

NOTES

1. Yriarte 1867, 138.
2. Viñaza 1887, 267.
3. Beruete 1915, 179, no. 167.
4. Valentin de Sambricio, "Goya no fué afrancesado," *Arriba*, 31 March 1946, 12.
5. Valverde 1979, 278.
6. Baticle 1992, 315.
7. Brown and Mann 1990, 24.

PROVENANCE: Serafín García de la Huerta collection, Madrid; 1840–1842, inventory of Serafín García de la Huerta, most likely no. 871; 1867, collection marquis de Heredia, Madrid; 1887, collection Benito Garriga, Madrid; 24 March 1890, auctioned at Hôtel Drouot, Paris, no. 4; collection Hubert Debrosse, Paris; 6 April 1900, auctioned by Hubert Debrosse, Hôtel Drouot, Paris, no. 45; collection Eugène Kraemer, Paris; 1906, Durand-Ruel, Paris; collection Henry Osborne Havemeyer, New York; 1907, collection Louisine W. Havemeyer; 1929, collection Mrs. P.H.B. Frelinghuysen, Morristown, New Jersey; 1963, National Gallery of Art, Washington.

EXHIBITIONS: New York 1915, no. 7; New York 1950, no. 15; Hamburg 1980–1981, no. 296; Amsterdam 1981–1982; Washington 1986–1987; Lille 1998–1999, no. 37.

BIBLIOGRAPHY: Gudiol 1970, no. 522; Gassier and Wilson 1971, no. 835; Valverde 1979, 278; Brown and Mann 1990, 24–27; Baticle 1992, 315; Glendinning 1994, 105–106, 110; Morales 1994, no. 370.

38. *Cesárea Goicoechea y Galarza, 1805*

Oil on copper
Diameter 8.9 cm
Rhode Island School of Design
Museum of Art, Providence, Gift
of Mrs. Murray S. Danforth

Inscribed on verso: 1805 / Goya /
a los 12 años / la Cesarea

PROVENANCE: Olivia Carstairs, New
York; 1931, M. Knoedler & Co., New
York; 1933, Martin Birnbaum; 1934,
donated to the Providence Museum
by Mrs. Murray S. Danforth.

EXHIBITIONS: Madrid, London, and
Chicago 1993–1994, no. 73.

BIBLIOGRAPHY: Gudiol 1970, no.
505; Gassier and Wilson 1971, no.
848.

Among the seven known miniatures of Goya's relatives by marriage (see cat. 39) figures this image of Cesárea, the baby of the family, then twelve years old. Goya portrays her from a slightly greater distance than is usual in his portraits and places her at half-length in strict profile. Like her sisters, the youngest wears an Empire-style gown, a high-waisted shift with long sleeves, and a French hat, both of a simplified design appropriate to her age. The lace trim is limited to a discreet border at the neckline. The hat is a kind of bonnet, of flexible weave, adorned with a little ribbon; the side flaps cover the child's ears and the bonnet ties under her chin. Her small, thin body contrasts with her large eyes; her gaze indicates candor and tenderness. The profile pose allows us to appreciate the long, narrow nose inherited from her mother: the trait is obvious in the black pencil drawing, also in profile, of Juana Galarza, which Goya made of his son's mother-in-law in 1805, in preparation for this series of miniatures (private collection). AR

39. *Gerónima Goicoechea y Galarza, 1805*

Oil on copper
Diameter 8.9 cm
Rhode Island School of Design
Museum of Art, Providence, Gift
of Grenville L. Winthrop

In 1932 Mayer published this miniature of Gerónima along with one of her sister, Cesárea, the youngest of the Goicoechea family (cat. 38).[1] Both portraits bear an inscription on the reverse side stating the subject's name and age, the date, and the author of the work. The German researcher read the final number in both inscriptions as a six and consequently dated the roundels to 1806.

Most experts, however, see a five in the now barely legible writing. In 1805 Javier Goya married Gumersinda Goicoechea, occasioning Goya's series of miniatures on copper.

Gerónima appears, like the other sitters, in half-length, but turned three-quarters to the right. At fifteen she teeters on the brink between childhood and adult life: she will soon be regarded by adults as marriageable. Perhaps for this reason the painter subtly suggests her womanly shape, presenting her as both grown woman and little girl. The same approach is evident in the rounded features and the shy and dreamy expression on the face of the countess of Haro, who married at fifteen (cat. 47). A child of well-to-do middle-class parents, Gerónima wears a headdress less ornate than an aristocrat would wear. The surface of her hat shimmers; it is probably made of shiny cloth and not of plant fiber like her sister Gumersinda's.

Goya had a lifelong preference for painting on canvas and particularly on thick-textured fabric, but he sometimes painted on wood and, very occasionally, on less conventional materials, such as ivory and copper. He used each to its best advantage. Wood, for instance, was an excellent base for extremely precise portraiture, like the portrait of María Teresa de Vallabriga, in which Goya exploited the smoothness of the surface to accentuate the luminous face of his subject (cat. 23). The painter was well acquainted with the qualities offered by copper; in both 1793 and 1794 he executed a series of cabinet paintings on copperplates. The brushwork is fine and varied, full of movement and rhythm; the paint itself seems to play with the brilliance of the base material, leaving visible the underlying preparation and relief. In the small roundels Goya lets the characteristic texture of the dark reddish foundation strokes emerge; they stand out, clearly visible, in many places. Frequently he failed to fill in with a fine brush the narrow gaps left by the thicker strokes on the background preparation, creating great vibrancy on the surface. The effect serves to evoke, for example, the stiffness of the lace at the sitter's neckline. Similarly, the approach intensifies the tactile quality of Gerónima's throat. AR

NOTES

1. Mayer 1932, 113–116.

Inscribed on verso: 1805 / a los 15 años / Geronima / por / Goya

PROVENANCE: Olivia Carstairs, New York; 1931, M. Knoedler, & Co. New York; 1933, Martin Birnbaum; 1934, donated to the Providence Museum by Grenville L. Winthrop.

EXHIBITIONS: Paris 1979, no. 192; Madrid, London, and Chicago 1993–1994, no. 72.

BIBLIOGRAPHY: Gudiol 1970, no. 504; Gassier and Wilson 1971, no. 847.

38

39

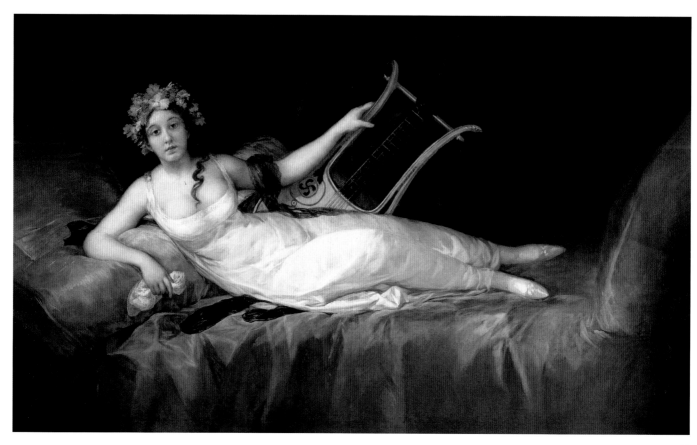

40

40. *The Marchioness of Santa Cruz, 1805*

"She is very lovely and her welcoming smile, when she is speaking, enchants. Goya must have known this young beauty for many years, for her mother was a patron of his."[1] So remarked Lady Holland in the early nineteenth century of Joaquina Téllez-Girón y Alfonso Pimentel, daughter of the duke and duchess of Osuna, whose beauty was already renowned. Goya had indeed known her since childhood. Her parents had purchased many works from him, including the 1787–1788 family portrait showing her in the center, held by her mother (cat. 27). In 1805 the duchess of Osuna commissioned this painting of her twenty-one-year-old daughter, by that time married four years to Don José Gabriel de Silva-Bazán y Waldstein, marquis of Santa Cruz. Goya chose a rectangular format, depicting the marchioness lying on a divan and propped up on a cushion. Joaquina wears white muslin—her descendants called this painting "Grandma in a slip"—without stays, as is clear from the slight shadow of the navel visible through the transparent gown.[2] Her attire, which leaves the upper part of her breasts bare, is completed by a black shawl that decoratively circles her body and by the handkerchief she holds in her right hand. Leaves and fruits crown her head. One long ringlet tumbles down freely, just far enough to reach her bosom and intensify the portrait's sensuality. Joaquina gazes at the painter, no longer, however, with the childlike curiosity she displayed in the family portrait: she now looks toward him with a "a deep look of dreamy greeting."[3] She holds a guitar, made to resemble a lute, on which is visible the Basque X-shaped cross, insignia of the house of Santa Cruz. The lyre represents the young woman's taste for poetry, connecting her with the realm of Apollo, god of music and the arts, disciplines basic to the extensive cultural training she undoubtedly received in her father's enlightened household. But Apollo is also Phoebus, the god of sun and of light, symbols that during the Enlightenment came to signify the supremacy of Reason. In opposition to Apollo's world Goya crowns his subject with vines and clusters of grapes, allusions to the sensuous and passionate regions of Bacchus, or Dionysius, god of wine and ecstasy. The physicality so obviously emanating from the young

Oil on canvas
124.7 x 207.9 cm
Museo Nacional del Prado,
Madrid, inv. 7070
Madrid only

———————

PROVENANCE: from its creation until 1941 in possession of the heirs of the marchioness of Santa Clara; from 1941, Bilbao, collection Félix Fernández Valdés; 1980, his daughter; 1983, sold in Madrid to Antonio Saorín Bosch, who took it out of Spain; 1985, Lord Wimborne attempts to auction the painting in London (Christie's), but the English courts acknowledge its illegal export and prohibit its auction; 1986, the Spanish government compensates the owner and the painting enters the Museo Nacional del Prado, Madrid.

EXHIBITIONS: Madrid 1928, no. 68(54); Paris 1961–1962, no. 59; Madrid, Boston, and New York 1988–1989, no. 66; Madrid 1995, no. 20; Madrid 1996c, no. 125.

BIBLIOGRAPHY: Gudiol 1970, 496; Gassier and Wilson 1971, no. 828; Licht 1983, no. 238–243; Mena Marqués 1986, 61–65; Morales 1994, no. 352.

woman is directed toward her husband, the marquis of Santa Cruz, and probably suggests less intellectual pursuits, such as her devotion to bullfights, also remarked on by Lady Holland: "Santa Cruz' wife seems to follow her mother's tastes, for she heads for the bleachers where fans feel closest to the matadors."[4] Thus we see the marchioness less as an Apollonian muse on Parnassus than as an Enlightenment muse, the incarnation of the era's pronounced ambiguities.

Jacques-Louis David's portrait of Madame Récamier (Musée du Louvre, Paris) and Antonio Canova's *Paolina Borghese* (Galleria Borghese, Rome) have been cited as sources for this work, since in both paintings the sitter reclines on a divan "in the antique manner." Other possible models include a Titian Venus and Goya's own *Maja desnuda* (cat. 54). But Goya, respecting the standards of classicism, rejected the diagonal lines of his mysterious female nude in favor of perpendicular planes defined by the divan and by the marchioness' form. Beruete notes the influence of Velázquez, since the color range, based on whites and pinks, is closely related to the Sevillan painter's palette in the *Rokeby Venus*.[5] Goya outlines with great mastery the divan and the draperies, using long, light brushstrokes as if for a watercolor, just as Velázquez did in *The Infanta Margarita* (Museo Nacional del Prado, Madrid). He shapes the human figure, however, with sharper definition and greater variation in the composition and quality of the impasto. AR

NOTES
1. Holland 1910, 105, 107, 196.
2. Ezquerra del Bayo 1934, 35.
3. Mena Marqués 1986, 62.
4. Holland 1910, 105, 107, 196.
5. Beruete 1916, 103.

41. *Antonia Zárate, 1805–1806*

Oil on canvas

103.5 x 82 cm

The National Gallery of Ireland, Dublin

We know of two portraits of the actress Antonia Zárate, and they come together here for the first time since their exhibition in Madrid in 1900. In addition to the present work, in which the model is seated on a sofa holding a white fan, perhaps of ivory, there is also a portrait in the collection of The Hermitage in St. Petersburg (cat. 44).

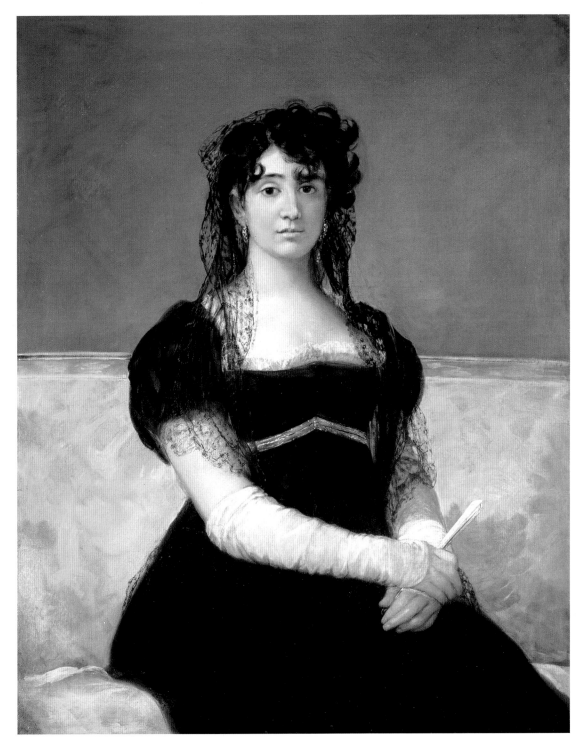

41

PROVENANCE: 1900, Adelaida Gil y Zárate, heirs of Antonia Zárate, Madrid; M. Knoedler & Co., London; c. 1911, collection of Sir Otto Bei, London; 1930, Alfred Beit; collection of Sir Alfred and Lady Beit, Blessington, Ireland; 1987, gift of Sir Alfred and Lady Beit to the National Gallery of Ireland.

EXHIBITIONS: Madrid 1900, no. 47; London 1911, no. 52; London 1920–1921, no. 129; London 1928, no. 26; London 1931, no. 12; London 1947, no. 7; Le Cap 1948; Dublin 1957, no. 74; Stockholm 1959–1960, no. 146; Paris 1961–1962, no. 60; London 1960–1964, no. 94; London 1972, no. 116; London 1981, no. 72; Lille 1998–1999, no. 36.

BIBLIOGRAPHY: Gudiol 1970, no. 562; Gassier-Wilson 1971, no. 892; Crombie 1973, 23–27; Brown 1984, 21; Mulcahy 1988, 20–21; Baticle 1992, 308; Morales 1994, no. 391.

Born in Barcelona in 1775, Antonia Zárate was a renowned actress who performed with her sister María in Madrid. The sisters belonged to a family of actors and artists, as did the sitter's husband, Bernardo Gil, a singer and comic actor in the Teatro del Príncipe. Their son, Antonio Gil y Zárate, became a celebrated poet and playwright. Valentín Carderera notes that Antonio owned two portraits of his mother by Goya: "Goya painted Doña Antonia Zárate...twice, once in 1810 and again in 1811, both are in the possession of her son."[1] It is unclear if one of the portraits cited by Carderera is the one exhibited here. Nor is there agreement as to which of the two extant works was painted first. But Antonia's low-cut garment, with raised lace at the borders, her hairstyle and the fine mantilla falling to her shoulders with marked naturalness, and her gloved arms match the style of the first decade of the nineteenth century. Her attire and the placement against a neutral background coincide with the compositional system employed in *Young Lady Wearing a Mantilla and Basquiña* (cat. 37) and *Young Woman with a Fan* (cat. 42), both dated between 1805 and 1806, the date accepted by Harris and Glendinning for the Dublin portrait.[2] Antonia is closer to these astonishingly elegant middle-class women than to the famed actress María del Rosario Fernández Ramos, called "La Tirana" (the Tyrant), whom Goya had painted toward the end of the eighteenth century. Portraits of La Tirana, an emancipated woman who could fend for herself, display an impressive physicality, forceful and defiant. Zárate, on the other hand, is slim and delicate. A kind of melancholy envelops her, resulting from her distant and internalized gaze.

Goya almost certainly did the painting from life, with Antonia posing, perhaps in his study: we agree with Xavier de Salas that the couch upholstered in yellow damask in the style of Louis XVI may be the one cited in the 1812 inventory of goods divided between Goya and his son, Javier, which comprised "eight armless chairs in yellow damask...[and]...a matching divan."[3] This divan becomes a shining stage for the actress—richly attired in black—intensifying her beauty. AR

NOTES
1. Salas 1931, 176, no. 22.
2. Harris 1969, no. 25; Glendinning 1963, no. 94.
3. Sánchez Catón and Salas 1963, 69.

42. *Young Woman with a Fan*, 1806–1807

In an effort to identify this young woman, scholars have turned to the inventory of Goya's property by Antonio Brugada taken after the painter's death, since in the sale of the collection of the marquis of Salamanca—one of the mid-nineteenth-century owners of the painting—it is listed as having come from Goya's collection.[1] Gudiol identifies this portrait with that listed by Brugada as number 10: "Portrait of Doña Catalina Viola with a fan. Half length." Morales, on the other hand, relates it to Brugada's number 25: "Portrait of a lady with fan, half length."[2]

Xavier de Salas and Enriqueta Harris recognized in this portrait the daughter-in-law of the painter, Gumersinda Goicoechea, married in June 1805 to Goya's son, Javier.[3] This is confirmed by comparing the portrait with the miniature of Gumersinda—one of the series painted by Goya in 1805 (fig. 1; see cats. 38 and 39). In spite of the fact that her form appears fuller in the portrait, we can see similarities in the faces and coloring of both, such as the wide set eyes and heavy eyelids. Comparison with a full-length portrait as well as a pencil drawing in which Goya shows Gumersinda in profile[4] shows the similarity in her long brows, which cross part of her temples before disappearing beneath her wavy hair.

Harris suggests that Goya painted his daughter-in-law between 1806 and 1807, either when she was pregnant, or after she gave birth to Mariano, Goya's only grandson.[5] The style of her dress also supports the date. The portrait is similar in style to *Young Lady Wearing a Mantilla and Basquiña* (cat. 37); the two sitters also share a resemblance to suggest that the young woman in the Washington portrait might be Gumersinda's older sister, Manuela Goicoechea. The painter sets both against a neutral background, one standing, the other seated, looking toward the viewer with a somewhat dreamy and distant gaze. Moreover, Goya describes the personality of each sitter in accord with the character presented in the miniatures painted in 1805 (figs. 1 and 2). There, Manuela wears an elaborate lace collar to cover her neck and dresses in a conservative fashion, enveloped meticulously with her mantilla; Gumersinda

Oil on canvas

103 x 83 cm

Musée du Louvre, Paris, RF M32

Madrid only

———————

PROVENANCE: Mariano Goya (?); marquis of Salamanca, Madrid; 1867, Alphonse Oudry, Paris; 16 April 1869, Mr. Edward; 7 March 1870, Ed. Kums; 17 May 1898, Musée du Louvre, Paris.

EXHIBITIONS: Paris 1935, no. 535; New York 1936, no. 12; Paris 1938, no. 13; Montauban 1942, no. 35; Paris 1961–1962, no. 67; Paris 1963, no. 118; London 1963–1964, no. 93; The Hague and Paris 1970, no. 37.

BIBLIOGRAPHY: Gudiol, 1970, no. 659; Gassier and Wilson 1971, no. 890; Brejon de Lavergnée and Thiébaut 1981, 115; Laclotte and Cuzin 1982, 221; Morales 1994, no. 389; Harris 1994, no. 21.

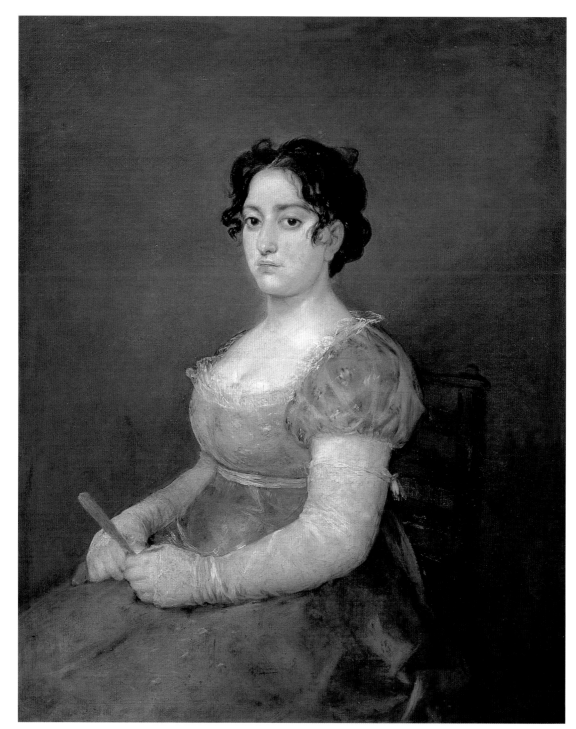

42

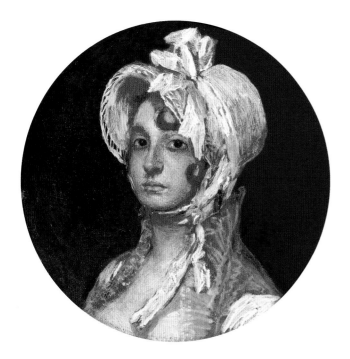

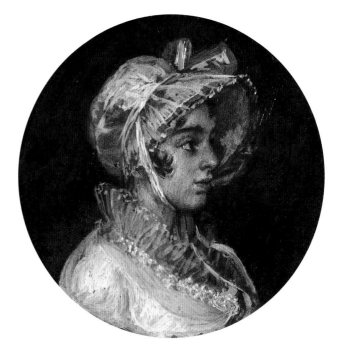

shows herself more openly than her older sister, and again shows—as in the miniature—a preference for low-cut necklines that show her voluptuous bosom. AR

NOTES

1. Gassier and Wilson 1971, 381–382.
2. Gudiol 1970, no. 659; Morales 1994, 302–303, no. 389.
3. Salas 1964b, 99–110; Harris 1994, 72, no. 21.
4. Gassier and Wilson 1971, nos. 842 and 851.
5. Harris 1994, 72, no. 21.

Fig. 1 Francisco Goya, *Gumersinda Goicoechea*, 1805, oil on copper, Museum of Saragossa

Fig. 2 Francisco Goya, *Manuela Goicoechea*, 1805, oil on copper, Museo Nacional del Prado, Madrid, inv. 7461

43. *Señora Sabasa García*, c. 1806/1811

Goya's compositional scheme in this painting might be described as simplicity carried to perfection. Portrayed at half-length and angled to the left, the young woman is set before a dark background. Goya presents her without jewelry or any other type of detail to identify her social status. Nonetheless, the result is a supremely elegant portrait—recalling veiled Greco-Roman female torsos—

Oil on canvas
71 x 58 cm
National Gallery of Art,
Washington, Andrew W. Mellon
Collection 1937.1.88

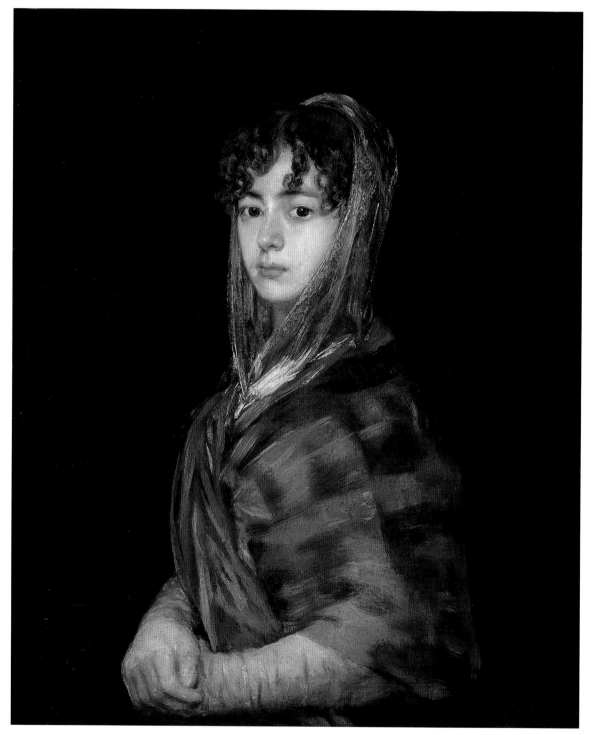

43

typical of Goya's private portraiture at the time. The young woman's shoulders, like her arms, are covered by a wide shawl in golden brown tones. Long, fingerless kidskin gloves cover her forearms, wrists, and the tops of her hands, which are crossed delicately in front of her. She does not even carry the ubiquitous fan seen in so many of Goya's portraits of women. Against the dark background, the painter defines her pale face with refinement and precision: her elegant nose, plump lips, and dark, shining eyes, which emphasize her serene and somewhat reserved character. Under a gauzy, transparent veil, the edges of which are adorned with small designs, the sitter's fashionable ringlets fall over her forehead, matching the informality of her pose. The young woman is enveloped in neutral space, within which her erect torso and her head create a triangular shape: the head—the focal point of the painting— marks one angle. The painter places the remaining two angles at the bottom of the left forearm (the elbow and the crossed hands), below which the painting is cut off.

The simplicity of the composition notwithstanding, a wealth of technical resources is at Goya's command when he turns his long, full brushstrokes to the texture of the fabric of his model's attire. These strokes contrast sharply with the fine touches, painstakingly applied to evoke the sheen of her hair or her facial definition, the latter resembling a miniature. The variety of brushstrokes and the controlled technique visible in the face are characteristic of the artist, as is apparent in the portrait of the countess of Haro (cat. 47) from about the same time. The expressive strokes in the countess' clothing evince a stylistic connection with the brushstrokes of Sabasa García's shawl.[1]

Sabasa is the surname of the model's family. Valverde discovered that she is María García Pérez de Castro.[2] She was born in 1790, the niece of Evaristo Pérez de Castro, whom Goya had painted in 1806 (Musée du Louvre, Paris). The painter was probably acquainted with the young woman, who married Juan Peñuelas in 1820 in the Castro's home. She appears to be about twenty years old, which would date the canvas from the second decade of the century. Goya's compositional scheme is typical of his portraits of young women of the upper middle class. He uses the same system in representing Thérèse-Louise de Sureda (cat. 33), which dates from same period, and the woman in *Young Lady Wearing a Mantilla and Basquiña* (cat. 37). In these portraits Goya stresses youthful elegance, dispensing with symbols and tokens that might distract the viewer. AR

NOTES

1. See Brown and Mann 1990, 10 n. 8.
2. Valverde 1983, 108–109.

BIBLIOGRAPHY: Gudiol 1970, no. 527; Gassier and Wilson 1971, no. 816; Camón 1980–1982, III, 157; Valverde 1983, 108–109; Brown and Mann 1990, 9–12; Baticle 1992, 306; Morales 1994, 283.

44. *Antonia Zárate*, 1811

Oil on canvas

71 x 58 cm

State Hermitage Museum,
St. Petersburg

———————

PROVENANCE: Antonio Gil y Zárate;
Adelaida Gil y Zárate, Madrid; XII
marquis de Villafranca and XIV duke
de Medina Sidonia, Madrid; 1900, M.
Havemeyer, New York; 1923–1930,
Mrs. Howard B. George, Washing-
ton; 1939, auctioned by Sotheby's in
London; M. Knoedler & Co., New
York; Marshall Field, New York;
countess de Fleur, Paris; 1972, gift of
Armand Hammer to The Her-
mitage, St. Petersburg.

EXHIBITIONS: Madrid 1900, no. 48;
New York 1940, no. 33; New York
1950, no. 22; New York 1955, no. 176;
Leningrad, Moscow, and Kiev 1972–
1973; Leningrad 1977, no. 18; Madrid
1981; Stockholm 1994–1995, no. 31.

BIBLIOGRAPHY: Gudiol 1970, no. 561;
Gassier and Wilson 1971, no. 893;
Crombie 1973, 23–25; Mulcahy
1988, 20–21; Morales 1994, no. 396.

In this half-length portrait Antonia Zárate wears a reddish coat and a kerchief adorned with a hairpin in the shape of a crescent moon. Her face seems empty; it lacks the vibrancy typical of Goya's masterpieces, the vividness readily perceived in the actress' larger portrait (cat. 41). There are signs suggesting that the Dublin painting may have provided a prototype for this bust. In both, for instance, the sitter's curls are conspicuous beneath her headdress: two stylized locks that fall asymmetrically over the forehead and cover her eyebrows. The lips and the semicircles defining the nostrils are also surprisingly similar. This particular painting was probably completed after the actress' death in 1811, the year Carderera cites for one of the images owned by her son.[1] Upon the artist's death, Antonio Gil may have commissioned the bust to commemorate his famous mother, who in the current picture is more fancifully attired than in the elegant Dublin portrait. AR

NOTES
1. Salas 1931, 176, no. 22.

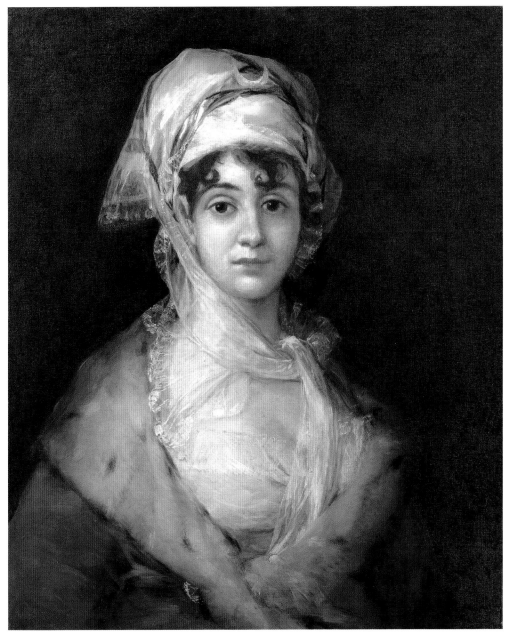

44

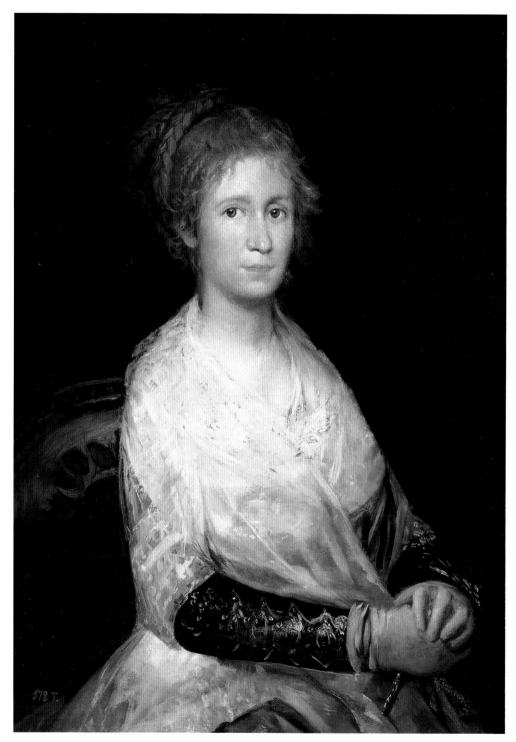

45

45. *Josefa Bayeu (?)*, c. 1814

Goya presents this unknown young woman—whose traditional identification has recently been challenged—in half-length, seated, gazing at him with alert, intelligent eyes. On its admission to the Museo de la Trinidad, the painting was titled *Portrait of the Painter's Wife, Doña Josefa Bayeu*. In July 1773 Goya had married Francisco Bayeu's sister; he mentions the fact himself in his Italian notebook. The identification of the sitter as his spouse is based, however, not on documentation but only on statements made by its first purchaser, who acquired the work from the painter's descendants. The woman's age and appearance fail to support this usual assumption, because the wide range of dates proposed for the portrait (between 1790 and 1800 according to Mayer; between 1808 and 1812 according to Beruete) and the apparent age of the sitter do not coincide with Josefa Bayeu's age.[1] If the canvas was painted in 1798, the date most recently accepted,[2] then the painter's wife would have been fifty years old, whereas the sitter is still in her thirties. Neither do the young woman's fine, delicate features agree with the only indisputable portrait of Josefa, an 1805 profile on paper, in which Goya does not conceal his wife's age or the flaccidity of her flesh. (She had given birth to six children of whom only Javier survived.) The model's youth, the style, and the technique all preclude the portrait's representing Josefa or, for that matter, having been executed in the eighteenth century. New research confirms that her dress and coiffure are of a style fashionable after the Napoleonic War. The hair has no switches and is unpowdered, as was the style in the 1790s. It is worn naturally, bound into plain braids fastened at the back and leaving a few shorter wisps to frame the face. This style dates from the French Restoration.

The lighting and the coloration are similar to those of Goya's 1815 self-portrait (Museo del Academia de Bellas Artes de San Fernando, Madrid). The subject is sharply defined against a dark, neutral background; as is the case with Goya's more intimate portraits, this concentrates the viewer's attention. The features, terseness, and pallor of her clear face are precisely modeled.

Oil on canvas

82 x 58 cm

Museo Nacional del Prado, Madrid, inv. 722

PROVENANCE: 1866, acquired by the Ministery of Development, Dirección General de Instrucción Pública de Román de la Huerta for the Museo de la Trinidad; 1872, Museo Nacional del Prado; 1876, first mentioned in the museum's catalogue.

EXHIBITIONS: Geneva 1939, no. 8; Kyoto and Tokyo 1971–1972, no. 28; Barcelona 1977, no. 20; Paris 1979, no. 7; Leningrad and Moscow 1980, no. 30; Hamburg 1986, no. 43; Geneva 1989, no. 66; Saragossa 1992, no. 30; Madrid 1996c, no. 98; Saragossa 1996a, no. 34; Lille 1998–1999, no. 32.

BIBLIOGRAPHY: Gudiol 1970, no. 320; Gassier and Wilson 1971, no. 686; Agueda and Salas 1982, 32, note 98; Morales 1994, no. 198; Mena Marqués 2001.

Roseate varnish accentuates her cheeks, whereas her attire and the remaining details of the composition are left somewhat undefined. Large brushstrokes, expressive and abstract, evoke the complicated gold-thread ornamentation on her sleeves and hint at the textures of her shawl and skirt. With folded, gloved hands the woman clutches on her lap the gilded hint of an object which the forcefulness of her pose suggests is something other than a fan, Goya's nearly ubiquitous accessory in portraits of women.

As Mena Marqués has demonstrated, there is another reason for assigning a postwar date to this painting.[3] Doubtless on account of scarcity of materials, Goya employed a canvas that had already been used: the Prado's technical department x-rayed this canvas and revealed an underlying female portrait very similar to those Goya was painting during the last decade of the eighteenth century. The current work is painted directly on top of the earlier one without prior preparation; the entire surface was simply covered with dark, dense paint. The reutilization of a canvas, coupled with the uninflected technique so far removed from the painter's customary manner with female portraiture, leads Mena Marqués to the conclusion that the woman in the painting must be someone very close to Goya.[4] Otherwise she would never consent to being painted over a preexisting face. Her identity should therefore be sought among the women of Goya's immediate circle, for instance, Leocadia Zorilla, the painter's very last companion. AR

NOTES
1. Mayer 1923, no. 307; Beruete 1917, no. 255.
2. Madrid 1996c, 376–377.
3. Mena Marqués 2001.
4. Mena Marqués 2001.

46

46. *Rita Luna, 1814–1818*

Oil on canvas

43 x 35.5 cm

Stanley Moss–Art Focus,
Riverdale, New York

———————

PROVENANCE: Mariano Goya; Valentín de Carderera, Madrid; duke of Béjar, Madrid; Bernardina Roca de Togores y Téllez-Girón; Francisco Escrivá de Romaní y Roca de Togores, Madrid; the count and countess of Oliva, Madrid; Newhouse Galleries, New York; Kimbell Art Museum, Fort Worth, Texas; Stanley Moss.

EXHIBITIONS: Madrid 1902, no. 989; Madrid 1928, no. 71; Dallas 1982–1983, no. 15.

BIBLIOGRAPHY: Gudiol 1970, no. 656; Gassier and Wilson 1971, no. 1565; Crombie 1973, 27; Morales 1994, no. 487.

Both Goya's son, Javier, and his grandson, Mariano, divested themselves of all the works they had inherited. Mariano, for instance, sold to Valentín Carderera a substantial assortment of paintings, appending the prices he was asking for each. As confirmed by the shipping receipt, this group included "A portrait of Rita Luna, actress from Moratín's time."[1] Carderera purchased it along with a sketch of the duke of Wellington (British Museum, London) and a few etchings, such as *The Giant* (Bibliothèque Nationale, Paris). The collector listed the only painting in the shipment as "A portrait of the celebrated actress painted when no longer young. Bust only."[2] The story of the discovery of these works is a trifle romantic: according to Mariano, he found them in a walled-up cupboard where they had been stored, for reasons unknown to him, in 1818. Specialists have been content to record a short biography of the sitter: Rita Luna, born 28 April 1770, was an acclaimed actress specializing in dramatic roles. She retired from public life in 1804 and resided in Toledo, Málaga, and Pardo, where, according to Viñaza, this portrait was made.[3] She also lived in Madrid, where she died in 1832. AR

NOTES
1. Gassier and Wilson 1971, Appendix VII.
2. Gassier and Wilson 1971, Appendix VII.
3. Viñaza 1887, 239, no. LXIX.

47. *The Countess of Haro,* before 1808

María Ana de Silva y Waldstein was the daughter of María Ana Waldstein (later Wartemberg) and José Joaquín, ninth marquis of Santa Cruz. In 1802, at the age of fifteen, she married Bernardino Fernández de Velasco, count of Haro. She died in 1805.

Lafuente Ferrari dates this painting earlier, preferring 1803 rather than 1805—the year proposed by Beruete and Ezquerra del Bayo—because the model's "childlike" expression suggests an earlier portrait, perhaps on the occasion of her wedding.[1]

Over her chemise María Ana wears a light turquoise dress with shoulder straps, possibly muslin, and a rose-colored shawl. In her hair is a diadem adorned with a rose, a style that remained in vogue even up to 1814. The flower is made of a velvet-like fabric; its soft texture absorbs the light, which in contrast spills upon the countess from above, shimmering on her gilded comb. Her features and her hair are executed with an extremely precise technique, as exquisite as if they appeared in a miniature, yet the brushstrokes also reflect great energy. Goya suggests the shape and texture of the ear through swift, strong, assured strokes. With still broader and galvanized strokes he conveys the size and round-ness of the shoulders. To refine the face, the painter emphasizes the curve and the tip of the countess' nose with precise touches. He accentuates her liveliness by painting her black pupils in a different size and shape; the white touches evoke her shining eyes and animate, together with the lachrymal (produced by a drop of red varnish), her gaze. The grayish tone of the priming, exposed in the luminous surface of the countess' bust, hints at a refined aristocratic pallor, and the painter exploits the shadows to perfect the skin and the throat. Goya's technical mastery is demonstrated by the astonishing economy of brushstrokes, which often achieve several aims at once. Note the perfect definition of the throat, firm and straight, where the painter uses the rim of the brush to gather in relief the light that enters from right to left, while using the same rim to form the space between the countess' torso and the back of the armchair.

Oil on canvas

59 x 36 cm

Private collection

Madrid only

———————

PROVENANCE: collection of the marquis and marchioness of Santa Cruz; duchess of San Carlos, Madrid; Bührle collection, Zurich; private collection.

EXHIBITIONS: Madrid 1913, no. 151; London 1920–1921, no. 118; Madrid 1928, no. 40.

BIBLIOGRAPHY: Gudiol 1970, no. 517; Gassier and Wilson 1971, no. 805; Glendinning 1992, no. 29; Morales 1994, no. 330.

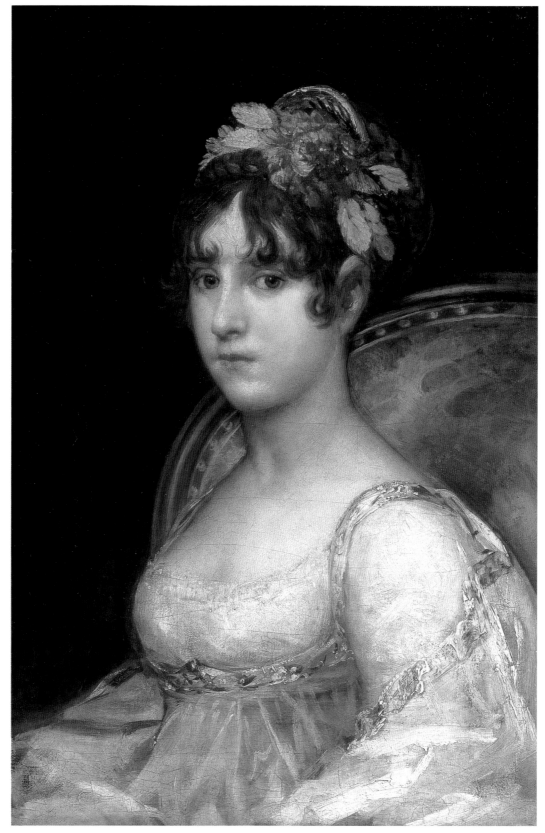

47

Around the breast a quite different technique is evident, described by Gudiol as anarchic in the area of the dress.[2] But the brushstrokes model precisely the lines representing creases and pleats in the material of the shawl. The painter follows the lines of the fabric as it falls into weaker folds in the shawl, with its stiffer texture, and into small pleats in the gown itself, with its softer quality. The shawl is edged, like the décolleté, with gold thread, which Goya highlights with heavier impasto appropriate to its greater volume. The tremendous technical differences between the painstakingly finished bust and the schematic strokes covering the remainder of the portrait arouse curiosity. One explanation might be María Ana's premature demise and the abandonment of the project. But the degree of abstraction in technique is similar to that of pictures dated later than this one. Similarities also exist between the simple brushstrokes forming the countess' right arm and the "static" ones used to define the erect torso of the young woman once identified as Josefa Bayeu, dated by Mena Marqués to 1814 (cat. 45). As in that portrait, Goya needs very few strokes to fix the figure perfectly in its space. Though almost in profile, the countess' right shoulder is still discernible—the painter follows through on her position with great accuracy—giving the portrait a finished look and the torso a more natural aspect. The shoulder is indicated by a smattering of strokes that evoke the curve under the tight, dark strap and the raised lace border.

Stylistic details bring this portrait closer to Goya's later works, making it likely that the painter in fact executed it subsequent to the countess' death and painted her face from another canvas. The careful technique and the position of the bust recall smaller format portraits, such as the miniatures he made of his daughter-in-law's family (cats. 38 and 39). It may be that María Ana Waldstein Wartemberg, since 1782 the honorary director of painting at the Real Academia de Bellas Artes de San Fernando, commissioned this painting in honor of her deceased daughter. If the mother was indeed Goya's patron for a post mortem portrait, then the work must date from before June 1808, when the mother of the countess of Haro died.

The chair is an artistic invention, serving less as a seat than as a visual support for the delicate upper body. Seen from the front, the chair seems to shimmer, bringing vibrancy to the countess' image. The glints of gold, the upholstery in soft mauve, and the reflections off the studs, all painted differently, work together with the brilliant reflections in the eyes, enlivening the young woman's slightly absent and introspective gaze. AR

NOTES
1. Ferrari 1928, 41–42, no 40; Beruete 1916, 104; Ezquerra del Bayo and Pérez Bueno 1924, 37.
2. Gudiol 1970, no. 517.

48

48. *Gossiping Women*, c. 1785–1790?

We lack reliable information concerning the date and purpose of this canvas. Stylistic evidence connects the scene—majas reclining on a hillock—with works Goya created in the 1780s and the early 1790s. Thus Sambricio proposes that the painting is a cartoon for a tapestry that was never woven.[1] Du Gué Trapier, on the other hand, maintains that it was one of the overdoors for Sebastián Martínez' home in Cadiz, mentioned by Nicolás de la Cruz, count of Maule, in his travel log.[2] When the painting was exhibited recently, Luna compared the woman's position, reclining and seen from the back, with Velázquez' *Rokeby Venus* (The National Gallery, London).[3]

But the technique and style of this canvas have little in common with the delicacy of, for instance, the *Sleeping Woman* (cat. 52), which may indeed have belonged to the overdoor series noted by the count of Maule. Nor does it seem likely that the present work was one of the cartoons completed in the 1780s, when Goya used a great variety of brushstrokes to convey the varied qualities and textures of the majas' attire. One need only call to mind the cartoons of the Four Seasons, where the painter highlights with enormous subtlety the effects of light and shadow on the faces of his protagonists, placed in landscapes in which the atmosphere is set forth clearly. AR

NOTES
1. Sambricio 1946, 173.
2. Trapier 1964, 8–9.
3. Madrid 1996c, 356.

Oil on canvas
59 x 145 cm
Wadsworth Atheneum Museum of Art, Hartford, Connecticut, The Ella Gallup Sumner and Mary Catlin Sumner Collection Fund

PROVENANCE: marchioness of Bermejillo del Rey, Madrid; Kurt M. Stern; viscount of Heudencourt, Paris; Durlacher Bros., New York; 1929, gift of Ella Gallup Sumner and Mary Catlin Sumner to the Wadsworth Atheneum.

EXHIBITIONS: Paris and The Hague 1970, no. 4; Dallas 1982–1983, no. 1.5 (sic.); Madrid 1996c, no. 77.

BIBLIOGRAPHY: Gudiol 1970, no. 321; Gassier and Wilson 1971, no. 370; Morales 1994, no. 214.

49. *The Picnic*, 1788–1798

Oil on canvas

41.3 x 25.8 cm

The Trustees of the National

Gallery, London

PROVENANCE: 1798, the duke and
duchess of Osuna, La Alameda,
Madrid; 1896, sale, ducal house of
Osuna; acquired by The National
Gallery, London.

EXHIBITIONS: Madrid 1896, no. 78;
London 1947, no. 8; London 1981, no.
66; Madrid, London, and Chicago
1993–1994, no. 27; Lille 1998–1999,
no. 21.

BIBLIOGRAPHY: Gudiol 1970, no. 254;
Gassier and Wilson 1971, no. 274;
MacLaren 1970, 9–11; Arnaiz 1987,
B61; Tomlinson 1993, 184–185;
Morales 1994, no. 188.

In a woodland clearing young people are enjoying the bread, and especially the
wine, they have brought in a basket. Their empty bottle lies overturned on the
grass, suggesting that the festivities are well advanced. The youth dressed in
yellow with his head in his hands is perhaps feeling queasy: or he may be cov-
ering his ears to block out the hideous singing of the young man seated in the
center, who raises his left hand in a toast. This second figure stares at the maja
directly before him, who no longer evinces much resistance to his alarmingly
direct form of courtship. A group in the middle ground, including another
young woman, observes the scene with amusement.

Goya had treated the subject of a country picnic before, in a tapestry car-
toon (cat. 1). But despite the thematic resemblance, the rather theatrical antics
of the cartoon figures have little in common with this ingenious sketch. The
characters in the earlier version were grouped in a foreground frieze, whereas
here they occupy various depths, closed at the back not by a view of the Man-
zanares River but by leafy trees. Goya shows the treetops intertwined, prefac-
ing the imminent union of the couple in the foreground. The woman's role has
changed as well. While the orange seller in the cartoon faced the gallants with
great authority and assertiveness, this maja seems defensive. Cornered by the
lascivious youth, legs spread apart, she will "fall" soon enough.

The Picnic is thought to belong to a series of sketches Goya prepared in
1788 for the tapestry cartoons destined for the infantas' bedroom at the Pardo
palace, where most of the subjects dealt with the festival of Saint Isidore. The
group's principal drawing, *The Meadow of San Isidro* (cat. 17), shows the popu-
lace celebrating the saint's day on the banks of the Manzanares; in *Blindman's
Buff* (Museo Nacional del Prado, Madrid) and *The Picnic*, Goya represents
more marginal episodes from the famous festival.

Bearing in mind the playful character of the other scenes, which are closely
linked to rococo paintings on countryside topics, the unrefined, suggestive
behavior depicted in this sketch seems ill-suited to the young daughters of the
prince and princess of Asturias. Goya is clearly alluding to female virtue,

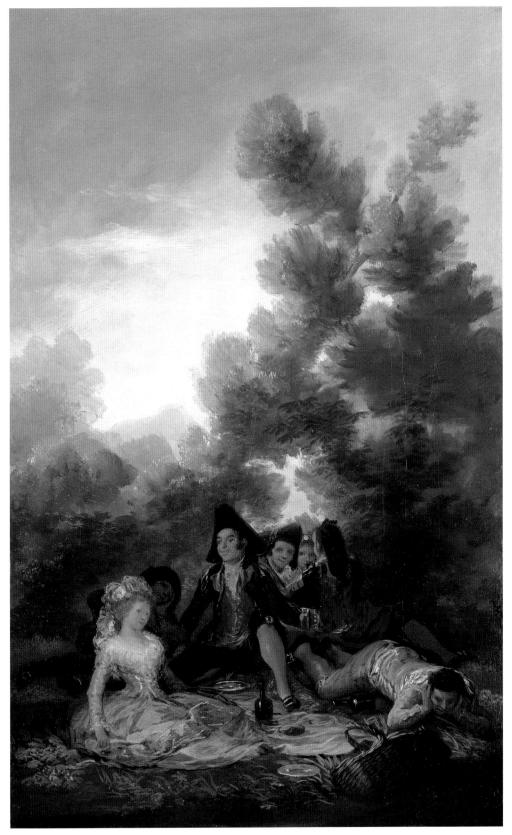

49

threatened by the uncontrolled passions produced by the abuse of alcohol—a cause, too, of nausea in some and slumber in others. Threats to female virtue would once again be the theme in *Girls Bearing Water Jugs* (Museo Nacional del Prado, Madrid), which Goya painted several years later for the new study built for the infantas' father. Wilson-Bareau feels that *The Picnic* might be understood as a moralistic lesson for the young princesses, or as merely a *divertimento* for their parents.[1]

Nevertheless, the painting has been connected with other works by Goya. Arnaiz, for instance, has identified it as *Autumn* (cat. 15), which was missing from the Osuna collection in 1867.[2] Tomlinson, on the other hand, thinks it might have accompanied the sale of the seven "country topics."[3] AR

NOTES

1. Wilson-Bareau 1993–1994, 178.
2. Arnaiz 1987, 303–305.
3. Tomlinson 1989, 184, questions the traditional attribution of this painting to the series of tapestry sketches of 1788. Pointing out the indecorous theme as well as formal differences when compared to the tapestry sketches, she suggests that this painting was perhaps added to the series in the late 1790s, on the occasion of its sale to the duke and duchess of Osuna.

50. *"La Beata" with Luis de Berganza and María Luisa de la Luz,* 1795

Oil on canvas

30.7 x 25.5 cm

Arango Collection, Madrid

Signed, dated, and inscribed at lower right: Luis de Berganza año 1795. Goya

This small painting is a companion piece to *The Duchess of Alba and "La Beata"* (cat. 51), in which Cayetana, duchess of Alba, teases her maid—identified by José Ezquerra del Bayo as Rafaela Luisa Velázquez—by frightening her with a coral amulet.[1] Popular tradition among the uneducated claimed that such jewels were effective protection against the "evil eye." Much given to prayer, Rafaela soon became "La Beata" (a "beata" is an obsessively religious old woman) of the Alba household and, as the painting indicates, the target of jokes and mischief on the part of the children residing in the Albas' Madrid palace. Rafaela is a source of amusement for the steward's son, Tomás de Berganza, and for María Luisa de la Luz, who was taken in by the duchess of Alba and treated as her own daughter. The two children, of the same age, have

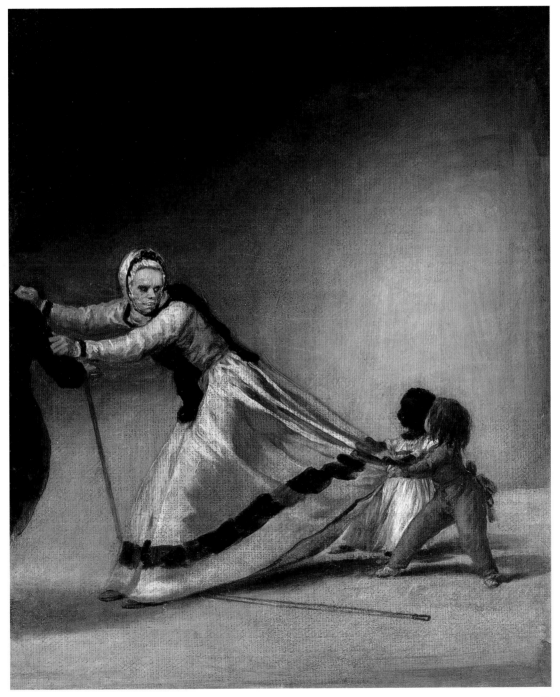

50

PROVENANCE: duchess of Alba; bequeathed to Tomás Berganza and by him to his son Luis de Berganza; 1900, Carmen Berganza de Martín; Isabel and Carmen Fernández Martín, by inheritance from their mother, Pilar Martín Usera; sold to the present owner.

EXHIBITIONS: Madrid 1900, no. 103; Madrid, London, and Chicago 1993–1994, no. 65

BIBLIOGRAPHY: Gassier and Wilson 1971, no. 353; Glendinning 1981, 240; Baticle 1992, 225–226; Glendinning 1992, 121–123.

"attacked" the old woman and are tugging at her skirts. Instead of laughing, "la Beata" reacts as though her balance was truly imperiled, dropping her cane to grasp the sleeves of a figure shown from the back and cut off by the edge of the painting. His black vestments suggest he is the abbot Pichurris, who appears again with his back turned and in the background in a subsequent drawing with the duchess in front (Metropolitan Museum of Art, New York). The old woman's anger is precisely what inspires the children's mirth, and they urge each other on. The boy wears a suit like those found on children in Goya's tapestry cartoons of the period, while the little girl is wearing a white dress, similar to a shift, with a red sash that matches her collar and coral bracelets. She is obviously attired in imitation of her adoptive mother, who appears in a white gown in the large portrait Goya executed that same year (see p. 40, fig. 5). María Luisa de la Luz is the subject of a poem by Manuel Quintana and the protagonist of an affectionate sketch in the Sanlúcar album, painted in the summer of 1796 and featuring the child seated on the duchess' lap (see p. 61, fig. 3).[2]

The action of the painting under discussion, like its companion, takes place in an undefined space, void of allusions to the rich and renowned ornamentation of the Alba palace on Barquillo Street. In the small composition *The Duchess of Alba and "La Beata,"* Goya kept the background dark, perhaps in reference to the old woman's obscurantist superstitions. Here, however, he surrounds the children with plentiful and warm light, suggesting the happiness apparent in their game. With total success Goya portrays, in this incident, childhood as a joyous and playful moment, in contrast to the bitterness of the elderly woman. In the companion scene he depicts senescence as an age entrenched in faded, outworn beliefs and employs the young duchess as a bridge between the two stages of life. Though she is a married woman, the taste for childish play is still alive in her, which is apparent in the easy freedom of her actions. AR

NOTES
1. Ezquerra del Bayo 1928, 190.
2. Wilson-Bareau 1993–1994, 260.

51. *The Duchess of Alba and "La Beata,"* 1795

María del Pilar Teresa Cayetana de Silva Álvarez de Toledo, thirteenth duchess of Alba, was one of Goya's major patrons. She commissioned from him several portraits: one of herself in 1795 (see p. 40, fig. 5), another of her husband, the marquis of Villafranca, whom she married at the age of twelve (Museo Nacional del Prado, Madrid), and a third, painted in 1797, also of herself, now widowed and with mantilla (see p. 41, fig. 6).

The relationship between the duchess, who on her father's death in 1770 had inherited her grandfather's title and fortune, and the then already celebrated painter was marked by surprising directness and mutual trust. This gave rise to the popular legend, needless to say entirely unsubstantiated, of a love affair between the improbable couple. The duchess felt free to visit the painter in his studio, requesting he paint her face (that is, possibly, apply makeup) then and there, and also commissioning a full-length portrait, presumably among those mentioned above. Goya confirms this meeting in a letter to his friend Zapater: "You really ought to come help me paint the Alba woman, who showed up in the studio yesterday demanding I paint her face then and there, and she got her way. In any case I like it better than painting on canvas, but I still have to do her full-length."[1] The duchess invited Goya to her Madrid palace of Liria, where he completed small-scale paintings astonishing in the intimacy of their subject matter and their apparent spontaneity. Goya's close observation of the inhabitants of the palace resulted in genre paintings, such as this one.

For *The Duchess of Alba and "La Beata"* the painter employed a thick canvas and prepared a light ground layer on which he sketched the figures, covering the background later with a fine layer of watery blue-gray and leaving visible in the lower corner his signature and the date. In this playful scene we recognize the duchess, in yellow, by her famous black ringlets. Cayetana is having fun. She confronts "La Beata," identified by José Ezquerra del Bayo as Rafaela Luisa Velázquez, with a coral amulet that protects against the evil eye.[2] The panic-striken old woman defends herself with a cross, as if from a demonic apparition.

Oil on canvas
30.7 x 25.5 cm
Museo Nacional del Prado,
Madrid, inv. 7020

Signed and dated: Goya year 1795

PROVENANCE: duchess of Alba; by descent to Tomás Berganza; 1900, Carmen Berganza de Martín; 1985, sold Sotheby's, Madrid, 27 February, lot 35; 1985, acquired by the State for the Museo Nacional del Prado.

EXHIBITIONS: Madrid 1900, no. 102; Paris 1987–1988, no. 101; Saragossa 1992, no. 23; Madrid, London, and Chicago 1994, no. 64; Stockholm 1994–1995, no. 17; Madrid 1995, no. 19; Madrid 1996c, no. 86.

BIBLIOGRAPHY: Gudiol 1970, no. 368; Gassier and Wilson 1971, no. 352; Glendinning 1992, 123; Morales 1994, no. 258.

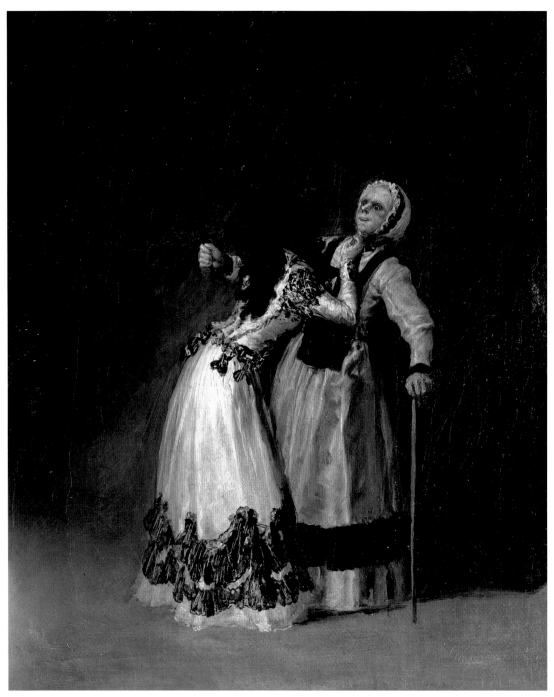

Following his illness in 1793, Goya found cabinet paintings particularly suited to his creative capacities. In such noncommissioned works he could express himself freely; he was under no obligation to cater to a patron's tastes. *The Duchess of Alba and "La Beata,"* along with its companion piece *"La Beata" with Luis de Berganza and María Luisa de la Luz* (cat. 50), deal with topics Goya chose himself. The duchess must have liked them, for she kept the peculiar pair. In a commissioned work it would have been unthinkable for her to be seen from behind, or for her to yield pride of place to a servant facing front. Defying the norms of neoclassicism, according to which genre painting was vastly inferior to paintings on historical themes, Goya chose daily life as his subject. To focus attention on his characters he placed them in an undefined space, ignoring the rich and renowned decor of the Alba palace.

As is typical in his cabinet pictures, Goya worked the small canvas with quick, fine brushstrokes and innovative technique. For example, he detailed the duchess' lace with the hard end of the brush and seemed to carve the black paint surfaces with short scratches.

In addition to their meetings in the palace on Barquillo Street, the duchess of Alba also permitted Goya to attend her in the summer of 1796 at her home in Sanlúcar de Barrameda, the peaceful estate where, after the Italian notebook, the painter found he could return to drawing as a creative medium. Here he completed the delicate sketches of the Sanlúcar album and his Madrid album. Both drew inspiration from the noble lady who serves as subject throughout most of the pages, which would in turn provide the iconographic basis for numerous etchings in the Caprichos. AR

NOTES

1. Salas and Agueda 1982, 225, no. 135.
2. Ezquerra del Bayo 1928, 190.

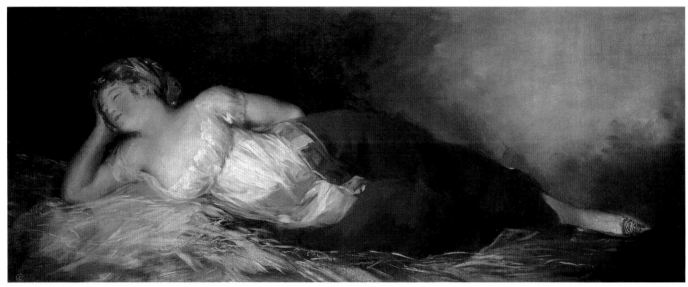

52

52. *Sleeping Woman*, c. 1792

Lying on a bed of straw, this young woman enjoys a pleasant dream in a barely defined space. It would be speculation to decipher it either as a granary or as a shadow emanating from some barely recognizable trees in the background of the canvas (Ferrari.) Supporting her head with her right hand as her elbow leans against the floor, she does not seem like a country girl or a maja, because she is dressed in a frock made of a simple white material that folds in fine pleats. Her short-waisted garment, short sleeves, and open neckline highlight the sensuality that the model radiates with her posture as sleeping beauty. In a suggestive form, the red woolen cloth accentuates her wide hips and thighs and marks her pubic area with its golden fringe. Even as a static body, the composition evokes the rhythm of a contrapposto: Goya conveys the contraction and relaxation of her limbs through her bent leg, which contrasts with her straight leg, and through the arm placed behind her back, which corresponds formally to the bent arm supporting her head.

The outfit is completed with a scarf in different shades of blue that gathers her curly blond hair and the pointed slipper into which her white stockinged leg slides. Although the tonality of the painting centers on the saturated red of the wool cloth that attracts the gaze of the spectator, the warm brightness that highlights her breast and the diffuse light that emanates from the background balance this.

The posture of the young woman assures better visibility for the spectator looking up at her. In addition the rectangular format, size, and high viewpoint of this work suggest that it might have been a relief figure placed high on the wall, perhaps above the lintel of a door, or the mantel of a fireplace. This painting is often referred to in conjunction with Count Maule, Nicolás de la Cruz Bahamonde, and his well-known *Trip from Spain to France and Italy*, published in 1813. Maule asserts in his account that Sebastián Martínez—in whose house in Cadiz Goya recovered from his illness in 1792—had in his possession three panels over the door by Goya's hand. Gassier and Wilson infer,

Oil on canvas

59 x 145 cm

Luis Mac-Crohon Collection, Madrid

———————

PROVENANCE: 1928, first appearance in public; collection of Francisco Acebal y Arratia

EXHIBITIONS: Madrid 1900, no. 59; Madrid 1913; Madrid 1928, no. 1; Madrid-London-Chicago 1993–1994, no. 74; Madrid 1995–1996, no. 24

BIBLIOGRAPHY: Gassier and Wilson 1970, no. 914; Gudiol 1970, no. 351; Glendinning 1978; Symmons 1988, 25; Baticle 1992, 344; Morales 1994, no. 417

and others such as Morales Marín seem certain, that one of those paintings is the one of which we speak here.

Goya resorted to the rectangular format on several occasions, for example, in the *Maja desnuda* (cat. 54) or in the *Marchioness of Santa Cruz* (cat. 40), cited as a descendant of *Sleeping Woman*. Sleep is a constant theme in Goya's work, and it can have a purely picturesque meaning, as in the sleeping girl in the cartoon of *The Laundresses* (cat. 10); or it can represent the key concept of the Enlightenment, as in *The Dream of Reason Produces Monsters* (Capricho 43). Closer to the dream of the washerwoman, the dream of the sleeping girl does not produce monsters but simply attracts the gaze of the voyeur. The onlooker recognizes in the sleeping beauty an expectant giving of herself, like the sleeping Ariadne of Titian and the sensual shepherdess of Watteau and the rococo painters. Her reclining posture and her head supported by a bent arm evoke not only the iconography of the ultimate sinner, but also the repentant Mary Magdalene, reconsidered in the scriptures (Hofmann). Goya found examples of such popular iconography in the work of Becerra or Coffermanns in the Royal Collection of Ferdinand VII. AR

53. *Sleep*, c. 1798–1808

Oil on canvas

44.5 x 77 cm

The National Gallery of Ireland, Dublin

———————

PROVENANCE: 1900, marquis of Casa Jiménez, Madrid; his widow; 1924, Mathilde Kocherthaler collection, Berlin; heirs of Mathilde Kocherthaler; Heinemann collection, New York; Thomas Agnew & Sons, London; 1969, National Gallery of Ireland.

The provenance of this painting prior to 1900, along with the identity of its commissioner, is unknown. Some authorities connect the work with a group of three overdoors Goya painted for Sebastián Martínez, in whose house the painter lived during his illness in the winter of 1792–1793. Nicolás de la Cruz, count of Maule, notes the works in his book *Viaje de España a Francia e Italia (Journey From Spain to France and Italy)* but does not mention the subjects of the paintings. Du Gué Trapier identifies *Gossiping Women* (cat. 48) and *Sleeping Woman* (cat. 52) as two of these overdoors, and Gudiol adds *Sleep*.[1] But Rosemary Mulcahy points out that the three works bear very distinct imprints, and are dissimilar, too, in coloration and size. *Sleeping Woman* is twice as large as *Sleep* and in it warm red and yellowish tones predominate. The female figure in the Dublin canvas, in contrast, is painted with brushstrokes of a

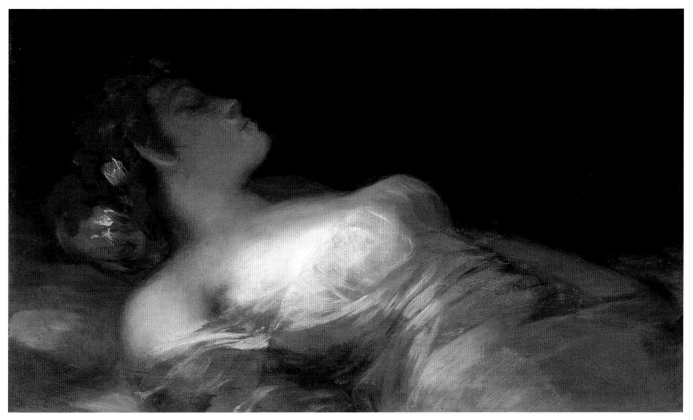

53

EXHIBITIONS: Madrid 1900, no. 120;
Berlin 1908, no. 18; Paris and The
Hague 1970, no. 32; Paris 1979,
no. 8; Hamburg 1980–1981, no. 292;
Tokyo 1993 1994, no. 52, Madrid
1996c, no. 76.

BIBLIOGRAPHY: Gudiol 1970, no. 323;
Gassier and Wilson 1971, no. 746;
Baticle 1970, no. 32; Mulcahy 1988,
19–20; Morales 1994, no. 326.

different thickness and impasto on a gray base that Mulcahy finds comparable
to the *Maja vestida* (cat. 55).[2] Baticle thinks that Manuel Godoy, who collected
erotic scenes in his private study, may have commissioned this sensual sleeper,
and suggests that the work was painted around the same time as the famous
majas, between 1795 and 1805.[3] AR

NOTES

1. Trapier 1964. 8–9; Gudiol 1970, no. 323.
2. Mulcahy 1988. 19–20.
3. Baticle in Paris and The Hague, 1970, 190, no. 32.

54. *Maja desnuda (Naked Maja)*, 1797–1800

Oil on canvas

98 x 191 cm

Museo Nacional del Prado,
Madrid, inv. 742

PROVENANCE: 1800, seen by
González de Sepúlveda in the "secret
study" of the Godoy palace, Madrid;
1808 removed and placed in the Real
Academia de Bellas Artes de San Fer-
nando; 1814, seized by the Inquisi-
tion; 1836, returned to the Academy;
12 September 1901, the Museo
Nacional del Prado by royal order;
1910, first mentioned in the
museum's catalogue.

EXHIBITIONS: Madrid 1900, no. 9;
Geneva 1939, no. 6; London
1963–1964, no. 85; New York 1964;
Kyoto and Tokyo 1971–1972, no. 31;
New York and Washington 1976, no.
6 and 7; Mexico 1978, no. 37;
Barcelona 1977, no. 36; London 1990;
Madrid 1996c, no. 94.

On 16 March 1815 the tribunal of the Inquisition issued a subpoena for Goya to
appear, "that he might acknowledge and declare the works to be his, why he
created them, at whose request and to what end."[1] The questions posed to the
Aragonese painter concerned two enigmatic paintings: The *Maja desnuda* and
the *Maja vestida*. His reply, if any, remains unknown.

 Though the canvases have aroused the curiosity of numerous scholars, the
Inquisition's questions remain unanswered since the early nineteenth century.
We do not know who commissioned the paintings. Research focused first on
the duchess of Alba, who had presented to Manuel Godoy, for his private study,
Velázquez' *Toilet of Venus* as well as a sixteenth-century Italian school Venus. It
was there that Pedro González de Sepúlveda saw the *Maja desnuda* in 1800.[2] If
true, such an account supports arguments that the duchess herself served as
the model, and that, as Viardot suggested in 1843, she ordered the head altered
to conceal her identity.[3] More recent investigations incline toward the Prince of
Peace (Godoy) himself as patron:[4] Goya had developed a most productive artis-
tic relationship with him at the time. Baticle proposes Pepita Tudó, Godoy's
mistress, as the most likely model, claiming that her head was refashioned in
1797, when Godoy wed the countess of Chinchón.[5]

 What is certain is that the *Maja desnuda* was painted before 1800, since
Sepúlveda's commentary gives us the date *ante quem*. It was hidden in Godoy's

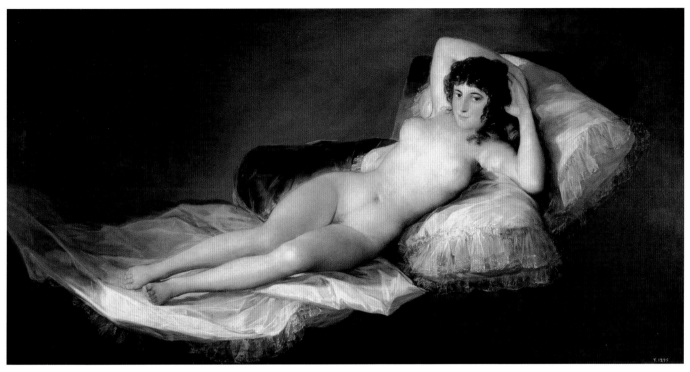

54

BIBLIOGRAPHY: Gudiol 1970, no. 539; Gassier and Wilson 1971, no. 743; Licht 1979 (1983), 83–91; Bull and Harris 1986, 643–654; Tomlinson 1992a, 115–127; Tomlinson 1992b, 59–64; Glendinning 1992, 246; Morales 1994, no. 314; Haidt 1995, 477–503; Nagel 1997.

private study, along with the duchess of Alba's two generous gifts. The *Maja vestida* was added shortly thereafter and is mentioned in Frédéric Quilliet's 1808 inventory.[6]

It is commonly alleged that Goya sought to create companion paintings, either in the style of Titian, whose *Venus and Adonis* complements the *Danae* when the two are placed face to face, or along the lines of Juan Carreño's *Monstruas* (Museo Nacional del Prado, Madrid), naked and clothed.[7] Although the *Maja vestida* is smaller, it was meant to provide—almost literally—"closure" for the earlier painting.[8] Various models are advanced as Goya's source of inspiration: the two Venuses from the same private study, whether Velázquez' (Harris), the Titian copy (Tomlinson), or perhaps the Titian *Bacchanal* (Clark).[9] But to grasp Goya's genius we need only note the novel concept of the female nude he had assumed. Goya jettisons "excuses" for the nude: his model is not asleep, nor does she feign ignorance about being observed. Quite the contrary. She exposes herself without modesty, her arms behind her head, her pubis the center of the composition. Guests in Godoy's private study hailed her as the most lofty incarnation of female beauty; subsequent centuries have acclaimed her as the prototype of Spanish womanhood.

Sepúlveda criticized the *Maja desnuda*, rather unjustly, as "a work devoid of draftsmanship and clumsy in coloration."[10] But the academic engraver was doubtless shocked by so shameless a display of the human body. A more objective assessment would stress Goya's great mastery of human anatomy, clearly observable in his full-figure nude studies from life, or earlier, in the perfectly balanced *Christ on the Cross* (Museo Nacional del Prado, Madrid), the painting that gained him admittance to the Real Academia de Bellas Artes de San Fernando in 1780. Goya's skill is obvious in this painting, as well as in the *Maja vestida*, where the play of cold light and subtle shadow shape the figure with absolute assurance. The maja reclines on a green velvet sofa, covered by a sheet and a pillow adorned with lace, astonishing in its delicate transparency and tonal gradation. The pallor and chill of the lighting and the chosen range of color, her positioning, and her level of exposure to the viewer all recall the Ariadnes of classical sculpture. But this Ariadne is awake, and fixes her gaze directly on the observer, thus transforming the encounter between them into an erotic occasion. AR

NOTES

1. Figueroa 1929, 3–7; Canellas López 1981, Doc. CXXV.
2. Canalís 1979, 301–302.
3. Viardot 1843, 179.
4. See Rose 1983a and Tomlinson 1992a, 115–116.
5. Baticle 1992, 258–263.

6. Gallo 1900, 95–126; Rose 1983b, Doc. 1, 423–452.

7. Licht 1979 (1983), 88.

8. Gassier and Wilson 1971, nos. 743–744; Nagel 1997, 97–102.

9. Bull and Harris 1986, 653; Harris in London 1990, 13. See also Tomlinson 1992a, 118–119, and Clark 1953, 191.

10. Canalís 1979, 301–302.

55. *Maja vestida (Clothed Maja)*, 1800–1805

Since the early nineteenth century the *Maja vestida* has been paired with the *Maja desnuda* (cat. 54), the latter painted before 1800, when Pedro González de Sepúlveda mentions it after his visit to Prime Minister Manuel Godoy's palace.[1] No mention is made of the *Maja vestida*, which led Elías Tormo to conclude, in 1902, that this canvas dates from a later period.[2] Although the source of the commission is unknown, the work is thought to have been executed between 1800 and 1805, when the painter's professional ties to Godoy ended. The *Maja vestida* is first cited in an 1808 inventory, carried out after the Prince of Peace (Godoy) fell from grace and his assets were seized by Ferdinand VII.[3] Under the French occupation, Joseph Bonaparte commanded his agent Frédéric Quilliet to inventory all Godoy's holdings. Quilliet classified both majas in the third section of his inventory as works of secondary nature: his take on the subject agrees with Sepúlveda's criticism of the *Maja desnuda:* "ill drawn and clumsy in coloration."[4]

The moment the paintings came to light, scholars strove to confirm that the duchess of Alba was their model. French authors in particular—Louis Viardot and Charles Baudelaire, for instance—endorsed this tale, believing the image to be that of an aristocrat dressed as an Andalusian maja, then considered the perfect incarnation of Spain and the soul of *majismo*. But close observation reveals inaccuracies of dress that have little to do with any known Andalusian attire, even that of a maja. Like the *Maja desnuda*, this clothed one reclines on a divan, her hands crossed behind her head, and looks out at the observer. Although she is called a maja, she is not wearing the characteristic attire of women of this plebeian class, whom Goya frequently drew or painted

Oil on canvas

95 x 190 cm

Museo Nacional del Prado, Madrid, inv. 741

———

PROVENANCE: 1808, Godoy collection; 1808, sequestered by order of Ferdinand VII; Real Academia de Bellas Artes de San Fernando, "almacen de cristales"; 1813, confiscated by the Inquisition; 1836, Real Academia de Bellas Artes de San Fernando; 12 September 1901, Museo Nacional del Prado; 1910, first mentioned in the museum's catalogue.

EXHIBITIONS: Madrid 1900, no. 8; Geneva 1939, no. 7; London 1963–1964, no. 86; New York 1964; Kyoto and Tokyo 1971–1972, no. 30; New York and Washington 1976, nos. 5 and 8; México 1978, no. 36; Barcelona 1977, no. 37; London 1990; Madrid 1996c, no. 95.

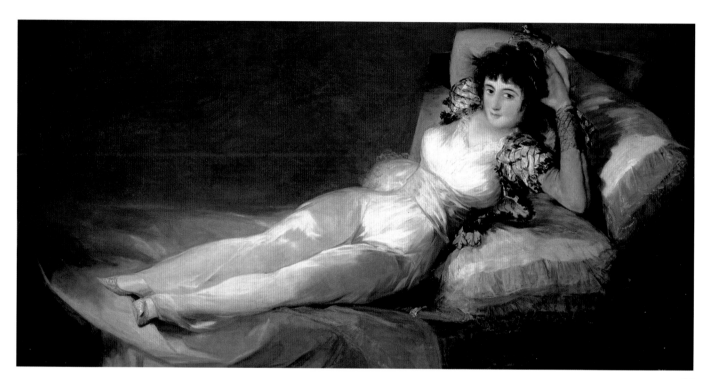

55

and of whose dress he possessed very precise knowledge. She displays neither the traditional *basquiña* nor the usual hair arrangement: she wears neither hair netting nor mantilla. Her body is clothed in a white chemise, cinched at the waist by a broad sash. The little jacket she wears is not the characteristic *jubón*, the bodice seen on the maja in the foreground of *The Meadow of San Isidro*, but rather a different item of clothing loosely based on it. Her shoes have pointed toes, better suited to a lady than a maja; the majas preferred square-toed shoes with silver buckles. Given these discrepancies, it is worth noting that early commentators on the painting did not see in the model a maja at all, but rather a "Clothed Venus" or a "Gypsy": the painting is so listed in the 1813 inventory of Godoy's assets ordered by Ferdinand VII.[5] In a recently published document from the General Register of Attachments of 22 November 1814, both majas are classed with "five obscene paintings," a classification that failed to prevent the exhibition of the *Maja vestida* (as it did the *Maja desnuda*) in the halls of the Real Academia de Bellas Artes de San Fernando, which had the canvases in its keeping from 1836 until 1901.

The *Maja desnuda* and the *Maja vestida* mark two technical extremes. The former is defined by exact and finished brushstrokes, and the painter indulged in a brilliantly executed tonal gradation, stressing the subtleties of the surfaces. The *Maja vestida*, by contrast, reveals abrupt brushstrokes that seem in constant motion. Here strong colors summarily describe the flashy jerkin and the green of the divan, in no way a literal copy of the earlier couch, in which Goya highlighted the velvet textures. Space in the *Maja vestida* is flat. The painter dispenses with the diffuse background lighting that clearly evokes surrounding areas in the *Maja desnuda*. The delicious laces and fabrics have likewise been modified and simplified. These might well arouse the envy of the *Maja vestida*, reclining as she does on a less elegant and less opulent piece of furniture. AR

NOTES

1. Canalís 1979, 301–302.
2. Tormo 1902, 214 and 218.
3. Canalís 1979, 301–302.
4. Canalís 1979, 301–302.
5. Quilliet described the majas as "*Gitana nue/Gitana habillée*" (see Canalís 1979, 301–302), and as a "Clothed Venus" in the inventory of 1813 (see Sentenach 1921).

BIBLIOGRAPHY: Gudiol 1970, no. 540; Gassier and Wilson 1971, no. 744; Licht 1979 (1983), 83–91; Rose 1983a, no. 13; Rose 1983b, no. 247; Bull and Harris 1986, 643–654; Hempel-Lipschutz 1987, 219–220; Baticle 1988, 72–74; Tomlinson 1992a, 115–127; Tomlinson 1992b, 50–64; Glendinning 1992, 246; Morales 1994, no. 315; Nagel 1997.

56. *Brigand Stripping a Woman*, 1808–1811

Oil on canvas

41.5 x 31.8 cm

Marqués de la Romana
Collection, Madrid

———————

PROVENANCE: Juan de Salas, Palma
de Mallorca; prior to 1811, Pedro
Caro, marquis de la Romana, Palma
de Mallorca; 13 May 1870, sold Hôtel
Drouot , Paris; c. 1900, marquis de la
Romana, Madrid; by inheritance to
the present owner.

EXHIBITIONS: Madrid 1900, no. 60;
Madrid 1913; Madrid 1921, no. 5;
Brussels 1985, no. 28; Madrid 1985,
no. 46; Madrid, London, and Chicago
1993–1994, no. 77; Madrid
1995–1996, no. 27.

BIBLIOGRAPHY: Gudiol 1970, no.
348; Gassier and Wilson 1971, no.
916; Baticle 1992, 344; Volland 1993,
249–250; Hofmann 1993–1994,
55–56; Morales 1994, no. 419.

Goya often resorted to series paintings, composing his images on the basis of a shared theme or meaning, and using the subject matter or iconography of each work to link it with its pendant, or with other canvases from the same series. Early examples of this practice are his tapestry cartoons, unified by the decor programmed for a particular chamber, or the album drawings and theme-based sequences of the Caprichos. Other important examples are provided by the genre paintings dating from the early 1790s, or by the Maragato series: an entire cinematographic sequence consisting of six "takes" on the capture of a bandit by a monk. Toward the end of the nineteenth century, and along these same lines, Goya painted a story sequence concerning outlaws, to which the present scene belongs. Bandits as highwaymen, the protagonists of several sketches from the Madrid album, constituted a popular cabinet painting subject for Goya. One of the first examples is *The Assault on the Coach*, which forms part of the "country scenes" sequence adorning the Alameda palace of the duke and duchess of Osuna; another is *The Assault by Thieves,* a cabinet painting from 1793 (both private collections). A consecutive reading of the criminal series reveals images of steadily intensifying violence. Barbarous acts reach their unspeakable culmination in *Brigand Murdering a Woman* (cat. 57). Here, unlike the earlier attack scenes, the painter concentrates on the commonplace humiliations women endured during such misfortunes. The observer is witness to the bandits' protraction of the victim's suffering, intimately linked to her sex and very deliberately depicted by Goya. Before killing them, the bandits undress and brutally rape the women.

As he does in the other scenes from the set of paintings owned by the marquis de la Romana, Goya organizes the compositions through sharp contrasts of light and shadow. This time he abandons the cities, the site of crime and disease, and climbs high into the mountains, a setting that turns out to be no safer, for it is the highwaymen's abode. The three paintings are set in dark mountain caves; the story—conveyed by thick brushstrokes—seems to explode in light. This painting provides the connection between *Bandits Shooting Their*

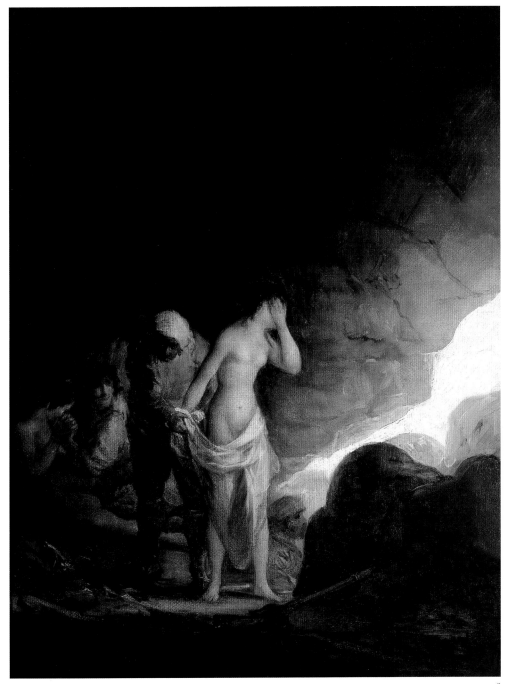

56

Prisoners and *Brigand Murdering a Woman*. An old bandit is slowly stripping his victim, who turns away, shielding her face with her hand, in a gesture of shame and despair. The first bandit's companion watches from the background, smiling and enjoying himself, ignoring the pleas of the second victim, who lies on the ground. The clothing torn from the women, a jumble of loose brushstrokes in blue and red, amidst which one blue shoe is discernible, along with the red sparks released by the brazier on the opposite side of the canvas, mark the sole touches of color in Goya's restricted range: the painting is almost a chiaroscuro.[1] The technique is based on fine glazes laid over a clear preparation, which allows the texture of the canvas to shine through, particularly in the delicate body of the main victim. AR

NOTES
1. Wilson-Bareau 1993–1994, 277–278.

57. *Brigand Murdering a Woman*, 1808–1811

Oil on canvas
41.5 x 31.8 cm
Marqués de la Romana
Collection, Madrid

PROVENANCE: Juan de Salas, Palma de Mallorca; prior to 1811, Pedro Caro, marquis de la Romana, Palma de Mallorca; 13 May 1870, sold Hôtel Drouot, Paris; c. 1900, marquis de la Romana, Madrid; by inheritance to the present owner.

EXHIBITIONS: Madrid 1900, no. 58; Madrid 1913; Madrid 1928, no. 36; Madrid, London, and Chicago 1993–1994, no. 78; Madrid 1995–1996, no. 28.

Following the shootings of the male travelers and the rape of the female, the de la Romana triptych on bandits concludes with this scene, which, like the preceding works, is set in a rocky landscape outside a cave. Collapsed on the ground and mortally wounded, as indicated by the blood emerging from her side, a woman lies screaming in desperation. She is struggling: her slightly raised leg is her last attempt at resistance. The bandit crouching over his victim puts an end to the struggle: he bends his right arm up behind her back and thrusts a dagger into her throat. Goya employs different techniques for the young assassin and his wretched victim. Broad, expressive strokes evoke the criminal's curly hair, his yellowish vest, and the transparent gloss of his white shirt with its rolled-up sleeves, which expose one muscular arm. Finer strokes were used for the clear varnishing that functions, as it did in one of the earlier scenes (cat. 56), to model the woman's body. Her pale skin once more resembles the polished surface of a marble statue. The original fabric of all these paintings reached just to the edge of the frame; fortunately, this canvas was

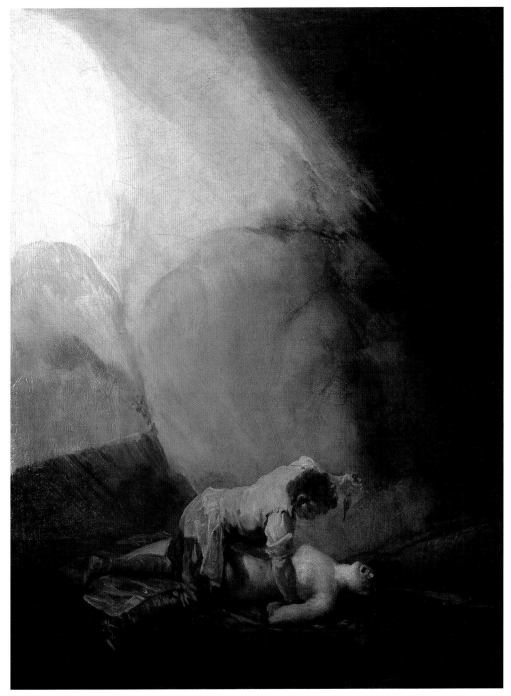

57

BIBLIOGRAPHY: Gudiol 1970, no. 350; Gassier and Wilson 1971, no. 917; Baticle 1992, 344; Volland 1993, 249–261; Hofmann 1993–1994, 55; Morales 1994, no. 420; Klein 1998, 236.

never folded over, so the light tone of the preparatory layer remains visible around the edges of the composition. The painter uses this background as a middle tone to evoke the luminous quality of the female body and the lighter-colored rocks.

Confronted with this portrayal of violence, one wonders why Goya chose to paint such scenes and what motivated the marquis de la Romana to acquire them. The scenes have been interpreted as an artistic reaction to an actual incident that was discussed in contemporary news, yet they lack any particulars concerning the real people involved, the time, or the location of the crime.[1] The new date suggested for the series allows a connection between this painting and the kidnapping scene from the Caprichos, subtitled *They Carried Her Off! (Que se la llevaron!).*[2] Here again, Goya emphasizes feminine fragility and the irrational savagery of the male, inflamed by lust and desire, a leitmotif of the Caprichos etchings and many other images and satirical sketches of the period.[3] Gerlinde Volland and Peter Klein, however, view Goya's insistence on terror and violence as an artistic reflection of the current popular debate on the aesthetics of the Sublime, analyzed by Edmund Burke in his famous treatise *A Philosophic Inquiry Into the Origen [sic] of Our Ideas on the Beautiful and the Sublime* (1757).[4] In this text Burke describes terror as one source underlying our sense of the Sublime. Rape and the exposure of nude female bodies are seen as as acts of male dominance with erotic associations, explained by Diderot—Burke's loyal follower—as a legitimate variation on the terrifying Sublime, whose literary equivalent is found in the works of the marquis de Sade. From a feminist standpoint, only male observers could derive aesthetic pleasure from the scene, which betrays Goya's supposed misogyny.[5] This interpretation makes the painter a pioneer psychologist in the analysis of the murder of women: the victim's open mouth becomes a fixed feature in the iconography of crimes of passion, as is obvious in the work of George Grosz and Otto Dix. AR

NOTES
1. Madrid 1995–1996, 106.
2. Wilson-Bareau 1993–1994, 278.
3. Wilson-Bareau 1993–1994, 278.
4. Volland 1993, 252; Klein 1998, 236.
5. Volland 1993, 252.

58. *Vagabonds Resting in a Cave,* 1808−1811

In addition to the two pictures entitled *The Monk's Visit* and *Prison Interior* and the bandit trilogy, all in vertical format and painted on a lightly prepared ground, three more works, on separate topics without a common link, form part of the eight cabinet paintings belonging to the marquis de la Romana. *Plague Hospital, Execution in a Military Camp,* and the present canvas might just as well have been painted at a different time: the compositions are executed in a rectangular shape against an orange-toned preparation, rendering them warmer than the others.

The theme of this work has been variously interpreted. Mayer entitled it "Thieves' Den," but other scholars view the locale and its protagonists as a "Gypsy Cave" or a "Bandits' Cave."[1] Desparmet Fitz-Gerald called it *Vagabonds Resting in a Cave.*[2] Morales dates the series to 1810 or 1811 and relates the scene to the War of Independence; he sees the figures as guerrillas or soldiers guarding hostages.[3] But in 1993, when the paintings were cleaned, previously invisible details emerged allowing us to specify the subjects and dates involved, which coincide with the Caprichos. As he did in the murderous bandit scenes, Goya sets the present work inside a cave in which a cold, diffused light clings, entering from the open landscape. Inside, a group of donkeys seek shelter, along with men and women who, judging by their picturesque attire, are probably gypsies. This oddly peaceful assembly of human beings and animals has spent the night beside a fire, which is seen smoldering in the background. In the foreground a gypsy lies on his back, still deep in sleep. He is partially covered by his blue cape; the woman in the middle ground watches him. Just beside the entryway other gypsies are engaged in morning conversation, like the pair in the background by the fire. The subject of the painting is immediately clarified by the appearance of shearing scissors centered at the lower rim of the composition, a detail that was revealed by the cleaning. The gypsies can be identified accordingly as sheep-shearers who have spent their daily earnings on prostitutes, and the painting thus relates to various etchings from the Caprichos. According to Wilson-Bareau and Mena

Oil on canvas

33 x 57 cm

Marquis de la Romana Collection, Madrid

PROVENANCE: Juan de Salas, Palma de Mallorca; prior to 1811, Pedro Caro, marquis de la Romana, Palma de Mallorca; 13 May 1870, sold Hôtel Drouot, Paris; c. 1900, marquis de la Romana, Madrid; by inheritance to the present owner.

EXHIBITIONS: Madrid 1900, no. 57; Madrid 1913; London 1920−1921, no. 122; Madrid 1928, no. 34; Madrid, London, and Chicago 1993−1994, no. 79; Madrid 1995−1996, no. 29.

BIBLIOGRAPHY: Gudiol 1970, no. 354; Gassier and Wilson 1971, no. 920; Baticle 1992, 344; Morales 1994, no. 423.

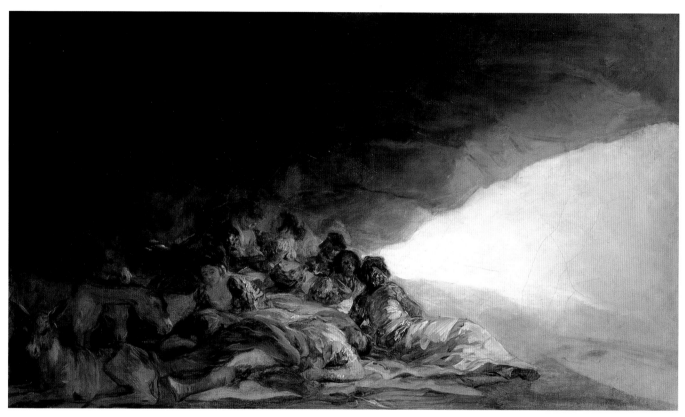

58

Marqués, both the woman observing the sleeping shearer and the proximity of the shears suggest the women "shaving" or "fleecing" their clients, a theme Goya had presented in *La descañona* (Capricho 35).[4] The topic likewise provoked the mockery of genre painters and caricaturists, who dealt with uncontrolled male passions and how easily they were exploited.

The donkeys may be a further allusion to the Caprichos. They are the protagonists in the so-called "assinines," where a teacher's ignorance before his student is satirized in the Capricho subtitled *Doesn't the Disciple Know More? (Si sabrá más el discípulo?)*. Or perhaps the donkeys are present to show how the couples reached their nocturnal refuge, which they will leave as soon as day has dawned fully. AR

NOTES

1. Yriarte 1867, 147 ("Scène de bandits"); Viñaza 1887, 289, no. LVIII ("Cueva de gitanos"); Mayer; 1923, no. 603.
2. Desparmet Fitz-Gerald 1928–1950, 227, no. 193 ("Caverne de vagabonds").
3. Morales 1994, no. 423.
4. Wilson-Bareau and Mena Marqués in Madrid, London, and Chicago 1993–1994, 283.

59. *Shootings in a Military Camp, 1808–1811*

The eight cabinet paintings that have been in the possession of the marquis de la Romana since the early nineteenth century deal with diverse aspects of daily violence: robbery, rape, or murder, where women play an undeniably central role. Goya makes women the prime victim of these miseries, as though through their reactions he could widen his emotional range. Human suffering caused by violence culminates in the present tragedy: the lighting and the central placement underscore the importance of women. The calm of night is suddenly broken by the soldiers' attack, mercilessly firing at other soldiers stationed there, producing a bloodbath. In the background is a tent, touched with red brushstrokes, an iconographic depiction of the flames that consume the enclosure. The dead lie to the lower left; their bloodstains are defined with the same reddish material. In the midst of the panic, several uninjured

Oil on canvas

32.6 x 57 cm

Marquis de la Romana Collection, Madrid

Madrid only

PROVENANCE: Juan de Salas, Palma de Mallorca; prior to 1811, Pedro Caro, marquis de la Romana, Palma de Mallorca; sold 13 May 1870, Hôtel Drouot, Paris; c. 1900, marquis de la Romana, Madrid; by inheritance to the present owner.

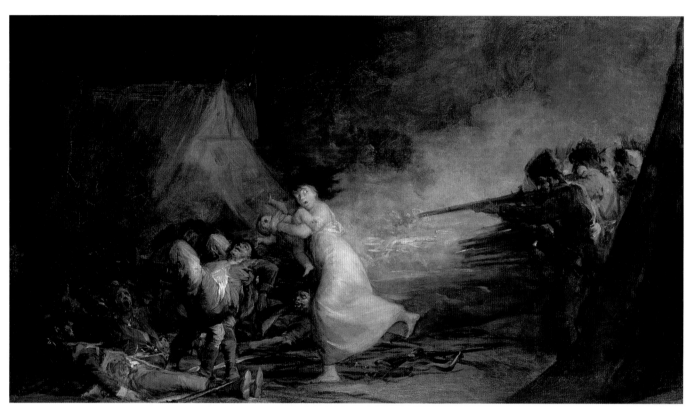

59

comrades strive to rescue the mortally wounded. The distorted faces of the dead attest to the massacre: wild gazes, black eye sockets, and open mouths with the teeth exposed. In all the confusion, Goya focuses on the young mother who flees with her child in her arms. The attackers block off the composition at her right flank, sending the viewer's attention to the woman who, racing away, turns a terrified glance towards her executioners. Goya centers the light, emerging from the shooting and from the conspicuous yellow dress, precisely on the pale skin of her face and breast. There he locates the core of the drama, although the woman's presence in the middle of a military encampment remains somewhat puzzling; perhaps she is a soldier's wife. Yet her luminous quality, together with the central placement, give her an unreal aura, as though she were in fact allegorical. Whatever her significance, the actual events of and the reasons for this nocturnal slaughter become mysterious since recent scholarship established the marquis de la Romana's collection as predating the War of Independence. Before 1993, when the series was reviewed and restored, opinions were unanimous: shootings and dead soldiers meant an incident from the war that began in 1808, ten years after the date indicated by more recent research.[1] Today it is suspected that *Shootings in a Military Camp* is, on the contrary, a story about "real life," or even an allegory, whose meaning underlies the entire sequence of paintings.[2]

The iconography of the picture anticipates other shooting scenes in the Disasters of War etchings, where soldiers execute rebels or civilians, among them women and children. The woman with the child is a precursor of the valiant woman from the etching *And They Are Wild Beasts* (cat. 115), who whirls around to face her attackers and to fight back. Both are barefoot; both have a shoulder bared, and both protect their offspring, one holding the child behind her back and the other in front, fleeing the danger. AR

NOTES

1. Mayer 1923, no. 606, interprets it as a war scene; see also Desparmet Fitz-Gerald 1928–1950, 250, no. 222; and Sánchez Catón 1946, 86.
2. Wilson-Bareau and Mena Marquéz in Madrid, London, and Chicago 1993–1994, 286.

EXHIBITIONS: Madrid 1900, no. 56; Madrid 1913; Madrid 1928, no. 41; Brussels 1985, no. 27; Madrid 1989, no. 45; Madrid, London, and Chicago 1993–1994, no. 81; Madrid 1995–1996, no. 31.

BIBLIOGRAPHY: Gudiol 1970, no. 355; Gassier and Wilson 1971, no. 921; Baticle 1992, 344; Morales 1994, no. 424.

60. *The Young Women (The Letter)*, 1813–1820

Oil on canvas

181 x 125 cm

Palais des Beaux Arts de Lille

———————

PROVENANCE: Javier Goya, Madrid, 1828–1836; sold to Baron Taylor in 1836 for the Galerie Espagnole of Louis-Philippe, Paris; his sale, Christie's, London, 1853, no. 353; acquired by Durlacher for 25 livres; Warneck, Paris 1874, Palais des Beaux Arts de Lille.

EXHIBITIONS: Valenciennes 1918, no. 139; Paris 1938, no. 20; Ghent 1950, no. 36; Bordeaux 1956, no. 40; Paris 1963, no. 126; Berlin 1964, no. 18; Paris and The Hague 1970, no. 42; Leningrad and Moscow 1987, no. 6; New York 1992–1993, no. 53; Tokyo 1993–1994, no. 56; Madrid 1996c, no. 146; Cambrai, Valenciennes, and Douai 1996–1997; Lille and Philadelphia 1998, 97–102; Lille 1998–1999, no. 53.

The Young Women has traditionally been seen as a pendant to *The Old Women (Time)* with which it has hung for over a century in the Palais des Beaux Arts in Lille. However, this assumption has been successfully challenged during the past decade. *The Old Women* is included in an inventory of Goya's paintings taken in 1812 on the death of his wife, Josefa Bayeu; *The Young Women* is not. X-radiography has shown that *The Old Women* is painted over an allegorical composition, a trait that links it to two other works painted over other allegorical compositions of the same series—the *Majas on the Balcony* (see p. 247, fig. 2) and *A Maja and Celestina* (private collection, Madrid). Moreover, it has been discovered that *The Old Women* was originally smaller and subsequently enlarged, presumably to serve as a pendant to *The Young Women.*

The Young Women was purchased from Javier Goya by Baron Taylor while he was assembling works for exhibition in the Spanish Gallery that opened in the Musée du Louvre in 1838. There it was exhibited as a pendant to *The Forge* (The Frick Collection, New York), to which it is identical in size. This would seem to be the pairing intended by the artist. Both these works—in contrast to the series of large genre scenes included in the 1812 inventory—are painted on fresh canvases, which might suggest they were painted after the conclusion of the Napoleonic War in Spain, when supplies such as canvas again became available.

The pairing of *The Young Women* and *The Forge* recalls earlier works by the artist in its juxtaposition of female and male, upper class and working class, leisure and labor, contemplation and activity. Since his early years as a painter of tapestry cartoons, Goya often enriched his genre scenes through such devices: in *The Crockery Vendor* (cat. 5) and *Autumn (The Grape Harvest)* (cat. 16), upper and lower classes are juxtaposed; *Autumn* also sets members of the upper classes against the background of the working classes—a composition repeated in *The Young Women.*

The lap dog begging for attention at the feet of the young woman has been compared to the beseeching suitor who—it is assumed—has written the letter. But we should not jump to the conclusion that Goya is condemning the

BIBLIOGRAPHY: Loga 1903, 217, no.
517; Mayer 1923, 70, 82, 94, 213, no.
630; Desparmet Fitz-Gerald 1928–
1950, I: no. 242; Sánchez-Cantón
1930, 72, pl. 65; Venturi 1941, 36–38;
Gassier 1963, 241, fig. 151; Salas 1964,
99–110; Gudiol 1970, no. 583; Hours
1970, 100; Gassier and Wilson 1971,
no. 962; Licht 1979 (1983), 204;
Gudiol 1980, no. 552; Baticle 1981,
no. 104; Oursel 1984, 190–191; Heckes
1991, 93–100; Baticle 1993, 383;
Morales 1994, no. 393; Tomlinson
1994, 213; Wilson-Bareau 1996, 96n.
6, 166; Mena Marqués 1998, 25–37.

young woman as a cruel mistress. Portrayed in thought as she reads a letter,
she recalls the images of contemplative women seen in the drawings of album
C (cat. 103). Although comfortably situated in society—she has a maid to carry
her parasol—she does not flaunt her charms as do women in Goya's drawings
who are the target of moralizing captions (cat. 106). Like so many of Goya's
genre scenes, *The Young Women* invites multiple interpretations and may well
suggest the artist's sympathy with his imagined subject. JT

ATTRIBUTED TO GOYA

61. *Majas on a Balcony*, 1814–1819?

Oil on canvas

195 x 125.7 cm

Lent by The Metropolitan
Museum of Art, H. O. Have-
meyer Collection, Bequest of Mrs.
H. O. Havemeyer, 1929

The *Majas on a Balcony*, whether by Goya or merely inspired by one of his
works, attests to the artist's interest in both popular types and in illusionism.
These interests were anticipated by his fresco in the dome of the church of
San Antonio de la Florida in Madrid (1798), where majas are among those
leaning on a balustrade, looking at the viewer standing below. Such themes
were not unique to Goya, however. Sometime after 1800, Charles IV had
commissioned exquisite decorations for a small pleasure house, known as the
Casa del Labrador (house of the worker), on the grounds of the palace at
Aranjuez. There we find a possible precedent for Goya's *Majas on a
Balcony* in the painting of a young dandy and a woman wearing a black
mantilla and *basquiña*, who speak to each other as they lean over a fictive
balustrade (fig. 1).

Another possible source of inspiration is the painting *Two Women at a
Window* by the seventeenth-century Spanish artist Bartolomé Esteban Murillo
(National Gallery of Art, Washington). Goya undoubtedly knew the work: not
only was it in the collection of the duke of Almodóvar, but it had been
engraved by Joaquín Ballaster in 1808, and a copy was in the royal palace.
Murillo's painting portrays *ventaneras* (women of the window)—a term that
connotes the wantonness of women who showed themselves at the window to
attract attention. Even though women of Goya's time had far more opportu-
nity to appear in public spaces than did those of Murillo's era, Goya still
invokes a similar connotation, as the coy gazes of the flirtatious women lead us
to question their motives.

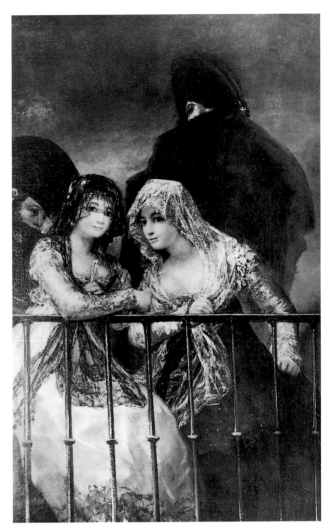

Perhaps no single work by—or possibly, attributed to—Goya has been the subject of more speculation over the past decade than has this version of *Majas on a Balcony.* Long considered one of the jewels of the collection of the Metropolitan Museum of Art, it suffered an abrupt fall from grace in 1993, when its attribution was challenged, on the basis of comparison with works that had been exhibited at the museum during the 1989 exhibition *Goya in the Spirit of Enlightenment.*[1]

In the 1995 exhibition *Goya in The Metropolitan Museum of Art,* this canvas was exhibited with another version of the same subject, in a private collection in Switzerland (fig. 2). The catalogue summarizes the debate concerning its attribution. Arguments against the painting included the observations that "almost all of Goya's undisputed canvases were recorded during his lifetime in one manner or another," and that this work only appears in an inventory seven years after Goya's death. It is not possible to find parallels for the facial expressions or the painting of the flesh, silks, and lace in the rest of Goya's work. In

Fig. 1 Attributed to Zacarías González Velázquez and Luis Jappelli, *Woman and a Dandy,* c. 1806, oil on canvas, Casa del Labrador, Aranjuez (photograph courtesy of the Patrimonio Nacional, Madrid)

Fig. 2 Francisco Goya, *Majas on a Balcony,* 1808–1812, oil on canvas, private collection.

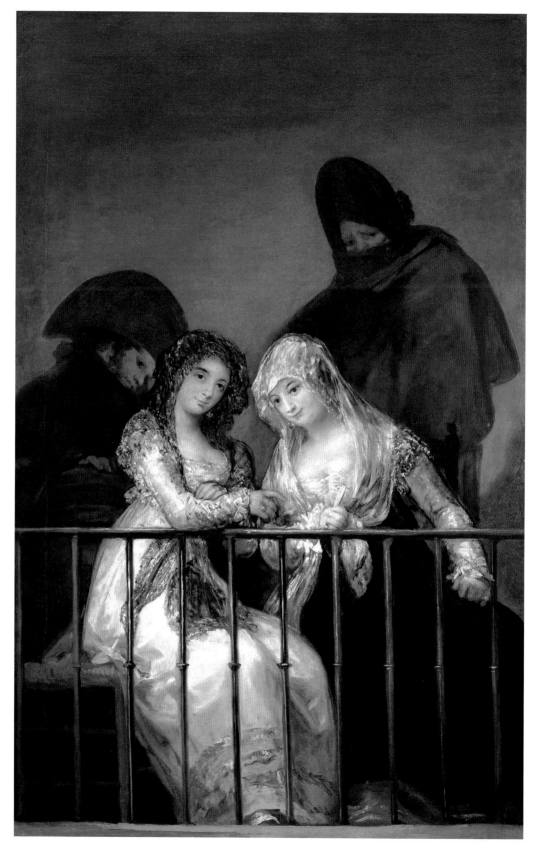

61

addition, the balcony was painted before the figures, a sure sign of a copy, and the use of a palette knife signals the hand of a Goya imitator. To counter, arguments in support of the attribution stated: the painting has been extensively restored and therefore cannot be firmly deattributed; the underdrawing shows the hand of the master; and the use of the palette knife, a very difficult technique, indicates the work of a sure master, not an imitator.[2]

Arguments against the attribution of the painting dominated a substantive review of the exhibition, written by one of the scholars involved in the debate, who did not accept the attribution to Goya. That author describes the Metropolitan's painting as "throwing away" the crisp complementary color scheme of the version in Switzerland, "through the lack of definition in its smeared and intermingled tones, and the distracting exposure of the red ground." The background figure is "flaccid," and the composition is said to lack "élan and cohesion." The author concludes that it is not possible to assign a hand to the work, only to "say with certainty 'Not Goya'."[3]

Responses to these arguments were voiced in a conference in 1996 and published in the accompanying publication.[4] Several arguments in favor of deattribution were raised. Why, it was asked, would an imitator use a palette knife if the original artist had not used such a tool? It was suggested that Goya did indeed use a kind of palette knife *(espátula)* fashioned from wood cane (a substitution made necessary by a shortage of materials imposed by the Napoleonic War). The same author pointed out that the canvas used for *Majas on a Balcony* was the same kind found in other paintings by Goya, and also that the x-rays showed that the balcony had been painted on top of the figures.[5]

Proceedings of the conference also summarized a presentation by Hubert von Sonnenberg, chairman of The Sherman Fairchild Paintings Conservation Center at the Metropolitan Museum of Art, supporting the attribution of the painting to Goya. Von Sonnenberg cited the opinions of several Goya specialists who agreed with his findings.[6] Nevertheless, in 1998 Manuela Mena Marqués described the painting as a work "studied in depth and rejected from the catalogue of Goya."[7] JT

NOTES

1. New York 1993, 15.
2. New York 1995, 66.
3. Wilson-Bareau 1996, 98−100.
4. Torres 1996, 131−149.
5. Torres 1996, 133, 136, 140, 145.
6. Hubert von Sonnenberg, "Sobre el Cuadro de La Majas al Balcón del Metropolitan Museum de Nueva York," in *Actas* 1996, 150−155.
7. Manuela Mena Marqués "Goya: La Question n'est pas résolue," in Lille and Philadelphia 1998, 35.

BIBLIOGRAPHY: Yriarte 1867, 90; Lefort 1876, 373; Bensusan 1902, 37, repro. 22; Loga 1903, 217, no. 513; Mayer 1903, 76ff., no. 628, repro. pl. 241; Stokes 1914, 350, no. 498; Brinton 1915, no. 89; Beruete 1917, II: 169, no. 228, repro. pl. 50; Zapater 1924, repro. pl. 294; Brieger-Wasserbogel 1924, repro. 68; Lafond 1924, 108, no. 43, repro. opp. 4; Havemeyer 1931, 43, repro. 42; Wehle 1940, 248−250, repro.; New York 1958, 34, no. 190, repro.; Havemeyer 1961, 83, 138, 144, 153−158; Schickel 1968, 25, repro. 17, detail repro. 25; Gassier and Wilson 1971, no. 960; Lugano 1986, 144, as by Goya; Weitzenhoffer 1986, 141, 154−156, 206, 254, color repro. pl. 122; Paris 1988, 324; Tinterow 1993: 13−17, 52−53, repro. 16, pl. 13, as copy after Goya; Morales 1994, 311−312, no. 416, repro., as by Goya; Wilson-Bareau 1996, 95−103, repro. 98; Wilson-Bareau 1997, 26n. 2, 36.

62. *A Maja and Celestina*, 1824–1825

Carbon black and watercolor on
ivory
5.4 x 5.4 cm
Private collection

———————

"It's true that last winter I painted on ivory and I have a collection of some
forty studies but it's an original miniature that I have never seen because it
isn't done with dots and things that look more like Velázquez' brush than like
Mens [*sic*]."[1] One of the "forty studies" Goya mentions in his 20 December
1825 letter to Joaquín Ferrer is this *Maja and Celestina*. The scene is painted on
a fine ivory leaf, like the rest of the series, of which only twelve have been pre-
served. Goya insists with some pride that he did not accomplish this work by
juxtaposed dots crafted with the brushtip, but rather through forceful, precise
strokes reminiscent of Velázquez' lines and not Mengs' more finished technique.

The procedure was described in detail in 1858 by Laurent Matheron,
author of the first monograph on Goya.[2] Matheron may have consulted
Antonio Brugada, a fellow painter and friend of the Aragonese master during
his exile in Bordeaux.[3] His information agrees with the results produced by
Eleanor Sayre in her 1966 (1979) analysis. Sayre confirmed that Goya started
off with a black preparation, manipulating the surface to extract light colors
until he exposed the luminous ivory.[4]

The detailed and finished strokes connect this *Maja and Celestina* techni-
cally with the small composition entitled *Susannah and the Elders* (private col-
lection). In both cases the painter applies delicate white touches to perfect
Susannah's clothing, or the maja's lace mantilla, and scrapes a tool over the
breast to convey the underlying garments. The scenes also share a spatial
design based on two planes and occupied by a female protagonist and a back-
ground figure. The maja replaces Susannah and the celestina takes the place of
the elders. Yet the roles in the biblical tale have changed: whereas the elders
were harassing Susannah, the young woman in Goya's painting is flaunting
herself to their view, perhaps hoping for a client. She is protected by the aged
celestina, who turns her face, muffled in a white mantle, toward the front. The
young woman-celestina pairing is a constant theme throughout Goya's oeuvre,
for example in the Sanlúcar album drawings, or in his later output dating from
the war years. During that time, Goya painted his acclaimed *Majas on a Balcony*

62

(see p. 247, fig. 2) and *Maja and Celestina on a Balcony* (private collection), registered in section 24 of the 1812 inventory. In one of these canvases a young woman leans forward against a railing and melancholically gazes out from high up on her balcony. Goya uses the same composition here, but for this smaller format suppresses the railing and puts the celestina back once again in the second plane. The arrangement of the figures at first glance recalls Bartolomé Esteban Murillo's *Two Women at a Window* (National Gallery of Art, Washington), which has always been viewed as a reference point for *Majas on a Balcony* (cat. 61), but which in fact more closely resembles the present painting. In Murillo's work, as in Goya's, the girl appears with one arm bent, cheek in hand, and smiling frankly at the observer. Goya transforms the background companion, who conceals her shameless smile behind her mantle, into an old celestina. AR

NOTES

1. Goya 1924, 55, letter no. III; Canellas López 1981, 389, no. 273.
2. Matheron 1858, unpaginated.
3. Wilson-Bareau 1993–1994, 324–325.
4. Sayre 1966 (1979), unpaginated.

63. *Monk Talking to an Old Woman, 1824–1825*

Ivory

5.7 x 5.4 cm

The Art Museum, Princeton University. Museum purchase, Fowler McCormick, Class of 1921, Fund

PROVENANCE: Edward Habich, Kassel; 27–28 April 1889, sold Habich, Stuttgart; sold Richard L. Feigen & Company, New York.

EXHIBITIONS: Madrid, London, and Chicago 1993–1994, no. 108.

On 2 May 1824 Goya asked permission from King Ferdinand VII "to take the waters at Plombières to ease the aches and ailments that plague him at his advanced age."[1] Having been granted a leave of absence, Goya—almost eighty years old at the time—crossed the border, heading to Bayonne on 24 June and then to his true destination. Following several months in Paris, Goya settled in Bordeaux, a city full of Spanish expatriots, among them Leandro Fernández de Moratín, who like others had sought refuge from Ferdinand VII's intolerable repression in Spain. Goya arrived "deaf, old, awkward, and weak," according to one of Moratín's letters to Juan Antonio Melón.[2] Once established in his new home, however, the painter wielded his paintbrush somewhat frenetically, leading Moratín to remark in July of 1825 that "he paints wildly, refusing ever to correct anything he has painted."[3] Such a frenzy of activity makes it possible for Goya to have executed, as he claims in a letter dated 20 December 1825, the "forty

63

BIBLIOGRAPHY: Gudiol 1970, no. 748; Gassier and Wilson 1971, no. 1685; Sayre 1979.

studies," a series of small ivories of which only a dozen remain.[4] Why the painter chose a format so unusual in his work, and only comparable to the miniatures of his family by marriage done on copper roundels in 1805 (see cats. 38 and 39), is unknown. In both groups he eschews ordinary miniaturist techniques and employs the brush as though for a large-scale work, applying the strokes swiftly but with precision. The ivories center around small genre scenes with familiar topics. *Monk Talking to an Old Woman* is a case in point. In five square centimeters Goya places two heads, one frontally and the other almost in profile. The faces are defined by the strong contrasts between the ivory and the black base coat. Goya scratches the surface with a sharp tip to accentuate the whites of the eyes and the shape of the teeth; a black line creates the nostrils and the lips, while a tinted brushstroke perfects the folds of the old woman's mantle. As Sayre points out, the juxtaposition of the two figures obviously evokes one of the Black Paintings in which a monk seems to be yelling at an aged hermit (Museo Nacional del Prado, Madrid).[5] But unlike the bearded hermit, in this miniature the old crone's eyes show shock and terror originating in something outside the confines of the composition: what could this be but the viewer himself? The liveliness of the figures, their emotion, and their somewhat diabolical characterization are, according to Sayre, common traits of the ivories as a whole.[6] AR

NOTES

1. Canellas López 1981, 496, no. CXLV.
2. Canellas López 1981, 497, no. CXLVII.
3. Canellas López 1981, 503, no. CXLVIV.
4. Goya 1924, 55, letter no. III; Canellas López 1981, 389, no. 273.
5. Sayre 1996, unpaginated.
6. Sayre 1996, unpaginated.

64. *Reclining Nude, 1824–1825*

The ivory miniature of the *Reclining Nude* was one of the "forty studies" Goya mentions in his letter of 1825 to Ferrer.[1] One analysis of his technique was supplied to us, fortuitously, by Laurent Matheron in his famous monograph of 1858 printed in Bordeaux, where Goya died thirty years before. In Bordeaux, Matheron contacted the painter's friends and profited from Antonio Brugada's extensive knowledge of the artist and his work: "He blackened the ivory plate and released a drop of water that quickly spread, removing part of the base and tracing random light areas; afterwards he used these grooves and got something original and unexpected."[2] Eleanor Sayre's technical analysis confirms Matheron's account: the painter coated the ivory with *humo de negro* (black vapor) and later on brought out the lighter tones by treating the surface with water or working it with tools.[3] As with etchings, Goya starts with the darker colors and advances toward the lighter; he employs the ivory tone to color the woman's body and to create the light reflected on the rock. To accent the boldest lines, he rakes the fine surface with a sharp implement. With transparent and opaque washes, he skillfully evokes the fabrics, carnations, and other more subtle details: a blue-green wash for the material covering the woman's torso; black touches for the curves and folds. Goya lightly sketches in her facial features, taking advantage of the dark preparation—as Sayre's analysis demonstrated—to form the shadows falling on her left cheek. Her dreamy expression, charged with sensuality, links this woman more closely to the *Maja desnuda* (cat. 54), the female nude par excellence, than to *Susannah and the Elders* (private collection), the other female nude in this series, whom Sayre considers the incarnation of feminine modesty.[4] AR

Carbon black and watercolor on ivory
8.7 x 8.6 cm
Museum of Fine Arts, Boston, Ernest Wadsworth Longfellow Fund

PROVENANCE: Sir William Stirling-Maxwell(?); Archibald Stirling; Mrs. Stirling; Museum of Fine Arts, Boston.

EXHIBITIONS: London 1928, no. 11; London 1938, no. 27; Madrid, London, and Chicago 1993–1994, no. 110.

BIBLIOGRAPHY: Gudiol 1970, no. 739; Gassier and Wilson 1971, no. 1688; Sayre 1979.

NOTES
1. Goya 1924, 55, letter no. III; Canellas López 1981, 389, no. 273.
2. Matheron 1858, unpaginated.
3. Sayre 1966, unpaginated.
4. Sayre 1966, unpaginated.

64

65–94. The Caprichos and Related Drawings

The eighty aquatint etchings known as the Caprichos, published in early 1799 and probably executed over the two preceding years, comprise Goya's best-known series of etchings. On 17 January 1799 the artist received payment for four sets of these prints from the duke and duchess of Osuna. The advertisement appeared in the *Diario de Madrid* on 6 February 1799, and again on 19 February 1799, describing these etchings as a

> Collection of prints of whimsical subjects, invented and etched by Don Francisco de Goya. The author is convinced that censuring human errors and vices—although it seems the preserve of oratory and poetry—may also be a worthy object of painting. As subjects appropriate to his work, he has selected from the multitude of stupidities and errors common to every civil society, and from the ordinary obfuscations and lies condoned by custom, ignorance, or self-interest, those he has deemed most fit to furnish material for ridicule, and at the same time to exercise the author's imagination.[1]

As with all etchings, the quality of the impression changes dramatically between editions, but also within the printing of a single edition. Exhibited here are prints from a very early impression of the first edition, which shows the full range of Goya's techniques—of etching, drypoint, or burnishing—before these effects were lessened through wear on plates. The many approaches that have been taken to the series confirms its unique complexity, as Goya's unprecedented use of the etching technique as well as the series' history and imagery still provide scholars with food for thought.[2] In this brief introduction, I turn from questions of early reception to focus instead on a single question that I have raised previously, namely, the internal chronology of the series and its imagery in the years preceding its publication.[3] The proposed chronology takes as its point of departure a study of the preparatory drawings for the series, published almost four decades ago by Enrico Crispolti.[4] That author traced the chronology according to the changing style of the preliminary

drawings for the etchings—as Goya progressed from very detailed pen and ink drawings to the most minimal sketches in red chalk—as well as the style of the etchings themselves. I then consider what this tells us about the evolution of Goya's imagery of women in the Caprichos.

The earliest drawings for this series are those bearing the manuscript title "*sueño*" (dream), detailed drawings executed in pen and ink (cats. 65 and 67). The dependence on line to define form in these drawings suggests that they were conceived as preliminaries for etchings, a suspicion confirmed by the platemark on many of the pages, showing that they were transferred directly to the plate. Background tones and shadows are achieved through hatching with only a minimal use of aquatint. Precisely defined figures, often caught in flight against a sky that is a single, pale tone, illustrate scenes of witchcraft, the first conceived themes of the Caprichos.

The preparatory drawing for *What a Sacrifice!* (cat. 80), number fifteen within the numbered sequence of twenty-seven *sueños* drawings, turns from witchcraft to social satire, and more specifically the relationship between the sexes. Drawing and etching introduce the theme of women as commodity, which dominates the second phase of the series' development. In this phase, Goya moves away from the very controlled pen and ink drawings of the earlier *sueños* drawings toward a broader definition of form and more dramatic tonal contrasts, translated into the bolder aquatint backgrounds of the etchings. He also abandons the sepia ink of the *sueños* drawings and experiments with red chalk, sanguine wash, and often a combination of both. As the technique of the preliminary drawings loosens to create more broadly defined figures, the scale of the figures on the page increases, as is seen by comparing the imprisoned women in *Because She Was Susceptible* (cat. 83) and its preliminary drawing with figural counterparts in *Where Is Mother Going?* (cat. 66).

As happens so often in Goya's work, this increased technical freedom parallels a growing iconographic freedom, as images become more overtly symbolic in nature. For example, no one suspects that the bride in *They Say Yes and Give Their Hand to the First Comer* (cat. 81) in fact attended her wedding in a mask or with a simian elder behind her: these attributes are added to imply the bride's duplicity and, possibly, the greed of her elder. *Now They Have a Seat* (cat. 90) belongs to this same group, as women carry chairs *(asientos)* on their heads, an ironic reference to the judgment *(asiento)* they lack. And as the iconography loosens, so does the technique of the preparatory drawings. These become increasingly sketchy chalk images that suggest that Goya, who matured as a printmaker during the intensive elaboration of this series, now transferred to the plate only the most general markings, and then elaborated them with etching needle and aquatint on the plate directly.

Although only broadly defined here, the cursory chronology nevertheless suggests how the imagery of women was elaborated as Goya developed this series. Goya began with scenes of witchcraft—which can best be contextualized by their relation to the series of witchcraft paintings executed for the duke and duchess of Osuna in 1797–1798. Goya's earliest images of men and women—such as *What a Sacrifice!*—recall late eighteenth-century English caricature, which Goya undoubtedly knew.[5] Had the Caprichos developed no further than this, they would undoubtedly be seen as a Spanish counterpart to the caricatures of British artists. But Goya did not stop here, going on to develop the imagery that blurred the boundaries between the symbolic, the everyday, and the supernatural. Evil and folly literally transform his figures, as vanity blinds the women in *Till Death* (cat. 91), and fickleness—real or perceived—encourages the duchess of Alba to sprout butterfly wings and take to the air. The Caprichos does not single out women for satire, but merely suggests that women and men are equal partners in the *"la multitud de extravagancias y desaciertos, que son comunes en la sociedad civil...."* JT

NOTES

1. Translated in Sayre et al. 1989: "Colección de estampas de asuntos caprichosos, inventadas y grabadas al aguafuerte por D. Francisco de Goya. Persuadido el autor de que la censura de los errores y vicios humanos (aun que parece peculiar de la eloqüencia y la poesia) puede tambien ser objeto de la pintura: ha escogido como asuntos proporcionados para su obra, entre la multitud de extravagancias y desaciertos, que son comunes en toda sociedad civil, y entre la preocupaciones y embustes vulgares, autorizados por la costumbre, la ignorancia ó el interes, aquellos que ha creido mas aptos á subministrar materia para el ridiculo, y exercitar al mismo tiempo la fantasic del artifice." Reproduced in Harris 1963, 103.

2. Blas 1999.

3. Tomlinson 1989a.

4. Crispolti 1963, 391–433.

5. Wolf 1991.

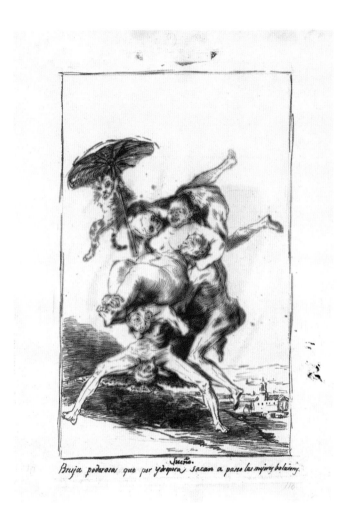

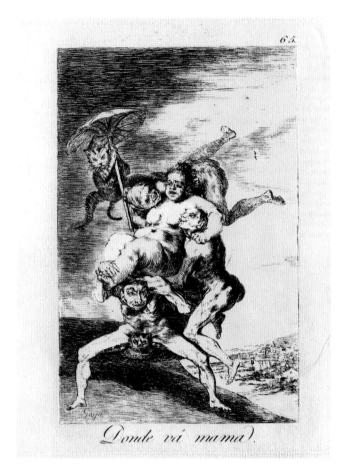

65. *Sueño. Bruja poderosa que por ydropica sacan a paseo las mejores boladoras (Dream. Mighty Witch Who Because of Her Dropsy Is Taken for an Outing by the Best Flyers)*, 1797–1798

Pen and sepia on paper

24 x 16.8 cm

Museo Nacional del Prado, Madrid, D. 4205

66. *Donde vá mamà? (Where Is Mother Going?)*, 1797–1798

Etching and aquatint on paper

21.4 x 14.9 cm

Brooklyn Museum of Art, A. Augustus Healy Fund, Frank L. Babbott Fund, and Carll H. de Silver Fund, 37.33.75

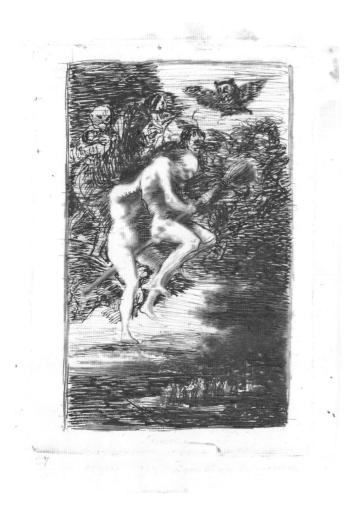

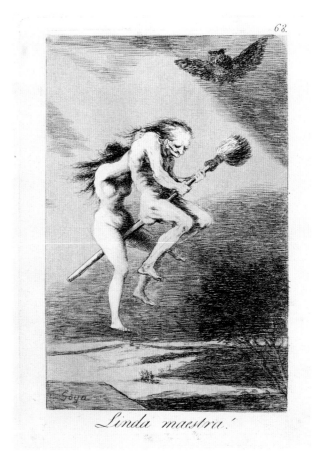

63.

Linda maestra!

67. *Sueño. De Brujas…Agente en diligencia*
(Dream. Of Witches…Running an Errand), 1797–1798

Pen and sepia on paper

24.7 x 17.4 cm

Museo Nacional del Prado, Madrid, D. 4203

68. *Linda maestra! (Pretty Teacher!)*, 1797–1798

Etching, aquatint, and drypoint on paper

21.4 x 14.9 cm

Brooklyn Museum of Art, A. Augustus Healy Fund,

Frank L. Babbott Fund, and Carll H. de Silver Fund, 37.33.68

69. *A Young Man with Two Majas* (recto), 1796–1797

Brush, brown and gray wash over traces of black chalk on paper

23.2 x 14.5 cm

Thaw Collection, The Pierpont Morgan Library, New York

70. *Majo Watching a Gallant Bowing to a Maja* (verso), 1796–1797

Brush and indian ink wash, touched with brown and black over pencil

23.2 x 14.5 cm

Thaw Collection, The Pierpont Morgan Library, New York

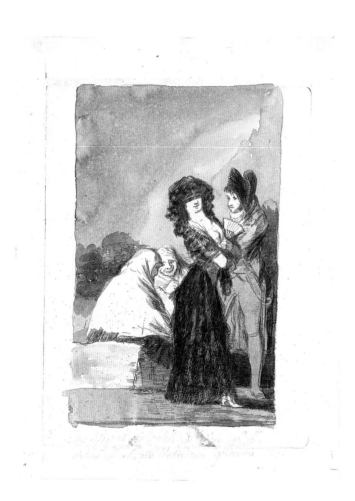

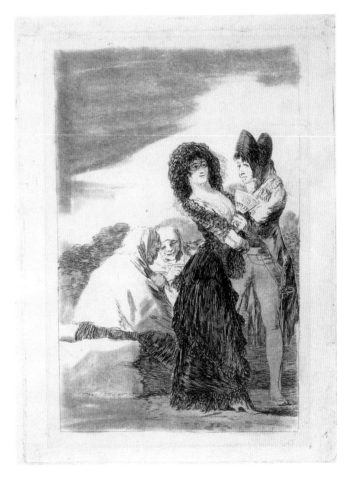

71. *Las viejas se salen de risa p.^r q.^e saben q.^e el no lleba un quarto (The Old Women Laugh Themselves Sick Because They Know He Hasn't a Bean)*, 1797–1798

Pen and sepia, indian ink wash on paper; inscription in

black crayon

24.5 x 18.5 cm

Museo Nacional del Prado, Madrid, D. 4199

72. *Tal para qual (Two of a Kind)*, 1797–1798

Working proof

Etching on paper retouched with black chalk, rubbed or

stumped

19.9 x 15.1 cm

National Gallery of Art, Washington, Rosenwald Collection,

1943.3.4720

P. 5

Tal para qual.

73. *Tal para qual (Two of a Kind)*, 1797–1798

Etching and black chalk on paper

20 x 15.1 cm

Brooklyn Museum of Art, A. Augustus Healy Fund,

Frank L. Babbott Fund, and Carll H. de Silver Fund, 37.33.5

74. *Ni asi la distingue (Even Thus He Cannot Make Her Out)*,
1797–1798

Working proof

Etching, aquatint, and drypoint on paper

20 x 15.1 cm

National Gallery of Art, Washington, Rosenwald Collection,

1953.6.69

75. *Ni asi la distingue (Even Thus He Cannot Make Her Out)*,
1797–1798

Etching, aquatint, and drypoint on paper

20 x 14.9 cm

Brooklyn Museum of Art, A. Augustus Healy Fund,

Frank L. Babbott Fund, and Carll H. de Silver Fund, 37.33.7

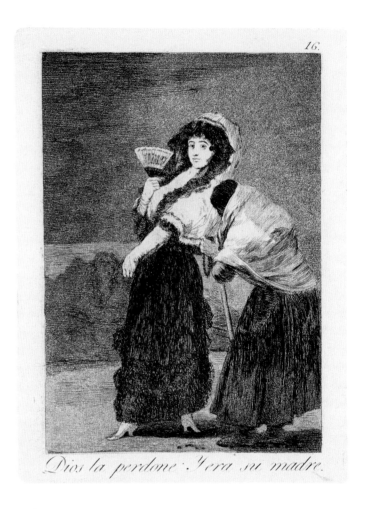

76. *Se aberguenza de q.ᵉ su madre le able en publico, y le dice, perdone Vm. p.ʳ Dios (She Is Ashamed That Her Mother Should Speak to Her in Public, and Says, Please Excuse Me),* 1797–1798

Pen and sepia, indian ink wash on paper; inscription in black crayon

24.5 x 16.9 cm

Museo Nacional del Prado, Madrid, D. 3920

77. *Dios la perdone: Y era su madre (God Forgive Her: And It Was Her Mother),* 1797–1798

Etching, aquatint, and drypoint on paper

20.2 x 15.1 cm

Brooklyn Museum of Art, A. Augustus Healy Fund, Frank L. Babbott Fund, and Carll H. de Silver Fund, 37.33.16

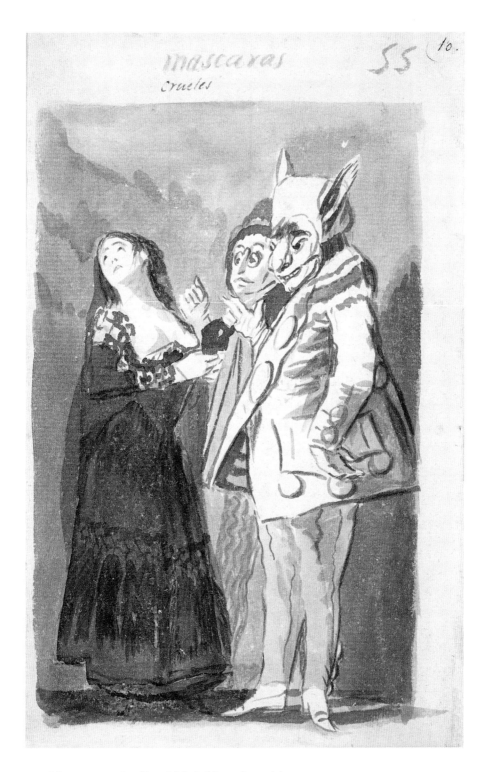

78. *Mascaras crueles (Cruel Masks)* (recto), 1796/1797

Brush, black ink, and gray wash with scraping on laid paper

23.7 x 15 cm

National Gallery of Art, Washington, Woodner Collection,

1991.182.10.a

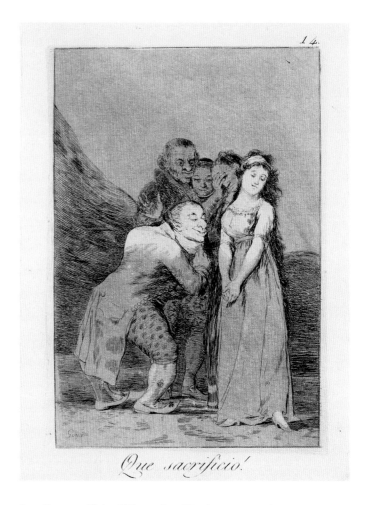

79. *Sacrificio de Ynteres (Sacrifice of Interest)*, 1797–1798

Pen and sepia on paper

23.8 x 16.8 cm

Museo Nacional del Prado, Madrid, D. 4195

80. *Que sacrificio! (What a Sacrifice!)*, 1797–1798

Etching and aquatint on paper

20.2 x 15.1 cm

Brooklyn Museum of Art, A. Augustus Healy Fund,

Frank L. Babbott Fund, and Carll H. de Silver Fund, 37.33.14

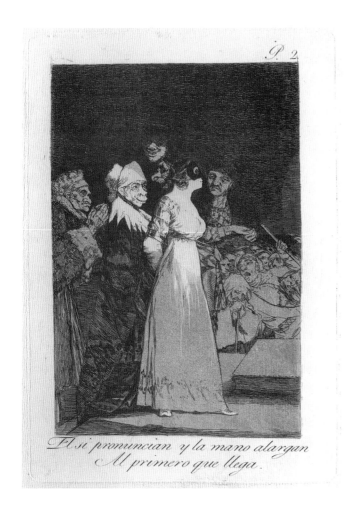

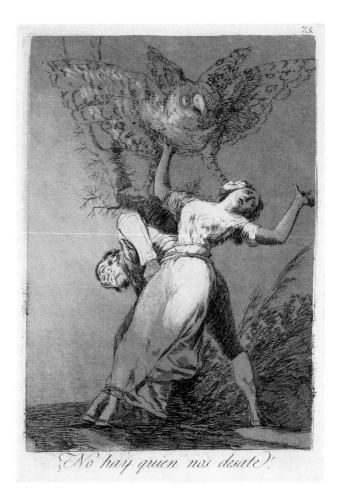

81. *El si pronuncian y la mano alargan / Al primero que llega* (They Say Yes and Give Their Hand to the First Comer), 1797–1798

Etching, aquatint, and drypoint on paper

20.2 x 15.1 cm

Brooklyn Museum of Art, A. Augustus Healy Fund, Frank L. Babbott Fund, and Carll H. de Silver Fund, 37.33.2

82. *No hay quien nos desate?* (Is There No One to Untie Us?), 1797–1798

Etching and aquatint on paper

21.7 x 15.2 cm

Brooklyn Museum of Art, A. Augustus Healy Fund, Frank L. Babbott Fund, and Carll H. de Silver Fund, 37.33.75

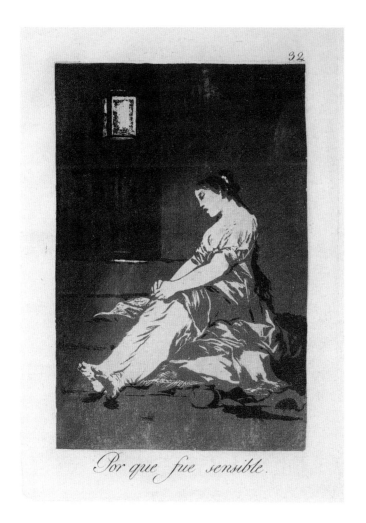

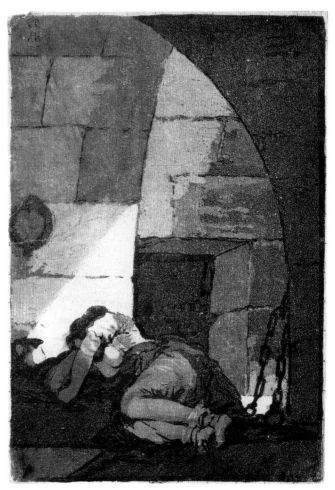

83. *Por que fue sensible (Because She Was Susceptible)*,
1797–1798

Aquatint on paper

21.8 x 15.2 cm

National Gallery of Art, Washington, Rosenwald Collection,

1943.3.4711.ff

84. *Woman in Prison*, 1797–1798

Burnished aquatint, touched with black chalk on paper

18.5 x 12.5 cm

Biblioteca Nacional, Madrid, BN 45621

85. *Las miedosas à un gato muy negro (They Are Scared of a Very Black Cat)* (recto), 1796–1797

Brush and indian ink on paper

23.6 x 14.7 cm

Private Collection

86. *S.ⁿ Fernando ¡como hilan! (San Fernando, How They Spin!)* (verso), 1796–1797

Brush and indian ink on paper

23.6 x 14.7 cm

Private Collection

87. *Las rinde el Sueño (Sleep Overcomes Them)*, 1797–1798

Etching and aquatint on paper

21.9 x 15.4 cm

Brooklyn Museum of Art, A. Augustus Healy Fund,

Frank L. Babbott Fund, and Carll H. de Silver Fund, 37.33.34

88. *Que viene el Coco (Here Comes the Bogeyman)*, 1797–1798

Etching and aquatint on paper

21.7 x 15.2 cm

Brooklyn Museum of Art, A. Augustus Healy Fund,

Frank L. Babbott Fund, and Carll H. de Silver Fund, 37.33.3

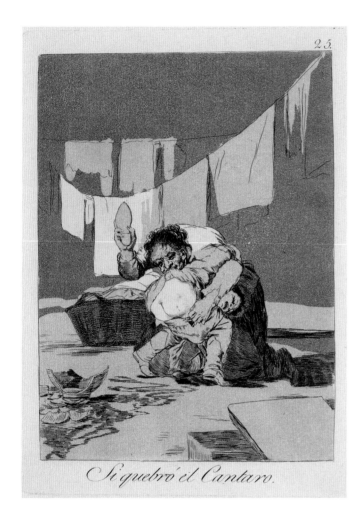

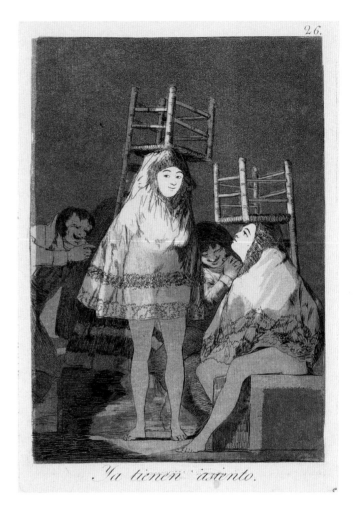

89. *Si quebró el Cantaro (If He Broke the Pitcher)*, 1797–1798

Etching and aquatint on paper

21.7 x 15.2 cm

Brooklyn Museum of Art, A. Augustus Healy Fund,

Frank L. Babbott Fund, and Carll H. de Silver Fund, 37.33.25

90. *Ya tienen asiento (Now They Have a Seat)*, 1797–1798

Etching and aquatint on paper

21.7 x 15.2 cm

Brooklyn Museum of Art, A. Augustus Healy Fund,

Frank L. Babbott Fund, and Carll H. de Silver Fund, 37.33.26

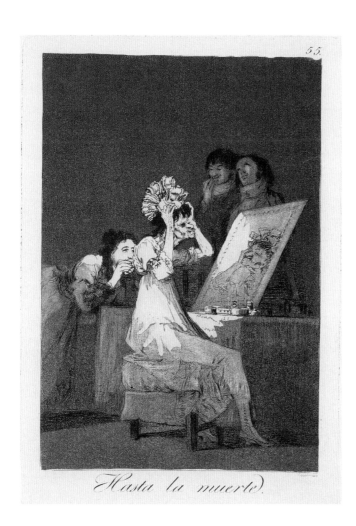

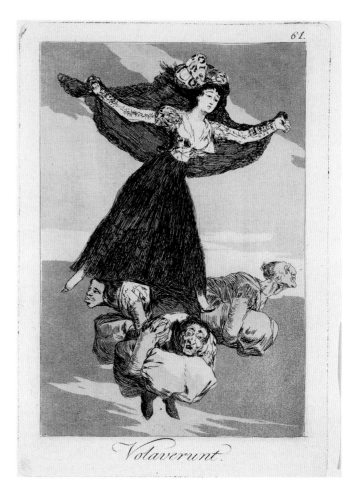

91. *Hasta la muerte (Till Death)*, 1797–1798

Etching, aquatint, and drypoint on paper

22.1 x 15.4 cm

Brooklyn Museum of Art, A. Augustus Healy Fund,

Frank L. Babbott Fund, and Carll H. de Silver Fund, 37.33.55

92. *Volaverunt (Gone for Good)*, 1797–1798

Etching, aquatint, and drypoint on paper

20.6 x 14.8 cm

Brooklyn Museum of Art, A. Augustus Healy Fund,

Frank L. Babbott Fund, and Carll H. de Silver Fund, 37.33.61

93. *Volaverunt (Gone for Good)*, 1797–1798

Preliminary drawing

Red chalk on paper

19.2 x 14.2 cm

Museo Nacional del Prado, D. 4223

94. *Sueño. De la mentira y la ynconstancia (Dream. Of Lying and Inconstancy)*, 1797–1798

Pen, sepia, black crayon, and indian ink wash on paper

23.7 x 16.6 cm

Museo Nacional del Prado, Madrid, D. 3916

95–114. Album Drawings and Lithographs

From the beginning of his career, Goya drew: we know drawings that can be related to early tapestry cartoons and some religious commissions, and we also have preparatory drawings for the series of etchings executed after Velázquez in the later 1770s.[1] Undoubtedly, others have been lost or remain unidentified, since many of these early drawings have no salient traits that would identify them as Goya's work. Not surprisingly, questions of attribution arise.[2] These works are rarely discussed, as our attention is more often drawn to the preliminary drawings that document the evolution of the artist's prints; more recently, attention to Goya's "album" drawings has been revived as the subject of a major exhibition.[3] For experimental subject matter, drawings offer multiple advantages over prints, since they are less expensive and less complicated to produce. They also offer more immediate gratification, as the artist works directly on the paper. Drawings could record subjects that would never find an audience and thus reflect Goya's most immediate thoughts on the nature of women.

The drawings that Goya undertook during and after 1796 that cannot be related to prints or paintings are thought to have constituted eight albums, although we know very little of what these albums looked like during his lifetime. Early authors note that Goya's son, Javier, owned three (rather than eight) large *libros de dibujos*, which apparently remained intact until his death in 1854. These were sold by Goya's grandson, Mariano; soon the drawings were removed from the three books for individual sale.[4] Given that there were three books of drawings, why do we discuss eight albums? As Pierre Gassier has noted, the coherency of the eight albums, commonly identified by the letters A–H that had been assigned by Eleanor Sayre,[5] is based on the kind of paper and the medium chosen by the artist. The paper is characterized by its make, tint, quality, and the disposition of the chain lines in relation to the subject. Although the use of letters to designate the albums corresponded to what was thought to be the chronology, this has been—and continues to be—revised,

for which reason the letter designations should not be seen as corresponding to a specific chronological order.

For each album, a single type of paper was used, and there is a general unity in the medium throughout.[6] However, to qualify these groups of drawings as albums—indicating some kind of bound collection of individual sheets—might be misleading to the modern viewer, since many, if not most, of them were probably loose sheets of paper. Although it is generally agreed that the first album (album A or the Sanlúcar album) was a bound sketchbook, the early nature of the other "albums" is less clear. For example, an argument that album B was bound has been justified by the common trim of many of its pages, as well as a tear in the lower right corner seen in the earlier sheets of the numbered sequence. However, it is possible that the artist had the works bound after he created the album—much as his series of prints were bound. If album B was originally bound (and its pages fixed in order), it is curious that the artist bothered to number its pages; moreover, the drawings themselves show no sign of a binding interrupting the movement of the artist's hand. It is generally agreed that album C was not bound.

This is not the place to review the makeup and chronology of the drawings, but only to suggest that many questions remain. To date, our focus has been on the makeup and chronology of the albums as a whole, rather than on looking at individual drawings or series within the albums (clearly defined by similarities in themes, captions, as well as sequential numbering). Given the complexity of these albums, it is not surprising that they are dated to a multiyear span. But we might ask if it would not be more productive to liberate the drawings from the concept of the album and begin to examine them in relation to drawings and works in other media.

Such an approach might facilitate consideration of the chronology of the drawings, which remains inconclusive. Arguments for the chronology are often circumstantial. One argument for dating album C to 1808–1814 is that Spanish paper was used, reflecting a wartime shortage of the imported Netherlandish paper used in some other albums. However, given the state of Europe throughout the Napoleonic period, it seems possible that the paper trade may have been interrupted far before the conflict spread to Spain in 1808. Another justification is made on the basis of subject matter, since album C encompasses the "Inquisition series" that is generally dated to these years, when the survival of that institution was being discussed in the Spanish Parliament or Cortes, in exile in the southern port city of Cádiz. Other drawings—those of single figures that open the album, for example—elude circumstantial arguments. Underlying these connections between events and dating of drawings is the

assumption that Goya drew what he witnessed, reflected in the characterizations of these as "journal" albums. Unfortunately, the imposition of such a reading imposes strict parameters on how we see these images, as illustrations rather than as inventions.

The importance of the concept of "invention" in relation to Goya's drawings cannot be overstated. It is thought that Goya undertook the Sanlúcar album three years after discovering the unlimited invention that was possible when he painted without commission, creating the series of cabinet pictures of 1793–1794. This realization had been documented in the often-cited letter to Don Bernardo de Iriarte of January 1794, sent to accompany a series of cabinet paintings submitted to the Real Academia de Bellas Artes de San Fernando. The drawings undertaken in 1796–1797 offer a graphic counterpart to the free execution seen in those cabinet paintings. Although Goya starts in a very straightforward manner with the controlled execution seen in the Sanlúcar album, by the midpoint of the subsequent Madrid album (perhaps little more than a year later) he was exploring fantastic subject matter in broadly brushed drawings, dramatized through the use of washes. His freedom was not only thematic but technical, as he turned his back on the controlled chalk or ink drawings he had developed in earlier years. His background as a painter led to his quick mastery of the media of ink and washes. Moreover, attention has recently been drawn to his working of the surface of his drawings, and the multiple kinds of strokes and scraping technique he used—all of which might reflect his experience as a master printmaker, handling the etching needle, drypoint, and burin.[7] In both prints and drawings, Goya extended the expressive potential of the monochromatic. His drawings are part of a larger, ongoing, multimedia experimentation.

It was undoubtedly Goya's involvement with the expressive potential of drawing that led him to lithography.[8] Although a print medium, lithography—in which the artist transfers a drawing or draws directly on the lithographic stone—allowed the artist to exploit techniques he had mastered as a draftsman. He was no longer limited to the lines of the etching needle but could instead vary the line for expressive purposes, working with ink, pen, brush, and eventually lithographic crayon. Nor did he have to build up tones through various layers of aquatint, but could transfer these directly onto the lithographic stone—even though in early attempts, such as *La Lectura*, the tones break down. Lithography made it possible to reproduce drawings—and interestingly, Goya chose to experiment early on with very diverse images of women. What was probably his first lithograph, dated February 1819, shows an old woman at a spinning wheel. Soon after, he turned to a theme of male-female confrontation in *Expressive of Double Strength* (cat. 112), in which a

man restrains a woman. The delicate form of the woman and the very unkempt figure of the man suggest that the woman might be fighting off an unwanted advance—a strange subject for reproduction and possible sale. This implies that in these early lithographic experiments, Goya was more interested in testing this medium, recently introduced in Madrid, than in creating a salable image. JT

NOTES

1. Gassier 1975, 23–72.
2. Tomlinson 1989b, 36–37.
3. The essential reference for this drawings, outdated only because more drawings have come to light since its publication, is Gassier 1973. See also Wilson-Bareau 2001.
4. Wilson-Bareau 2001, 24–25.
5. Sayre 1958, 116–136.
6. Gassier 1973, 13.
7. Wilson-Bareau 2001, 21.
8. For the history and technical details on Goya's lithography, see Vega 1990, 54–65.

95. *Weeping Woman and Three Men* (recto), 1796–1797

Brush and indian ink wash on paper

23.5 x 14.6 cm

Lent by The Metropolitan Museum of Art, Harris Brisbane
Dick Fund, 35.103.4/.5

96. *A Maja and Two Companions* (verso), 1796–1797

Brush and indian ink wash on paper

23.5 x 14.6 cm

Lent by The Metropolitan Museum of Art, Harris Brisbane
Dick Fund, 35.103.4/.5

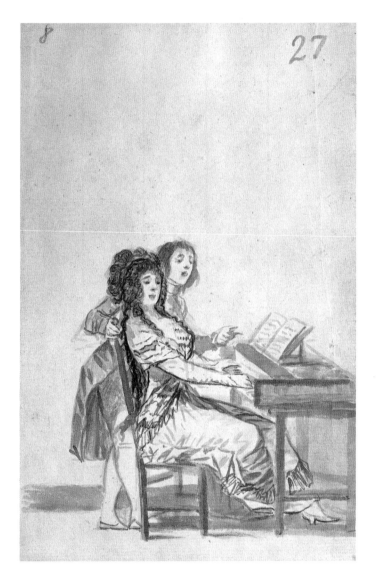

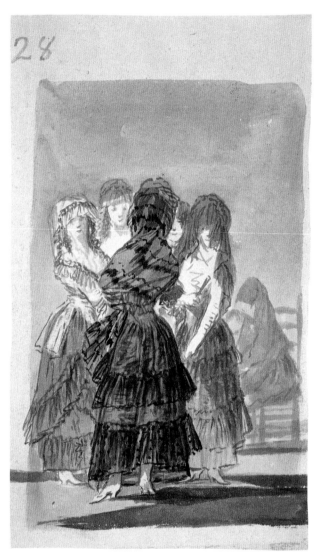

97. *Concert at the Clavichord* (recto), 1796–1797

Brush and indian ink wash

23.5 x 14.5 cm

Museo Nacional del Prado, Madrid, D. 4181

98. *Group of Majas on the Paseo* (verso), 1796–1797

Brush and indian ink wash

23.5 x 14.5 cm

Museo Nacional del Prado, Madrid, D. 4181

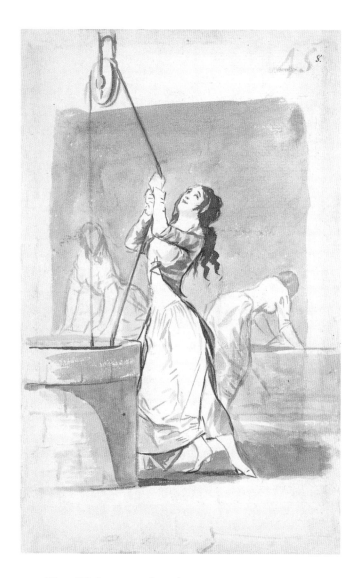

99. *Three Washerwomen* (recto), 1796–1797

Brush and indian ink wash on paper

23.5 x 14.6 cm

Lent by The Metropolitan Museum of Art, Harris Brisbane
Dick Fund, 35.103.8/.9

100. *A Young Woman at a Well* (verso), 1796–1797

Brush and indian ink wash on paper

23.5 x 14.6 cm

Lent by The Metropolitan Museum of Art, Harris Brisbane
Dick Fund, 35.103.8/.9

101. *Solo porque le pregunta, si esta buena su madre se pone como un tigre (Just Because She Is Asked if Her Mother Is Well She Acts Like a Tigress)* (recto), 1796–1797

Brush and indian ink wash on paper

23.5 x 14.7 cm

Thaw Collection, The Pierpont Morgan Library, New York

102. *Confianza (Trust)* (verso), 1796–1797

Brush and indian ink wash on paper

23.4 x 14.6 cm

Thaw Collection, The Pierpont Morgan Library, New York

103. *Unholy Union*, 1801–1803?

Brush, indian ink wash, traces of pen and ink on laid paper

17.6 x 12.7 cm

Lent by The Metropolitan Museum of Art, Robert Lehman
Collection, 1975.1.975

104. *Q.ᵉ Necedad! dar los destinos en la niñez (What Stupidity!
To Determine Their Fates in Childhood)*, 1808–1815?

Brush and indian ink wash

20.5 x 14.3 cm

Museo Nacional del Prado, Madrid, D. 3195

105. *Piensalo bien (Think It Over Well)*, 1808–1815?

Brush and indian ink wash on paper

20.5 x 14.2 cm

Museo Nacional del Prado, Madrid, D. 3912

106. *Lastima es q.ᵉ no te òcupes en otra cosa (It's a Pity You Don't Have Something Else to Do)*, 1808–1815?

Brush, brown wash, pen, and black ink on paper

20.2 x 13.9 cm

The J. Paul Getty Museum, Los Angeles, 83.GA.35

107. *Pr Liberal? (For Being a Liberal?)*, 1808–1815?

Brush, gray and brown washes on paper

20.5 x 14.2 cm

Museo Nacional del Prado, Madrid, D. 4074

108. *Despues lo veras (You'll See Later)*, 1808–1820?

Brush and indian ink wash on paper

26.6 x 18.7 cm

Lent by The Metropolitan Museum of Art, Harris Brisbane
Dick Fund, 35.103.18

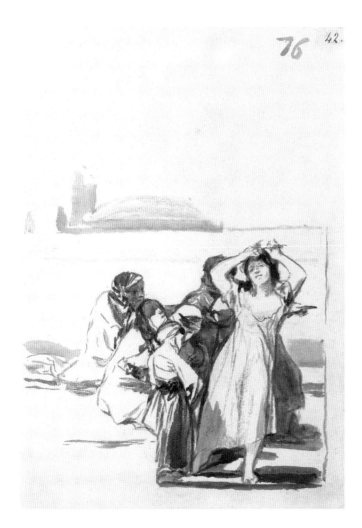

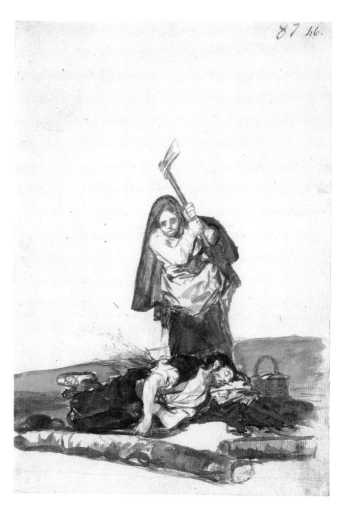

109. *A Disheveled Woman with a Group*, 1815–1820?

Brush and brown wash over light black crayon on paper

20.6 x 14.5 cm

Lent by The Metropolitan Museum of Art, Harris Brisbane
Dick Fund, 35.103.42

110. *Woman Murdering a Sleeping Man*, 1815–1820?

Brush and brown wash on paper

20.5 x 14.3 cm

Lent by The Metropolitan Museum of Art, Harris Brisbane
Dick Fund, 35.103.46

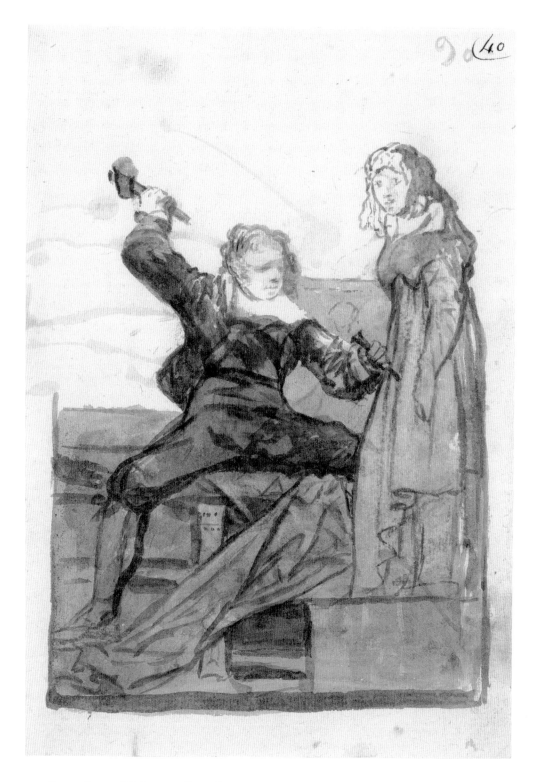

111. *Pygmalion and Galatea*, c. 1815–1820

Brush and brown wash on paper

20.5 x 14.1 cm

The J. Paul Getty Museum, Los Angeles, 85.GA.217

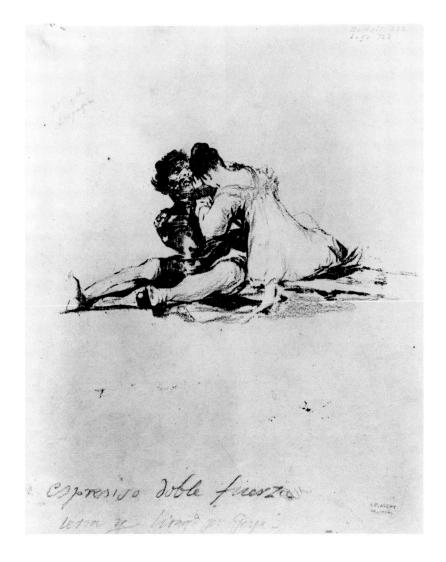

112. *Expresivo doble fuerza (Expressive of Double Strength)*, c. 1819

Transfer lithograph retouched in black crayon on paper
8 x 11.5 cm
S. P. Avery Collection, Miriam and Ira D. Wallach Division of Arts, Prints and Photographs, The New York Public Library, Astor, Lenox and Tilden Foundations

113. *Woman Reading to Two Children*, 1820–1823
Crayon lithograph on paper
11.5 x 12.5 cm
Museum of Fine Arts, Boston, Katherine E. Bullard Fund in memory of Francis Bullard, 1970.467

114. *Group with Sleeping Woman (Woman in a Trance),*
1820–1823

Crayon lithograph on paper

13 x 16 cm

Museum of Fine Arts, Boston, Katherine E. Bullard Fund in

memory of Francis Bullard and Gift of Landon T. Clay, 1970.622

115–124. The Disasters of War

In 1863, thirty-five years after Goya's death, the Real Academia de Bellas Artes de San Fernando published the first edition of *Los Desastres de la Guerra* (The Disasters of War). Prior to that, the etched plates, preliminary drawings, and proof impressions pulled by the artist had been stored in boxes by the artist's son, Javier, who died in 1854. The artist's grandson, Mariano, brought the collection to light, and the proofs soon found their way into collections throughout Europe. The plates for the Disasters and for the Disparates were purchased by the Academy in 1862.[1]

Also in 1863, the collector Valentin Carderera published an article describing a complete set of proofs in his collection, pulled either by Goya or under his supervision.[2] He wrote that sixty-eight of the etchings illustrate the *malheurs de l'invasion,* and fourteen others recalled the satires of the Caprichos. This thematic division reflects that made in the manuscript title page of Carderera's volume: *Fatal consequences of the bloody war in Spain with Bonaparte and other emphatic caprichos in 85 prints, invented, drawn and engraved by the original painter Don Francisco de Goya y Lucientes.*[3] According to the daughter of Ceán Bermúdez, who gave the album to Carderera, Goya had given this collection of prints to her father so that he might correct the captions penciled in the lower margins. Many of these link consecutive images, leaving no doubt that they were added after the final ordering of the eighty etchings in the Ceán-Carderera volume. These titles were engraved prior to the printing of the first edition.

The proof impressions featured in this exhibition were printed either by Goya or under his supervision. In the delicacy of their controlled tones, the result of careful inking of the plates, they differ radically from the impressions of the first edition. The heavy inking of the first edition darkens the image and lessens the contrasts of light and dark intended by the artist. Without the heavy inking, the working proofs let us appreciate Goya's mastery of light and dark, as well as the very detailed rendering that captures individual expressions and gestures amid the turmoil.

The subject of these etchings is well-known: they offer scenes inspired by the war in Spain against Napoleon (1808–1814) and of the famine in Madrid (1811–1812), as well as the images of the Emphatic Caprichos. Three plates—the earliest within the series—are dated 1810; Carderera wrote that Goya completed the series by 1820. This date has been the subject of much discussion, and recently the time frame for the series has been convincingly reduced to 1810–1815. This would suggest that the last etched images, the Emphatic Caprichos, were completed immediately before, or as Goya began, the etchings of the Tauromaquia, published in 1816. It would also mean that these images refer either to the events of the war itself or to the earliest years of the repressive restoration of Ferdinand VII.[4]

By 1863, when the first edition was published, wartime photography was developing. In the 1850s Roger Fenton and others recorded the Crimean War in pictures, while in the United States, Mathew Brady was one of many photographers to record the tragedy of the Civil War. It is possible that the circulation of such photographs created a context for the publication of Goya's series, which within its own time perhaps would have been seen to be as unintelligible to the general public as the Caprichos had been. For these etchings marked a radical, and seemingly intentional, departure from the clearly unambiguous and propagandistic engravings in circulation from 1808 to 1814. These documented specific heroes, events, and places, clearly identified in their titles or captions.[5] Goya rejects this genre, for even when he seems to allude to a specific heroine such as Agustina of Aragon (cat. 116), he refuses to offer any identifying caption. Confrontations are removed from time and place, and costumes are not specific, so that these etchings stand as a more general commentary on the vicissitudes of war than as documentation of a particular war.

For many years it was thought that Goya was deterred from publishing the scenes of war and famine because of the repressive restored regime.[6] More recently, the question has been posed as to whether he even intended to publish the series.[7] In the portrayal of violence, this imagery is without precedent. Goya moves in close as witness and observer, rejecting the more polite panoramic view seen in Jacques Callot's *The Miseries of War*, with which the Disasters are often compared.[8] Violence disfigures faces and any vestige of classical beauty is denied: piled corpses are twisted like rag dolls; the bodies of women who can no longer struggle against their oppressors are contorted as they are vanquished (cat. 119).

To understand the complexity of these etchings, we have to overcome a modern bias to read them as documents, a bias that might be attributed to our familiarity with images of atrocity in the media. Goya doubtless takes the struggle against Napoleon as his point of departure but invents an imagery

that is emphatic in condemning that violence—even more injurious to society than the vices he had condemned in the etchings of the Caprichos. As the "documentary" images of the series approach allegory, they offer a point of departure not only for the Emphatic Caprichos but also for the series of the Disparates that Goya would undertake later the same decade. JT

NOTES

1. The essential work on this series is Blas Benito and Matilla 2000.
2. Carderera 1863, 237–249.
3. In addition to the eighty published plates, the Ceán-Carderera album included two plates related to the Disasters and three small etchings of prisoners: "Fatales consequencias/ de la sangriente guerra en España con Buonaparte/ y otros caprichos enfaticos/ en 85 estampas/ inventadas, dibuxadas y grabadas, por el pintor original/ D. Francisco de Goya y Lucientes./ En Madrid."
4. This thoughtful redating of the etchings is the result of research undertaken by Jesusa Vega, whose contribution to our understanding of the series is contextualized by Blas Benito 1996, 81–85.
5. Vega 1996, 17–40.
6. Sayre 1974, 128–129.
7. Blas Benito 1996, 60.
8. Cuno et al. 1990.

115. *Y son fieras! (And They Are Wild Beasts!)*, 1810–1814

Working proof

Etching, burnished aquatint, drypoint, and burnishing on paper

15.9 x 21 cm

Museum of Fine Arts, Boston, 1951 Purchase Fund, 51.1625

116. *Que valor! (What Courage!)*, 1810–1814

Working proof

Etching, drypoint, and burnishing on paper

15.6 x 20.8 cm

Museum of Fine Arts, Boston, 1951 Purchase Fund, 51.1627

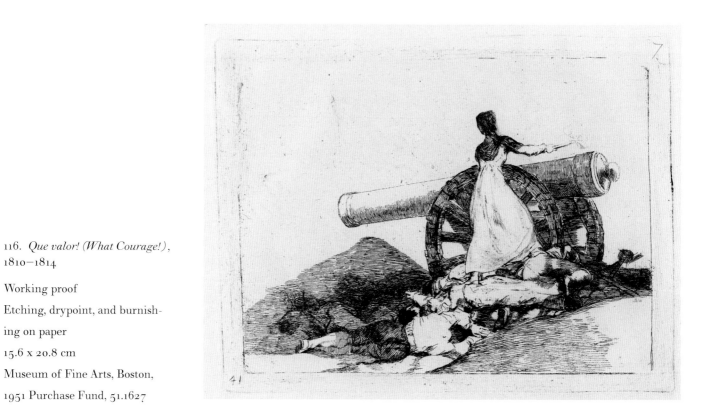

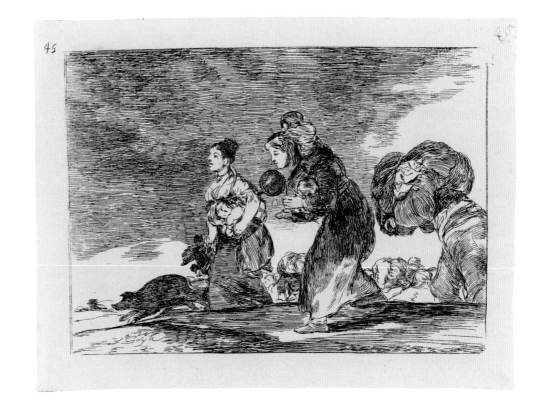

117. *Y esto tambien (And This, Too)*, 1810–1814

Working proof
Etching, drypoint, and burin
on paper
16.2 x 21.6 cm
Museum of Fine Arts, Boston,
1951 Purchase Fund, 51.1669

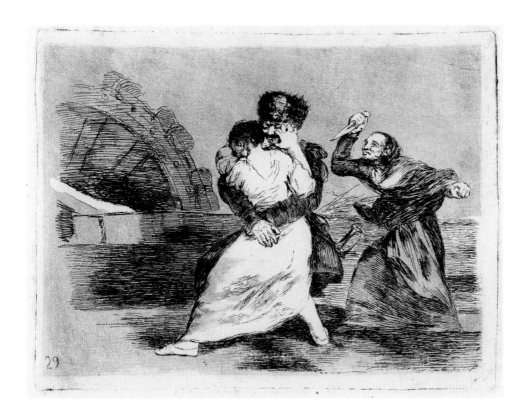

118. *No quieren (They Do Not Want To)*, 1810–1814

Working proof
Etching, burnished aquatint,
burin, and drypoint on paper
15.5 x 20.3 cm
Museum of Fine Arts, Boston,
1951 Purchase Fund, 51.1629

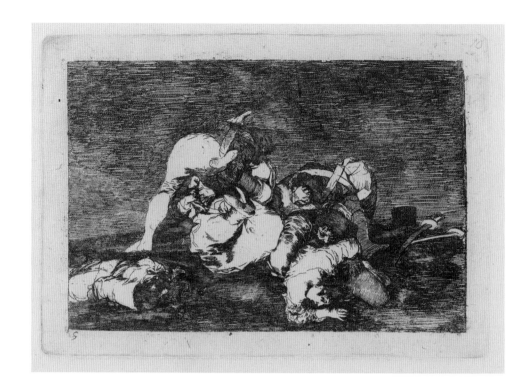

119. *Tampoco (Nor Do These)*,
1810–1814

Working proof
Etching on paper
14.9 x 21.9 cm
Museum of Fine Arts, Boston,
1951 Purchase Fund, 51.1630

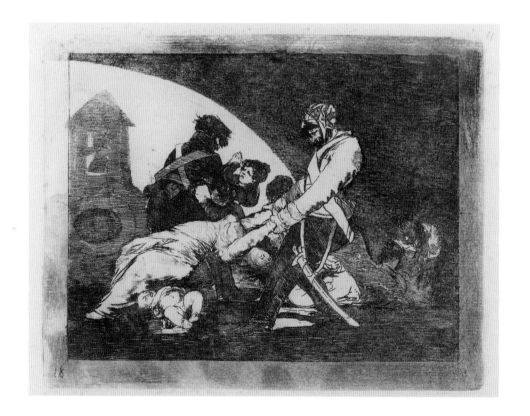

120. *Ni por esas (Neither Do These)*, 1810–1814

Working proof
Etching, aquatint and lavis (or sulphur tint), burin, and drypoint on paper
16.2 x 21.3 cm
Museum of Fine Arts, Boston,
1951 Purchase Fund, 51.1631

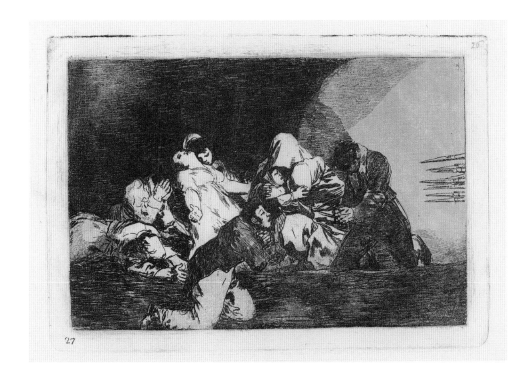

121. *No se puede mirar
(One Can't Look)*, 1810–1814
Working proof
Etching, drypoint, burin,
burnished aquatint, and lavis
on paper
14.4 x 21 cm
Museum of Fine Arts, Boston,
1951 Purchase Fund, 51.1651

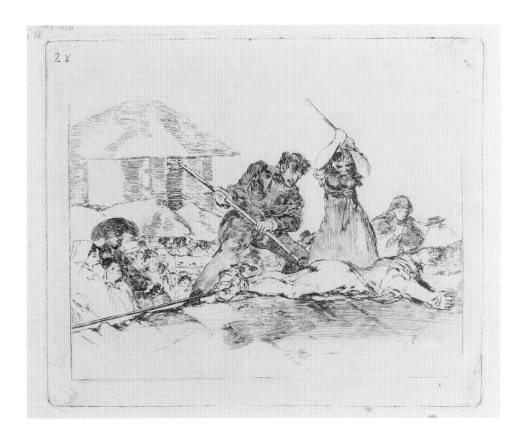

122. *Populacho (Rabble)*,
1814–1816

Working proof
Etching and drypoint on paper
17.7 x 22 cm
Museum of Fine Arts, Boston,
Gift of William A. Coolidge,
1973.725

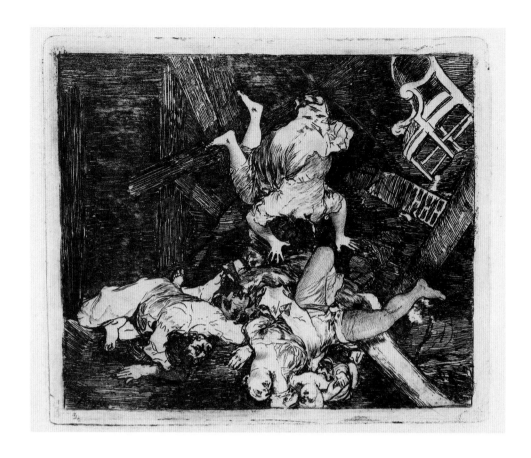

123. *Estragos de la guerra*
(Ravages of War), 1810–1814
Working proof
Etching, drypoint, burin, lavis,
and burnishing on paper
14.1 x 17 cm
Museum of Fine Arts, Boston,
Gift of Jeptha H. Wade and M.
and M. Karolik Fund, 1973.727

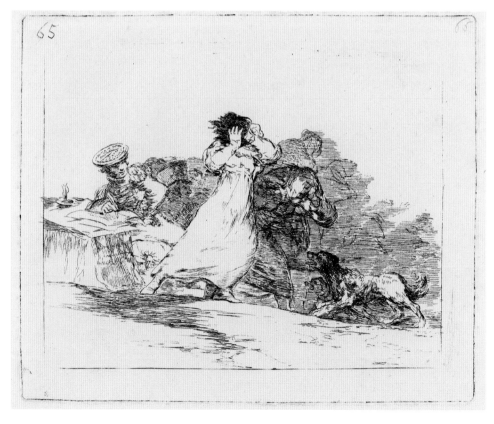

124. *Qué alboroto es este?*
(What Is This Hubbub?),
1814–1816
Working proof
Etching and burin on paper
17.9 x 22.1 cm
Museum of Fine Arts, Boston,
1951 Purchase Fund, 51.1685

125–128. The Disparates

In the world of *disparate,* a woman sprouts a second head as she runs, pan-
icked, toward shelter among a crowd of crones (cat. 127); in another scene,
women toss puppets resembling men and donkeys in a blanket (cat. 125). Mon-
sters of nature—giants, two-headed women, men and women conjoined to
form a creature with two heads and four feet—become routine. The space
where these figures dwell is unreal: depth is ambiguous, locations undefined,
and even landscapes assume monstrous forms. About two decades before he
worked on these etchings, Goya had inscribed a drawing of the *sueños* series
with the words, "the dream of reason produces monsters" *(el sueño de la razón
produce monstruos).* In so doing he acknowledged lapses from a world of rea-
son; in the Disparates, reason never existed.

The coincidence of this world with Carnival—the annual pre-Lenten cele-
bration in which social order is overturned—has often been noted. The event
of Carnival may have inspired specific subjects seen in these etchings, includ-
ing the tossing of dolls in blankets, giants, circle dances, and stiltwalkers. Even
the two-headed figures portrayed might find a possible prototype in the char-
acter of *la pepa,* a costumed figure with a single trunk, two heads, and four
feet.[1] Although Goya did not intend to illustrate Carnival specifically, clearly
the topsy-turvy world of the pre-Lenten festival may have provided a vocabu-
lary for his world of nonsense. As Nigel Glendinning has observed:

> In carnivalesque scenes, an ambience of subversion, irrationality, violence
> predominates, and the same spirit manifests itself in other themes: the
> dance and the circus, with its evocation of artistic or instinctive mysterious
> powers, and the dexterity of man and animals; erotic passion—at times
> frustrated by parents or advisors—and unequal marriages.... Within the
> context of the Carnival, the non-sensical is the norm.[2]

Like the Disasters, the twenty-two etchings known as the Disparates were
never published during Goya's lifetime. Given their baffling subject matter, we
must ask if Goya even intended to publish them. None of the plates bears a

date, although all must have been etched prior to Goya's departure from Madrid in 1824. One etching in the series—showing winged men flying and entitled *Modo de volar*—was included in the Tauromaquia album (published in 1816) given by Goya to Ceán Bermúdez. But this does not mean that the plate must date to 1816.[3]

Around midcentury, a complete set of eighteen trial proofs was printed in a private edition that has been dated variously to 1848, 1849, and 1854. Images from this set of proofs are exhibited here. The first edition was printed by the Real Academia de Bellas Artes de San Fernando in 1864. Thirteen years after the first edition was published, four more plates (including *Sure Folly*, cat. 128) were published in the French periodical *L'Art*. This brought the number of plates in the series to twenty-two, although the manuscript number "25," written on an early proof of *Unbridled Folly* (cat. 126) might suggest that even more images once existed.

Referred to in Academy records as *"caprichos,"* the first edition was published with the title *Los Proverbios*. However, the association of these images with traditional proverbs was challenged from the outset.[4] Today, we are much more sympathetic to the open-ended (and perhaps preverbal) nature of Goya's unique imagery, which gives form to human emotions and psychological states that defy reduction to words. Although we might not understand what we see, or be able to reduce it to words, we feel a visceral reaction to what is shown. Yet this is a fairly recent change in the general attitude toward the series: as late as 1963 Tomás Harris used the title "proverbios" as a point of departure in his catalogue of Goya's engravings and lithographs, assigning a specific proverb to each image.[5]

The alternative and now generally accepted title *disparate* originated in manuscript captions of several early proofs, which began to come to light in the early twentieth century. The meaning of *disparate*, loosely translated as "folly," is explained in Covarrubias' classic dictionary of the Spanish language, *Tesoro de la lengua Castellana*, as the noun based on the adjective *dispar*, meaning "without rational parity or equivalent." As a result of the discovery of the manuscript titles, the women tossing mannikins and donkeys in a blanket became *Feminine Folly* (cat. 125), the woman on the tightrope *Sure Folly* (cat. 128), and the woman carried off by a horse *Unbridled Folly* (cat. 126). Such titles seem well suited to the inconclusive nature of Goya's imagery, as he avoids explanation in favor of evocation, insisting that the viewer construct the meaning—or confront its absence. JT

NOTES
1. Baroja 1965, 226.
2. Glendinning 1996, 66–67.

3. According to Carderera, the album was given to Ceán for him to write the titles. However, since we know that Goya first advertised the prints in October 1816 without titles, we do not know when the title plate (that generally followed Ceán's titles) was added. For this reason, we should not interpret inclusion of *Modo de volar* in this set as conclusive evidence for a date of 1816.

4. Melida 1865, 313–316.

5. Harris 1963.

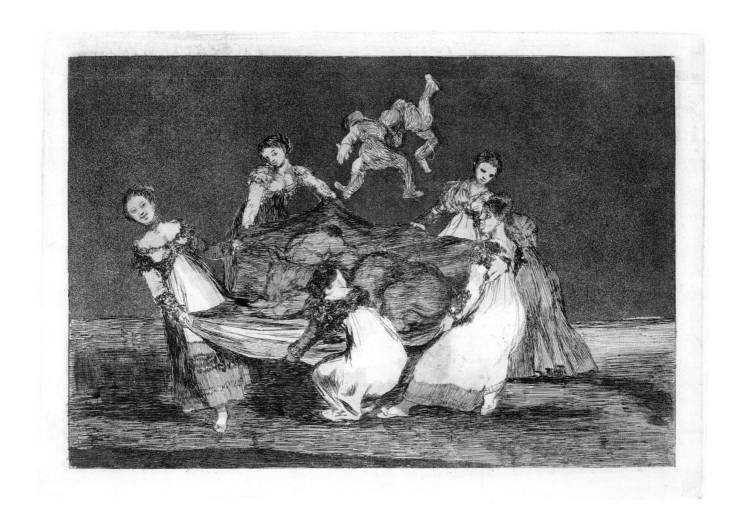

125. *Disparate femenino (Feminine Folly)*, c. 1816–1819

Posthumous trial proof c. 1854–1863

Etching, aquatint, and (drypoint?)

24.7 x 35.6 cm

National Gallery of Art, Washington, Rosenwald Collection,

1951.10.43

127. *Disparate pobre*
(Poor Folly), c. 1816—1819

Posthumous trial proof c. 1854—1863

Etching, burnished aquatint,

drypoint, and burin

24.5 x 35.7 cm

National Gallery of Art, Washington, Rosenwald Collection,

1951.10.53

126. *Disparate desenfrenado
(Unbridled Folly)*, c. 1816–1819
Posthumous trial proof c.
1854–1863
Etching, burnished aquatint, and
drypoint
24.5 x 35.7 cm
National Gallery of Art, Wash-
ington, Rosenwald Collection,
1951.10.52

128. *Disparate puntual
(Sure Folly)*, c. 1816–1819

Etching, aquatint, and
(drypoint?)
21.9 x 32.8 cm
National Gallery of Art,
Washington, Print Purchase
Fund (Rosenwald Collection),
1970.32.2

Bibliography

ACTAS 1996 *Actas del Congresso Internacional "Goya 250 años después."* Madrid, 1996.

AGUADO 1994 Aguado, Ana María, et al. *Textos para la historia de las mujeres en España.* Madrid, 1994.

ÁGUEDA 1984 Águeda, Mercedes. "Novedades en torno a una serie de cartones de Goya." *Boletín del Museo del Prado* V, 13 (1984): 41–46.

ÁGUEDA 2001 Águeda, Mercedes. *"La Tirana" de Francisco de Goya.* Madrid, 2001.

ÁGUEDA AND SALAS 1982 Águeda, Mercedes, and Xavier de Salas, eds. *Francisco de Goya. Cartas a Martín Zapater,* Madrid, 1982.

AGUILERA 1946 Aguilera, Emiliano M. *Pintores españoles del siglo XVIII.* Barcelona, 1946.

AGUILERA 1948 Aguilera, Emiliano M. *Los trajes populares de España vistos por los pintores españoles.* Barcelona, 1948.

ALBRECHT 1985 Albrecht, Juerg. "Die *Pinturas negras* von Francisco de Goya. Der Gemäldezyklus aus der Quinta del Sordo bei Madrid." *Künstlerhäuser von der Renaissance bis zur Gegenwart* (1985): 177–193.

ALCALÁ FLECHA 1979 Alcalá Flecha, Roberto. *Superstición y brujería en el arte de Goya.* Seville, 1979.

ALCALÁ FLECHA 1984 Alcalá Flecha, Roberto. *Matrimonio y prostitución en el arte de Goya,* Cáceres, 1984.

ALCALÁ FLECHA 1988 Alcalá Flecha, Roberto. *Literatura e ideología en el arte de Goya,* Saragossa, 1988.

ANDIOC 1982a Andioc, René. "Moratín inspirateur de Goya." In *Goya regards et lectures.* Aix-en-Provence, 1982: 25–32.

ANDIOC 1982b Andioc, René. "Sobre Goya y Moratín hijo." *Hispanic Review* LX, 2 (1982): 119–132.

ANES 1988 Anes, Gonzalo. "Ideas y aspiraciones de libertad en la época de Goya." In Madrid 1988: 27–53.

ANES 1994 Anes, Gonzalo. *Historia de España: El Siglo de las Luces.* Vol. 4. Madrid, 1994.

ANGELIS 1974 Angelis, Rita de. *La obra pictórica completa de Goya.* Barcelona, 1974.

ANGUIANO 1988 Anguiano de Miguel, Aida. "Iconografía femenina en los *Caprichos* de Goya." *Coloquios de iconografía: ponencias y comunicaciones.* Madrid, 1988: 227–233.

ANGULO ÍÑIGUEZ 1940 Angulo Íñiguez, Diego. "La familia del infante don Luis pintada por Goya." *Archivo Español de Arte* XIV, 41 (1940): 53–58.

ANGULO ÍÑIGUEZ 1962 Angulo Íñiguez, Diego. "El *Saturno* y las *Pinturas negras* de Goya." *Archivo Español de Arte* XXXV, 138 (1962): 173–177.

ANGULO ÍÑIGUEZ 1979 Angulo Íñiguez, Diego. "Murillo y Goya." *Goya* 148–150 (1979): 210–213.

ANSÓN NAVARRO 1995 Ansón Navarro, Arturo. *Goya y Aragón. Familia, amistades y encargos artísticos.* Saragossa, 1995.

ANSÓN NAVARRO 1997 Ansón Navarro, Arturo. "Religión y religiosidad en la pintura de Goya." In *Francisco de Goya y Lucientes. Su obra y su tiempo.* Saragossa, 1997: 91–109.

ARCO 1953 Arco Garay, Ricardo del. *Temas aragoneses.* Saragossa, 1953.

ARIÈS AND AYMARD 1985 Ariès, Philippe, and Maurice Aymard. *Histoire de la vie privée.* 3 vols. Paris, 1985.

ARIÈS AND DUBY 1985–1987 Ariès, Philippe, and Georges Duby. *Histoire de la vie privé: De la Renaissance aux Lumières.* Vol. III. París, 1985–1987.

ARNAIZ 1987 Arnaiz, José Manuel. *Francisco de Goya. Cartones y tapices.* Madrid, 1987.

ARNAIZ 1996 Arnaiz, José Manuel. "Goya y el infante don Luis de Borbón." In Saragossa 1996b: 19–35.

ARNAIZ AND MONTERO 1986 Arnaiz, José Manuel, and Ángel Montero. "Goya y el infante don Luis." *Anticuaria* XXVII, 44–45 (1986): 51.

AULLÓN DE HARO 1996 Aullón de Haro, Pedro. "Sobre el sentido de los *Disparates.*" In *Disparates: tres visiones.* Madrid, 1996: 17–32.

BAETJER 1980 Baetjer, Katharine. *European Paintings in The Metropolitan Museum of Art by Artists Born in or before 1865.* New York, 1980.

BAKER 1999 Baker, Christopher, and Tom Henry. *The National Gallery. Complete Illustrated Catalogue*. London, 1999.

BANNET 1997 Bannet, E. Tavor. "The Marriage Act of 1753: A Most Cruel Law for the Fair Sex." In *Only Connect: Family Values in the Age of Sentiment: Eighteenth-Century Studies*. Vol. 30. Baltimore, 1997: 233–254.

BARCELONA 1929 *Exposición Universal*. Barcelona, 1929.

BARCELONA 1977 *Goya* [exh. cat., Palacio de Pedralbes.] Barcelona, 1977.

BARETTI 1770 Baretti, Joseph. *A Journey from London to Genova, through England, Portugal, Spain and France*. 2 vols. London, 1770.

BAROJA 1965 Baroja, Julio Caro. *El Carnaval: Análisis histórico-cultural*. Madrid, 1965.

BAROJA 1966 Baroja, Julio Caro. *Las brujas y su mundo*. Madrid, 1966.

BAROJA 1974 Baroja, Julio Caro. *Ritos y mitos equívocos*. Madrid, 1974.

BARTA 2001 Barta, Ilsebill. "Le Corps discipliné: sexuation du langage gestuel à l'époque des Lumières." In *Conceptualizing Woman in Enlightenment Thought*. Berlin, 2001.

BASEL 1953 *Goya. Gemälde. Zeichnungen. Graphik. Tapisserien* [exh. cat., Kunsthalle.] Basel, 1953.

BATICLE 1970 Baticle, Jeannine. "Goya et l'Aragon du 'Siècle des lumières.'" In *La Revue du Louvre* 20 (1970): 283–286.

BATICLE 1986 Baticle, Jeannine. "Los maravillosos goyas del Museo Lázaro." *Goya* (1986): 5–9.

BATICLE 1987 Baticle, Jeannine. "Goya y la duquesa de Alba: ¿Qué tal?" In *Goya. Nuevas visiones. Homenaje a Enrique Lafuente Ferrari*. Madrid, 1987: 61–71.

BATICLE 1992 Baticle, Jeannine. *Goya*. París, 1992.

BATICLE Y MARINAS 1981 Baticle, Jeaninne, and Cristina Marinas. *La Galerie Espagnole de Louis-Philippe au Louvre 1838–1848*. Paris, 1981.

BAUDELAIRE 1976 Baudelaire, Charles. "De l'essence du rire et généralement du comique dans les arts plastiques." In *Oeuvres complètes*. París, 1976.

BECKFORD 1966 Beckford, William. *Un inglés en la España de Godoy (cartas españolas)*. Trans. J. Pardo. Madrid, 1966.

BÉDAT 1974 Bédat, Claude. *L'Académie des Beaux-Arts de Madrid, 1744–1808*. Toulouse, 1974.

BELGRADE 1981 *Exposición de arte español* [exh. cat., Gradski Istoriceski Musej.] Belgrade, 1981.

BENSUSAN 1902 Bensusan, S. L. "Goya: His Times and Portraits, Part I." *Connoisseur* 2 (January 1902): 37.

BERGER 1977 Berger, Morroe. *Real and Imagined Worlds. The Novel and Social Science*. Cambridge (Mass.), 1977.

BERLIN 1908 *Francisco de Goya* [exh. cat., Galerie Paul Cassirer.] Berlin, 1908.

BERLIN 1964 *Meisterwerke aus den Museum in Lille* [exh. cat., Schloss Charlottenburg.] Berlin, 1964.

BERLIN 1980 *Bilder von Menschen in der Kunst des Abendlandes* [exh. cat., Gemäldegalerie Staatliche Museen Preussischer Kulturbesitz.] Berlin, 1980.

BERUETE (1916) (1917) (1918) 1928 Beruete y Moret, Aureliano. *Goya, pintor de retratos* (1916); *Goya, composiciones y figuras* (1917); *Goya grabador* (1918). Madrid, 1928.

BIHALJI-MERIN 1987 Bihalji-Merin, Oto. "Goya y Gea." In *Goya: Nuevas visiones. Homenaje a Enrique Lafuente Ferrari*. Madrid, 1987: 101–118.

BLANCO WHITE 1822 Blanco White, José María. *Letters from Spain*. 1822.

BLAS BENITO 1996 Blas Benito, Javier. "Los *Desastres de la Guerra* y su fortuna crítica." In *Estampas de la Guerra de la Independencia* [exh. cat., Calcografía Nacional, Real Academia de Bellas Artes de San Fernando.] Madrid, 1996.

BLAS BENITO 1999 Blas Benito, Javier. *Francisco Goya, El libro de los Caprichos*. Madrid, 1999.

BLAS BENITO AND MATILLA 2000 Blas Benito, Javier, and José Manuel Matilla. *El Libro de Los Desastres de la Guerra*. Madrid, 2000.

BOEHN 1928–1929 Boehn, Max von. *La moda. Historia del traje en Europa desde los orígenes del Cristianismo hasta nuestros días*. 8 vols. Barcelona, 1928–1929.

BOLUFER 1998 *See* Peruga 1998b.

BOTTINEAU 1986 Bottineau, Yves. *L'Art de cour dans l'Espagne des Lumières 1746–1808*. Paris, 1986.

BOURDEAUX 1951 *Francisco de Goya, 1746–1828* [exh. cat., Musée des Beaux-Arts.] Bordeaux, 1951.

BOURDEAUX 1956 *De Tiepolo à Goya* [exh. cat., Musée des Beaux-Arts.] Bordeaux, 1956.

BOURDEAUX 1959 *Découverte de la lumière des primitifs aux impressionistes* [exh. cat., Musée des Beaux-Arts.] Bordeaux, 1959.

BOURDEAUX AND BUENOS AIRES 1981 *Panorama de la pintura española desde los Reyes Católicos a Goya* [exh. cat., Musée des Beaux-Arts; Palacio del Consejo Deliberante.] Bordeaux, 1981.

BOURDEAUX, PARIS, AND MADRID 1979–1980 *L'art européen à la Cour d'Espagne au XVIIIe siècle* [exh. cat., Musée des Beaux-Arts; Museo Nacional del Prado; Grand Palais.] Paris, 1979–1980.

BOURGOING 1789 Bourgoing, Jean-François. *Travels in Spain*. 3 vols. London, 1789.

BOZAL 1981 Bozal, Valeriano. "Goya y la imagen popular." *Cuadernos Hispano-americanos* 374 (1981): 249–270.

BOZAL 1983 Bozal, Valeriano. *Imagen de Goya*. Barcelona, 1983.

BOZAL 1987 Bozal, Valeriano. "El arbol goyesco." In *Goya. Nuevas visiones. Homenaje a Enrique Lafuente Ferrari*. Madrid, 1987: 119–132.

BOZAL 1989 Bozal, Valeriano. *Goya. Entre Neoclasicismo y Romanticismo*. Madrid, 1989.

BOZAL 1993 Bozal, Valeriano. "El paisaje en la pintura de Goya." In *Los Paisajes del Prado*. Madrid, 1993: 285–302.

BOZAL 1994 Bozal, Valeriano. *Goya y el gusto moderno*. Madrid, 1994.

BOZAL 1997 Bozal, Valeriano. *Pinturas negras de Goya*. Madrid, 1997.

BRAHAM 1981 Braham, Allan. *El Greco to Goya. The Taste for Spanish Paintings in Britain and Ireland*. London, 1981.

BREJON DE LAVERGNÉE 1998 Brejon de Lavergnée, Arnauld. "Fortune critique des *Jeunes* et des *Vieilles* du Musée de Lille." In Lille and Philadelphia 1998: 97–102.

BREJON DE LAVERGNÉE AND THIÉBAUT 1981 Brejon de Lavergnée, Arnauld, and Dominique Thiébaut. *Catalogue sommaire illustré des peintures du Musée du Louvre. II Italie, Espagne, Allemagne, Grande-Bretagne et divers*. Paris, 1981.

BRIEGER-WASSERBOGEL 1924 Brieger, Lothar. *Francisco de Goya*. 1924.

BRINTON 1915 Brinton, Selwyn. "Goya and Certain Goyas in America." *Art in America* (April 1915).

BROWN 1984 Brown, Jonathan, and José Manuel Pita Andrade, eds. *El Greco, Italy, and Spain*. Washington, 1984.

BROWN AND MANN 1990 Brown, Jonathan, and Richard G. Mann. *Spanish Paintings of the Fifteenth through Nineteenth Centuries*. The Collections of the National Gallery of Art Systematic Catalogue. Washington, 1990.

BRUSSELS 1985 *Goya. Europalia 85. España* [exh. cat., Musées Royaux des Beaux-Arts de Belgique.] Brussels, 1985.

BULL AND HARRIS 1986 Bull, Duncan, and Enriqueta Harris: "The Companion of Velázquez's *Rokeby Venus* and a Source for Goya's *Naked Maja*." *The Burlington Magazine* CXXVIII, 1002 (1986): 643–654.

BURBACH 1980 Burbach, Rainer. *Goya in der Krise seiner Zeit*. Stuttgart, 1980.

CALVERT 1908 Calvert, Albert F. *Goya. An Account of his Life and Works*. London, 1908.

CALVO SERRALLER 1990 Calvo Serraller, Francisco. *La novela del artista. Imágenes de ficción y realidad social en la formación de la identidad artística contemporánea, 1830–1850*. Madrid, 1990.

CALVO SERRALLER 1993 Calvo Serraller, Francisco. "Concepto e historia de la pintura de paisaje." In *Los paisajes del Prado*. Madrid, 1993: 11–27.

CALVO SERRALLER 1998 Calvo Serraller, Francisco. "El acecho del desnudo: figuras del erotismo en la pintura occidental." *Claves* 84 (1998): 50–53.

CALVO SERRALLER 2001 Calvo Serraller, Francisco. *Francisco de Goya. Obras maestras del Museo del Prado*, Madrid and Barcelona, 2001 (in press).

CALVO SERRALLER, MENA MARQUÉS, AND URREA 1994 Calvo Serraller, Francisco, Manuela B. Mena Marqués, and Jesús Urrea. *El Cuaderno Italiano. 1770–1786. Los orígenes del arte de Goya* [exh. cat., Museo Nacional del Prado.] Madrid, 1994.

CAMÓN 1980–1982 Camón Aznar, José. *Francisco de Goya*. 4 vols. Saragossa, 1980–1982.

CANALIS 1968 Canalis, Enrique Pardo. "La iglesia zaragozana de San Fernando y las pinturas de Goya." *Goya* 84 (1968): 358–365.

CANALIS 1979 Canalis, Enrique Pardo. "Una visita a la Galería del Príncipe de la Paz." *Goya* 148–150 (1979): 300–311.

CANELLAS LÓPEZ 1981 Canellas López, Ángel, ed. *Francisco de Goya, Diplomatario*. Saragossa, 1981.

CARACAS 1983 *Simón Bolívar, bicentenario de su nacimiento 1783–1983*. [exh. cat., Galería de Arte Nacional y Bellas Artes.] Caracas, 1983.

CARDERERA 1860 Carderera, Valentín. "François Goya. Sa vie, ses dessins et ses eaux-forts." *Gazette des Beaux-Arts* VII (1860): 215–227.

CARDERERA 1863 Carderera, Valentín. "François Goya." *Gazette des Beaux-Arts* 15 (1863): 237–249.

CASTRO 1930 Castro y Jarillo, Antonio de. *La Sala de Goya del Museo de la Real Academia de San Fernando*. Madrid, 1930.

CEÁN BERMÚDEZ 1800 Ceán Bermúdez, Juan Agustín. *Diccionario histórico de los más ilustres professores de las Bellas Artes en España*. Madrid, 1800.

CHAN 1983 Chan, Victor. "New Light on Goyas's Tapestry Cartoon: *La Boda*." *Gazette des Beaux Arts* 6, 101 (1983): 33–38.

CHAN 1985 Chan, Victor. "Goya's Tapestry Cartoon of the Straw Manikin: a Life of Games and a Game of Life." *Arts Magazine* LX, 2 (1985): 50–58.

CHICAGO 1934 *A Century of Progress: Exhibition of Paintings and Sculptures*. Chicago, 1934.

CHICAGO 1941 *Paintings, Drawings, Prints. The Art of Goya*. [exh. cat., The Art Institute of Chicago.] Chicago, 1941.

CIOFALO 1995 Ciofalo, John J. "Unveiling Goya's *Rape of Galatea*." *Art History* 18 (1995): 477–498.

CLARK 1953 Clark, Kenneth. *The Nude: A Study in Ideal Form*. Kingsport, 1953.

COHEN 1973 *See* Cohen 1994.

COHEN 1994 Cohen, Ronald. "Más investigación sobre *La Boda* de Goya. Los motivos para creer que se ha cortado el cartón del Prado." *Boletín Museo Instituto Camón Aznar* 55 (1994): 81–88.

CONSIDÉRATIONS ... 1791 *Considérations sur les arts du dessin en France, suivies d'un plan d'Académie, ou d'École publique, et d'un système d'encouragement*. Paris, 1791.

COOK 1945 Cook, W. "Potraits by Goya." *Gazette des Beaux-Arts* XXVIII (1945): 151–162.

CORTISSOZ 1937 Cortissoz, Royal. *An Introduction to the Mellon Collection*. Boston, 1937.

CRISPOLTI 1963 Crispolti, Enrico. "Processo elaborativo e cronologia dei *Caprichos* di Goya." In *Scritti di Storia dell'Arte in onore di Maria Salmi*. Rome, 1963: 391–433.

CROMBIE 1973 Crombie, Theodore. "Goya and the Stage." *Apollo* 98 (July 1973): 22–27.

CROW 1985 Crow, Thomas E. *Painters and Public Life in Eighteenth-Century Paris*. New Haven and London, 1985.

CRUZ Y BAHAMONDE 1813 Cruz y Bahamonde, Nicolás de la (Count of Maule). *Viage de España, Francia e Italia*, Cádiz, 1806–1813.

CRUZ VALDOVINOS 1987 Cruz Valdovinos, José Manuel. "La partición de bienes entre Francisco y Javier Goya a la muerte de Josefa Bayeu y otras cuestiones." In *Goya. Nuevas visiones. Homenaje a Enrique Lafuente Ferrari*. Madrid, 1987: 133–153.

CRUZ VALDOVINOS 1989 Cruz Valdovinos, José Manuel. "Inquisidores e ilustrados: Las pinturas y estampas 'indecentes' de Sebastián Martínez." In *El arte en tiempo de Carlos III. IV Jornadas de Arte*. Madrid, 1989: 311–319.

CRUZADA VILLAAMIL 1870 Cruzada Villaamil, Gregorio. *Los tapices de Goya*. Madrid, 1870.

CUMBERLAND (1807) 1969 Cumberland, Richard. *Memoirs*. 2 vols. London, 1807. Rev. ed. New York, 1969.

CUNO ET AL. 1990 Cuno, James, et al. *Fatal consequences: Callot, Goya, and the Horrors of War* [exh. cat., Hood Museum of Art, Dartmouth College.] Hanover, NH, 1990.

DALLAS 1982–1983 *Goya and the Art of his Time* [exh. cat., Meadows Museum, Southern Methodist University.] Dallas, 1982–1983.

DARNTON 1993 Darnton, Robert. *New Perspectives on Historical Writing*. Cambridge, 1991.

DEMERSON 1975 Demerson, Paula de. *María Francisca de Sales Portocarrero, condesa de Montijo, una figura de la Ilustración*. Madrid, 1975.

DESPARMET FITZ-GERALD 1928–1950 Desparmet Fitz-Gerald, Xavier. *L'Oeuvre peint de Goya*. 4 vols. Paris, 1928–1950.

DETROIT INSTITUTE OF ARTS 1944 *The Detroit Institute of Arts: Catalogue of Paintings*. Detroit, 1944.

DOMÍNGUEZ ORTIZ 1976 Domínguez Ortiz, Antonio. *Sociedad y estado en el siglo XVIII español*. Barcelona, 1976.

DOMÍNGUEZ ORTIZ 1987 Domínguez Ortiz, Antonio. "La mujer en el tránsito de la Edad Media a la Moderna." In *Estudios de historia económica y social de España*. Granada, 1987: 151–162.

DOMÍNGUEZ ORTIZ 1988 Domínguez Ortiz, Antonio. *Carlos III y la España de la Ilustración*. Madrid, 1988.

DUBLIN 1957 *Paintings from Irish Collections* [exh. cat., Municipal Gallery of Modern Art.] Dublin, 1957.

EAUBONNE 1977 Eaubonne, Françoise d'. *Histoire de l'art et lutte des sexe*. Paris, 1977.

ENCINA 1928 Encina, Juan de (Ricardo Gutiérrez Abascal). *Goya en zig-zag. Bosquejo de interpretación biográfica*. Madrid, 1928.

EZQUERRA DEL BAYO 1928 Ezquerra del Bayo, Joaquín. "Iconografía de Goya." *Arte Español* IX, 9 (1928): 310–311.

EZQUERRA DEL BAYO (1928) 1959 Ezquerra del Bayo, Joaquín. *La duquesa de Alba y Goya*. Madrid, 1928. Rev. ed. Madrid, 1959.

EZQUERRA DEL BAYO 1934 Ezquerra del Bayo, Joaquín. *Retratos de la familia Téllez-Girón, novenos duques de Osuna*. Madrid, 1934.

EZQUERRA DEL BAYO AND PÉREZ BUENO 1924 Ezquerra del Bayo, Joaquín, and Luis Pérez Bueno. *Retratos de mujeres españolas del siglo XIX*. Madrid, 1924.

FEIJÓO 1997 Feijóo, Benito J. *Defensa de la mujer. Discurso XVI del Teatro Crítico*. Barcelona, 1997.

FERNÁNDEZ 1996 Fernández, Pedro Jesús. *Quien es quien en la pintura de Goya*. Madrid, 1996.

FERNÁNDEZ CORDERO 1993 Fernández Cordero, M. J. *Pastoral y apostolado de la Palabra*, 1993.

FERRARI 1928 Ferrari, Enrique Lafuente. *Centenario de Goya. Exposición de Pinturas* [exh. cat., Museo Nacional del Prado.] Madrid, 1928.

FERRARI 1947 Ferrari, Enrique Lafuente. *Antecedentes, coincidencias e influencias del arte de Goya*. Madrid, 1947.

FERRARI 1949 Ferrari, Enrique Lafuente. "Goya y el arte francés." In *Goya. Cinco estudios*. Saragossa, 1949: 43–66.

FERRARI 1969 Ferrari, Enrique Lafuente. *Francisco de Goya y Lucientes: Mujeres en el Museo del Prado*. Granada, 1969.

FIGUEROA 1929 Figueroa, Fernando Iglesias. *Goya y la Inquisición*. Madrid, 1929.

FISCHER 1802 Fischer, Christian-August. *Travels in Spain in 1797 and 1798*. London, 1802.

FLORENCE 1986 *Da El Greco a Goya: i secoli d'oro della pittura spagnola* [exh. cat., Palazzo Vecchio.] Florence, 1986.

FOLGUERA CRESPO 1997 Folguera Crespo, P. "¿Hubo una revolución liberal burguesa para las mujeres? (1808–1868)." In *Historia de las mujeres en España*. Madrid, 1997: 421–449.

FRANCÉS 1923 Francés, José. "La Sala de Goya en la Real Academia de San Fernando." *La Esfera* XV, 745 (1923).

FRANKFURT 1937 Frankfurt, Alfred. "The Mellon Gift to the Nation." *Art News* 35 (1937).

FREDERICKSON 1985 Frederickson, Burton B. "Goya's Portraits of the Marqueses de Santiago and San Adrián." *J. Paul Getty Museum Journal* 13 (1985): 135–140.

FREDERICKSON 1986 Frederickson, Burton B. "Goya's *Portrait of the Marquesa de Santiago*: A Correction." *J. Paul Getty Museum Journal* 14 (1986): 151.

FREDERICKSON 1988 Frederickson, Burton B. *Masterpieces of Painting in the J. Paul Getty Museum.* Malibu, 1988.

GÁLLEGO 1978 Gállego, Julián. *En torno a Goya.* Saragossa, 1978.

GÁLLEGO 1979 Gállego, Julián. "Francia y Goya." *Goya* 148–150 (1979): 250–259.

GÁLLEGO 1983 Gállego, Julián. "Los retratos de Goya." In Madrid 1983: 49–76.

GÁLLEGO 1997 Gállego, Julián. "La figura de la maja, desde Goya hasta Zuloaga." In *La Mujer en el Arte Español*, VIII Jornadas de Arte. Madrid, 1997: 323–239.

GALLO 1900 Gallo, Juan Pérez de Guzmán y. "Las colecciones de cuadros del Príncipe de la Paz." *La España Moderna* 140 (1900): 95–126.

GARRIDO 1984 Garrido, Carmen. "Algunas consideraciones sobre la técnica de las *Pinturas negras* de Goya." *Boletín del Museo del Prado* V, 13 (1984): 4–40.

GASSIER 1973 Gassier, Pierre. *Francisco Goya: Drawings of Goya: The Complete Albums.* New York and Washington, 1973.

GASSIER 1975 Gassier, Pierre. *The Drawings of Goya: The Sketches, Studies and Individual Drawings.* New York, 1975.

GASSIER 1979 Gassier, Pierre. "Les portraits peints par Goya pour l'Infant Don Luis de Borbón à Arenas de San Pedro." *Revue d'Art* 13, 43 (1979): 9–23.

GASSIER 1984 Gassier, Pierre. *Goya testigo de su tiempo.* Madrid, 1984.

GASSIER AND WILSON 1971 Gassier, Pierre, and Juliet Wilson. *The Life and Complete Work of Francisco Goya.* New York and London, 1971.

GAUTIER 1858 Gautier, Théophile. *Voyage en Espagne.* Paris, 1858. Rev. ed. Paris, 1964.

GAYA NUÑO 1958 Gaya Nuño, Juan. *La pintura española fuera de España (historia y catálogo).* Madrid, 1958.

GENEVA 1939 *Les chefs-d'oeuvre du Musée du Prado* [exh. cat., Musée d'Art et d'Histoire.] Geneva, 1939.

GENEVA 1989 *Du Greco à Goya: chefs-d'oeuvres du Prado et des collections espagnoles* [exh. cat., Musée d'Art et Histoire.] Geneva, 1989.

GERARD 1988 Gerard, Veronique. "Les Deux Majas de Goya." *Beaux Arts* 62 (November 1988): 72–74.

GERBET 1994 Gerbet, Marie-Claude. *Les noblesses espagnoles au Moyen Âge. XIe–XVe siècle.* Paris, 1994.

GHENT 1950 *Quarante chefs d'oeuvre du Musée de Lille* [exh. cat., Musée des Beaux-Arts, Ghent.] Ghent, 1950.

GLENDINNING 1963 Glendinning, Nigel. "Goya and Arriaza's 'Profecía del Pirineo.'" *Journal of the Warburg and Courtauld Institutes* (1963): 363–367.

GLENDINNING 1969 Glendinning, Nigel. "Goya's Portrait of Andrés del Peral." *Apollo* LXXXIX, 85 (1969): 200–203.

GLENDINNING 1975 Glendinning, Nigel. "The Strange Translation of Goya's *Black Paintings.*" *The Burlington Magazine* CXVII, 86 (1975): 465–479.

GLENDINNING 1976 Glendinning, Nigel. "Variations on a theme by Goya: *Majas on a Balcony.*" *Apollo* CIII, 167 (1976): 40–47.

GLENDINNING 1977 Glendinning, Nigel. *Goya and his Critics.* New Haven and London, 1977.

GLENDINNING 1978a Glendinning, Nigel. "Goya on Women in the *Caprichos*: The Case of Castillo's Wife." *Apollo* CVII (February 1978): 130–134.

GLENDINNING 1978b Glendinning, Nigel. "A Solution to the Enigma of Goya's *Emphatic Caprices.*" *Apollo* 107 (March 1978): 186–191.

GLENDINNING 1981 Glendinning, Nigel. "Goya's Patrons." *Apollo* CXIV, 2 (1981): 236–247.

GLENDINNING 1983 Glendinning, Nigel. "La fortuna de Goya." In Madrid 1983: 21–47.

GLENDINNING 1985 Glendinning, Nigel. "Goya's *Portrait of the Marquesa de Santiago.*" *J. Paul Getty Museum Journal* 13 (1985): 141–146.

GLENDINNING 1986a Glendinning, Nigel. "A Footnote to Goya's *Portrait of the Marquesa de Santiago.*" *J. Paul Getty Museum Journal* 14 (1986): 151.

GLENDINNING 1986b Glendinning, Nigel. "Goya's Country House in Madrid, The Quinta del Sordo." *Apollo* CXXIII, 288 (1986): 102–109.

GLENDINNING 1986c Glendinning, Nigel. "Changing Patterns of Taste in Goya's Time." In Lugano 1986.

GLENDINNING 1987 Glendinning, Nigel. "El retrato en la obra de Goya. Aristócratas y burgueses de signo variado." In *Goya. Nuevas visiones. Homenaje a Enrique Lafuente Ferrari.* Madrid, 1987: 183–195.

GLENDINNING 1992a Glendinning, Nigel. *Goya. La década de Los Caprichos: retratos 1792–1804* [exh. cat., Real Academia de Bellas Artes de San Fernando.] 2 vols. Madrid, 1992.

GLENDINNING 1992b Glendinning, Nigel. "Recuerdos y angustias en las pinturas de Goya, 1793–1794." In *Goya* [exh. cat., Exposición Universal Sevilla.] Seville, 1992: 133–158.

GLENDINNING 1993 Glendinning, Nigel. "Las *Pinturas negras.*" In *Goya: Jornadas en torno al estado de la cuestión de los estudios sobre Goya.* Madrid, 1993: 41–51.

GLENDINNING 1994 Glendinning, Nigel. "Spanish Inventory References to Paintings by Goya, 1800–1850: Originals, Copies and Valuations." *The Burlington Magazine* 1091 (1994): 100–110.

GLENDINNING 1996 Glendinning, Nigel. "Motivos carnavalescos en la obra de Goya." In *Disparates: tres visiones.* Madrid, 1996.

GONZÁLEZ DE ZÁRATE 1990 González de Zárate, Jesús María. *Goya: lo bello y lo sublime.* Vitoria, 1990.

GONZÁLEZ PALENCIA 1946 González Palencia, Angel. "El estudio crítico más antiguo sobre Goya." *Boletín de la Real Academia de la Historia* (1946): 75–87.

GOODY 1983 Goody, J. *The Development of the family and marriage in Europe*. Cambridge, 1983.

GOWING 1966 Gowing, Lawrence. "Goya and the *Black Paintings*." *The Burlington Magazine* CXVIII, 762 (1966): 487–488.

GOYA 1924 *Goya: Colección de cuatrocientos cuarenta y nueve reproducciones de cuadros, dibujos y aguafuertes de don Francisco Zapater y Gómez en 1860*. Madrid, 1924.

GOYA 1982 Goya, Francisco. *Cartas a Martín Zapater*. Madrid, 1982.

GOYA 1989 *Goya y los pintores de la Ilustración*. San Sebastián, 1989.

GOYA 1992 *Goya. Grabador y Litógrafo. Repertorio Bibliografico*. Madrid, 1992.

GRANADA 1955 *Goya* [exh. cat., Palacio de Carlos V.] Granada, 1955.

GRAVES 1985 Graves, Robert. *Los mitos griegos*. 2 vols. Madrid, 1985.

GUARDIA PONS 1981 Guardia Pons, Milagros. "El gran cabrón del *Aquelarre* de Goya." *Boletín del Museo e Instituto Camón Aznar* IV (1981): 23–35.

GUDIOL 1970 Gudiol Ricart, José. *Goya*. 4 vols. Barcelona, 1970.

GUDIOL 1980 Gudiol Ricart, José. *Conversaciones sobre Goya y el arte contemporaneo*. Saragossa, 1980.

HADJINICOLAOU 1997 Hadjinicolaou, Nicos. "El deseo erótico en la obra de Goya." In *La Mujer en el Arte Español*, VIII Jornadas de Arte. Madrid, 1997: 297–307.

HAIDT 1995 Haidt, Rebecca. "Los besos de amor and La Maja desnuda: The Fascination of the Senses." *Revista de estudios hispanicos* 29, no. 3 (1995): 477.

HAIDT 1998 Haidt, Rebecca. *Embodying Enlightenment: Knowing the Body in Eighteenth-Century Spanish Literature and Culture*. New York, 1998.

HAMBURG 1980–1981 *Goya. Das Zeitalter der Revolutionen. Kunst um 1800 (1789–1830)* [exh. cat., Kunsthalle.] Hamburg, 1980–1981.

HAMBURG 1986 *Eva und die Zukunft. Das Bild der Frau seit der Französischen Revolution* [exh. cat., Kunsthalle.] Hamburg, 1986.

HARA 1997 Hara, Jacqueline. *Francisco Goya: Letters of Love and Friendship*. New York, 1997.

HARRIS (1969) 1994 Harris, Enriqueta. *Goya*. London and New York, 1969. Rev. ed. 1994.

HARRIS 1963 Harris, Tomás. *Goya: Engravings and Lithographs*. 2 vols. Oxford, 1963.

HAUTECOEUR 1926 Hautecoeur, Louis. *Musée National du Louvre. Catalogue des Peintures exposées dans le Galeries. II École Italienne et École Espagnol*. Paris, 1926.

HAVEMEYER 1931 *The H. O. Havemeyer Collection: Catalogue of Paintings, Prints, Sculpture and Objects of Art*. Portland, Maine, 1931.

HAVEMEYER 1958 *The H. O. Havemeyer Collection: The Metropolitan Museum of Art*. 2d ed. New York, 1958.

HAVEMEYER 1961 Havemeyer, Louisine B. *Sixteen to Sixty: "Memoirs of a Collector."* New York, 1961.

HECKES 1991 Heckes, Frank. "Goya's *Les Jeunes* and *Les Vieilles*." *Gazette des Beaux Arts* (February 1991): 93–100.

HELD 1964 Held, Jutta. *Farbe und licht in Goyas Malerei*. Berlin, 1964.

HELD 1971 Held, Jutta. *Die Genrebilder der Madrider Teppichmanufaktur und die Anfänge Goyas*. Berlin, 1971.

HELD 1987 Held, Jutta. "Between Bourgeois Enlightenment and Popular Culture: Goya's festivals, old women, monsters and blind men." *History Workshop Journal* 23 (1987): 39–58.

HELD 1993 Held, Jutta. "La pintura española de paisaje en el siglo XVIII." In *Los paisajes del Prado*. Madrid, 1993: 255–269.

HELD 2001 Held, Jutta. "Los cartones para tapices." In *Goya. Obras maestras del Museo del Prado*. Madrid and Barcelona, 2001 (in press).

HELMAN 1955 Helman, Edith. "The elder Moratín and Goya." *Hispanic Review* XXIII (1955): 219–230.

HELMAN 1958 Helman, Edith. "*Caprichos* and *monstruos* of Cadalso and Goya." *Hispanic Review* XXVI (1958): 200–222.

HELMAN 1959 Helman, Edith. "The younger Moratín and Goya: on *duendes* and *brujas*." *Hispanic Review* XXVII (1959): 103–122.

HELMAN 1960 Helman, Edith. "Moratín y Goya: actitudes ante el pueblo en la Ilustración española." *Revista de la Universidad de Madrid* IX, 35 (1960): 591–605.

HELMAN 1963 Helman, Edith. *Trasmundo de Goya*. Madrid, 1963.

HELMAN 1964 Helman, Edith. "Identity and Style in Goya." *The Burlington Magazine* CVI, 730 (1964): 30–37.

HELMAN 1970 Helman, Edith. *Jovellanos y Goya*. Madrid, 1970.

HELMAN 1987 Helman, Edith. "Algunos sueños y brujas de Goya." In *Goya. Nuevas visiones. Homenaje a Enrique Lafuente Ferrari*. Madrid, 1987: 197–205.

HELSTON 1983 Helston, Michael. *Spanish and Later Italian Paintings*. London, 1983.

HELSTON 1989 Helston, Michael. *Painting in Spain During the Later Eighteenth-Century*. London, 1989.

HEMPEL-LIPSCHUTZ 1987 Hempel-Lipschutz, Ilse. "Théophile Gautier y su 'quimera retrospectiva.'" In *Goya. Homenaje a Enrique Lafuente Ferrari*. Madrid, 1987: 207–225.

HERRAN DE LAS POZAS 1949 Herran de las Pozas, Agustín de la. *Pinturas negras y apocalipticas de Goya*. Bilbao, 1949.

HERRANZ RODRÍGUEZ 1996 Herranz Rodríguez, Concha. "Indumentaria goyesca." In *Actas 1996*: 251–270.

HERRERO AND GLENDINNING 1996 Herrero Carretero, Concha, and Nigel Glendinning. "El estado de la cuestión: cartones y tapices." In *Actas 1996*: 23–37.

HERRERO, SANCHO AND MARTÍNEZ CUESTA 1996 Herrero Carretero, Concha, José Luis Sancho, and J. Martínez Cuesta. *Tapices y cartones de Goya.* In Madrid 1996.

HETZER 1950 Hetzer, Theodor. *Francisco Goya und die Krise der Kunst um 1800.* Darmstadt, 1950.

HOFMANN 1993–1994 Hofmann, Werner. "El naufragio permanente." In Madrid, London, and Chicago 1993–1994: 43–65.

HOLLAND 1910 Holland, Elisabeth, Lady. *The Spanish Journal of Elisabeth, Lady Holland.* London, 1910.

HOLO 1985 Holo, Selma. "An Unexpected Poseur in a Goya Drawing." *J. Paul Getty Museum Journal* 13 (1985): 108.

HOURS 1970 Hours, Madeleine. "Analyse scientifique des peinture. Essai de méthodologie." *Annales, Laboratoire de recherche des Musées de France* (1970): 2–18.

IGLESIAS 1989 Iglesias, Carmen. "Educación y pensamiento ilustrado." In *Actas del Congreso Internacional sobre Carlos III y la Ilustración.* Vol. III. Madrid, 1989: 1–30.

IGLESIAS 1997 Iglesias, Carmen. "La nueva sociabilidad: mujeres nobles y salones literarios y políticos." In *Nobleza y sociedad en la España moderna.* Vol. II. Madrid, 1997: 179–230.

IGLESIAS 1999 Iglesias, Carmen. *Razón y sentimiento en el siglo XVIII.* Madrid, 1999.

JACKSON 2001 *The Majesty of Spain* [exh. cat., Mississippi Museum of Art.] Jackson, Miss., 2001.

JEDLICKA 1940 Jedlicka, G. "Die nackte und die bekleidete Maja von Francisco de Goya y Lucientes." *Galerie und Sammler* 7 (1940): 97–102.

JOVELLANOS 1963 Jovellanos, Melchor Gaspar de. "Memoria sobre educación pública, o sea, tratado teórico-práctico de enseñanza." In *Obras* (Biblioteca de Autores Españoles). Madrid, 1963: 230–267.

JUNOT 1831–1835 Junot, Laure. *Memoirs,* 8 vols. London, 1831–1835.

JUNQUERA 1959 Junquera, Paulina. "Un lienzo inédito de Goya en el Palacio de Oriente." *Archivo Español de Arte* XXXII, 127 (1959): 185–192.

KAGANÉ, LINNIK, AND SEMIONOVA 1981 Kagané, L., I. Linnik, and K. Semionova. *Tesoros del Ermitage.* Madrid, 1981.

KANY 1932 Kany, Charles E. *Life and Manners in Madrid 1750–1800.* Berkeley, 1932.

KITTS 1995 Kitts, Sally-Ann. *The Debate on the Nature, Role and Influence of Women in Eighteenth Century Spain.* New York, 1995.

KLEIN 1998 Klein, Peter. "Insanity and the sublime: aesthetics and theories of mental Illness in Goya's "Yard with lunatics" and related Works." *Journal of the Warburg and Courtauld Institutes* 61 (1998): 198–252.

KLINGENDER 1948 Klingender, Francis D. *Goya in the Democratic Tradition.* London, 1948.

KYOTO AND TOKYO 1971–1972 *El arte de Goya. Exposición extraordinaria de Goya en Japón* [exh. cat., Museo Municipal and Museo Nacional de Arte Occidental.] Tokyo, 1971–1972.

LABORDE (1809) 1827 Laborde, Alexandre. *A View of Spain.* 5 vols. London, 1809. *Itineraire descriptif de L'Espagne.* 6 vols. Paris, 1827.

LACLOTTE AND CUZIN 1982 Laclotte, Michel, and Jean-Pierre Cuzin. *The Louvre. French and other European Paintings.* London, 1982.

LAFOND 1902 Lafond, Paul. *Goya.* Paris, 1902

LAFOND 1907 Lafond, Paul. "Les dernières années de Goya en France." *Gazette des Beaux-Arts* XXXVII (1907): 114–131 and 241–257.

LAFOND 1924 Lafond, Paul. *Goya.* Paris, 1924.

LÁZARO GALDIANO 1959 Lázaro y Galdiano, José. "Some Emblematic Sources of Goya." *Journal of the Warburg and Courtauld Institutes* XXII (1959): 106–131.

LEFORT 1876 Lefort, Paul. *Francisco de Goya. Étude biographique et critique, suivie de l'essai d'un catalogue raisonné de son oeuvre gravé et lithographié.* Paris, 1876.

LENINGRAD 1977 *Nuevas adquisiciones del Ermitage* [exh. cat., The State Hermitage Museum.] Leningrad, 1977.

LENINGRAD AND MOSCOW 1980 *Obras maestras de la pintura española de los siglos XVI al XIX* [exh. cat., The State Hermitage Museum; Pushkin Museum.] Leningrad, 1980.

LENINGRAD AND MOSCOW 1987 *Pintores españoles del siglo XIX: de Goya a Picasso* [exh. cat., The State Hermitage Museum; Pushkin Museum.] Leningrad, 1987.

LEVEY 1966 Levey, Michael. *Rococo to Revolution. Major Trends in Eighteenth-Century Art.* London, 1966.

LEVITINE 1959 Levitine, G. "Some Enblematic Sources of Goya." *Journal of the Warburg and Courtaud Institutes* XXII (1959): 114–131.

LICHT 1973 Licht, Fred. "Goya's Portrait of the Royal Family." In *Goya in perspective.* Englewood Cliffs, NJ, 1973.

LICHT (1979) 1983 Licht, Fred. *Goya. The Origins of Modern Temper in Art.* London and New York, 1979. Rev. ed. 1983.

LICHT 1998 Licht, Fred. "Ya no es una diosa. *Las Majas* de Goya y el desnudo en los orígenes de la época moderna." In *El desnudo en el Museo del Prado.* Madrid and Barcelona, 1998.

LILLE AND PHILADELPHIA 1998–1999 *Goya: un regard libre.* [exh. cat., Musée des Beaux-Arts de Lille; Philadelphia Museum of Art.] Paris, 1998–1999.

LINK 1801 Link, Henry Frederick. *Travels in Portugal and through France and Spain.* London, 1801.

LOGA 1903 Loga, Valerian von. *Goya.* Berlin, 1903.

LONDON 1901 *Descriptive and Biographical Catalogue of the Exhibition of Works by Spanish Painters* [exh. cat., Art Gallery of the Corporation of London.] London, 1901.

LONDON 1911 *Exhibition of Old Masters* [exh. cat., Grafton Galleries.] London, 1911.

LONDON 1920–1921 *Exhibition of Spanish Paintings at the Royal Academy* [exh. cat., Royal Academy of Arts.] London, 1920–1921.

LONDON 1928 *Exhibition of Spanish Art, Including Pictures, Drawings and Engravings by Goya* [exh. cat., Burlington Fine Arts Club.] London, 1928.

LONDON 1931 *An Exhibition of Old Masters by Spanish Artists* [exh. cat., Tomás Harris Gallery.] London, 1931.

LONDON 1938 *Spanish Painting from El Greco to Goya* [exh. cat., The Spanish Art Gallery.] London, 1938.

LONDON 1947 *An Exhibition of Spanish Paintings* [exh. cat., The National Gallery.] London, 1947.

LONDON 1963–1964 *Goya and his times* [exh. cat., Royal Academy of Arts.] London, 1963–1964.

LONDON 1972 *The Age of Neo-Classicism* [exh. cat., Royal Academy of Arts; Victoria and Albert Museum.] London, 1972.

LONDON 1981 *El Greco to Goya. The Taste for Spanish Paintings in Britain and Ireland* [exh. cat., The National Gallery.] London, 1981.

LONDON 1987 *Old Master Paintings from the Thyssen-Bornemisza Collection* [exh. cat., The Royal Academy of Arts.] London, 1988.

LONDON 1990 *Goya's Majas* [exh. cat., The National Gallery.] London, 1990.

LÓPEZ 1995 López, François. "La culture des élites espagnoles à l'Époque Moderne." *Bulletin Hispanique* 97, 1 (January–June 1995).

LÓPEZ 1997 López, François. "Les Livres des espagnols à l'Èpoque Moderne." *Bulletin Hispanique* 99, 1 (January–June 1997).

LÓPEZ 1998 López, François. "Lisants et lecteurs en Espagne. XVe–XIXe siècle." *Bulletin Hispanique* 100, 2 (July–December 1998).

LÓPEZ AYALA 1988 López Ayala, Ángeles y Braulio. "Mujer y trabajo." *Historia 16* (May 1988): 33–40.

LÓPEZ REY 1948 López Rey, José. "Four visions of women's behavior in Goya's graphic work." *Gazette des Beaux-Arts* (November 1948): 355–364.

LÓPEZ VÁZQUEZ 1981 López Vázquez, José Manuel. *Goya: el programa neoplatónico de las pinturas de la Quinta del Sordo.* Santiago de Compostela, 1981.

LUGANO 1986 *Goya nelle collezioni private di Spagna: Thyssen-Bornemisza* [exh. cat., Villa Favorita.] Lugano, 1986.

LYNCH 1989 Lynch, John. *Bourbon Spain 1700–1808.* Oxford, 1989.

MACKENZIE 1941 Mackenzie, H. F. "Interpreting Goya: A Study of his Art and his Influence." *Chicago Institute of Art Bulletin* 35 (1941): 21–22.

MACLAREN 1970 MacLaren, Neil. *National Gallery Catalogues: The Spanish School.* London, 1970.

MADRID 1805 Real Academia de Bellas Artes de San Fernando

MADRID 1846 *Catálogo de las obras de pintura, escultura y arquitectura* [exh. cat., Liceo Artístico y Literario.] Madrid, 1846.

MADRID 1896 *Catálogo de los Cuadros de la Antigua casa Ducal de Osuna expuestos en el Palacio de la Industria y de las Artes* [exh. cat., Palcio de la Industria y de las Artes.] Madrid, 1896.

MADRID 1900 *Obras de Goya* [exh. cat., Ministerio de Instrucción Pública y Bellas Artes.] Madrid, 1900.

MADRID 1902 *Exposición Nacional de Retratos* [exh. cat., Ministerio de Instrucción Pública y Bellas Artes.] Madrid, 1902.

MADRID 1908 *Exposición histórico-artística del centenario del Dos de Mayo.* Madrid, 1908.

MADRID 1913 *Exposición de pinturas de la primera mitad del siglo XIX* [exh. cat., Sociedad Española de Amigos del Arte.] Madrid, 1913.

MADRID 1918 *Exposición de retratos de mujeres españolas por artistas españoles anteriores a 1850* [exh. cat., Sociedad Española de Amigos del Arte.] Madrid, 1918.

MADRID 1926 *Retratos de niños en España* [exh. cat., Sociedad Española de Amigos del Arte.] Madrid, 1926.

MADRID 1928 *Centenario de Goya. Exposición de Pinturas* [exh. cat., Museo Nacional del Prado.] Madrid, 1928.

MADRID 1932 *Antecedentes, coincidencias e influencias del arte de Goya* [exh. cat., Sociedad Española de Amigos del Arte.] Madrid, 1932.

MADRID 1946 *Exposición conmemorativa del centenario de Goya* [exh. cat., Palacio Real.] Madrid, 1946.

MADRID 1949 *Bocetos y estudios para pinturas y esculturas* [exh. cat., Asociación de Amigos del Arte.] Madrid, 1949.

MADRID 1951 *Goya* [exh. cat., Museo Nacional del Prado.] Madrid, 1951.

MADRID 1961 *Francisco de Goya, IV Centenario de la capitalidad* [exh. cat., Casón del Buen Retiro.] Madrid, 1961.

MADRID 1979 *Madrid: Testimonios de su historia* [exh. cat., Museo Municipal.] Madrid, 1979.

MADRID 1981 *Tesoros del Ermitage* [exh. cat., Museo Nacional del Prado.] Madrid, 1981.

MADRID 1982 *Goya y la Constitución de 1812* [exh. cat., Museo Municipal.] Madrid, 1982.

MADRID 1983 *Goya en las colecciónes madrileñas* [exh. cat., Museo Nacional del Prado.] Madrid, 1983.

MADRID 1985 *Arte sacro de la archidiócesis de Madrid-Alcalá.*

MADRID 1987 *Tesoros de las collecciónes particulares madrileñas. Pinturas desde el siglo XV a Goya* [exh. cat., Real Academia de Bellas Artes de San Fernando.] Madrid, 1987.

MADRID 1988 *Los pintores de la Ilustración* [exh. cat., Centro Cultural de Conde Duque.] Madrid, 1988.

MADRID 1989 *ARCO* [exh. cat., Pabellón de Exposiciones de la Casa de Campo.] Madrid, 1989.

MADRID 1991 Madrid, José Valverde. "Cuatro retratos goyescas de la sociedad madrileña." *Anales del Instituto de estudios madrileños* 30 (1991): 23–36.

MADRID 1992–1993 *Goya. La década de Los Caprichos: retratos 1792–1804* [exh. cat., Real Academia de Bellas Artes de San Fernando.] Madrid, 1992–1993.

MADRID 1995 *La belleza de lo real. Floreros y bodegones españoles en el Museo del Prado, 1600–1800* [exh. cat., Museo Nacional del Prado.] Madrid, 1995.

MADRID 1995 *Reales Fábricas.*

MADRID 1995–1996 *Goya en las collecciónes españolas* [exh. cat., Banco Bilbao Vizcaya.] Madrid, 1995–1996.

MADRID 1996a *Estampas de la Guerra de la Independencia* [exh. cat., Museo Municipal de Madrid.] Madrid, 1996.

MADRID 1996b *Tapices y cartones de Goya* [exh. cat. .Palacio Real.] Madrid, 1996.

MADRID 1996c *Goya: 250 aniversario* [exh. cat., Museo Nacional del Prado.] Madrid, 1996.

MADRID, BOSTON, AND NEW YORK 1988–1989 *Goya and the Spirit of Enlightenment* [exh. cat., Museo Nacional del Prado; Museum of Fine Arts; The Metropolitan Museum of Art.] New York, 1988.

MADRID, LONDON, AND CHICAGO 1993–1994 *Goya. El capricho y la invención. Cuadros de gabinete, bocetos y miniaturas* [exh. cat., Museo Nacional del Prado; Royal Academy of Arts; The Art Institute of Chicago.] Madrid, 1993–1994.

MARAVALL CASESNOVES 1999a Maravall Casesnoves, José Antonio. "La estimación de la sensibilidad en la cultura de la Ilustración." In *Estudios de historia del pensamiento español: Siglo XVIII.* Vol. IV. Madrid, 1999: 381–411.

MARAVALL CASESNOVES 1999b Maravall Casesnoves, José Antonio. "La idea de felicidad en el programa de la Ilustración." In *Estudios de historia del pensamiento español: Siglo XVIII.* Vol. IV. Madrid, 1999: 231–268.

MARAVALL CASESNOVES 1999c Maravall Casesnoves, José Antonio. "El sentimiento de nación en el siglo XVIII: la obra de Forner." In *Estudios de historia del pensamiento español: Siglo XVIII.* Vol. IV. Madrid, 1999: 59–85.

MARTÍN GAITE 1972 Martín Gaite, Carmen. *Usos amorosos del XVIII en España.* Madrid, 1972.

MATHERON 1858 Matheron, Laurent. *Goya.* Paris, 1858.

MAYER 1920–1921 Mayer, August L. "Goya als Frauenmaler." *Kunst und Künstler* XIX (1920–1921): 415–422.

MAYER 1923 Mayer, August L. *Francisco de Goya.* Munich, 1923.

MAYER 1932 Mayer, August L. "Zu Goya." *Pantheon. The Cicerone* IX (April 1932): 113–116.

MEXICO 1978 *De El Greco a Goya* [exh. cat., Museo de Bellas Artes.] Mexico, 1978.

MELÉNDEZ VALDÉS (1821) 1986 Meléndez Valdés, Juan. *Discursos forenses.* Madrid, 1821. Rev. ed. Madrid, 1986.

MÉLIDA 1865 Mélida, Enrique. "*Los Proverbios.* Colección de diez y ocho láminas inventadas y grabadas al agua fuerte por D. Francisco Goya." *El Arte en España* 3 (1865).

MENA MARQUÉS 1986 Mena Marqués, Manuela B. "Noticias del Prado: el retrato de *La marquesa de Santa Cruz* en el Museo del Prado." *Boletín del Museo del Prado* VII, 19 (1986): 61–65.

MENA MARQUÉS 1998 Mena Marqués, Manuela B. "Goya, la question n'est pas résolue." In Lille and Philadelphia 1998: 25–37.

MENA MARQUÉS 2000 Mena Marqués, Manuela B. *Goya and Spanish Painting of the XVIIIth Century.* Madrid, 2000.

MENA MARQUÉS 2001 Mena Marqués, Manuela B. "Metamorfosis de un lienzo ¿El retrato de Josefa Bayeu?" In *Francisco de Goya. Obras maestras del Museo del Prado.* Madrid and Barcelona, 2001 (in press).

MISTRAL 1935 Mistral, Emilio. "Goya ante la Inquisición. Proceso contra sus dos *majas.*" *Estudio* XIII, 144 (1935): 3–4.

MITCHELL 1982 Mitchell, Timothy. "Goya's the Crockery Vendor." *Pantheon* XL, 1 (1982): 3–4.

MOFFITT 1990 Moffitt, John F. "Hacia el esclarecimiento de las *Pinturas negras* de Goya." *Goya* 215 (March–April 1990): 282–293.

MONACO 1958 *Le Siècle du Rococo* [exh. cat., Consejo de Europa.] Monaco, 1958.

MONTAUBAN 1942 *Chefs-d'Oeuvre espagnols du Musée du Louvre* [exh. cat., Chambre de Commerce.] Montauban, 1942.

MORALES 1979 Morales y Marín, José Luis. *Los Bayeu.* Saragossa, 1979.

MORALES 1990 Morales y Marín, José Luis. *Goya, pintor religioso.* Saragossa, 1990.

MORALES 1994 Morales y Marín, José Luis. *Goya. Catalogo de la pintura.* Saragossa, 1994.

MORALES 1997a Morales y Marín, José Luis. "La mujer en Goya." In *La Mujer en el Arte Español,* VIII Jornadas de Arte. Madrid, 1997: 285–296.

MORALES 1997b Morales y Marín, José Luis. *Las Parejas Reales de Goya. Retratos de Carlos IV y María Luisa de Parma,* Zaragoza, Gravur, 1997.

MORALES AND ARNAIZ 1988 Morales y Marín, José Luis, and José Manuel Arnaiz. *Los pintores de la Ilustración* [exh. cat., Centro Cultural Conde Duque.] Madrid, 1988.

MULCAHY 1988 Mulcahy, Rosemarie. *Spanish Paintings in The National Gallery of Ireland.* Dublin, 1988.

MULLER 1979 Muller, Priscilla E. "A Look at Artists, Academy and Taste in Eighteenth-Century Spain." In *A Symposium on The Art of the Age of Charles III* [Santa Barbara Museum of Art and National Gallery of Art, Washington]. Santa Barbara, 1979: 1–18.

MULLER 1984 Muller, Priscilla E. *Goya's Black Paintings. Truth and Reason in Light and Liberty.* New York, 1984.

MULLER 1997 Muller, Priscilla E. "Discerning Goya." *Metropolitan Museum Journal* 31 (1996): 175–187.

MUNICH AND VIENNA 1982 *Von Greco bis Goya. Vier Jahrhunderte Spanische Malerei* [exh. cat., Haus der Kunst; Künstlerhaus.] Munich, 1982.

NAGEL 1997 Nagel, Ivan. *Der Künstler als Kuppler. Goyas Nackte und Bekleidete Maja.* Vienna, 1997.

NEW YORK 1912 *Paintings by El Greco and Goya* [exh. cat., M. Knoedler & Co.] New York, 1912.

NEW YORK 1915 *Loan Exhibition of Paintings by El Greco and Goya* [exh. cat., M. Knoedler & Co.] New York, 1915.

NEW YORK 1917 *Exhibition of the Royal Manufacture of Tapestry and Carpets of His Majesty the King of Spain* [exh. cat.] New York, 1917.

NEW YORK 1934 *A Loan Exhibition of Paintings by Goya* [exh. cat.] New York, 1934.

NEW YORK 1936 *Francisco de Goya: His Paintings, Drawings and Prints* [exh. cat.] New York, 1936.

NEW YORK 1940 *New York's World Fair: Masterpieces of Art* [exh. cat.] New York, 1940.

NEW YORK 1950 *A Loan Exhibition of Goya, for the Benefit of the Institue of Fine Arts* [exh. cat., Wildenstein & Co.] New York, 1950.

NEW YORK 1955 *Goya: Drawings and Prints* [exh. cat.] New York, 1955.

NEW YORK 1965 *Feria Mundial de Nueva York* [exh. cat., Spanish Pavilion.] New York, 1965.

NEW YORK 1969 *In the Shadow of Vesuvius* [exh. cat.] New York, 1969.

NEW YORK 1992–1993 *Masterworks from the Musée des Beaux-Arts, Lille* [exh. cat., Metropolitan Museum of Art.] New York, 1992–1993.

NEW YORK 1993 *Splendid Legacy: The Havemeyer Collection* [exh. cat., Metropolitan Museum of Art.] New York, 1993.

NEW YORK 1995 *Goya in the Metropolitan Museum* [exh. cat., Metropolitan Museum of Art.] New York, 1995

NEW YORK AND WASHINGTON 1976 *Goya* [exh. cat., Metropolitan Museum of Art; National Gallery of Art.] Washington, 1976.

NOCHLIN 1999 Nochlin, Linda. *Representing Women.* Singapore, 1999.

NORDSTRÖM 1962 Nordström, Folke. *Goya. Saturn and Melancholy.* Stockholm, 1962.

NOTICIA 1828 *Noticia de los cuadros que se hallan colocados en la Galeria del Museo del Rey Nuestro Señor, sito en el Prado de esta Corte.* Madrid, 1828.

ORTEGA LÓPEZ 1997 Ortega López, Margarita. "Siglo XVIII: la Ilustración." In *Historia de las mujeres en España.* Madrid, 1997: 347–414.

OSTALÉ TUDELA 1926 Ostalé Tudela, Emilio. *Goya, las mujeres y el amor.* Saragossa, 1926.

OURSEL 1984 Oursel, H. *Le Musée des Beaux-Arts de Lille.* Paris, 1984.

PARIS 1878 *Exposición Universal.* Paris, 1878.

PARIS 1919 *Exposition de peinture espagnole moderne* [exh. cat., Palais des Beaux-Arts.] Paris, 1919.

PARIS 1935 *Goya: exposition de l'oeuvre gravée, des peintures, de tapisseries et de cent dix dessins du Musée du Prado* [exh. cat., Bibliothèque Nationale.] Paris, 1935.

PARIS 1938 *Peintures de Goya des collections de France* [exh. cat., Musée de l'Orangerie.] Paris, 1938.

PARIS 1961–1962 *Francisco de Goya y Lucientes, 1746–1828* [exh. cat., Musée Jacquemart-André.] Paris, 1961–1962.

PARIS 1963 *Trésors de la peinture espagnole. Églises et musées de France* [exh. cat., Musée du Louvre; Musée des Arts Décoratifs.] Paris, 1963.

PARIS 1979 *Goya 1746–1828, Peintures-Dessins-Gravures* [exh. cat., Centre Culturel du Marais.] Paris, 1979.

PARIS 1987–1988 *De Greco à Picasso. Cinq siècle d'art espagnol* [exh. cat., Musée de Petit Palais.] Paris, 1987–1988.

PARIS 1989 *La Révolution française et l'Europe.*

PARIS AND THE HAGUE 1970 *Goya* [exh. cat., Musée de l'Orangerie; Mauritshuis.] Paris, 1970.

PARIS AND NEW YORK 1992 *Lille, chefs-d'oeuvre d'un grand musée européen* [exh. cat., Grand Palais; Metropolitan Museum of Art.] Paris, 1992.

PARIS AND ROME 1987 *Subleyras, 1699–1749* [exh. cat., Musée du Luxembourg; Villa Medici.] Paris, 1987.

PAULIEN 1965 Paulien, Saint. *Goya. Son temps, ses personages.* Paris, 1965.

PEMÁN 1978 Pemán, María. "La colección artística de don Sebastián Martínez, el amigo de Goya, en Cádiz." *Archivo Español de Arte* 201 (1978): 53–62.

PEMÁN 1992 Pemán, María. "Estampas y libros que vió Goya en casa de Sebastían Martínez." *Archivo Español de Arte* 259–260 (1992): 303–320.

PEREYRA 1935 Pereyra, Carlos. *Cartas confidenciales de la reina María Luisa y de don Manuel Godoy.* Madrid, 1935.

PÉREZ SÁNCHEZ 1984 Pérez Sánchez, Alfonso E. "Las mujeres 'pintoras' en España." In *La imagen de la mujer en el arte*

español. Actas de las Terceras Jornadas de Investigación Inter-disciplinaria, Seminario de Estudios de la Mujer de la Universidad Autónoma de Madrid. Madrid, 1984: 73–86.

PÉREZ SÁNCHEZ 1985 Pérez Sánchez, Alfonso E. "Goya, temoin de la violence." In Brussels 1985: 51–61.

PÉREZ SÁNCHEZ 1987 Pérez Sánchez, Alfonso E. "Goya en el Prado. Historia de una colección singula." In *Goya. Nuevas visiones. Homenaje a Enrique Lafuente Ferrari.* Madrid, 1987: 307–322.

PÉREZ SÁNCHEZ AND SAYRE 1989 Pérez Sánchez, Alfonso E., and Eleanor A. Sayre. *Goya y el espíritu de la Ilustración* [exh. cat., Museo Nacional del Prado.] Madrid, 1989.

PERRY 1990 Perry, Mary Elizabeth. *Gender and disorder in Early Modern Seville.* Princeton, 1990.

PERUGA 1998a Peruga, Mónica Bolufer. "Lo íntimo, lo doméstico y lo público: representaciones sociales y estilos de vida en la España ilustrada." *Studia Historica* 19 (1998): 85–116.

PERUGA 1998b Peruga, Mónica Bolufer. *Mujeres e ilustración: La construcción de la feminidad en la ilustración española.* Valencia, 1998.

PHILADELPHIA 1876 International Exhibition, Philadelphia.

PITA ANDRADE 1979 Pita Andrade, José Manuel. "Una miniatura de Goya." *Boletín del Museo del Prado* 1 (1979): 12–16.

PITA ANDRADE 1989 Pita Andrade, José Manuel. *Goya, obra, vida, sueños.* Madrid, 1989.

PONZ 1772–1794 Ponz, Antonio. *Viaje de España.* 18 vols. Madrid, 1772–1794.

PUENTE 1987 Puente, Joaquín de la. "Goya decimonónico y los goyescos españoles del siglo XIX." In *Goya. Nuevas visiones. Homenaje a Enrique Lafuente Ferrari.* Madrid, 1987: 323–367.

QUIN 1823 Quin, Michael. *A Visit to Spain.* London, 1823.

RAMÍREZ Y GÓNGORA 1774 Ramírez y Góngora, Manuel Antonio. *Óptica del cortejo. Espejo claro en que con demostraciones prácticas del entendimiento se manifiesta lo insubstancial de semejante empleo.* Córdoba, 1774.

REUTER 2000 Reuter, Anna. "Cartones para tapices." In Mena Marqués 2000: 141–186.

RIBEIRO 1984 Ribeiro, Aileen. *Dress in Eighteenth-Century Europe, 1715–1781.* London, 1984.

RIBEIRO 1988 Ribeiro, Aileen. *Fashion in the French Revolution.* London, 1988.

RIPA 1698 Ripa, Cesare. *Iconologie ou la Sciences des Emblemes.* Amsterdam, 1698.

RITCHIE 1941 Ritchie, Andrew Carnduff. "The Eighteenth Century in the National Gallery: Italian, English, French and Spanish Masters." *Art News* 40 (June 1941): 39.

ROME 2000 *Goya* [exh. cat., Palazzo Barberini.] Rome, 2000.

ROSE 1983a Rose-de Viejo, Isadora. "Pinturas en el Museo del Prado procedentes de la antigua colección de Manuel Godoy." *Boletín del Museo del Prado* IV, 12 (1983): 170–178.

ROSE 1983b Rose-de Viejo, Isadora. *Manuel Godoy. Patrón de las artes y coleccionista.* 2 vols. Madrid, 1983.

ROSE 1999 Rose-de Viejo, Isadora. "Goya/Rembrandt: la memoria visual." In *Rembrandt en la memoria de Goya y Picasso.* Madrid, 1999.

ROSE 2001 Rose-de Viejo, Isadora. "Las alegorías de Goya para el palacio madrileño de Godoy." In *Francisco de Goya, Obras maestras del Museo del Prado.* Madrid and Barcelona, 2001 (in press).

ROUSSEAU (1782) 1997 Rousseau, Jean-Jacques. *Las confesiones.* Mauro Armiño, ed. Madrid, 1997.

RUEDA HERNANZ 2000 Rueda Hernanz, Germán. *Españoles emigrantes en América (siglos XVI–XX).* Madrid, 2000.

RÚSPOLI 2000 Rúspoli, Enrique. "La condesa de Chinchón." *Boletín de la Real Academia de la Historia* CXCII, cuaderno I (2000): 129–152.

SÁEZ PIÑUELA 1971 Sáez Piñuela, María José. "Goya en la moda de su tiempo." *Goya* 100 (1971): 232–239.

SALAS 1931 Salas, Xavier de. "Lista de cuadros de Goya, hecha por Carderera." *Archivo Español de Arte y Arqueología* 20 (1931), 176, no. 22.

SALAS 1950 Salas, Xavier de. "Miscelánea goyesca." *Archivo Español de Arte* 23 (1950): 335–346.

SALAS 1964a Salas, Xavier de. "El Goya de Valdemoro." *Archivo Español de Arte* XXXVII, 145–148 (1964): 281–293.

SALAS 1964b Salas, Xavier de. "Sur les tableaux de Goya qui appartirent à son fils." *Gazette des Beaux-Arts* LXIII (1964): 99–110.

SALAS 1965 Salas, Xavier de. "Inventario de las pinturas de la colección de don Valentín Carderera." *Archivo Español de Arte* XXXVIII, 149–152 (1965): 207–227.

SALAS 1968 Salas, Xavier de. "Precisiones sobre pinturas de Goya: *El Entierro de la Sardina*, la serie de obras de gabinete de 1793–1794 y otras notas." *Archivo Español de Arte* XLI, 161 (1968): 1–16.

SALAS 1968–1969 Salas, Xavier de. "Inventario. Pinturas elegidas para el Príncipe de la Paz, entre las dejadas por la viuda Chopinot." *Arte Español* XXVI, 1 (1968–1969): 29–33.

SALAS 1974 Salas, Xavier de. "Dos notas a dos pinturas de Goya de tema religioso." *Archivo Español de Arte* XLVII, 88 (1974): 383–396.

SALAS 1979a Salas, Xavier de. *Guía de Goya en Madrid.* Madrid, 1979.

SALAS 1979b Salas, Xavier de. "Minucias sobre Goya. Sobre el significado de las *Pinturas negras* de la Quinta." In *Estudios sobre literatura y arte dedicados al profesor Emilio Orozco Díaz.* Granada, 1979, III: 245–258.

SALAS 1994 Salas, Xavier de. *La familia de Carlos IV*. Barcelona, 1944.

SALCEDO RUIZ 1924 Salcedo Ruiz, Ángel. *La época de Goya*. Madrid, 1924.

SALTILLO 1950–1951 Saltillo, Marqués del. "Colecciónes madrileñas de pinturas: la de D. Serafín García de la Huerta." *Arte Español* XVIII, 204 (1950–1951): 169–210.

SALTILLO 1952 Saltillo, Marqués de. *Miscelánea madrileña, histórica y artística. Goya en Madrid: su familia y allegados (1746–1856)*. Madrid, 1952.

SAMBRICIO 1946 Sambricio, Valentín de. *Tapices de Goya*. Madrid, 1946.

SAMBRICIO 1957 Sambricio, Valentin de. "Los retratos de Carlos IV y María Luisa, par Goya." *Archivo Español de Arte* 30 (1957), 92.

SAN FRANCISCO 1937 *Paintings, Drawings and Prints by Francisco Goya, 1746–1828* [exh. cat., California Palace of the Legion of Honor.] San Francisco, 1937.

SÁNCHEZ CANTÓN 1916 Sánchez Cantón, Francisco Javier. *Los pintores de cámara de los Reyes de España*. Madrid, 1916.

SÁNCHEZ CANTÓN 1930 Sánchez Cantón, Francisco Javier. *Francisco Goya*. Paris, 1930.

SÁNCHEZ CANTÓN 1931 Sánchez Cantón, Francisco Javier. "La estancia de Goya en Italia." *Archivo Español de Arte* VII (1931): 182–184.

SÁNCHEZ CANTÓN 1942 Sánchez Cantón, Francisco Javier. *Museo del Prado. Catálogo de los cuadros*. Madrid, 1942.

SÁNCHEZ CANTÓN 1946a Sánchez Cantón, Francisco Javier. "Cómo vivía Goya." *Archivo Español de Arte* XIX (1946): 73–109.

SÁNCHEZ CANTÓN 1946b Sánchez Cantón, Francisco Javier. "Goya, pintor religioso." *Revista de Ideas Estéticas* IV, 15–16 (1946): 3–33.

SÁNCHEZ CANTÓN 1951 Sánchez Cantón, Francisco Javier. *Vida y obras de Goya*. Madrid, 1951.

SÁNCHEZ CANTÓN AND SALAS 1963 Sánchez Cantón, Francisco Javier, and Xavier de Salas. *Goya y sus Pinturas negras de la "Quinta del Sordo."* Barcelona, 1963.

SÁNCHEZ VENTURA 1928 Sánchez Ventura. "Santas Justa y Rufina." *Aragón* 31 (1928): 151.

SARAGOSSA 1991–1992 *Goya* [exh. cat., La Lonja.] Saragossa, 1991–1992.

SARAGOSSA 1996a *Realidad e imagen. Goya 1746–1828* [exh. cat., Museo de Zaragoza.] Saragossa, 1996.

SARAGOSSA 1996b *Permanencia de la memoria: cartones para tapiz y dibujos de Goya*. [exh. cat., Museo de Zaragoza.] Saragossa, 1996.

SARAGOSSA 1996c *Goya y el infante don Luis de Borbón. Homenaje a la infanta doña María de Vallabriga* [exh. cat., Patio de la Infanta.] Saragossa, 1996.

SARAGOSSA 1997 *Después de Goya: una mirada subjetiva*. [exh. cat., Museo de Zaragoza.] Saragossa, 1997.

SARASÚA 1996 Sarasúa, Carmen de. "Un mundo de mujeres y de hombres." In *Vida cotidiana en tiempos de Goya*. Madrid, 1996: 65–72.

SAYRE 1958 Sayre, Eleanor A. "An Old Man Writing: A Study of Goya's Albums." *Boston Museum Bulletin* LVI (1958): 116–136.

SAYRE 1966 (1979) Sayre, Eleanor A. "Goya's Bordeaux Miniatures." *Boston Museum Bulletin* LXIV, 337 (1966): 84–123. Also in Paris 1979.

SAYRE 1974 Sayre, Eleanor A. *The Changing Image: Prints by Francisco Goya*. Boston, 1974.

SAYRE 1979 Sayre, Eleanor A. "Goya: A Moment in Time." *Stockholm Nationalmuseum Bulletin* III, 1 (1979): 28–49.

SAYRE 1980 Sayre, Eleanor A. *Goyas "Spanien, Tiden och Historien" en allegori över antagandet av 1812 ars spanska författing* [exh. cat., Nationalmuseum.] Stockholm, 1980.

SAYRE 1985 Sayre, Eleanor A. "The *Portrait of the Marquesa de Santiago* and Ceán's Criticism of Goya." *J. Paul Getty Museum Journal* 13 (1985): 147–150.

SAYRE ET AL. 1989 Sayre, Eleanor A., et al. *Goya and the Spirit of Enlightenment*. [exh. cat., Museum of Fine Arts, Boston.] Boston, 1989.

SCHICKEL 1968 Schickel, Richard. *The World of Goya*. Princeton, 1968.

SCHULZ 2000 Schulz, Andrew. "Satirizing the senses: the representation of perception in Goya's *Los Caprichos*." *Art History* XXIII, 2 (June 2000): 153–181.

SEBASTIÁN 1979 Sebastián, Santiago. "Interpretación iconológica de las *Pinturas negras* de Goya." *Goya* 148–150 (1979): 268–277.

SEBASTIÁN 1980 Sebastián, Santiago. *Iconografía e iconología en el arte de Aragón*. Saragossa, 1980.

SEMPLE 1807 Semple, Robert. *Observations on a Journey through Spain and Italy to Naples*. 2 vols. London, 1807.

SENTENACH 1876 Sentenach, Narciso. *Catálogo de los cuadros, esculturas, grabados y otros objetos artísticos de la colección de la antigua Casa Ducal de Osuna*. Madrid, 1876.

SENTENACH 1900 Sentenach, Narciso. "Notas sobra la Exposición de Goya." *La España Moderna* 138 (1900): 34–53.

SENTENACH 1907 Sentenach, Narciso. *La Pintura en Madrid desde sus orígenes hasta el siglo XIX Boletín de la Sociedad Española de Excursiones*. Madrid, 1907.

SENTENACH 1914 Sentenach, Narciso. *Los grandes retratistas en España*. Madrid, 1914.

SENTENACH 1921 Sentenach, Narciso. "Fondos selectos del Archivo de la Academia de San Fernando: la galería del Principe de la Paz." *Boletín de la Real Academia de Bellas Artes de San Fernando* XV (1921): 59–60.

SENTENACH 1923 Sentenach, Narciso. "Fondo selecto del archivo de la Academia de San Fernando: Goya, académico." *Boletín de la Real Academia de Bellas Artes de San Fernando* XVII (1923): 169–174.

SEVILLE 1929 *Exposición Hispanoamericana.* Seville, 1929.

SEVILLE 1982 *Obras maestras en collecciónes particulares* [exh. cat., Caja de Ahorros de San Fernando.] Seville, 1982.

SOLER 1985 Soler, Richard. *Goya and the Nothern Tradition.* Houston, 1985.

SOLVAY 1905–1906 Solvay, Lucien. "Les femmes de Goya." *L'Art et les artists* II (1905–1906): 193–205.

SORIA 1943 Soria, Martín S. "Agustín Esteve and Goya." *Art Bulletin* XXV (1943): 239–266.

SORIA 1948 Soria, Martín S. "Goya's Allegories of Fact and Fiction." *The Burlington Magazine* XC, 538 (1948): 196–200.

SORIA 1949 Soria, Martín S. "Las miniaturas y retratos-miniaturas de Goya." *Cobalto* XLIX, 2 (1949): 1–4.

STAROBINSKI 1988 Starobinski, Jean. *1789. Los emblemas de la razón.* Madrid, 1988.

STOCKHOLM 1959–1960 *Stora Spanska Mästare* [exh. cat., Nationalmuseum.] Stockholm, 1959–1960.

STOCKHOLM 1980 *Goyas "Spanien, Tiden och Historien" en allegori över antagandet av 1812 ars spanska författing* [exh. cat., Nationalmuseum.] Stockholm, 1980.

STOCKHOLM 1994–1995 *Goya* [exh. cat., Nationalmuseum.] Stockholm, 1993–1994.

STOICHITA 1999 Stoichita, Victor, and Anna María Coderch. *Goya. The Last Carnival.* London, 1999.

STOKES 1914 Stokes, Hugh. *Francisco Goya.* 1914.

STONE 1990 Stone, Lawrence. *The Family, Sex, and Marriage in England 1500–1800.* Princeton, 1977.

SULLIVAN 1982–1983 Sullivan, Edward J. *Goya and the Art of his Time* [exh. cat., Meadows Museum, Southern Methodist University.] Dallas, 1982–1983.

SYMMONS 1988 Symmons, Sarah. *Goya In Pursuit of Patronage.* London, 1988.

SYRACUSE AND MILWAUKEE 1957 *An Exhibition of Spanish Painting* [exh. cat., Syracuse Museum of Fine Arts; Milwaukee Art Institute.] Syracuse, N.Y., 1957.

TINTEROW 1993 Tinterow, Gary. "The Havemeyer Pictures." In New York 1993: 13–17.

TOKYO 1993–1994 *Desde Veronés a Goya. Pinturas y dibujos del Palais des Beaux-Arts de Lille* [exh. cat., Tobu Museum of Art, Tokyo; Yokohama Museum of Art; Aichi Prefectural Museum of Art, Nagoya; Kitakyushu Municipal Museum of Art.] Tokyo, 1993–1994.

TOKYO, AMAGASAKI, AND PUKUSHIMA 1987 *Spanish Paintings of the 18th and 19th Century. Goya and his Time* [exh. cat., Seibu Museum of Art; Seibu Tsukashin; and Iwaki City Museum Fukushima.] Tokyo, 1987.

TOLEDO 1941 *Spanish Paintings* [exh. cat., Toledo Museum of Art.] Toledo, Oh., 1941.

TOMLINSON 1984 Tomlinson, Janis A. "Goya y lo popular." *Pantheon* XLII (1984): 23–29.

TOMLINSON 1989a Tomlinson, Janis A. *Graphic Evolutions: The Print Series of Francisco Goya.* New York, 1989.

TOMLINSON 1989b Tomlinson, Janis A. *Francisco Goya. The Tapestry Cartoons and Early Career at the Court of Madrid.* Cambridge, 1989.

TOMLINSON 1991 Tomlinson, Janis A. "Burn it, Hide it, Flaunt it: Goya's Majas and the Censorial Minds." *Art Journal* L, 4 (1991): 59–64.

TOMLINSON 1992a Tomlinson, Janis A. *Goya in the Twilight of Enlightenment.* New Haven and London, 1992.

TOMLINSON 1992b *See* Tomlinson 1991.

TOMLINSON 1994 Tomlinson, Janis A. *Francisco Goya y Lucientes 1746–1828.* London, 1994.

TOMLINSON 1996 Tomlinson, Janis A. "Evolving Concepts: Spain, Painting, and Authentic Goyas in Nineteenth-Century France." *Metropolitan Museum Journal* 31 (1996): 189–202.

TOMLINSON 2001 Tomlinson, Janis A. "La familia de Carlos IV." In Mena Marqués 2001.

TONE 1999 Tone, John Lawrence. "Spanish Women in the Resistance to Napoleon, 1808–1814." In *Constructing Spanish Womanhood: Female Identity in Modern Spain.* Victoria Lorée Enders and Pamela Beth Radcliff, eds. Albany, 1999: 259–266.

TORMO 1900 Tormo y Monzo, Elías. "Las pinturas de Goya y su clasificación cronológica." *Revista de la Asociación Artístico Barcelonesa* (1900).

TORMO 1902 Tormo y Monzo, Elias. "Las pinturas de Goya y su clasificación cronológica." *Varios Estudios de Arte y Letras* I, 1–2 (1902): 214 and 218.

TORRALBA 1990 Torralba Soriano, Federico. *El entorno familiar de Goya.* Saragossa, 1990.

TORRECILLAS FERNÁNDEZ 1985 Torrecillas Fernández, María del Carmen. "Nueva documentación fotográfica sobre las pinturas de la Quinta del Sordo de Goya." *Boletín del Museo del Prado* VI, 17 (May–August 1985): 87–96.

TORRECILLAS FERNÁNDEZ 1992 Torrecillas Fernández, María del Carmen. "Las pinturas de la Quinta del Sordo fotografiadas por J. Laurent." *Boletín del Museo del Prado* XIII, 31 (1992): 57–68.

TORRES 1996 Torres, María Teresa Rodríguez. "Economía de Guerra en Goya. Cuadros pintados con cañas." In *Actas* 1996: 131–149.

TOWNSEND 1791 Townsend, Joseph. *A Journey through Spain in the Years 1786 and 1787.* 3 vols. London, 1791.

TRABAJO 1985 *El trabajo de las mujeres a través de la historia.* Centro Feminista de Estudios y Documentación. Madrid, 1985.

TRAEGER 1990 Traeger, Jörg Traeger. "Goyas Königliche Familie: Hofkunst und Bürgerblick." *Münchner Jahrbuch der Bildenden Kunst* 41 (1990): 147–181.

TRAPIER 1964 Trapier, Elisabeth du Gué. *Goya and his Sitters. A Study of his style as a Portraitist.* New York, 1964.

VALENCIENNES 1918 *Geborgene Kunstwerke aus dem besetzten Nordfrankreich* [exh. cat., Musée des Beaux-Arts.] Valenciennes, 1918.

VALLENTIN 1994 Vallentin, Antonina. *Goya.* Madrid, 1994.

VALVERDE 1979 Valverde, José. "La librera de la calle de Carretas." *Goya* 148–50 (1979): 278–279.

VALVERDE 1983 Valverde, José Valverde. "El Retrato de doña Sabasa García por Goya." *Goya* 177 (1983): 108–109.

VALVERDE 1988 Valverde, José. "Leocadia Zorrilla, la amante de Goya." In *Coloquios de Iconografía.* Madrid, 1988, II: 435–439.

VEGA 1990 Vega, Jesusa. *Origen de la litografía en España: El Real Establecimiento Litográfico.* Madrid, 1990.

VEGA 1996 Vega, Jesusa. "El comercio de estampas en Madrid durante la Guerra de la Independencia." In *Estampas de la Guerra de la Independencia* [exh. cat., Academia de Bellas Artes de San Fernando.] Madrid, 1996.

VENICE 1989 *Goya, 1746–1828* [exh. cat., Galleria Internazionale d'Arte Moderna di Ca'Pesaro.] Venice, 1989.

VENTURI 1941

VIARDOT 1843 Viardot, Louis. *Les Musées d'Espagne, d'Angleterre et Belgique. Guide et mémento de l'artiste et du voyageur.* Paris, 1843.

VIGIL 1986 Vigil, Mariló. *La vida de las mujeres en los siglos XVI y XVII.* Madrid, 1986.

VILLAMANA AND BAEZA 1928 Villamana, Elena, and Aniana Baeza. "La mujer y la moda en tiempos de Goya." *Aragón* 31 (1928): 96–97.

VIÑAZA 1887 Viñaza, Conde de la (C. Muñoz y Manzano). *Goya: su tiempo, su vida, sus obras.* Madrid, 1887.

VOLLAND 1993 Volland, Gerlinde. *Männermacht und Frauenopfer. Sexualität und Gewalt bei Goya.* Berln, 1993.

WALDMANN 1998 Waldmann, Susan. *Goya and the Duchess of Alba.* Munich, London, and New York, 1998.

WASHINGTON 1986–1987 *Goya. The Condesa de Chinchón and Other Paintings, Drawings, and Prints from Spanish and American Private Collections and the National Gallery of Art.* Washington, 1986–1987.

WEHLE 1940 Wehle, Harry B. *The Metropolitan Museum of Art: A Catalogue of Italian, Spanish and Byzantine Paintings.* New York, 1940.

WEITZENHOFFER 1986 Weitzenhoffer, Frances. *The Havemeyers: Impressionism Comes to America.* New York, 1986.

WILLIAMS 1976 Williams, Gwyn A. *Goya and the Impossible Revolution.* London, 1976.

WILSON 1977 Wilson, Michael. *The National Gallery of London.* London, 1977.

WILSON-BAREAU 1988 Wilson-Bareau, Juliet, ed. *Édouard Manet. Voyage en Espagne.* Caen, 1988.

WILSON-BAREAU 1993/1994 Wilson-Bareau, Juliet. *Goya: Truth and Fantasy.* New Haven and London, 1994.

WILSON-BAREAU 1996a Wilson-Bareau, Juliet. "Goya in the Metropolitan Museum." *The Burlington Magazine* 1115 (1996): 95–103.

WILSON-BAREAU 1996b Wilson-Bareau, Juliet. "Goya and the X Numbers: The 1812 Inventory and Early Acquisitions of Goya Pictures." *Metropolitan Museum Journal* 31 (1996): 159–174.

WILSON-BAREAU 1997 Wilson-Bareau, Juliet. *Manet, Monet, and the Gare Saint-Lazare.* [exh. cat., National Gallery of Art.] Washington, 1997.

WILSON-BAREAU 2001 Wilson-Bareau, Juliet. *Goya: Drawings from his Private Albums.* London, 2001.

WITTMANN 1998 Wittmann, R. "¿Hubo una revolución en la lectura a finales del siglo XVIII?" In *Historia de la lectura en el mundo occidental.* Madrid, 1998: 435–472.

WOLF 1990 Wolf, Reva. *Francisco de Goya and the Interest in British Art and Aesthetics in late Eighteenth-Century Spain.* Ph.D. diss. Ann Arbor, 1990.

WOLF 1991 Wolf, Reva. *Goya and the Satirical Print.* [exh. cat., Boston College Museum of Art.] Boston, 1991.

WOLFTHAL 1999 Wolfthal, Diane. *Images of Rape: The "Heroic" Tradition and its Alternatives.* Cambridge and New York, 1999.

WORTH 1990 Worth, Susannah. *Andalusian dress and the Andalusian image of Spain: 1759–1936.* Ph.D. diss., Ohio State University, 1990.

WYLD 1981 Wyld, Martin. "Goya's Re-use of a Canvas for Doña Isabel." *National Gallery Technical Bulletin* 5 (1981): 38–43.

WYNDHAM LEWIS 1970 Wyndham Lewis, D. B. *El mundo de Goya.* Madrid, 1970.

YOKOHAMA, CHIBA, YAMAGUCHI, KOBE, AND TOKYO 1993–1994 *Titian to Delacroix: Master European Paintings from the National Gallery of Ireland* [exh. cat., Yokohama; Chiba; Yamaguchi; Kobe; Tokyo.] Tokyo, 1993–1994.

YRIARTE 1867 Yriarte, Charles. *Goya. Sa biographie, les fresques, les toiles, les tapisseries, les eaux-fortes et le catalogue de l'oeuvre.* Paris, 1867.

ZAPATER 1868 Zapater Gómez, Francisco. *Goya. Noticias biográficas.* Saragossa, 1868.

ZAPATER 1924 Zapater Gómez, Francisco. *Goya. Noticias biográficas.* Madrid, 1924.

Index of Titles

Photographic Credits

Cat. 34: Malcolm Varon, © 1995 The Metropolitan Museum of Art; Cat. 34, fig. 1: Photographic Services, The Metropolitan Museum of Art; Cats. 38 and 39: Cathy Carver; Cat. 60: © Photo RMN—P. Bernard; Cat. 63: Bruce M. White; Cat. 65: Museo Nacional del Prado, José Baztán y Alberto Otero; Cat. 67: Museo Nacional del Prado, José Baztán y Alberto Otero; Cat. 69: Schecter Lee; Cat. 70: Schecter Lee; Cat. 76: Museo Nacional del Prado, José Baztán y Alberto Otero; Cat. 93: Museo Nacional del Prado, José Baztán y Alberto Otero; Cat. 94: Museo Nacional del Prado, José Baztán y Alberto Otero; Cat. 95: © 1999 The Metropolitan Museum of Art; Cat. 96: © 1994 The Metropolitan Museum of Art; Cat. 99: © 1998 The Metropolitan Museum of Art; Cat. 100: © 2001 The Metropolitan Museum of Art; Cat. 101: Schecter Lee; Cat. 102: Schecter Lee; Cat. 103: © 2001 The Metropolitan Museum of Art; Cat. 104: Museo Nacional del Prado, José Baztán y Alberto Otero; Cat. 105: Museo Nacional del Prado, José Baztán y Alberto Otero; Cat. 106: © The J. Paul Getty Museum; Cat. 107: Museo Nacional del Prado, José Baztán y Alberto Otero; Cat. 108: © 1999 The Metropolitan Museum of Art; Cat. 109: © 2000 The Metropolitan Museum of Art; Cat. 110: © 1985 The Metropolitan Museum of Art.